WOMEN OF CONSCIENCE

WOMEN OF CONSCIENCE

Social Reform in Danville, Illinois
1890–1930

Janet Duitsman Cornelius AND *Martha LaFrenz Kay*

THE UNIVERSITY OF SOUTH CAROLINA PRESS

© 2008 University of South Carolina

Published by the University of South Carolina Press
Columbia, South Carolina 29208

www.sc.edu/uscpress

Manufactured in the United States of America

17 16 15 14 13 12 11 10 09 08 10 9 8 7 6 5 4 3 2 1

Library of Congress Cataloging-in-Publication Data

Cornelius, Janet Duitsman.
 Women of conscience : social reform in Danville, Illinois, 1890–1930 / Janet Duitsman
Cornelius and Martha LaFrenz Kay.
 p. cm.
 Includes bibliographical references and index.
 ISBN 978-1-57003-746-7 (cloth : alk. paper)
 1. Women social reformers—Illinois—Danville—History. I. Kay, Martha LaFrenz, 1938–
II. Title.
 HQ1439.D37C67 2008
 305.4209773'65—dc22

 2008006064

This book was printed on Glatfelter Natures, a recycled paper with 30 percent postconsumer
waste content.

CONTENTS

ILLUSTRATIONS

PREFACE

Our Journey

TRAVELING THE PATH that brought this book to fruition has taken us almost a decade, and we treasure the many helpers who guided us, smoothed the way over rough spots, and suggested new directions as we traced the evolution of Danville, Illinois, women from private to public personas a century ago. Our search to uncover the stories and significance of Danville's emerging women began about ten years ago, when Sue Richter told members of the worthy, but now defunct, Local History Group about her research into Danville's YWCA (Young Women's Christian Association). It was then that we learned how the Woman's Club had helped the young working women coming into Danville who needed a quiet and clean place to eat lunch and in some cases lacked social connections or a decent boardinghouse. We were fascinated to think that club members, definitely among the elites of the town, concerned themselves with the welfare of working women and that there was some connection among women across the social divide.

Sue Richter and her husband, Don, have done so much to keep local history alive through the Vermilion County Museum and their historical quarterly, the *Heritage of Vermilion County*. They suggested useful directions and sources for our research. As director of the museum, Sue opened its vertical files, scrapbooks, diaries, and valuable books, including early city directories, to us. Wendy Wilder and Jack Olmstead made us welcome as we spent hours poring over a wealth of material. We are indebted to them for their generosity, and to Don Richter for reading our manuscript.

Another local historian, journalist Kevin Cullen, raised the community's consciousness of the richness of Danville and Vermilion County history in his articles for the *Danville Commercial-News* over many years in the late twentieth century. Kevin shared suggestions and articles with us, immeasurably

helping our work on the Danville Woman's Club and on prostitution in the city.

Richard Cannon, truly passionate about local history, also inspired and aided us in our explorations. Dick was an indefatigable researcher who produced a rich history of his own hometown, Fithian, and who taught a course in Vermilion County history at the Danville Area Community College for many years. His sociologically oriented perspective and his statistical and oral research on Danville's African Americans influenced the directions of our research of Danville history. In addition, his careful reading of our manuscript before his untimely death was a great help to us in finishing our work.

Other careful and insightful readers include Janet's granddaughter Wendy Camp, a professional editor, and friends Joanne Wheeler of the University of Illinois and Kay Murphy of the University of New Orleans.

Among our most treasured helpers were those who gave us firsthand accounts of their lives or those of their elders. Our friend Melissa Merli, a perceptive journalist, introduced us to her grandmother Rose Fava Merlie, who spoke to us when she was one hundred years old about her life as a young woman in Westville's Italian immigrant community. Dorothy Livesey Sturm Duensing, in her nineties, shared her recollections of the elitism she felt when she first came to Danville as a young teacher. It was our last visit to our friend before she passed away.

We were fortunate in locating another woman just in time to get her valuable recollections. In 2001, acting on a suggestion from Donna Martin, we asked Gladys Walker for an interview. She was a week short of her 101st birthday. Though deaf, she was sharp in her mind and still vigorous in her opinions. We had sent some written questions before the interview and added more on a pad for her to read and answer. Her insights about the benefits of the YWCA to young women workers were succinct and quotable, and they revealed her as their leader, who stood up to the elites on the YWCA board and local businessmen on their behalf. Gladys Walker's clarity of mind and memory of that time were a gift to us, and we have tried to do her justice in this book. A broader picture of her life and efforts was provided after her death by her son, Wesley Walker, who had made her proud by choosing the YMCA as his life's work after college. Wesley shared pictures, impressions, and his father's diary to illustrate, as he said, how community outreach was as natural as breathing was for Gladys.

Another serendipitous connection was our contact with Marilyn Coolley Carley, the only direct descendant of suffragist Nellie Coolley. Through a friend we obtained a telephone number for Marilyn in California, and our resulting conversations proved fruitful and enjoyable. Marilyn was only five when her activist grandmother died, but she had her own and her mother's

memories of this imposing, charismatic woman. She shared many pictures, samples of Nellie's longtime bridge column for the *Danville Commercial-News* and other writings, and material on the medical, civic, and horse-breeding activities of Nellie's husband, Dr. Elmer Burt Coolley. We also appreciate Marilyn's enthusiasm for our project and her interest in its progress.

Doris Krueger invited us into her home to talk about the early activities of the Lutheran church ladies. Margaret McElwee and Mary Rothery shared their memories of Holy Family Catholic Church. Father Geoffrey E. L. Scanlon and Richard Lewis opened the archives of Holy Trinity Episcopal Church. We consulted Sybil Stern Mervis's history of Danville's Jewish community in the *Heritage of Vermilion County* and received helpful answers to our many questions in personal conversations with her. Ivadale Foster shared her knowledge of the early church ladies in the African American denominations.

We consulted a history of the Clover Club written by Luise Snyder, who also received us in her home for an interview about her connections to the English family. Clover members Joan Ring and her sister Susan Freedlund invited us to the Ring home for discussion of their mother and grandmother, both temperance advocates. Clover member Marlene Cannon gave us insights into Danville's social scene during the 1920s. The only living Clover who is a descendant of a club founder, Rosamond McDonel, shared pictures and memories of her great-grandmother Eliza Webster, the generous matriarch of the Vermilion County Children's Home "Board Ladies." In 1989 McDonel's brother Dan Olmsted, UPI bureau chief in Washington, D.C., wrote an anniversary history of the Children's Home, which proved a valuable source. Clover member Ellen Jewell invited us into her home for family stories regarding her late husband's great-grandfather W. R. Jewell, opinion leader and editor of the *Danville Daily News*.

Another rewarding interview took place in the apartment of Doris Slusser and Audrey Slusser Oswalt, granddaughters of Viola Slusser, longtime matron of the Children's Home, and her husband, known as "Uncle George" to the orphans. The sisters recalled many visits to the home, which was where their grandparents lived. Anna Marie Kukla passed along memories of the home from her grandmother Sylvia Macy, who was a resident as a child. Aggie Miller, also a former resident, was helpful in a telephone interview.

Lou O'Brien gave us details about the women who worked in his family's commercial laundry, the first steam laundry in Danville. Dr. John Curtis shared recollections of his early medical practice when doctors made house calls, even to the infamous houses on Green Street. Vic Pate, who grew up in Danville's Green Street neighborhood during the 1940s and 1950s, shared recollections of his life there and his memories of Danville's prostitution industry, which became so notorious that the commander of Chanute Air

Force Base in Rantoul placed Danville off-limits to his airmen in 1956. Vic then recommended that we speak to Elizabeth Pitlick, who grew up in the same neighborhood in earlier years. Ninety-two-year-old "Libby" Pitlick was bright, assertive, and witty—a joy to interview. She readily shared with us her recollections of growing up as the daughter of Hungarian immigrants, of the convent and the nuns of St. Joseph's and Holy Cross churches, of her nodding acquaintance with the prostitutes in her old neighborhood, and of her career as a young, single, working woman. Dow Cooksey shared his vivid memories of Frances Pearson Meeks, from whom he received a scholarship award.

Taking student Molly Kreidler home after a Shakespearean field trip, we discovered to our surprise that she resided in the former home of the Danville Woman's Club. We were subsequently invited in for a tour of the brick building, whose spacious rooms with rich, dark woodwork and high ceilings reminded us of its former function.

The late Ellen Morris, former executive director of the YWCA, opened to us the YWCA papers, including a treasure of yearbooks, pictures, histories, records of events, and scrapbooks of clippings. Ellen also gave us some insights into the role of Danville elites on the YWCA board and suggested that we interview Lee McGrath, board member and a longtime executive director. Lee, who was ninety-six years old and self-composed, gave us useful recollections of the YWCA and of Danville's social structure. Carolyn Miller Coffman, YWCA executive director during the 1940s, shared many insights about personalities and about the way in which YWCA facilities were quietly integrated in 1946.

Carolyn helped us in another direction too. Her daughter Mary Coffman, our close friend, shared the diary of her grandmother Doris Zook Miller. Mary and her sisters admired Doris and considered the diary, with its list of boyfriends, a source of amusement, and we recognized its value as a chronicle of a young woman trying to find herself in her transition from girl to independent woman during the 1920s. We were fortunate that while working with Doris's diary both Carolyn and Mary were able to help us fill out the picture of her life.

Another diary came to us unexpectedly when Brenda Voyles, a student in Janet's History of Women class (which she teaches for Eastern Illinois University), presented us with three diaries that a colleague had purchased in an auction box of miscellaneous items. Brenda recognized that these were diaries by a working woman, a rare find. Elizabeth Stewart's diaries give a glimpse of a small-town working woman's life: her good times, her dreams, and above all her fellowship with her women friends.

We had been hearing rumors for a long time about the existence of another firsthand source, the diary of Mary Hessey Forbes (later English). Our friend

Judy Fippinger said she had read this wonderful, turn-of-the-century diary, which was in the possession of Phil and Dottie Rouse, but Phil and Dottie could not remember where they had put it. When they eventually located this treasure and shared it with us, we were introduced to a grieving but resourceful widow, whose diary became the basis of our prologue.

We had much-appreciated help from officials. Sheriff Pat Hartshorn, a former student, opened his office to us early in our quest to understand Danville's legal system and voting patterns. He knew whom we should approach to open up city and county records: Janet Myers, Danville city clerk; Barbara Dreher of the county clerk's office; Barbara Young, another former student and director of the Danville Board of Election Commissioners, and her smiling assistants Barbara Bailey and Sally Smith; and Sue Miller and Peggy Kincaid of the Fifth Judicial Circuit Clerk's Office. All of these women showed interest in our research and provided not only access but also office space in which to work. Attorney Bill Garrison and our former student Mayor Scott Eisenhauer answered our telephone queries. Another former student, Steve Laker, head of the Vermilion County Health Department, shared stories and books on public-health issues.

Members of the Danville Woman's Club kindly invited us to a meeting, opening the door to our access to all of the club's yearbooks, with the earliest volumes collected and bound for preservation. We owe particular thanks to Betty Goff, who loaned us the volumes and patiently waited until we had explored them several times and returned them to the Woman's Club. The yearbooks, which were a rich source for club structure and its broad range of activities, revealed the personalities of outstanding women of accomplishment.

As members of the Clover Club, a woman's study group founded in 1894 and still active today, we had easy access to its yearbooks and minutes, which documented the evolution of the club. Artifacts, program presentations written out in delicate handwriting, pictures, histories, and tender obituaries were treasure troves of information.

When we went searching for the history of the Children's Home, we knocked on the door of the Center for Children's Services because we knew it occupied the building that formerly housed orphans. The director at the time was Karen Kracht, who appreciated the importance of our research, was able to locate the early documents of the Children's Home in her vault, and generously provided office space.

Other doors were opened to us by the churches of Danville. St. James United Methodist Church (which had been St. James Methodist Episcopal Church until 1968) actually has a room called the "archive," which Jean Moody unlocked for us. She then guided us past random collections of old

pictures, maps, and Sunday school materials to a cabinet that contained several historical scrapbooks. These wonderful collections have been assembled, protected, and frequently updated. One of these scrapbooks introduced us to Cora Abernathy. Rev. Tiffany Black later reopened the archive room so that we could select a picture of Mrs. Abernathy and her Sunday school class. At the First Presbyterian Church archival materials are not so well organized, but they are legion, and we were welcome to dig through the boxes. We were delighted to discover the story of "First Pres" as compiled in a valuable church history by Louise Nelms and Eleanor Yeomans in 2001. At First Baptist Church we might never have located any records of the early activities of women had it not been for Lillian Whitten and Brenda Miller, who provided a church history written by Pastor Edward L. Krumreig in 1919. Lillian also led us through the gymnasium area and behind the Coke machine to a locked cabinet that contained the detailed minutes of the Ladies Aid Society. Pastor Jerry L. Cummins allowed us to interview him. Marty Burns provided a paper on women and missions that she had recently prepared.

Libraries and research centers were essential to our journey, and we are grateful for the expertise and helpfulness of our guides. Danville Public Library's research staff was the crew we bothered most frequently, and they were patient assistants with microfilm readings of many old newspapers, directories, and vertical files. Thanks to Roberta Allen, director of Reference and Archives, and library assistants John Bruns and Nancy Holler. The Illiana Genealogical Society, located in Danville, houses a rich collection and a helpful staff.

Fortunately we are located only thirty miles from one of the world's great university libraries. The University of Illinois research staff assisted us with censuses, newspapers, and journals. Director John Hoffman and James Cornelius (no relation) of the Illinois Historical Survey were especially helpful with primary and secondary collections and with their breadth of knowledge of sources. We are proud members of the Friends of the University of Illinois Library and frequent patrons of this tremendous facility.

One of the highlights of our research journey was a weekend spent in Evanston, Illinois, at the Frances E. Willard Memorial Library as we traced the activities of Danville's temperance ladies. Woman's Christian Temperance Union (WCTU) librarian and archivist Virginia Beatty not only opened the door to us but also spent the weekend personally searching out the exact documents we needed. She even arranged a private showing of the Willard homesite, which is on the same property, giving us added perspective on the humble beginnings of the charismatic Willard.

Also helpful with guidance were the staff members of the Chautauqua Archives, under the direction of Marlie Bendicken; the Chicago Historical

Society Archives, under the direction of Russell Lewis; and two essential Springfield, Illinois, institutions: the Illinois State Archives, where John Rinehart gave us assistance, and the Illinois State Library, whose research staff is directed by Kathryn Harris. The latter has the largest collection of Illinois newspapers in the state and also houses papers of the Illinois Federation of Women's Clubs, which we explored several times.

Our journey of several years has acquired many other helpers too numerous to mention. In expressing our gratitude to the following, we apologize for inadvertently omitting others. Marian Hall, Joan Griffis, the late Shirley Nesbitt, Norma Cole, and Virginia Boynton suggested areas for research and women to interview. Robert Sampson and Morgan McFarland shared unpublished manuscripts with us. The family of the late Carl Cunningham allowed us to purchase many of his books on Vermilion County and Illinois history.

We also recognize our debt to those who have gone before us in treasuring and keeping Danville and Vermilion County history. Hiram Beckwith's massive Vermilion County history of 1879 expertly celebrated the county's Native Americans and its pioneers. Gustavus Pearson compiled a biographical county history in 1903, and Jack Williams did another in 1930, both of which contain useful biographies and narratives. The best of Vermilion County histories for our purposes, however, was the two-volume *History of Vermilion County* published by Lottie Jones in 1911. Jones was one of the three "Jones Sisters" well known in the community: Miss Lydia was the homemaker, Miss Mary was the executive secretary of Illinois Printing Company, and Miss Lottie taught in the primary department at Washington School. In addition to teaching, Lottie tried in many ways to preserve national and local heritage. She was one of those many women of her era who believed that young people must be impressed with a knowledge of their past and a proper respect for its symbols. She wrote "Decisive Dates in Illinois History" for use in the schools, held workshops on teaching history, and helped to found the Danville branch of the Daughters of the American Revolution (DAR) in 1908, along with other active and socially prominent women. For the DAR, Lottie led a successful fund drive to place a statue of a "Minute Man" in front of the post office. The DAR also placed markers tracing Abraham Lincoln's travels along the Eighth Circuit trail in the county and on the lawn of the Fithian home, where Lincoln was a frequent guest.

Lottie Jones's *History of Vermilion County* shares some of the emphasis on the county's male founders that frustrated us in our search for material on women founders; the biographical volume 2, paid for by the male subscribers and biographees, mentions women only as wives, mothers, and daughters of the subjects. However, in volume 1 Jones tells of women as pioneers and religious leaders and celebrates their public roles as clubwomen and teachers to

a greater extent than other historians have. Lottie's stern character was also an inspiration; according to Louise Mills, another preserver of history, Lottie "admired Uncle Joe Cannon's forthright, headstrong, and forceful ways—which were not unlike her own." Her own refusal to compromise her ideals was well known, and her history is a gift to those who have come after her.

A very different woman from the same era also sought to preserve the past, but in her own way and her own version of the past. Florence "Flo" Woodbury was a member of the well-known family that founded Danville. She lived the active life of an individualist who did not have to be concerned about social position. Flo was a clubwoman, but the coed Cooking Club, members of which seemed to enjoy partying over cooking, was her chief endeavor. Flo and friends seemed to poke fun at Danville's club proliferation when they founded the G.I.P. Club and refused to reveal what the letters stood for or what the club did. She and her sister Lucy adopted the bicycling craze in the mid-1890s, and Flo became the first woman elected to an office in the American Bicycling Society. Her picture graced the cover of the first issue of *American Girl Magazine*.

In addition to bicycling, Cooking Club excursions, and the dance lessons she gave to children, Flo recorded the history of her time in scrapbooks that are now housed in the Vermilion County Museum. Some focus on her own exploits and those of her friends; others celebrate patriotism and great men in national and Illinois history. Through them we were able to get a glimpse of another sort of New Woman, one who went her own way. From Flo's scrapbooks we also sensed the wave of patriotism that suffused so much of the rhetoric of her times and which must have permeated the thinking of the citizens, at least in the ruling class, of Danville.

We also owe a debt to Katherine Stapp, renowned teacher and community activist, who celebrated Danville's distinctive citizens in two popular picture books: *History under Our Feet* (1968) and *Footprints in the Sands: Founders and Builders of Vermilion County, Illinois* (1975). While most of her "heroes" were from the traditionally male elites of Danville, Stapp also celebrated achievers in a diversity of occupations and accomplishments, including women, African Americans, and Native Americans. Her work has had a major impact on Danville citizens, as the importance of their heritage has grown in their awareness.

One of Danville's favorite sons, entertainer Bobby Short, wrote *Black and White Baby* (1971), an autobiographical record of growing up in Danville. Born in 1924, he began his piano and vocal career as a child prodigy in local schools, churches, and saloons. From him we borrowed the term "sin city" to describe Danville, and from him we learned much about the city's racial climate and the musical opportunities for a talented black boy in a white tux.

In conclusion, we thank our mothers, Irene Froman LaFrenz, who was 102 when she passed in 2006, and Mary Ellen Michael Duitsman, 96 as we go to press. They agreed to be interviewed on their impressions of the early twentieth century. Irene was the baby of her farm family, practically reared by her two much older sisters. She well remembered how energized her family and all the locals were when the summer Chautauqua tent went up and all her family climbed into the buggy to go to town and share the music and the lectures. Mary wrote an account of the typical work week of a country housewife; she still remembers how her mother, a favorite aunt, and a cousin somehow found time to get together and how they laughed and laughed, finding joy in each other, strengthening each other, and making their hard lives bearable. Though neither of us has a sister, our mothers' experiences have helped us appreciate that sisterhood was and is an integral part of women's lives. We treasure our friends, especially our women colleagues at Danville Area Community College, who have been so supportive during our long journey to create this book, and of course we include our daughters, granddaughters, and great-granddaughters in our circle of sisterhood.

INTRODUCTION

*The whole town rushed like a comet along the plane of improvement.
. . . The very air, resinous and sweet, had a peculiar tingle. . . . everybody
was going to succeed, and on the way could put up with a few
inconveniences.*

Mary Hartwell Catherwood, "Spirit of an Illinois Town"

THE MOOD OF DANVILLE, ILLINOIS, in the 1890s was captured in
these phrases from a short story by historical novelist Mary Hartwell Cather-
wood, who had come to Danville a few years earlier, taught school there,
married, and moved on. In 1890 Danville, Illinois—located on a bluff over-
looking the Vermilion River and ten miles from the Indiana border in east
central Illinois—was a medium-sized town with a population of about fifteen
thousand, on the verge of growth and change. Danville's communal living
patterns resembled those of other river and prairie towns of its era. People in
Danville walked everywhere, stopping along tree-lined streets to chat with
individuals who sat on their open porches, viewing the scene and displaying
themselves to passersby. Churches, which both bound and separated social
classes, punctuated the landscape. A variety of newspapers, a small library
(soon to be considerably enlarged), a new high school, elementary schools,
and two "seminaries" for higher education sought to unify and inform pub-
lic opinion. Imposing downtown buildings on Main and Vermilion streets
included banks, hardware and commercial stores, hotels, theaters, and an
opera house. Most services were personal: grocers filled orders; doctors prac-
ticed out of their homes as well as their offices; postmen delivered mail twice
a day; and the lone hospital was run by an order of Catholic nuns. Trans-
portation in this preautomobile era was also communal. The horse and
buggy, the riverboat, the railroad, and the streetcar gave residents of Danville
and outlying areas a shared experience.[1]

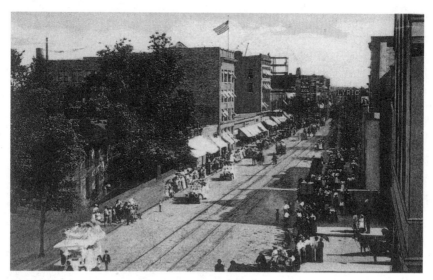

Danville street scene, c. 1900. Courtesy of Pat Phillips

Danville, like most midwestern river towns, was also a "cumulative community."[2] Its founders in the 1820s were mostly from the border South, but during the next decades settlers from the Northeast, as well as Irish and German immigrants, arrived. Catherwood described the people on Main Street as "literally walking through a square mile of Ohio cheer, Kentucky hospitality, New York far-sightedness with capital to back it, and native Illinois grit."[3] The shared experience of the Civil War gave perspective to the town, particularly since many of its most active and able "movers and shakers" came to Danville seeking a new life after their traumatic wartime service.[4] In addition, more European immigrants and a small African American community had come to Danville to work in its mines and to service its railroads.[5] By 1890 the town's prominent citizens resided in neighborhoods of spacious homes north and west of the main business section, while middle-class families spread out a few blocks farther, and the miners clustered in outlying neighborhoods and towns to the south. The community came together on Saturday's trading days, noon to midnight, when farmers and their families made their weekly or monthly shopping trips and the hotels and taverns did a booming business. Community events also drew larger crowds: political rallies, Chautauquas, festivals, agricultural fairs, picnics, and veterans' parades. Volunteer groups—baseball teams, bands, and firemen—attracted large and enthusiastic numbers. The leading men in town were not only movers and shakers but also joiners of lodges and civic associations.[6]

Catherwood titled her story "Spirit of an Illinois Town," and its "spirit" was a young woman, hardworking, artistically talented, and so possessed of all the moral virtues that she continued to model right conduct for less perfect men even after her sudden death in a tornado. Until 1890 Danville women played a lesser role in public events than men did, and no role at all in public organizations, except for ladies' aids and other church societies. Yet they were highly revered and credited for the successes of their men. Women had been raised to act the role of the "True Woman." As described by historian Barbara Welter, a "True Woman" was expected to conform to the ideals of domesticity, piety, purity, and submission. She was to live to serve others, and she was to focus her life on her home, her husband (whom she was always to obey), and her children. She was to set a high standard for the morals of the family and to be a model of religious observance.[7] This set of expectations was promoted for nineteenth-century woman; however, most women could not afford to conform to it, or would not. Many worked outside the home to support their families. The Civil War forced more women to assume traditional men's roles and public activities. After the war, women confronted the forces of industrial change, and a few active woman suffrage and civil rights leaders entered the national scene. By 1890 women had another ideal model for their behavior: the "New Woman," educated, confident, assertive, and ready to assume a public, as well as a private, role.[8] Danville's elite women were poised to embrace this ideal. As a descendant of one of the city's prominent families pointed out, the daring and ambitious men who built Danville chose equally able, strong-minded, active wives.[9] Though few if any of these women in 1890 had had the advantages of education beyond the local seminaries, they were travelers, readers, and activists. They embraced the revolution that was transforming women's lives throughout the nation. They began to put their consciences into action, joining with and supporting each other, learning, helping others, and eventually entering the political world of their growing city.

Women began to enter the public domain in Danville just as the town was going through a transformation. In the 1890s the town almost doubled its population to twenty-five thousand, gaining the status of a small city. Railroads connected Danville with major urban centers in the Midwest, including Chicago, St. Louis, and Indianapolis. Coal and zinc mines, brick manufacturing, and many small industries thrived. The National Home for Disabled Volunteer Soldiers, known locally as the Old Soldiers Home, was brought to Danville in the 1890s because of the influence of local congressman and Speaker of the House Joseph Gurney Cannon. Built on the east end of the city, by 1900 the Old Soldiers Home housed some twenty-five hundred veterans with government checks to spend, and it provided employment for local

citizens. The people of Danville supported millinery shops, clothing and department stores, restaurants, saloons, theaters, and personal services that included laundries and barbershops. African Americans, numbering more than a thousand in Danville by 1900, patronized their own stores, churches, and doctors.[10] While women could still walk or drive buggies to visit neighbors and families and take part in church activities, paved streets downtown and an electric-streetcar system widened their worlds, facilitating their shopping duties and their ability to join with other women beyond their own neighborhoods.[11]

Growth for Danville was not all peaceful and orderly, however. The nation's labor conflicts, battles between armed union workers and an armed National Guard, and the wave of racially charged lynchings extended to Danville in the 1890s and beyond. Two women, one a miner's daughter and the other a miner's wife, were killed in Grape Creek just outside of Danville in an 1894 clash between National Guard troops and members of the striking American Railway Union, which was linked to the Pullman strike begun the year before.[12] The following year two white men accused of attacking and raping a young girl were lynched on the Vermilion River Bridge. In 1903 another lynching brought national attention to Danville when rioters lynched and burned a black man who had been held in the city jail for murder. The mob also attacked the county jail, demanding that the sheriff release to them another black man accused of robbery and rape; the sheriff held off the angry crowd until the Illinois National Guard arrived in Danville, where they patrolled the streets to keep peace for two weeks.[13] In addition to violent events, an ongoing problem of corruption was generated in Danville's "sin city" areas: the lively Danville Junction in the northeast, which serviced the many travelers who changed trains at the junction; and the Commercial Street / Green Street area south of Main near St. Elizabeth's Hospital. Illegal gambling and prostitution were linked to the profitable liquor interests, which used copious bribes to corrupt the political system.

Danville's women did not attack the problems of labor conflict, lynchings, and prostitution directly, but they did become activists in *social housekeeping,* the term used for the actions of women who reached out beyond their own homes to bring cleanliness, order, morality, reason, and beauty to their communities. Women in Danville supported their churches and were passionate about Sunday schools, aid societies, and especially missions. They established a home for needy children and expanded their own minds through membership in literary clubs. Clubwomen worked for the welfare of children, for the health of the city, and for the safety of working girls. Active in the temperance movement, they developed political savvy that made them leaders in the fight for woman suffrage.

The story of Danville women's entry into the public sphere illustrates how women leaders on national and state levels galvanized those in small towns and cities into action. Chicago-area women led political activism and social reform in the Midwest, and Danville women recognized their leadership. They invited social worker Jane Addams to speak in Danville on the "Social Responsibilities of Citizenship," and they made pilgrimages to Hull House in Chicago to learn how to engage in community outreach at home. The Illinois Federation of Women's Clubs, spearheaded by Chicago women, met in Danville to approve a crucial vote advocating woman suffrage. African American women founded a Danville Colored Woman's Aid Club and joined it with the Federation of Illinois Colored Women's Clubs, led by Chicagoans Fannie Barrier Williams and Ida B. Wells. The Woman's Christian Temperance Union (WCTU), led by Frances Willard, held a state convention in Danville, and the Illinois Equal Suffrage Convention met twice in Danville as they fought for political rights for women. Like Champaign, Bloomington, Alton, Peoria, and other small Illinois cities, Danville reflected the impact of notable Chicago women on a wide population outside the big city.

Danville women's history is part of the story of American women's emerging consciences during the late nineteenth century. This story has been told effectively on a national level. However, an examination of Danville women also illustrates the usefulness of local community studies. Danville's experience diverges from national trends in some ways.

Chapter 1 chronicles Danville women's earliest ventures outside the home into the public life of their churches. Like other church women nationally, they acted first to fill local needs. Many volunteered to teach Sunday school and formed ladies' circles or societies, primarily to give essential support to the material needs of their churches. Then their passion turned to missions, which held a romantic fascination for women as a possibility for heretofore unimagined career opportunities. Missionary societies frequently doubled as benevolent societies and thus fulfilled women's need to nurture and protect, all in the service of God. Presbyterian, Methodist, and Baptist women in Danville exhibited a tenacity in their focus on fund-raising and their encouragement of foreign missions that sometimes led them into conflict with their ministers. If there was divergence between Danville and other church women nationally, it was that Danville undertook to support foreign missions primarily, while women in other cities often organized missions in their own neighborhoods. Danville church women were indeed active in local religiously connected benevolences such as the WCTU and the Young Women's Christian Association (YWCA), but they worked in these organizations across denominational lines instead of maintaining separate single-church appeals.

Historians of women usually chart the public evolution of the late nine-teenth-century New Woman in this sequence: first, women joined in church and benevolent activities; second, they began literary clubs for learning and sisterhood; third, they organized women's clubs for both literary and social housekeeping activities; and fourth, they moved on to engage in political activity for community welfare and woman's rights.[14] This theory of evolution has been questioned in studies of individual communities and time periods. Indeed, it takes some divergent turns in Danville, where women gained confidence in their abilities to study, speak, and bond with other women in literary study before they organized a major benevolent institution. Chapter 2 tells the story of the Clover Club, which began with a Chautauqua study circle established in 1890 but separated from Chautauqua in 1894 and created its own rules. Members of the Clover Club showed their independence from the beginning of the club's existence and likely separated from Chautauqua because they wanted to control their own literary practices and to read and write as they wished. They also chose to be exclusive, designating membership by invitation and legacy and restricting their membership to twenty-five, a group small enough to be entertained in most members' homes. Meeting every Monday afternoon, the club prized talent and a devotion to learning and the arts, but wealth and family connections were major factors in the selection of members. The members developed a strong sisterhood that exists in the Clover Club to this day.

The strong sisterhood and confidence that developed from literary studies led women to benevolent outreach in the Danville community. Traditionally, elite women had shared their time and wealth with the worthy poor, but benevolence took on a public aspect with the establishment of orphanages in the nineteenth century. Chapter 3 examines the creation of the Vermilion County Children's Home "Board Ladies" and compares it to the establishment of orphanages in other cities. Danville's Board Ladies, like other founders of orphanages, were motivated by a mixture of unease about children being assigned to the public poorhouse, a sense of obligation toward the poor, and an assurance that they had a superior way of life to convey to these children. They struggled with the problems of limited financial resources and staffing. Their rewards, though, were many: enhanced mobility, public approval, and an outlet for their religious zeal. The Vermilion County Children's Home Board Ladies differed from other managers of orphanages in some respects: they ran the Children's Home without male board members and held direct control of the administration of the home much longer than most boards did. The most important difference was that—because of the outstanding and long-enduring leadership of its first manager—the Danville Children's Home did not suffer from the "matron problem."

The Chautauqua study circles that Danville women founded in 1890 took two directions. While one evolved into the private and exclusive Clover Club, the other evolved into a very different women's organization—the Danville Woman's Club, the subject of chapter 4. Unlike the elite Clovers, the Woman's Club was a mixture of socially prominent young matrons, older elite women, teachers, and other professionals. Some members pursued the study of history, literature, art, and music, while others focused on philanthropy and political action. As the leader in coordinating smaller clubs all over Danville, the Woman's Club led the way in many social housekeeping and public-health-related projects and shone in times of crisis. It was the center for women's activities during World War I and worked with the Red Cross to fight influenza and tuberculosis. Though the Woman's Club undertook many civic projects, the health and welfare of women and children were its primary considerations.

Chapter 5 examines the public world of working women and their relationship to the clubwomen who are the focus of the preceding chapters. Danville's increasing numbers of employed women from the 1890s to the 1930s reflected national trends, but Danville was a "working woman's town"; in the twentieth century Vermilion County had the highest percentage of working women in Illinois.[15] Most Danville women's employment had some connection to traditional female work: domestic service, laundries, or family businesses, from large factories to mom-and-pop stores. Some worked in the "needle trades" or were employed in other factories that produced food, clothing, and other female-related items. A large number of young women grasped their new opportunity to become office workers, which gave rise to business colleges and business courses in high schools. The diary of clerical worker Elizabeth Stewart shows her frustrations with low pay and uncertain hours but also her pride in her work and the good times she shared with friends. Stewart lived with her parents, but many women left their homes on farms and in small towns to make lives for themselves in big cities or in small cities such as Danville. They were brave and resourceful as they made their way on their own, but they often needed help in a town such as Danville, with its low wages, scarce affordable housing, and thriving liquor, sex, and gambling industries.

Chapter 6 examines Danville's fame in the surrounding area as an entertainment center and a "sin city," where gambling, liquor, and commercial sex were readily available. Prostitutes ran the gamut from girls who were paid for companionship, to those who occupied or managed brothels, and even to those who were forced into sex, as exposed by Danville newspaper reporters and others during the white-slave crusade of the Progressive era. Single women who came to Danville in search of work ran the risk of being sidetracked into

sexual commerce, so clubwomen and church women established a Travelers Aid Society and a YWCA in 1910. Some scholars have portrayed the YWCA as stifling working girls' initiative by emphasizing traditional protection and exalting upper-middle-class values.[16] The program of the Danville Y, though, was shaped to a large extent by assertive working girls and a "third tier" of women professionals in an uneasy alliance with its elite board of directors. The Y offered parties, gymnastics, camping, a cafeteria, an inexpensive residence, an employment service, and classes in self-improvement—trying to meet as many needs as possible to keep working women from the temptations of "sin city."

Chapter 7 examines how women in Danville undertook political action and campaigned for the vote. This local community focus reveals the significance of conservative women, passionate advocates of temperance, as a grassroots factor in woman suffrage. Religiously oriented women were attracted to the WCTU, where they could put to use the organizational skills they had developed in missionary and aid societies to try to eliminate the availability and heavy use of alcohol, a threat to family stability. While national WCTU leader Frances Willard advocated a broad agenda for the WCTU, the Danville union focused on local needs and issues and fought an obvious evil in the city: the power of the liquor interests, which were closely tied to gambling and prostitution and which used their money to buy votes and bribe election officials to keep Danville "wet." Temperance women joined forces with the Equal Suffrage Association, which sought to fulfill the promise of American democracy by granting women their political rights, the theme of Susan B. Anthony's address in Danville in 1877. When Illinois women won the right to vote in presidential and municipal elections in 1913, Danville women promptly united to pass the measure long desired by temperance advocates—they voted Danville "dry" in 1917.

How Danville women managed their increasingly busy and challenging lives and how their husbands and families reacted to their changing roles—from True Woman to New Woman—vary as much as individuals and circumstances vary, as will be shown in the women profiled in this book. The changes and continuities experienced by Danville women are revealed by the two diaries discussed at the beginning and the end of the book. Mary Forbes, the 1890s True Woman, was interested in politics and civic affairs, but she chose to remain a private person, maintaining her identity as a mother and the wife of two prominent, elderly men. Doris Zook, the flapper of the 1920s, had the mobility and freedom that Mary Forbes lacked. She dated, danced, drank, and stayed out late with a succession of young men. She was proud of her office skills and voted in every election. However, her choices were traditional as well as modern: she was involved with her church for

her whole life; she embraced temperance; and she escaped her domineering mother in a very traditional way, by making a hasty marriage and having a daughter of her own.

Danville women made choices. Together with women everywhere in America they put their consciences into action as they moved out of their homes and worked together in public to support each other and to better their communities. As they did, they gained a new sense of the value and necessity of sisterhood and an increasing realization of their own worth and abilities.

WOMEN OF CONSCIENCE

Prologue THE DIARY OF MARY FORBES

*Twenty-two years ago today we had our first dinner here, and com-
menced housekeeping in this house. All these happy years. We have
been right here. My Dear husband enjoyed his garden and was always
at home. Our dear girls Delia and Carrie grew up here and was a great
comfort to us. How proud Mr. Forbes was of them. What lovely sweet
girls they are. He was ambitious to live to see them grown and settled in
life, always wanted them to have a good education. It was a great loss to
have him taken from us. Oh no one can ever know the lonely, sad hours
I have spent in the last year. I have been busy seeing to business etc but
I am glad I have something to occupy my mind, or what would I do.*

Diary of Mary Forbes, June 25, 1896

THUS REFLECTED MARY FORBES in her home at North and Walnut
streets, Danville, Illinois. The daughter of a family that had settled Danville
and become grocers, Mary became the second wife of Thomas Chester Forbes,
a wealthy landowner and prominent Danville citizen. Thomas Forbes had
died in January 1895 at age ninety-two, leaving his forty-five-year-old wife to
record her mourning in poignant diary entries. Besides providing therapy for
the grieving widow, Mary's diary offers modern readers an intimate view of
the daily life of a True Woman beset with sadness but poised on the thresh-
old of life-altering decisions. From June 25, 1896, until January 20, 1898,
Mary wrote brief but revealing entries nearly every day, filling the slim vol-
ume from cover to cover. The motif of the diary is Mary's loneliness, but the
reader is equally drawn to the details of Mary's daily life, which reveal her
love of her daughters and her home, her devotion to her church, her begin-
ning interest in community activities, and the confident way she stepped into
the complicated business affairs left unfinished by her husband. Almost as if
Mary knew she was writing for readers who would appreciate a narrative

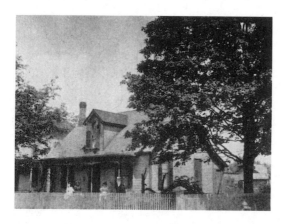

Thomas Forbes's house, with Mary on front porch behind her husband and daughters. From Lottie Jones, History of Vermilion County, *1:178*

"hook," she introduced a "gentleman caller"—at first cryptically and some-times in code, later in more detail but still with tantalizing brevity.

Mary Elizabeth Hessey married Thomas Chester Forbes in 1874, when she was twenty-four and he was seventy-two. The man she called "Mr. Forbes" or "Papa" in her diary became the father of her two daughters. He was originally from Connecticut, but "attracted to the rapidly growing west," he had become one of the founding fathers of Vermilion County in Illinois, a land broker, and a moneylender. According to Lottie Jones's *History of Vermilion County*, "his realty holdings became extensive and . . . his pros-perity increased."[1] His 1895 obituary in the *Danville Evening Commercial* records that at the time of his death Forbes was the "oldest resident of Ver-milion County, a pioneer of Danville's early days, and a very highly respected citizen."[2]

Mary's first diary entry, written on June 25, 1896, reflects on her life as a married woman and her deeply felt loss of her husband. In the fall of the same year, her loneliness still pervaded her diary: "September 3, 1896: Alone! Alone! Oh if I could speak or even look upon my dear one tonight. So many things I need his kind words and advice about, can I stand the long winter?" More than a year later she wrote: "November 1, 1897: Rained all night and still raining. The wind blowing and it is hard to carry an umbrella. . . . I wonder how, and where my dear ones are today—it seemed lonely when the days were bright. Oh! It is terribly gloomy today to be alone!" Between these two yearning entries, Mary Forbes (ever sensitive to the weather) undertook a journey of discovery as her loneliness was refocused and her self-sufficiency tested.

Mary may have been lonely, but she was seldom alone. For a while her two beloved daughters, Cordelia and Caroline ("Delia" and "Carrie" in the diary), were at home. Ages nineteen and sixteen, respectively, at the time of

their father's death, the girls were a comfort to their mother. Even so, Mary bravely pursued Mr. Forbes's wishes that his daughters "have a good education," sending them to St. James School in Albany, New York, in the fall of 1896. Scattered throughout the diary, entries from September 1896 through November 1897 indicate how much Mary missed them: "This is the last Sunday before the girls go to school. . . . Delia's first birthday away from home. . . . Oh how can I stay here alone. I could not even write the girls I was so homesick. . . . My head aches dreadful. . . . Another headache but at least a letter from Delia. . . . Papa's birthday. Dear kind letter from Carrie with love and sympathy for me in the morning mail."

Even with her daughters away, however, Mary was seldom alone. Mary's German maid, Bertha, may have lived in the home and was a companion. Mary frequently mentions "Addie," a seamstress who did the Forbes's sewing at Mary's house. Mary's business manager, Mr. Moore, came about twice a week to go over property matters and other financial accounts, to help in the yard, and to make travel arrangements. In addition, there was a parade of visitors to the Forbes's home: Mrs. Forbes (perhaps Mary's sister-in-law), Aunt Kate Forbes, Aunt Belle Hessey, other prominent ladies of Danville, acquaintances who came to negotiate business, and—with increasing frequency—a distinguished gentleman caller, Mr. Joseph English. Yet, Mary's diary entry for September 2, 1897, shows how she could be lonely even when surrounded by people: "Welcome, gentle rain. . . . Mrs. Kniffin and Belle here this evening on our porch. Delia playing [the piano]. Carrie and Mamie singing in the parlor. I am awful lonely tonight, seem quite discouraged."

Typical of women diarists, Mary recorded the concrete details of daily life. They give her diary an almost tangible reality—as in her descriptions of food. Writing about one meal she found particularly notable, Mary commented on October 24, 1897, that "Bertha had a good dinner. Roast chicken. Celery jelly, sweet and mashed potatoes, sliced tomatoes, tiny pickles, apples & hickory nut cake, grapes, but I could not eat much as I was alone and not hungry." When she sent the girls off to school, on September 28, Mary made sure her daughters would not go hungry on the train: "I fixed a lunch. Bread & butter, chicken & ham, pickles, cake & fruit." When the girls came back for the holidays, Bertha's Christmas dinner, as noted on December 28, was "lovely. . . . Turkey, cranberries, celery, white potatoes, peas, olives, raspberry jelly, spiced peaches, lemon jelly, Nut cake, Suet Pudding with hard sauce. Grapes. Macaroons. Tea."

Perhaps the rhythm and demands of women's work helped to keep Mary Forbes from deeper despair. In any case, she and Bertha washed on Mondays, regardless of the weather, as on January 18, 1897: "Monday. Cloudy. Windy. Got up late but managed to get the washing done." Even if it rained, she "got

the clothes dry and ironed" on Tuesday, which was ironing day. Friday was the day for weekend cleaning, shopping for staples, and running errands. On Sunday it was church in the morning, dinner with company, and more church events and socializing in the evening.

Mary listed her domestic accomplishments with pride, anchoring herself in the reality of daily duties. In 1897 she described spring cleaning:

> April 18: Bertha and I took the things out of the Parlor and had the wall-paper cleaned and the new carpet put down.
> May 4: Had my [bedroom] carpet dusted at Philips laundry.
> May 5: Planted the poppies Addie gave me, some morning Glories, cypress & transplanted the Nasturtiums. . . .
> May 6: We cleaned the bedroom & closet.
> May 19: Bertha & I cleaned the china closet today.

While Bertha was her only live-in and full-time servant, Mary paid for many other services. Seamstress Addie came to the house for several days at a time to sew dresses, dressing gowns, corset covers, comforters, and pillow-cases for the girls to take with them to their New York school. Mr. Bacon plowed the garden, planted flowers and bushes, and arranged for the lawn mowing, while Mr. Reed trimmed trees. Mr. Whitley helped Bertha with the spring cleaning: taking up carpets, washing the outside of the house, and whitewashing the walls in the kitchen, hall, and stairway. Carpets were dusted or replaced, and "the men" came in and repapered some rooms.

Mary regularly noted the challenges she had to meet because of the weather, as in her entries from January 21 through January 24, 1897: "It snowed last night this morning was very cold everything frozen up. It took a long time to get our Buckwheat cakes and sausage ready. I have fixed fires all day. The windows were all frost. . . . 6 below zero 8 A.M. Cold. Everything froze in the kitchen. The dining room windows all white with frost . . . did not go out of the house. . . . sleighs flying by."

In addition to her devotion to family and home, Mary Forbes exhibits the True Woman's devotion to her church, in this case the Episcopal Church. The diary reveals no interest in missionary societies, which had become a passion for many of Danville's Protestant women, but Mary made frequent references to attending church with friends on Sundays and sometimes during the week as well. Entries from February 1897 include: "Church on Valentine's Day. . . . Went up to church tea, had a lovely supper. . . . the ladies of the [Altar] Guild met in the afternoon to sew, all went to 5 o'clock services. . . . Went to church with Mrs. Kniffin and Mrs. Forbes."

Mary's daughters belonged to the Daughters of the King, an Episcopal organization for the spiritual and social support of women and girls. Delia,

before she went away to school in the East, often decorated the altar before Sunday church services.

An interesting series of diary entries suggests that Mary may have become a benefactress of her Episcopal church. In October 1896 she wrote: "After supper we went to church. Fr. Rockstroh had a very interesting talk." In early December of that year she mentioned, "Fr. Rockstroh called tonight and told me about the church meeting." On December 28 Rockstroh came to visit and explained to Mary that the church must have a new furnace. She recorded another pastoral visit on December 30. One year later, on January 7, 1898, the good father earned two mentions, one direct and the other indirect: "Fr. Rockstroh went to the station to see the girls off [to school]. . . . The new furnace . . . is so warm we could hardly stay in church."

Devoted to her church, Mary apparently had no other regular associations outside her home, despite the fact that Danville offered a growing number of public opportunities for women in the late 1890s. Groups such as the private and prestigious Clover Club and the ambitious Danville Woman's Club were well established, but Mary did not belong to them. Danville women were participating in, even founding, benevolent associations such as the Vermilion County Children's Home. While Mary made charitable contributions, she did not choose to venture personally into those activities.

Mary was apparently interested in political spectacle, as she recorded events in her diary during the exciting elections of 1896, which put a Reform candidate in the mayor's office. She may have attended some rallies, but she could have observed parades from her home, just a block off Main Street. She wrote:

Democratic Rally. Gov. [John Peter] Altgeld spoke at Fair Grounds. Horns, horns, & horns. (September 25, 1896)

Republican Rally. The town was full of people by 8 o'clock. Men on horseback flying by. Horns, horns & drums. Quite a big parade. Speaker [Senator J. C Burrows] Burroughs from Mich. spoke at Lincoln Park. The streets crowded all day, big torchlight procession tonight, with horns, lanterns, Roman candles, drums, noise, and songs. (September 26, 1896)

The crowd on the square is large. Drums. Hollowing and finally the cannon firing. The band is passing now going to serenade at Kimbrough's house. Hurrah for a good Mayor. (April 20, 1897)

Mary was most comfortable in her home, but more and more she ventured into the public sphere. On October 27, 1896, she took some visitors "to Mr. Moore's Office to see [William Jennings] Bryan." She recorded train trips out of town, the first an extensive trip in June 1897 to her daughters' school in Albany, New York. Mary described in entries from May 1 through

May 13, 1897, the pomp and ceremony of Delia's commencement, followed by her visit with her daughters to New York City, where they were hosted often by members of the Sill family (relatives of her husband's first wife, Mary Sill): "We left on 'the New York' River boat for the wonderful city, arriving at Grand Union Hotel about 6 P.M. . . . Saturday up early, started out to see the city. First went to Altmans where I left my sealskin to be made over. . . . Central Park carriage ride . . . Art Museum . . . elevated road over to Brooklyn and back . . . up the Hudson River to Albany . . . St. Pauls church just repaired by Tiffany . . . [return by] sleeping car to Indpls."

Later Mary recorded a two-week visit in August 1897 to Wisconsin, a popular destination for wealthy Danville residents during the hottest month of the year. During that visit she made day trips to Milwaukee, went to church, enjoyed beach picnics, entertained visitors, received letters from home, and attended band concerts. Other brief train visits to Indianapolis seem to have been business oriented; Mr. Forbes may have owned property there.

In addition to train travel, Mary recorded occasional local trips outside her home, usually in the company of lady friends, to downtown stores or cultural events. Mentions of these activities became more frequent, suggesting a woman who was developing a comfortable public persona:

> Addie and I went to the opening of the Golden Rule [new department store downtown], it was a dreadful crowd, pushing, crowding. The store was very beautiful. The millinery was fine. New Shoes. Lovely. (April 5, 1897)
>
> I went with Mrs. Forbes to Woman's Club rooms to see the art exhibit. China and pictures. (February 8, 1897)
>
> I went with Mrs. Forbes to the City Hall to dinner, a benefit for the Children's home . . . a large crowd estimated at 500 people. (February 9, 1897)
>
> Went to Lady Minstrel with Belle and Mrs. Forbes at Opera House. (May 21, 1897)
>
> I went with Mrs. Kniffin to Presbyterian Church to hear Jane Adams [sic] of Hull House fame for Woman's Club. (November 4, 1897)

Even as Mary Forbes was venturing out of her home and into the public sphere, it remained appropriate that most of her business affairs were handled in her home. Her husband had been a man of considerable wealth and property who lived to the age of ninety-two, and according to Mary's diary, he was "always at home." Therefore, it stands to reason that he had time to make plans for his estate and that he ran his business from home with the help of trusted assistants. That became Mary's pattern as well. She recorded

occasional business trips outside her home, to the bank or to Lawyer Calhoun's office, and occasionally she made trips into the country to visit her properties and sometimes to be entertained by tenants: "Delia, Carrie, Eunice and I left in a carriage with a good driver for the country. Mrs. Starr had a lovely dinner ready for us. . . . We all went down to the river and tried to fish. I caught the first one, about 6 in long."

Most of the people with whom Mary did business came to her home or were represented by the most frequently mentioned visitor in the diary, Mr. Moore: "Mr. Moore came to tell about the house at No. 1 [Mary often referred to the farms by number.]. . . . Mr. Moore this afternoon going over bills and books for August. . . . Mr. Moore planted grass seed in the yard. . . . Mr. Moore came for the trees to take to Farm No. 3. . . . Mr. Moore helped me with the list for the tax assessor. . . . Mr. Moore talked awhile about the farms brought me a copy of expense of Delia and Carrie's farms [Mr. Forbes apparently put property in his daughters' names before he died]. . . . Mr. Moore here today helping Delia with her Latin."

Obviously, Mr. Moore was involved with all of Mary's business affairs (and some domestic affairs as well). His constant attendance and steady advice were surely a comfort to her, and maybe she was learning the family business from him. However, Mary Forbes, who had been a pampered True Woman during the twenty-one years of her marriage, may be observed in her diary as she adjusted to her new circumstances and began to make necessary financial decisions on her own:

> I had a letter from Willie and answered it, wants to have me release the mortgage on part of his fathers lot. . . . I cannot, do not think it best. (March 26, 1896)
>
> Mr. and Mrs. Driskell & baby was here to dinner, said they had a good oats crop but had to sell at 10 cts. so I gave off 88 dollars on the first note now due. . . . (September 16, 1896)
>
> Mrs. Swisher was pleased to know we have decided to build addition to house on Farm No. 10. (February 17, 1897)
>
> Mr. McIntyre came early this morning, talked a long time about a road through the farm. Mr. Moore this afternoon. . . . (February 26, 1897)
>
> I went up to see Mrs. Shoaffs house, they want me to buy it, $6000. Good order lot 78 ft front × 132. Water. Gas. Soft coal furnace. (September 30, 1897)
>
> Eva came this morning, said the Morning Press said I was going to build flats on north Walnut St. and that Mrs. Nauth wanted to rent one if I could get them done by spring. About 10 a.m. Mr. McCoy came in to see if I would not let him "submit plans." Altogether was quite a surprise to me. (November 2, 1897)

[A week later] Miss Fera came to insure my flats I am going to build. (November 8, 1897)

The latter two diary entries indicate that Mary was occasionally subject to outside influences regarding the Forbes property, but most business information was entered into her diary with language that suggests knowledge and growing confidence, a woman "busy seeing to business," in her words. She sounds like a woman poised and able to step up and out into the public world.

Then along came the gentleman caller, Mr. Joseph Gibson English, who was first noted in the diary as an adviser but soon became an ardent suitor despite the protestations of his grown son. While "Papa" Forbes was a rich landowner, Joseph English was a rich landowner and a richer banker. According to Lottie Jones, he grew up in Perrysville, Indiana; became the mercantile partner of his father-in-law; and later moved to Danville, where he partnered with John L. Tincher: "They were among the first to seek a charter and organize a national bank following the passage of the national bank bill in February, 1863. They established the First National Bank of Danville. . . . Mr. English serving as its president from its inception until July, 1899. . . . From time to time Mr. English extended his efforts into other fields, becoming one of the heaviest real-estate dealers in this section."[3]

When Mr. English first came calling on Mary Forbes in 1897, he was a semiretired banker, seventy-seven years old, and twice a widower. Mary was forty-seven. His first visits in January, February, and March were offers of assistance to the bereaved widow, as indicated in entries for March 15 and 18, 1897: "Mr. English came to tell me about the [Forbes] cemetery lot"; "We went to the cemetery & Mr. E- and the Sexton was there and measured the lot . . . hope to give the order tomorrow, and soon have the monument up." His subsequent visits, of growing frequency, seem to have been focused on Mary, although she recorded them in vague terms such as "Mr. English called in this evening" (November 16, 1896) and "Mr. English was here this afternoon, we had a long talk" (April 17, 1897). Sometimes entries arouse the reader's curiosity: "Mr. E++++++" (February 19, 1897).

By summer Mr. English was bringing boxes of berries, books, and flowers. "He is planning a trip for us," Mary wrote. Instead he took a trip alone out West, which seems innocent enough. While he was gone, however, his son Charles Lewis ("Lew" in the diary), who was to become the president of the First National Bank when his father retired, came with his wife to pay a call on Mary Forbes. She had done business with the bank and likely received them with courtesy. However, her July 7, 1897, diary record of the visit is tension packed:

When I got home found Mr. and Mrs. Lew English here to see me. They were mad and opposed to my talking with their father, said I could have only one reason, mersenary [sic] for flattering and encouraging an old child-ish man, deaf and almost blind. I would be more respected in this commu-nity as Thomas Forbes widow than as J. G. English's wife. It would never be permitted by him [the son]. He would make it sad and sorry for me as long as his father lived and as long as I lived, it could not should not be. Called Delia and Carrie home talked to them as they had talked to me. It was sad to see and hear them. I wrote him [the father] about their coming and talking to us and told him how surprised and dumbfounded I was, I did not know what to say.

During the next two weeks, Mary recorded a second visit from Lew English and her frustration at receiving no reply from Mr. English. However, the elder English came calling as soon as he returned to Danville, and she wrote on July 23, 1897: "He seemed so glad to see me." Mary also recorded Mr. English's distress that his son had contradicted his wishes. On August 24 and August 27 she indicates, however, that Mr. English took another trip alone:

Mr. English here tonight, we had a long talk and farewell. I am very sorry to see him driven from home but feel it is better for him, for me, and his family that he should go away now, says he may stay three months.

Mr. English came to say goodbye [again], he goes tomorrow for the West, he asked me to write him and said he hoped we would be friends, took a last look at his flowers where he has worked all summer, says "They will do me no good now. I don't know when I will come back." Tears in his eyes when he went out, said, "the winter will be gloomy enough for me."

Mary concluded this entry with the refrain from the first pages of her diary: "Alone! Alone!"

As 1897 drew to a close, Mary recorded letters written by Mr. English from Oregon, and town gossip about their relationship, provided by her sister-in-law. Anticipating the holidays and the return home of Mr. English and her daughters, she wrote on December 3, 1897: "Oh! This awful lone-some rainy night. Alone! Alone. Those I love best are far away. How can I wait even two weeks more to see them." Two weeks later Mr. English arrived to deliver gifts: "Was so glad to see me." He visited Mary frequently, but as the diary draws to a close in January 1898, Mr. English "has to go West again." A modern reader is left with questions because no further diaries are available.

Did Mary Forbes see her daughters "grown and settled in life," as their father had wished? A partial answer to that question emerges from a visit to

Springhill Cemetery. The girls lived to adulthood, but both died unmarried, and Mary buried each of her "lovely sweet girls" in the Forbes cemetery plot. Cordelia, "Delia" in her mother's diary, died in 1911 at age thirty-five. Caroline, "Carrie" in the diary, died in 1929 at age fifty.

Did Mary Forbes, True Woman, come to terms with her grief over Papa Forbes? Apparently, for she overcame the obstacles and became the third wife of Mr. Joseph Gibson English in 1899, one month before Lew English took over the First National Bank.[4] A modern reader of Mary's diary hopes that she found happiness in her second marriage, for certainly she had her share of grief as she buried her first husband, her second husband, and then both of her daughters. Mr. English was buried in 1909 with his first two wives, two children who died in infancy, and one daughter. None of his other eight grown children are buried with him.

Mary lived until age eighty-five. Her death in 1935 made the front page of the *Danville Commercial-News,* but the story focuses on her second husband's accomplishment as founder of a bank.[5] Mary is buried with her first husband in the Forbes plot, between her two daughters. Her simple stone uses her maiden name:

MARY HESSEY. MOTHER.

Church Ladies

She hath done what she could.
Mark 14:8

AS PIETY WAS ONE OF THE QUALITIES of the True Woman, she usually accompanied her children and husband to the church of his choice. There she began to see opportunities for which she was prepared due to her strong faith, her maternal instincts, and her homemaking skills. As a lady of a Protestant congregation, she likely enjoyed her first sanctioned public role through her church—as Sunday school teacher, in a ladies' aid society, or later as she shared with other church ladies her "grand passion"[1] for the missionary movement. Women's dedicated work in their churches was motivated by their faith, and one of their rewards was the satisfaction of all evangelicals who witness for Christ. However, the women had other rewards beyond the spiritual; they were developing attitudes and skills essential to the New Woman.

One such woman was Cora Abernathy of St. James Methodist Episcopal Church in Danville. She lived to be over ninety years old, and for nearly forty of those years she was publicly active in her church. Her husband, Clinton Abernathy, was first deputy to the Vermilion County clerk for thirty years; with that security, Cora could have enjoyed the secluded life of a True Woman. However, she left her comfortable home on Logan Avenue to teach Sunday school and later to accept even more public responsibilities in part-time jobs as truant officer, observer of jail and the Vermilion County Poor Farm, and census taker. In one of her last contributions to her community, at age eighty-six, Cora wrote an autobiographical retrospective, which was published in the local newspaper[2] and is carefully preserved in the archives of St. James Church. She began her retrospective with references to her birth in Lawrenceville, Illinois, in 1851, and to her early education in a one-room

grade school: "Our text books were Rays Arithmetic and McGuffy's Reader, History and Geography." Later, at the close of the Civil War, she studied in the home of a Presbyterian minister. When she was fifteen, she took an examination to earn a teacher's certificate. She then taught briefly in schools until she met her husband. Cora and Clinton were married when she was twenty. She wrote of the wedding, "There was no musical instrument in any of the churches so I had my organ sent down and a friend played the wedding march. The first time a wedding march had ever been played in that church and you can be sure it created a sensation. . . . Never again will I be as happy in this life as when I stood at the altar."

Cora and Clinton had four children and took two other girls into their home and "loved them as [their] own." She stayed home with their children for eighteen years before resuming her public life of employment, but during those home-bound years she began to teach again on Sunday mornings. Sunday school teachers have been neglected in the study of religious women,[3] and Cora's lifelong commitment might be forgotten today had she not written her retrospective, which carried this headline: "Woman, 86, Sunday School Teacher Since 1900, Writes Her Life Story."

Cora recalled her many years of Sunday school teaching, first of "elderly ladies" and then of "young men" who "were later prominent in the business and professional life of the community." The class to which Cora devoted nearly thirty years was made up of the young women of the Searchers Class at St. James. She called them "my girls . . . [who] have been faithful to their trust and stood by me, always ready to give to the church in service and in money. In times of sickness and death they were always with me. In later years especially they have been the joy and comfort of my life."

While sitting alone in her home, long after her parents, her husband, and her children were gone, Cora wrote:

> Do you wonder when I sit in silence so much that I am never lonely? Many pictures hang on memory's walls and the first is my wedding. . . . When I was 17 my future husband sent me a valentine. On it were these words: "Love like mine can never die." It has gone with me through the years. . . . Death visited our home three times on Logan Avenue. My mother died in 1914, my oldest son in 1916, and my husband in 1921. That left to me a house desolate. . . . As I sit alone at twilight, a galaxy of pictures pass before me, I fancy I hear the voices calling, "Mama, come upstairs and hear my prayers." Then the babies appear in the picture when I rocked them to sleep and sang "Little Birdie in a Tree" until their eyes closed in slumber. Then came the school days and after that they went out into the world where only prayers could reach them.

Cora Abernathy (seated center) and her Sunday school class. Courtesy of St. James United Methodist Church, Danville, Illinois

I have one son. . . . I gave him a pocket testament when he left home and it carried him through two wars, said it was his mascot. Who knows? It may have been.

Many religious women of the previous century took comfort in a New Testament quotation from St. Mark 14:6–8. A woman poured an alabaster jar of costly ointment over Christ's head, and some in the group decried the waste of money that could have been given to the poor. Christ admonished them to silence: "Let her alone: why do you trouble her? She has done a beautiful thing to me. For you always have the poor with you, and whenever you will, you can do good to them; but you will not always have me. She has done what she could; she has anointed my body beforehand for burying." Cora concluded her retrospective with the same words: "I have been wonderfully blessed with good health and many kind friends. I feel I have lived a long and I hope a useful life and if I could have an epitaph on stone I would like it to be This . . . 'SHE HATH DONE WHAT SHE COULD.'"

MOBILIZING INTO ACTION: LADIES' AID AND MISSIONS

Cora Abernathy's years of service to St. James Church were focused on Sunday school, but that was not the only new avenue opening to Protestant church ladies. Rapidly developing ladies' aid societies gave women the opportunity to use their domestic skills in God's house. In addition, missionary societies broadened women's horizons and challenged them to spread their faith to pagans across the nation and throughout the world.

Danville was a town of many Protestant denominations at the end of the nineteenth century. Which churches would provide the most revealing picture

of their church ladies? Sydney E. Ahlstrom's *A Religious History of the American People* provides a sorting and selecting guide. Ahlstrom points to Presbyterians, Baptists, and Methodists as the most successful in the rapidly growing mission movement after the Civil War.[4] These three denominations are leaders in Danville, all three having been established in 1829 and being still prominent in the twenty-first century. Fortunately for researchers, the First Presbyterian Church, the First Baptist Church, and St. James United Methodist Church all are generous with their archival materials.

Ladies of other religious groups, such as Lutheran, Catholic, Jewish, and African American, deserve mention since they were mobilizing into action as well, although they focused much more on internal church activities than on missions. Retired pastor Dale Krueger and his wife, Doris, explained that Lutheran women were slower than their Protestant counterparts to take public actions. According to the Kruegers, the "mother" Lutheran church in Danville is Trinity Lutheran, of the Missouri Synod, founded in 1860 as a German-speaking congregation and providing services in German until the First World War. Focusing foremost on education, the Lutherans founded their school in 1864. The women of Trinity worked internally for their church and school until 1924, when they founded the Eunice Society for local outreach and missions. The national organization known as Lutheran Women's Missionary League was founded much later, in 1942, and is active to this day. The league still supports its budget in part by the use of "mite boxes," inspired by the poor New Testament widow mentioned by Mark and Luke.[5]

An internal history of St. Patrick's Catholic Church, founded in 1858, and an interview with Margaret McElwee, a ninety-two-year-old parishioner, indicate that Danville's Catholic laywomen were similar to Lutheran women in that they were focused inward on their church and its needs. McElwee recalled that women's activities included the Altar Society, the Legion of Mary, and Daughters of Isabelle—all internal groups that served the church and the parishioners. In addition to these local endeavors, Catholic laywomen were to fulfill their Christian duties by attention to their large families.[6] The Catholic women who assisted in their church's missions were nuns, who had vowed to practice a lifetime vocation. In 1882 German Franciscans of the Sacred Heart founded St. Elizabeth's Hospital, the first hospital in Danville. Sisters also operated St. Anthony's Orphanage, cared for the sick in their homes, taught in St. Joseph's school (coed), and founded St. Mary's Academy for girls. Laywomen raised funds for these projects to assist the Sisters.[7]

According to local Jewish historian Sybil Stern Mervis, Jewish women "in the old country" often ran businesses while their husbands studied Torah at the temple. When they immigrated to this country and eventually to Danville, some continued their business careers, but not in public. Instead they

worked upstairs in the many mom-and-pop stores on Main Street owned by Jewish families. Like the Catholics, the women of the temple were active but were expected to "take care of their own" rather than spread their faith through external mission efforts. Early twentieth-century women's Jewish organizations in Danville included a chapter of B'nai B'rith, which was the parent of the Anti-Defamation League, and the Ladies Mite Society at the temple, which focused its attention on the temple building as well as indigent Jews in town. Later in the 1950s the synagogue formed a sisterhood to promote religious education and a chapter of Hadassah to promote the newly established state of Israel.[8]

African American church life in Danville began with the founding of the Allen Chapel AME (African Methodist Episcopal) in 1865 and the Second Baptist Church in the 1890s. According to Danville leader Ivadale Foster, African American women did the church work; they "were and still are the backbone" of African American churches. Foster's mother, Edwarda C. Martin Foulks, brought her own Church of God from a "basement to a first floor church" through fund-raisers and soliciting donations. In Foster's church, Allen Chapel AME, the Senior Women's Auxiliary is responsible for the major part of the church's fund-raising through their annual dinners. In the early twentieth century, as now, African American women saw to it that their churches extended aid to the entire black community. Churches donated to homes for orphans, such as the Laura Lee Home in Danville, and aided the elderly and others in need.[9]

PRESBYTERIAN PATH OF DUTY

While the Danville women of the Lutheran, Catholic, and Jewish congregations were working for their churches and the African American women were working for their churches and communities, women members of First Presbyterian Church had their eyes on not only the local but also more distant horizons. Their organized activities began with the sanction and supervision of the men of the church and were focused on the internal needs of the church, but soon the women developed the confidence and skills to expand their fields of vision and work independently and passionately in the mission cause.

Danville was a frontier village in 1829 when the first communion was recorded at the Presbyterian Church of Danville, later known as First Presbyterian Church and now fondly known among locals as "First Pres." The list of eight founders includes surnames still recognized and respected in the community, especially Solomon Gilbert and Dr. Asa Palmer. Four women were among the founders: Mary Ann Alexander, described as "exemplary and dutiful"; Parmella Tomlinson, described as "calm and quiet"; and the Gilbert

sisters, Lucy and Submit. It is recorded and not to be doubted that Submit Gilbert knew her "path of duty."[10]

The success of the fledgling church is accredited to the 1831 arrival of an apparently charismatic and firm leader, Rev. Enoch Kingsbury, who had been sent from Ohio by the American Home Missionary Society. He and his wife, Fanny, made their home and reared their children in Danville, although Reverend Kingsbury spent much time on the roads (such as they were) to other start-up churches in Illinois. While her husband was away, Fanny sometimes taught school in her parlor and also gave tailoring and crochet lessons. "Tradition has always said that when Mr. Kingsbury rode in late Saturday night from his long trips, he found not only a hot supper awaiting him, but also a sermon, neatly written out, ready to be delivered the next day." The Kingsburys strongly supported abolition, temperance, and strict observance of the Sabbath.[11]

The organized and sanctioned efforts of the women of First Presbyterian, no doubt influenced by Fanny Kingsbury's activities, developed in two directions. As in most denominations, the earliest efforts focused inward on the local church and its needs. In the early days the activities of these church ladies were supervised by and sometimes directed by the church fathers. About forty years later, during the Great Awakening after the Civil War, the activities of Danville's Presbyterian church ladies began to focus outward on missions, both foreign and domestic. At the national level, this phase of the missionary movement records tensions between the women, who made up the majority of the congregations and who tirelessly raised money, and the men, who wanted to control the spending. If such tensions were at work in Danville, Illinois, they are not recorded in extant church documents.

Before Presbyterian women felt the evangelical call, the "grand passion" to spread their strong beliefs outside their own church, they felt the call to organize and raise money internally. The earliest woman's organization devoted to serve the First Presbyterian Church in Danville was the Dorcas Circle, established in 1831 and made up of young women of the church. They raised the funds and were able by 1859 to purchase the silver communion service, tankard and chalices, which are still carefully preserved at First Pres but no longer in use.[12] "Mr. L. Palmer went to New York, selected the service, guaranteed payment and later made the public presentation for the Society, as young women did not speak in public in those days."[13] The Dorcas Circle, sometimes referred to as Dorcas Society in church histories, continued until 1868.

Meanwhile, another group of church ladies established the Ladies' Sewing Circle, which met once a week in members' homes and worked toward the goal stated in their constitution: "Ardently desiring the completion of our

new church and wishing to aid in furnishing it in an appropriate manner."[14] Made up of women who were at least fifteen years old and willing to pay annual dues of twenty-five cents and attend the regular meetings, the circle sewed and cooked and socialized to raise funds for their projects. The high point of their contributions to the church came in 1868 when they had raised more than the four thousand dollars necessary for a pipe organ. They celebrated with a concert by a Chicago organist. Years later, when the third and current building was constructed to house First Presbyterian Church at Franklin and North and the previously celebrated organ was replaced, a letter of remembrance arrived from Eleanor Hill Short: "I played at the dedication of the church where your present one stands, poor little wheezy organ, often the mice built their nests among the reeds and it refused to utter a sound, but as you listen to your grand organ now, remember it did the best it could."[15]

The Dorcas Circle and the Ladies' Sewing Circle eventually merged with a third group and included a list of Danville Who's Who: Fanny Kingsbury (wife of the pastor), Elizabeth Harmon (wife of a Civil War colonel), Josephine Fithian (wife of a doctor who befriended Abraham Lincoln), Mary E. Lamon (also with Lincoln connections), and Eliza Webster (wife of a leading businessman). The newly merged group went through an interesting series of names. It was first the Ladies' Church Improvement Society, then the Pastor's Aid Society, and then the Pastor's Aid and Improvement Society. The latter group was proud to have assisted Pastor W. E. Parsons and his wife, Effie, in the founding of a much-needed facility for working girls, a tearoom in the church parlor, which later expanded into a popular lunchroom. This "Rest Club," as those in attendance called it, eventually evolved into Danville's YWCA.[16]

The Pastor's Aid and Improvement Society had to accept another name change when Reverend George H. Simonson declared that "he did not want the women improving him."[17] The result was the Aid and Improvement Society. The church ladies of that society were proud that they had purchased for their church the largest carpet in Danville: "May the prayer of a dear German woman who visited the church a few days ago be our prayer and inspiration. 'May you win as many souls this winter as there are yards in the carpet.' 'There are many yards in it,' was our reply. 'And there are many souls to be saved,' she said."[18]

The church ladies worked as the Aid and Improvement Society until the pastor's wife reorganized them into Westminster Guild in 1915. The guild grew quickly and divided into three circles: Senior, Sigma, and Junior. There were ten active circles at the time of the next reorganization into the Women's Association of the First Presbyterian Church in 1931. From a historical

perspective, the frequent renaming and reorganizing of women's church organizations looks like a frenzy, but it was more likely a gradual process reflecting increasing membership, developing and changing leadership, and the women's growing awareness of their autonomy at the local level.

While the local changes in ladies' church improvement societies indicate a positive move toward autonomy for women, at the national level the Ladies Board of Missions, established in 1871, likewise gained a measure of autonomy. It was originally meant to be a subordinate auxiliary to the all-male Board of Domestic Missions and the Board of Foreign Missions. However, due to the economic hard times of the 1870s, the Presbyterian General Assembly was unable to maintain its missionary work without more help from the women. Therefore, the Ladies Board of Missions, headed by the Church Woman's Executive Committee of Home Missions (WEC), was given official recognition and encouragement. The women were at last allowed to control the money they raised and to hire their own missionaries.[19]

The WEC changed its name to the Woman's Board of Home Missions in the 1890s, and it continued to grow despite administrative problems created by its largely volunteer staff. The ladies won legal independence and near autonomy (accountable only to the Presbyterian General Assembly) through incorporation in 1915. "For the first time, women had achieved a power base in the Presbyterian Church."[20] At its peak activity in the early 1920s, the Woman's Board of Home Missions boasted over four hundred thousand members in its missionary societies and young peoples' organizations, along with an annual budget of over one million dollars.[21]

However, the Presbyterian church ladies did not enjoy their independence for long. In 1923 the Presbyterian General Assembly combined all missionary boards under one umbrella called Presbyterian Board of National Missions. Public reasons for this focused on the need to organize more efficiently and thus reduce overlapping responsibilities and missed opportunities. Even though women congregates made up 60 percent of the Presbyterian Church, and even though they were losing a powerful platform and institutional sanction, they accepted this setback with no organized protest. However, as a few church fathers had feared, within a few years both the morale and the financial contributions of the women "plummeted," and the Presbyterian General Assembly called for a report on "Causes of Unrest among Women of the Church." This report was prepared by the former heads of both women's home and foreign mission boards. In it they deplored the limited respect and opportunity given to women in the church, and they may have been influential in a major breakthrough in 1930 when women were permitted ordination as elders. The sweeping reorganization of missionary boards in 1923 lasted through 1972. By then the church ladies' "grand passion" for missions

to convert the heathens had faded and been replaced by a commitment less focused on conversion and more focused on social justice.[22]

In 1871, the same year that the denominational Ladies Board of Missions was formed, the ladies of First Presbyterian were influenced to begin their own society by the visit of a foreign missionary. Rev. John M. Shedd, missionary to Persia, informed the church of his work and inspired the ladies to organize and begin their fund-raising for missions. The first treasurer's report of the new missionary society records $28 sent to support pupils in Persia and $103 collected and sent to Mrs. L. H. Murphy in Africa. In 1878 a Young Ladies Missionary Society was formed; its focus was on home mission boxes. The two groups combined in 1880 into the Women's Missionary Society (WMS) "for study and work" related to both foreign and home missions. This society's strategy, like that of most evangelical denominations, was that "each woman in the church is considered a member." The society's mission field included Persia, China, Korea, Brazil, and, following the denominational lead, the Indians in the Southwest of this country. The ladies raised their money through projects such as praise meetings, coffees, oyster suppers, and mite boxes.[23]

The passion to spread the gospel through missions grew, and by 1894 the ladies had adopted their first missionary, the Reverend Norman C. Whittemore, who was working in Korea. The church ladies of First Presbyterian prayed for, helped support, and kept in personal contact with Reverend Whittemore and his missionary work for forty-four years.[24]

Details of the ongoing work of the WMS are sketchy, but in addition to raising money, the ladies felt the need to know more about the exotic mission fields they were supporting. Map exercises regarding Korea were popular at WMS meetings, indicating that the ladies felt the need to learn about the land of their adopted missionary. In addition, they studied the geography of other, little-known countries that were opening to Christian missions: China, Siam, Laos, Japan, Africa, Persia, and South America.

In the early part of the twentieth century, when women working for missions were achieving their short-lived autonomy at the national level, mission activity was flourishing in Danville at First Presbyterian. Topics of study at WMS meetings indicate tensions in this country: "What Shall We Do with the Indian?," "The Japanese in America," "Romanists and Foreigners," "Mountain Whites," "Freedmen," "What is Mormonism?," and "Utah, the Storm Center."[25] The ladies studied foreign missions as well, especially Africa, the Orient, and South America. Reverend Whittemore of Korea remained in the ladies' prayers and on the church payroll. Sample budget figures for 1916–17 indicate local church salaries at $2,820, with additional church expenses adding up to a total of $6,600. Reverend Whittemore's salary is recorded at

$1,250. That same year saw $150 earmarked for "General Work Foreign Field," $500 for "City Missions," and $600 for "Home Missions." Thus, almost a third of the total church budget in 1916–17 was devoted to missions.[26]

After the Presbyterian General Assembly at the national level combined all the missionary boards for purposes of "efficiency" in 1923, one result was that local churches were no longer encouraged to adopt their own missionaries. "The denomination assigned mission work to different congregations with usually little contact with the missionaries."[27] As some of the farsighted, worried patriarchs of the Presbyterian General Assembly had predicted, the grand missionary passion shared by so many Presbyterian church ladies in the post–Civil War years and the early twentieth century began to diminish in Danville. Twenty-first-century mission activities still occur there, however, conducted by a coed group known as the Witness Team.

INDEPENDENT BAPTISTS

First Baptist Church, now at Vermilion and Voorhees, traces its beginning to Baptist circuit riders who met with eighteen locals in a frame building on the "Square" in 1829. Like any group devoted to liberty and democracy, and also distrustful of central authority, the Baptist denomination suffered discord. First Baptist debated the challenge of the "anti-mission" movement among Baptists, and the "missionary portion prevailed." The denomination had split into Northern and Southern Baptists in 1845 over the national issues of slavery and abolition, and this split was never to be healed. Danville's Baptists suffered "slavery agitation" but finally "took a decided stand against slavery . . . which caused the church to suffer greatly . . . to the extent that the church in 1865 discontinued holding services." Although the light of the church "was dim, it had never been extinguished," and in 1874 a revived church signed a covenant focusing on an "Evangelical Ministry." This focus was successful, the congregation grew, and eventually a grand new structure was built at Williams and Walnut. The state Sunday school convention was held there in 1915 and was an opportunity to showcase the new building and to confirm Danville's growing status among the Baptists of Illinois. The women of the church, however, got only this recognition for their work behind the scenes of the convention: "The Ladies' Aid Society served all the meals in the basement."[28]

The ladies of First Baptist were reported to have a small part in a meeting of the Bloomfield Association at the new church in 1919. True to their regional mind-set, First Baptist was geographically attached to the Northern/American Baptist Convention but was apparently more actively involved with the Bloomfield Association, which spread east to Paris, Illinois, west to

Champaign/Urbana, and south to Arcola and Arthur. It was named for a long-gone Pony Express stop on the way to Paris. Women in attendance at the Bloomfield meeting reportedly developed their passion for missions as they listened to "stirring and pathetic" stories about conditions of American Indians and pagans in foreign lands.[29]

Despite a lack of documentation on the beginning of the Women's Missionary Fellowship at First Baptist, we know that at the denominational level, mission activity was strong. The American Baptist Missionary Union (ABMU) was formed in 1845 to send missionaries to foreign fields. When a dearth of male candidates was apparent in 1869, the ABMU began accepting women missionaries, as long as they were satisfied with educational positions. Baptist women had worked with an ecumenical group but soon decided to establish their own societies in their usual, noncentralized style. Thirty-three circles came together in Boston to found the Woman's Baptist Foreign Mission Society in 1871. Soon thereafter a similar group formed in Chicago and another in San Francisco. R. Pierce Beaver, in his history of Protestant women in missions, says that the American Baptist Missionary Union approved such organizations as long as the union could "direct the work, appoint and assign the missionaries, fix salaries, and control appropriations." Like the Presbyterian women, the Baptist women accepted their limitations.[30]

Despite their auxiliary role in Baptist missions, the ladies' contributions continued to rise to a peak in 1921, when they celebrated the jubilee of their missionary society by raising $450,000. That same year the Baptists elected Helen Barrett Montgomery as president of the convention, the first time a woman was selected as head of a major American denomination. However, the nation was losing its "grand passion" for missions. The 1926–27 *Annual Report of the American Baptist Foreign Mission Society* admitted that contributions were down from $10 million to just over $4 million in six years and that "drastic readjustment and curtailing of work cannot longer be postponed."[31]

Since no records exist of the early Danville women's missionary society, the only source on women's first public activities at First Baptist are in the minutes of the Ladies' Aid Society, which provided information regarding busy activities from 1902 until 1918. Meeting once a month on the "2nd Tuesday after the missionary meeting," often in ladies' homes, the agendas of this society usually followed this pattern: scripture and singing, prayer, minutes, business, occasionally a program, often sewing, and a concluding Mizpah from Genesis 31:49: "[Laban] named . . . the pillar Mizpah, for he said, 'the Lord watch between you and me, when we are absent one from the other.'"

In addition to monthly meetings, frequent "thimble parties" and all-day quilting events were held. In the later years of their recorded activities, the

ladies appear to have inclined toward activities that sought to help those in need in their community. Like the ladies of First Presbyterian, the Baptist ladies began to respond to calls from outside their congregation: setting up a maternity chest at the YWCA in 1916; appointing a member to represent them at the Associated Charities (precursor of the Red Feather, Community Chest, and United Way); furnishing a room in the new wing of Lakeview Hospital; sending (briefly) a representative to the Federated Women's Club. During the war years, the society served dinner to soldiers, sent oranges to Battery A, established a "soldiers' fund," and did regular volunteering at the Red Cross office.

When membership was high, the group divided into subsections, as many as six in 1908, and at every meeting calls that had been made and flowers sent were reported. Apparently the ladies made calls during the week on sick members of the congregation, new members of the church, and parents of Sunday school children. Weekly numbers varied widely, but yearly highlights recorded were 902 calls in 1904 and 1,970 calls in 1915. The flowers apparently went to sick parishioners and into the pulpit, and they were a frequent subject of discussion and worry (funds often running low).

Above and beyond the calls and the flowers, an impressive array of activities for their church kept the ladies busy: purchases of new singing books for prayer service, new carpet for the choir box and entry, supplies for communion service, disposable "mite boxes" (sometimes one hundred per year), baptismal robes, refreshments for church meetings, paper for the church bulletins, dishes for the church kitchen, dinners for church meetings and in 1917 for soldiers, contributions toward church indebtedness, janitor's salary, and redecorating the parsonage. (The reader of the secretaries' detailed minutes begins to wonder what the church budget included.) In 1913 the Ladies Aid Society pledged one thousand dollars toward the new building. In 1915 they *borrowed* two thousand dollars to give to the building fund.

The array of money-raising activities is amazing: downtown Easter sales with the missionary circle, rummage sales, cookbook sales, circus-themed dinners, bazaars, "exchanges," canned-fruit sales, quilt sales, "rubber socials" (whatever they are), cake contests, and a parcel-post sale, complete with dead letter office for "useless items" for a penny. In October 1911 the pastor attended a meeting of the Ladies Aid Society and asked members to "do away for the rest of the year with money making affairs and devote more time to spiritual work." The only response in the minutes was a nonresponse: the Christmas bazaar was held on schedule.

Eventually, however, the fund-raising did come to a halt. It happened in the 1940s when First Baptist Church left the Northern/American Baptist Convention and joined the Association of Independent Churches of Illinois.

According to Pastor Jerry L. Cummins in a 2003 interview, this conservative association believes that "scripture teaches support of church and all auxiliary ministries is to be through tithes and offerings."[32] Another change brought about by this realignment with Independent Baptist Churches is an up-close-and-personal knowledge of and financial commitment to missionaries. First Baptist no longer sends its tithes and offerings away to support unknown missionaries in the field. In the democratic, Baptist way, it interviews and votes to select the missionaries the church will support. The Women's Missionary Fellowship remains active, helping to support up to thirty missionaries while maintaining a local guesthouse for visiting missionaries.[33]

THE METHOD OF THE METHODISTS

While Cora Abernathy was pursuing her forty-year service as a Sunday school teacher at St. James Methodist Episcopal Church, known as "St. James" to locals, many other ladies of Danville's Methodist denomination devoted themselves to the service of their church through aid and mission societies. They sought paths parallel to those of Danville's Presbyterian and Baptist church ladies. All three churches have rich and well-recorded histories dating back to the 1820s.

Methodism traces its beginnings in Danville to the riders of the Vermilion Circuit, who conducted their first services probably on the banks of the Middle Fork River in 1823. A minister was appointed in 1829, and meetings were held in homes. By 1837 the first structure built specifically for a Methodist congregation, the North Street Methodist Church, existed at the corner of North and Vermilion streets. (In church records the writers use the terms "North Street Church" and "First Church" almost interchangeably.) "The women occupied the benches on the right of the aisle, and the men on the left, while the aged ones of each sex sat in the 'amen corners.' There were Sunday morning services, and Sunday evening services, Sunday School in the afternoon, and Wednesday evening prayer services."[34]

The North Street Church established a mission church in 1857 at the corner of Seminary and Franklin streets; it was soon to be known as the Kimber Methodist Church. These two Methodist congregations often worked together, and both quickly outgrew their buildings, due in part to a revival led by the evangelist Billy Sunday, which came to Danville in 1910 and may have boosted membership in Danville churches by three thousand.[35] North Street and Kimber Methodists merged their talents and resources in 1919 and became known as St. James Methodist Episcopal Church.

By 1926 the new congregation built one of the grandest religious structures in Danville, an imposing building on the corner of Vermilion and Williams

that is still in use. Building costs are recorded at $350,000. Of course, the stock market crashed shortly after the new structure went up, so indebtedness was a problem faced by leaders of the new congregation. The Ladies Aid pledged $40,000 to apply to church indebtedness, which amount, according to a scrapbook in the church archive, "they have faithfully paid and are continuing to pay." "Dr. [Weldon E.] Bradburn and George Rearick saved us during the depression by working out a 20-year debt-amortization program, . . . but it was the ladies of the church who kept the doors open by the thousand-and-one ideas of raising money and their interesting work in bringing in the cash."[36]

The earliest women's organizations at North Street and Kimber Methodist churches, like the first women's organizations at First Presbyterian and First Baptist, were devoted to internal improvements. The Ladies Tea Society and the Ladies Guild came first, and they eventually merged into the Ladies Aid Society. This group held English teas in honor of one of their leaders, Maria English (a major street in Danville still bears her husband's name, and his pursuit of his third wife, Mary Forbes, is detailed in the prologue of this book). The ladies' major fund-raising activities, however, were church suppers, for which they donated not only the food supplies but also the silver, china, and linens. The most famous annual event was the Martha Washington Dinner, held at high noon and hosted by congregants in George and Martha costumes. The ladies of the society served in caps and kerchiefs. According to the church scrapbook, the Martha Washington Dinner "was the outstanding event of the year for church and community."

In the new building dedicated in 1927, all women's organizations eventually merged into the Women's Society of Christian Service (known as WSCS), which organized in a decentralized structure of "circles" modeled on their national model. In the beginning the Danville circles were divided geographically since transportation was often a problem. However, when the groups became "cliquy," a plan emerged to reform the circles every two years, with all names being reshuffled. "There were many dissenters" to the reorganization, but it proved worthwhile in "broadening church fellowship and friendships."[37]

By 1886 the Methodist church ladies began to look beyond the needs of their own church and to use their organizational and money-raising skills in support of missions. Like the Presbyterians, they showed their first interest in the more exotic foreign missions, and they called their organization the Woman's Foreign Mission Society (WFMS). "Missionaries from, and particularly supported by First Methodist were Professor and Mrs. Ernest Langdon at Lucknow, India; from Kimber were Miss Susie Mendenhall, Mrs. Lizzie Cunningham, Mrs. Fannie Fisher and Dr. Brown."[38] The mission fields of the Kimber missionaries were, unfortunately, not recorded.

One local lady's name is mentioned in all early accounts of foreign missions at the Methodist church: Bertha Payton. "Mrs. W. A. Payton, traveling in horse and buggy, collected each lady's missionary dollar. She had the enviable record of acting as treasurer of WFMS for 41 years, and as corresponding secretary of the Champaign District for 25 years. Both she and Mrs. Bedinger were honored for 75 years of service in WFMS. Their names are engraved on a memorial window in Tremont Street Church in Boston."[39]

A reference to Tremont Street Church is significant to Methodists because most accounts of the first missionary organization of Methodist women begin with a snowstorm that could not stop the "intrepid eight" on Tremont Street in Boston in March 1869. This small group was called together and challenged by a missionary wife from India, who convinced them that the Christian message would never reach the women of that country until women missionaries carried the message. They determined to support female missionaries, teachers, and Bible readers to achieve their purpose. By May of that same year the women were organized and publishing *Heathen Woman's Friend;* by November their first two women missionaries were sailing to India.[40]

Despite their quick mobilization and early successes, the Woman's Foreign Missionary Society had the same difficulty gaining acceptance as did the women in the Presbyterian and Baptist denominations. "We are *only women,* you know, and have been used to it for ages and ages," wrote one society member in 1881.[41] They continued their ambitious work under clouds of disapproval until 1884, when an effort was made to abolish the society. In an ironic development, the General Conference of the Northern Methodist Episcopal Church instead voted to recognize members of the society, who from that time on had more control over their missionary allocations and distributions than women in other denominations had over theirs. They maintained their near autonomy even through the 1920s, when other women's organizations were forced into mergers with male-dominated boards.[42]

The decentralized structure of the Woman's Foreign Mission Society may account for the success and autonomy the ladies enjoyed. The founders in Boston named forty-four vice presidents who spanned across fourteen states and set up regional branches similar to those that Frances Willard, herself a Methodist, would later use as the structure of the Woman's Christian Temperance Union. To promote a direct sense of commitment and participation, each society at the local level was assigned a specific missionary, school, or hospital to watch over, pray for, and support.

The results were so successful that the men of the General Conference had to silence their objections. In 1895 the Woman's Foreign Missionary Society was the largest of all denominational women's groups with the largest percentage of church ladies participating. The society would become "the

most powerful woman's missionary agency in the twentieth century."[43] Methodist historian Frederick A. Norwood suggests that the sanctioned and successful missionary efforts of the Methodist Episcopal Church women helped pave the way for the 1888 approval of the deaconess movement, allowing women a stronger voice than in other denominations. In Norwood's words, the lady deacons held a "quasi-ministerial status" that would not have been acceptable had not the church ladies already proved their worthiness in their mission work.[44]

Historical records at what is now known as St. James United Methodist Church are well organized into scrapbooks but are limited in number, so details of both the foreign and later the home mission activities are difficult to determine. However, one fact stands as clear support of the importance of home missions in that congregation: the national annual meeting of the Woman's Home Missionary Society was held at St. James on October 15, 1933. A program of the event is proudly posted in the scrapbook, and it records that several women were on the podium along with featured speaker Bishop Ernest Lynn Waldorf.

Apparently the grand missionary passion of the women of St. James Methodist Episcopal Church lasted through the disillusionment that affected so many others in the years after World War I. The autonomy granted by their General Conference and their local achievements were factors in their long-lasting devotion to missions, which is continued in the twentieth-first century by the United Methodist Women.

Danville's church ladies profiled here, Presbyterian, Baptist, and Methodist, illustrate the national pattern of development. Their first interests were focused on the internal needs of their churches, and their ever-increasing array of successful projects indicates that they enjoyed their new activism. The fathers of the churches were sometimes slow to approve but eventually had to appreciate the ladies' enthusiastic and untiring work for their churches and, of course, their financial contributions. When the "grand passion" for missions came to Danville beginning in the late 1870s, the women again illustrated the national pattern. They were inspired by missionary visits and stories to study and raise money for pagans in exotic countries, in the United States, and sometimes in Danville. Controversy raged over autonomy at the national level, and although local churches recorded little conflict, Presbyterian and Methodist women gained some control over their money and their missionaries. Protestant women at all levels continued to work within their limitations, and while the "passion" faded in the 1920s, their work for missions continues into the twenty-first century.

THE NEW WOMAN EMERGES

Working within their limited sphere, women of Danville's Protestant churches did what they could and made lasting contributions. Although they were not always recognized and sometimes were dissuaded, they devoted countless hours and dollars to support their own churches and, once the "grand passion" seized them, to support mission efforts both in this country and abroad. Their motive was primarily their evangelical faith; their rewards went far beyond the spiritual. These church ladies, who had little experience handling money, learned to raise it and manage it. Their spheres expanded and their autonomy grew as they took over their own aid societies and exercised their homemaking skills in God's house. Many developed public-speaking, organizational, and leadership skills, which they put to use in local and state-wide associations. Having little higher education, they studied and learned about the exotic mission fields they would never visit. Some imagined careers of sacrifice and service; most devoted themselves instead to support of missionaries already in the field. Church ladies were preparing to enter the public world with the growing confidence of New Women.

Cora Abernathy's years of service to St. James Methodist Episcopal Church apparently gave her that same confidence. For her 1937 retrospective, she remembered many public activities in addition to teaching Sunday school. She described the crowds and many campsites on the grounds of Lincoln Park during the Chautauqua summer tent event: "There were wonderful programs twice each day . . . talented speakers . . . educational . . . entertaining." For five years she belonged to a Chautauqua Circle: "I have a diploma and six seals." Later she joined the Danville Literary Circle, which merged into the Danville Woman's Club, "I being a charter member."

Cora worked for four years as a truant officer with a job description quite different from today's officer. She recorded that her work for the city schools put her in touch with "many needy children, and I was glad I could furnish clothing for them. . . . Many organizations gave the money, the saloonkeepers usually gave $50 and one year $75. It was hard work but I enjoyed it and considered these four years the most profitable of my life." For five years Cora was employed by the Associated Charities, "to visit the jail and county [poor] farm . . . and give a report . . . also took census in 1920. It took me three weeks and I enrolled 1,300 names."

She proudly recorded her work to help found the Young Women's Christian Association: "It was needed so much. After many meetings the plan began to take shape and finally became reality and stands today a living monument of the work and prayers of faithful women, many of whom have gone to

their reward." At the YWCA she served on the employment committee, which helped women find jobs and provided them a place to live.

Nearing the end of her remarkable life as a True Woman emerging into a New Woman, Cora Abernathy wrote: "If I could have an epitaph on stone I would like it to be this . . . 'SHE HATH DONE WHAT SHE COULD.'" Cora's humble stone in Springhill Cemetery is next to that of her husband, Clinton. Despite her wishes, her simple inscription reads:

CORA ABERNATHY
1851–1942.

Sisters of the Club

... mutual benefit to be obtained by members in intellectual pursuits.
Helen Hooven Santmyer, *And Ladies of the Club*

MARY FORBES PERSONIFIED the characteristics of the True Woman, focused on the world of her home and family and so defining her worth by marriage that she was willing to take prominent husbands who were much older than she was. However, during those same years when she decided to become Joseph English's third wife, other Danville women were adopting the persona of the New Woman and undertaking to transform both themselves and their community. It is difficult for twenty-first-century women, who live such public lives, to imagine how difficult this transformation was—for women to leave their homes regularly for objectives other than church and missionary work or similar benevolent efforts. They had to overcome a natural timidity about going against tradition and sometimes criticism or teasing about their selfish motives in doing so. Even so, they did go out of their doors, in large numbers by the turn of the century, to read and study together and to work through the political system to get things done in the community and eventually to achieve the vote. By engaging in these actions together, they gained a new sense of self-worth and a consciousness of their value as women.

The Clover Club was one of the earliest women's associations in Danville, and since it exists to this day, its history offers some answers as to why women ventured out to give an afternoon every week to literary study and what rewards they derived from their association with other women. Today's Clover Club has both preserved its traditions and made some changes since its beginning in the 1890s. "Exclusive" was the adjective most commonly applied to the Clover Club in its early decades, but its reputation on the pinnacle of Danville's social hierarchy has gradually changed. Clover descendants

are automatically granted membership, but many daughters and granddaughters have moved away from Danville, so its membership base is broader than it was in its early decades. In addition, in the early years of its founding, the Clover Club was very public; its yearly program was printed in the local papers, and its social occasions formed part of the society news. However, in recent decades the Clover Club has chosen to remain private, and few Danville people know of its existence. As members of a club that was exclusive and proud of its history, though, Clovers have kept everything since the 1890s: minutes, attendance records, news clippings, memorials, and yearly accounts compiled by its historians.

NATIONAL MODELS

In organizing the Clover Club, Danville women were responding to national movements among elite and active women. Two factors inspired American women to form literary clubs: the woman's club movement, which had begun after the Civil War; and the Chautauqua movement, which began in the 1870s.[1] Many fine historians have researched the beginning of women's literary clubs and examined their significance for women who gained confidence and self-development through working with others. As Anne Firor Scott concludes from her definitive study of women's associations in America, "for some women, working toward collective goals tapped wellsprings of creativity that had been quiescent in the narrow round of domesticity."[2] Women had gained confidence by working together during the Civil War to raise money and supplies for the troops. Religious associations had enabled women to unite to fill needs within their churches or missions. Black women had formed literary groups before the Civil War to help one another. In a few midwestern towns, including Quincy, Illinois, and New Harmony, Indiana, women had begun literary study clubs in the 1860s. Their greatest objective was to use their energies and the time they gained from having household help to seek the education they had missed. In her book about women who assumed public roles in Galveston, Texas, Elizabeth Hayes Turner notes, "Suddenly . . . women . . . set about taking stock in their own learning. Years of benevolence to others had edified them to pressing social needs, urging them to act, but the time had come for women to see to their own education."[3]

Another historian of women's clubs, Karen J. Blair, points out how significant literary clubs were in transforming women's images of themselves and what they could accomplish. Most upper- and middle-class American women had internalized the role of ideal ladies, isolated in their homes, "schooled only for service to others, powerless, and denigrated, even as they were revered." The cultural domain of the literary club was "a significant step for

the autonomy of women and their flight from the confinement of the home." Club life succeeded at reaching and assisting women to grow, "by altering their expectations of both their social functions and their ability to carry out change."[4] Women learned that silence and domesticity were no longer the virtues they once had been. As Danville Clover Mary Blackburn challenged her sisters in 1895: "Shall women sit down to polish when they are able to reform, to entertain when they might instruct?"[5]

Literary societies often evolved from self-education to community improvement and eventually to political action.[6] The Clovers did not. They chose to maintain their function as a literary club, gaining from the systematic and cooperative study of texts the intimacy and the autonomy that made their association deeply meaningful to them. They valued literacy as empowering and also as a way to maintain the traditions of womanhood that they wanted to preserve in a late nineteenth-century world of shifting definitions, politics, and cultural standards. Through literacy they could, in scholar Anne Ruggles Gere's words, incorporate the "long-standing ideology of womanhood" as nurturing others into the emerging ideology of a politically active and aware woman who trains her children in good citizenship, preserves the literary and historical traditions of the past, and also takes a public role in the community and nation.[7]

The elite women of Danville could dare to make this transformation because literary and women's clubs were multiplying in America and also because of the Chautauqua movement, which swept into the small towns as well as the big cities of America in the 1870s. Many nineteenth-century literary clubs, including the Clover Club, got their start with Chautauqua, which began in 1871 as a religious-based popular education movement, comparable to modern public radio and TV.[8] Chautauqua's founders and most of its early members were Methodist. They established a "summer camp" for learning on the grounds of a former Sunday school in western New York. Its religious connections helped make it acceptable to women whose previous activities outside the house were limited to church societies. However, despite its strongly Protestant religious base, Chautauqua's appeal was largely secular. Its purpose was to promote broad education for self-realization and action. One of its founders, the dynamic John Vincent, promoted Chautauqua and its programs as places for everyone who had the desire to learn. As he stated, study in the home and workplace in the midst of life would "train men and women everywhere to read and think and talk and do; and to read and think and talk and do with purpose, and that purpose, that they may *be*." To carry out these goals, Chautauqua operated a summer school with courses in literature, science, languages, the arts, and religion and also had a traveling tent program for lecture series, concerts, recitals, and study groups.

The tent program aroused and maintained interest in Chautauqua study in hundreds of communities, including Danville, where the tent was regularly set up in Lincoln Park.[9]

Few of the women who founded the Clover Club had had the chance to attain higher education beyond what Danville had to offer. Many were daughters of established and prosperous pioneers in business and real estate, but the opportunities for middle-class education in the area ended with seminaries and private academies and Danville High School, a select private school until 1889. While these institutions' content and standards were considerably higher than those of today's high schools, Danville women missed out on the college experience. Some Danville women attended summer classes at Chautauqua, and at least one Clover, Jennie Whitehill, returned summer after summer.[10]

Chautauqua is still a special place. Views from the shuttered houses with their gingerbread trim and bright hanging baskets of geraniums; quiet strolling on shaded walks, thanks to an absence of automobile traffic; the grand hotel with formal dining in the evening or sunny brunches on the long porch looking over the lake: all these provide a respite from the harried modern world. In addition, the multitude of programs and concerts seeks to satiate the eagerness for learning of those who visit it today, often for a week or two weeks every year. Its archive holds pictures of the impressive "graduation" ceremonies held annually for those who had completed a four-year course of study, and Pioneer House displays banners for each graduation year. The floor of the Temple of Philosophy is tiled with the mottoes of graduating classes.[11] The Clover Club had adopted the colors and motto of the Chautauqua graduating class of 1890: a clover designed in pink and green and inscribed with the motto "Ubi Mei, Ibi Apes," which translates as "Where there is honey, there are bees." Clover Club secretaries and historians often mentioned that they perceived themselves as busy worker bees collecting the honey of knowledge.[12]

Many men and women could not get away for summers of study at Chautauqua, so the Chautauqua Literary and Scientific Circle (CLSC) was begun in 1878. This four-year Chautauqua correspondence course was designed to help adults past school age acquire a "college student's general outlook upon the world and life, and to develop close and consecutive thought."[13] It was especially valuable to women who were at home and had neither time nor means to go to college. The curriculum wove together threads of higher and adult education, religious education, and women's education. The CLSC correspondence courses were designed for individual or group study, but individuals found it difficult to proceed with study by themselves, and so,

perhaps influenced by the general popularity of literary clubs, Chautauqua study circles took off rapidly.[14]

Danville's study circles began as small groups that federated as part of the CLSC and then spawned separate clubs, the longest lasting of which were the Danville Woman's Club and the Clover Club.[15] In October 1890 nineteen women met in the Chautauqua circle. Membership varied from nineteen to twenty-seven during the first year of the circle. By the time the circle had become the Clover Club in 1894, the new constitution limited membership to twenty. A constitutional amendment in 1895 expanded membership to twenty-five, where it has remained to this day. No doubt the strict limit on membership was to make it possible for the club to meet in members' homes, but it also helped protect the exclusive image of the club.

Since CLSC groups were encouraged to take on some of the accoutrements of women's colleges, such as class songs, colors, flowers, and titles, the new Chautauqua circle chose the clover, with pink and green as its colors. The original name of the circle that became the Clover Club was a matter of some debate. According to the club minutes, the committee appointed to study name possibilities had come up with "Aryan," but this was defeated by a vote of 9–5, and the name Lindisfarne was selected instead, by the same vote. "Lindisfarne" evoked the island community of that name off the English coast, where early medieval scholars struggled to maintain classical knowledge in a barbaric world. Perhaps the Lindisfarne circle members saw their efforts as heroic as well.[16]

The Lindisfarne circle became the Clover Club in 1894. The minutes do not explain why. The reason for the separation may have been reluctance to pay dues to Chautauqua or a desire to distance themselves from Chautauqua's Methodist connection or a distaste for the social gospel direction that the *Chautauquan* magazine was taking. However, the Clovers' desire to "control their own literary practices, writing and reading as they chose" was likely the major factor in their independent stance.[17] Nevertheless, ties remained, and Clovers did not forget their Chautauqua parentage. The club maintained some Chautauqua rituals and continued for a few years to order materials from the *Chautauquan* magazine and book club. Club members were invited to attend local Chautauqua lectures and to take part in the Danville Chautauqua Assembly held annually in August. In 1896 the Clover Club took up a collection in response to Vincent's appeal to build a Chautauqua chapel in New York. In 1904 the Clover Club historian gracefully acknowledged that Chautauqua "had prepared such splendid soil in which the Clover has budded and bloomed from year to year."[18] Julia Kimbrough's 1896 inaugural speech as president reflected the moral and intellectual aims

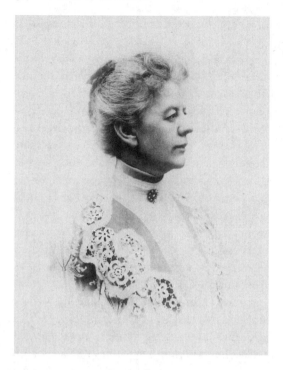

*Julia Tincher Kimbrough.
Courtesy of the Clover Club*

of Chautauqua: "We believe that all our sisters should devote themselves to the study of the true, the beautiful, the good. They should rightfully direct the talent with which God has endowed them. They should all aim to be in every way the equal of man in all departments, in intellectual as well as moral activity. . . . It is not my intention to moralize. I have only said this to faintly portray the underlying sentiment which animated the ladies of the Clover Club when they continued the organization of the Chautauqua Class of 1890."[19]

"PREEMINENTLY A CLUB WOMAN"

Julia Kimbrough's name and her spirit pervade the early minutes, annual histories, and newspaper accounts of the Clover Club. More than any other woman of her time, she represented for Danville an outstanding model of the New Woman.

In her pictures Julia looks assured and pleased, well dressed and coiffed, beautiful, competent, and intelligent. Clover Club papers highlight her as a beloved founder of the club, as a multiterm president appreciated for her cheerful and innovative leadership, and as a generous hostess. Her recorded speeches show that she was aware of the transformation taking place in women's roles and welcomed it. When assuming the presidency of the newly

founded Clover Club in 1896, she began by deliberately including Danville women in this transformation when she observed that "if you are interested in the development of 'woman,' you will perhaps be pleased to hear the part we are taking in her evolution." She promised that she and her sisters of the club would devote "a larger share of [their] time to useful studies" in order to become not only companions and moral advisers to their husbands but also their "intellectual equals."[20]

In addition to her own strong character, Julia's confidence derived from being a member of one of the most prominent families in Danville. Her father was John Tincher, founder of the First National Bank and member of the state legislature and the state constitutional convention before his death in 1871. Julia's husband, Erneis Kimbrough, was the son of a Georgetown, Illinois, doctor. Erneis became a lawyer, served in the state legislature in the 1880s, was elected for a term as Danville's mayor on the Reform ticket (1897–1900), won election as a judge from 1903 to 1915, and served on the state board of education. The Kimbroughs were wealthy enough to own a substantial house and employ servants. At a time when large families were still a custom, they had only one son, Robert, who died at the age of nine. Another hint of tragedy is the fact that an adopted daughter named Helen, whom Julia brought home from a trip, disappeared from the family story within a few years.[21] Whatever happened in her family setting, Julia Kimbrough was, in her own words, "preeminently a club woman." She not only was involved in Clover Club but also was a member of the Danville Woman's Club, for which she took charge of arrangements for the Illinois Federation of Women's Club's big state meeting in Danville in 1904. Erneis Kimbrough was a frequent speaker for Clover Club and appeared on the program at the state meeting of the Woman's Club Federation. Julia undoubtedly supported her husband's activities, as he supported hers, and she probably chronicled her own life in this exuberant description: "The woman at large now is preeminently a club woman. She breakfasts in her hat, lunches at the Club, sits on one or more boards thereafter, and lending her aid and influence to all suffering sisters, takes off her hat to retire, with the proud consciousness that she hasn't had an unoccupied moment in the day."[22]

Only her untimely death at the age of fifty-seven kept Julia Kimbrough from gaining more recognition in Danville histories. Modern Clovers are enriched by the knowledge of her breadth, her forthrightness, and her bright speeches.

STIMULATING MINDS

Julia Kimbrough took part in both of the Chautauqua circles that formed women's clubs in the 1890s, even though they went in different directions.

The Danville Woman's Club evolved from literary study to community and political reform, a story which will be told in chapter 4. The Clover Club, after a two-year membership (1903–5) in the Illinois Federation of Women's Clubs, chose to go its own way instead. Luise Snyder, Clover historian of the 1980s, explains the break with the Woman's Club Federation; Clovers realized that "they did not have the same goals as the Woman's Clubs: they did not want to raise money to pay dues and they did not want to be regulated."[23] The federation's 1904 vote to promote woman suffrage was likely another factor. The Clovers refrained from civic activity as a club with a few exceptions: in 1901 they raised money for the new Danville Public Library; they supported the "Shut-In Society"; and they contributed monthly to a "Travelers Fund" to help single women who arrived in Danville without funds. Their fragile program books indicate that Clovers did occasionally study topics related to community welfare and national progressive issues and even debated the Russo-Japanese War in 1904. The topic of "America" in 1908–9 included a March study on "What Women are Doing," with subtopics that included "Woman's Work and Influence," "History of the Woman's Movement," and "Woman's Legal Status in our State." The April program was entitled "Civic Improvement"; subtopics included "Local Betterments," "Vacation Schools," "Juvenile Courts," "Kindergarten Work," and "Notable Social Settlements and Workers."[24]

In 1909–10, at the peak of political progressivism, the Clovers studied Latin America, where the United States was playing a major role; American social problems; and forestry and conservation. Jennie Lindley, that year's historian, commented in her elegant but now faded handwriting that "as a country we have been wasteful of all our natural resources, forests, water, soil, gas, oil, coal, and so on. There was such an abundance, it seemed inexhaustible. Some have forecasted within this generation we will be hard pressed, if care is not taken. How to preserve our natural resources is one of the great problems of the day." Despite this serious topic, Clovers did not choose to be active in the environmental or any other movement. Lindley concluded her history of the Clover Club discussion of Progressive topics with a hint of regret and resignation: "We did not solve all our questions as 'Municipal Suffrage for Women,' 'What Women can do for Good Government,' 'Are We Becoming a Nation without Homes?' or 'Modern Methods for Caring for Dependent Classes.' Time alone can do this. We will help where we think best."[25]

Although they had decided to keep Clover Club independent and apart from local welfare and politics, members were conscious of their power and responsibility in the community. As individuals, Clover Club members participated in Danville Woman's Club, church, and other community welfare

activities and in benevolent projects such as the Vermilion County Children's Home, founded and supported through the efforts of, among others, Clover Eliza Webster and her daughters. During World War I many of the Clovers "were *untiring* in their work for the Red Cross, others knitted by night and by day for the beloved soldiers."[26] Shortly after the war, a Clover historian reflected on the club's unrealized potential for activism when she proclaimed that "the hope of progress lies in the *collective* effort of humanity (in just such little clubs as ours) which, as yet, is hardly conscious of its oneness, and has not imagined what it might perform if it worked with *one* purpose and together."[27] Still, Clovers "always came back to their original intent of form- ing a study group dedicated to stimulating their minds and to learning." The Clover Club historian of the 1980s reaffirmed that "raising money and spon- soring causes are not Clover Club goals."[28]

MEMBERSHIP

The two women's groups that came out of Chautauqua circles adopted con- trasting membership practices. The Danville Woman's Club members voted on new applicants (invitation only) but did not restrict the numbers. As a result, the membership soon soared into the hundreds and included general gatherings at meeting halls and smaller, more intimate circles that met for social welfare, political activity, and literary study. The Clover Club decided to remain as a small group. "Clover Club—Symbol of all that is intellectual and exclusive!" a club historian proclaimed.[29] Membership was limited, and members studied together and met in one another's homes. As Theodora Martin points out in her study of the Decatur Art Club, the determined insis- tence on small size suggests some subliminal factors at work: "a small, fixed circle of acquaintances satisfied a number of needs at once."[30] Except for whatever experience they had gained in their church groups, women were not used to an audience or to playing an active role in a nonfamilial group. In addition, Clovers reveled in their exclusiveness, and their restrictive member- ship exemplified the function of the study club as a "sorting process." As tra- ditional status broke down in an era of rapid change, work became the sorting device for men—farmer, banker, doctor, manufacturer. For many women, clubs served the same purpose, providing a specific distinction between like- minded women and others in the community. While for some the literary club was a genuine tool for social change, or was in fact the "middle-aged woman's university," for others it was a place to see and be seen, to acquire a patina of information and "culture," and to meet the right people.[31] The makeup of the Clover Club membership fulfilled the latter function quite well. In his 1930 history of Danville and Vermilion County, Jack Moore Williams names three clubs "that may well be said to provide the social and cultural

background of the city": the Home Decorative Club, the Monday Art Club, and the Clover Club. Williams describes them as having an "exclusive membership, representing the older families of the city," and he goes on to say that "in the rosters of the 3 organizations there might be termed the register of the 'First Families' for Danville."[32]

The Clover Club membership, limited to twenty-five since 1895, was by invitation only. Proposed members were voted on and had to be approved unanimously. Gere's observation that "clubwomen appropriated, both literally and figuratively, the intimacy of the mother-daughter relationship" was true for Clover Club.[33] Legacies were strong in the first decades. Daughters, daughters-in-law, and granddaughters were invited and expected to join. In early years Cloverettes, the children, were encouraged to begin their roles in the club by performing musical numbers or recitations or attending events planned especially for them. In 1902 the club historian proudly counted the addition of ten "Cloverettes" to the membership in its first eight years, supporting the estimate of another club historian that among the founders were six in the twenty-seven to thirty-one years age category, eight from forty-two to fifty-four years, and a few older—a stark contrast to today's membership with its majority of retirees.[34] The club developed three categories of membership: active, honorary, and in memoriam. Today there are four types of members: active, active honorary (can vote but do not present programs), inactive honorary, and in memoriam (the latter list, of course, continually grows longer). Clover Club insists that "once a Clover, always a Clover." Actually, no resignations are accepted. A member who drops out or moves away is placed on the inactive honorary list until she dies, and then she is on the in memoriam list.[35]

The Clover Club membership rosters from 1890 to 1910 show more breadth than Williams's characterization might indicate, although influential families were prominent in founding the Clovers. Julia Tincher Kimbrough, her mother, Caroline Tincher, and later her sister-in-law Clara represented the most influential Democrats in Danville as well as a major component of the banking industry. The majority of the members' political allegiances, though, were with the Republican Party. The most prominent of these was the Webster family. Eliza Webster and her daughters, Kate and Nellie, were early stalwarts of the Clover Club, and one of their descendants became and remains a Clover. Eliza's husband, A. L. Webster, one of the leading citizens of the town, took no political office but was an influential Republican behind the scenes. He achieved his initial prosperity by having founded a wholesale grocery company, but like John Tincher, his interests also extended to real estate, politics, and civic activities. He founded the Webster Home for Women

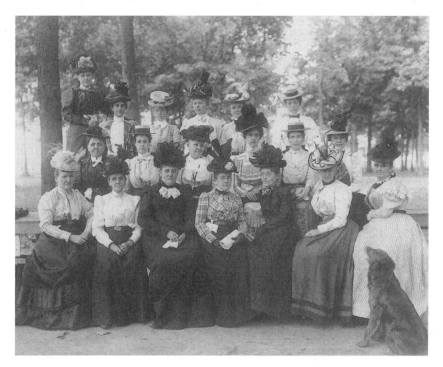

Clover Club annual picnic, 1899. Courtesy of the Clover Club

and, with Erneis Kimbrough, supervised the Danville Public Library and Spring Hill Cemetery.[36]

Among the treasures in the Clover Club memorabilia is an 1899 picture of the Clovers at their June picnic. Their "casual picnic" hats and the dog that seemed to be a necessary accompaniment are arresting, but the picture also furnishes clues to the many family and business connections among the Clover members and perhaps some hints about their personalities. Their relaxed posture in close proximity suggests that the Clovers had found a value in intimacy and sisterhood that was helping them build confidence in themselves.

Julia Kimbrough, among the tallest of the Clovers, is clearly a leader as she looks thoughtfully presidential in the center of the back row. Eliza Webster, a tiny woman dressed all in black, is seated in the front row; the sternness of her gaze and pursed lips is mitigated by large, round glasses and a grand, frivolous, feathered hat. Seated next to Eliza and turned toward her in a bright plaid blouse and high hat with flowers and giant plumes is another small woman, Anna Abdill, a daughter of old pioneers. Anna's two married

daughters, Kate and Clara, sit erect in matching straw boaters in the second row. Clara was married to Julia Kimbrough's brother John Tincher and lived next door to her mother-in-law Caroline Tincher, also a Clover. Alice Hull Phillips, at the end of the second row, one of the youngest of the group, wears a feather that angles a full two feet above the brim of her hat; she strongly resembles her mother, Elizabeth Hull, who stands next to Julia Kimbrough in the back row. Alice Shedd is posed in profile at the end of the first row, and her daughter Alice Shedd Martin is perched at the diagonal opposite, at the end of the third row, with her arm around Carrie Louis's shoulder.[37]

Tracing the connections of the women in the picture also suggests some of the business and political alliances that connected the Clovers and gives a sense of the Danville economy. Jennie Gregg Lindley stands next to Julia Kimbrough in a striped blouse and a flirtatious version of a straw boater. Her husband, Frank, was a lawyer in practice with Julia's husband Erneis Kimbrough, mayor of Danville at the time the picture was taken. Mary Freeman is seated in the front row and looking pensively at the camera. Her accountant husband was the longtime city clerk. Several of the women were married to grocers and wholesalers, including Eliza Webster, Permelia Ralston, and Harriet Fera, whose husband advertised himself as "the cash grocer." Anna Abdill's husband and son dealt in "hardware, stoves and tinware, mantels and grates, guns and ammunition." Alice Shedd too was married to a hardware dealer. Martha Giddings, referred to fondly as "our little Mrs. Giddings" by a club historian, is seated between the two Abdill daughters. Her husband and Elizabeth Hull's husband dealt in farm machinery and buggies. Only one woman in the 1899 picture, Clara Tincher, was married to a banker, and one, May Howard, looking intently at the camera in her straw boater at the end of the third row, to a doctor. Merchants were a respectable class among the prominent and, if successful, also invested in real estate and farmland. Though Eliza Webster was an orphan in modest circumstances when she married, Julia Tincher Kimbrough, Jennie Gregg Lindley, and others were known by their own substantial inheritances and connections as well as by those of their husbands.[38]

Another connection among the Clovers was proximity. Many of the members lived within a block or two of each other, and some were next-door neighbors. In early days they must have walked together to Clover meetings, sharing buggies only when the weather was bad. Almost all the Clovers lived within a few blocks, in the residential sections surrounding the businesses on North Vermilion and Main streets. The area was an enclave of intimacy and privilege, with household help for the Cloverettes and plenty of time for discussion of the "servant problem." The houses of a majority of members were large enough to host up to twenty-five members comfortably.[39]

With all their family connections and business ties, the Clover membership did spread beyond the elite. In the 1899 picture, Jennie Whitehill, a large woman dressed in black and with the marks of illness on her face, was a widow of several years. Jennie, though perhaps not well off, shared the enthusiasm of the other members for Chautauqua and for learning. A unique member was another widow, Medorah Hendrich, who was listed in the 1889 city directory as operating a "Ladies Bazaar" in her home—possibly a genteel ladies' boutique for her neighbors. One woman who worked outside her home is included in the picture: Sadie Coe, seated in the first row with her face down to display her stylish white hat with black detailing, was a bookkeeper at the First National Bank. (How she took time out on Monday afternoons to attend Clover meetings is a mystery.) Most Clovers were Protestant, but the club has included at least one Jewish member throughout most of its history. Carrie Plaut Louis, who stands in the third row with Alice Shedd Martin's arm around her, was a member of a large German Jewish immigrant family who came to Danville and did well in banking and real estate. Carrie was married to Isaac Louis, a partner in the Straus-Hecht department store. Other Clovers belonged to a variety of Methodist, Presbyterian, and Episcopal churches.[40]

Unlike the pattern of literary clubs elsewhere, few women professionals appear on early Clover Club rosters, with the exception of Josephine Durham, the librarian of the Danville Public Library, who was an honorary member. The membership of the Clovers evolved in the opposite direction from the trend taken by many women's literary clubs. The Wednesday Club of Galveston, studied by Elizabeth Turner, began, as did the Clovers, with a membership of "wives of influential commercial types." It remained and remains exclusive and restricted to twenty-five members, but after a few decades professional women—librarians, nurses, and especially teachers—joined. Their inclusion, according to Turner, "ultimately altered its curriculum and the women's outlook."[41] In contrast, the Clovers relied until recent years on legacies and country club affiliations and took pride in their exclusiveness.

Despite the fact that the Clovers were more restrictive in membership than some other woman's club models, their club activities were a key factor in broadening their own personal worlds. Clubwomen over and over spoke of the importance of the work they were accomplishing in "building bridges among women who tended to stick closely to people who shared their own religious, political, or family connections."[42] A typical Clover met weekly with women of different age groups and church and political affiliations. She and her sisters' husbands held different jobs in the upper or middle class. Clubs therefore, members believed, fostered tolerance and the exchange of ideas beyond the individual spheres of their members. In her well-known and

well-researched fictional reincarnation of the turn-of-the-century club move-
ment, ". . . *And Ladies of the Club,*" Helen Hooven Santmyer might have
been describing the Clovers when she said, "In spite of the disparity between
one and another of these women, they were oddly at their ease together; after
a few meetings of their club, they had already grown accustomed to each
other, and each other's limitations, whether they were of the purse or the
imagination."[43]

"SUSTAINED AND STRUCTURED WORK"

An examination of the Clover Club minutes and histories, enhanced by the
studies of other literary clubs by other scholars, leads to the conclusion that
members were attracted by the opportunity for "sustained and structured
work" or "systematic study."[44] Evidence is abundant in both format and cur-
riculum that the founders of Danville's Clover Club pursued these goals.
Their format can be viewed from two evolving perspectives: the yearly for-
mat and the weekly meeting format. Their curriculum can be viewed in a
single but also evolving continuum. From all perspectives, the goals of "struc-
tured work" and "systematic study" are clearly apparent.

Both format and curriculum of the Clover Club were influenced by the
system of their parent organization, the Chautauqua Literary and Scientific
Circle. In terms of yearly format, the CLSC women adopted a "college out-
look." Before they became independent Clovers, they followed the Chautau-
qua system for a university-style, four-year plan of regularly scheduled lessons
on broad topics. Their format included required attendance and home read-
ings (from the Chautauqua Press, among the first to produce paperbacks),
"teaching" assignments, special evening lectures, year-end examinations, out-
door "graduation" exercises in the spring of the year, and summer vacations.
In another small way the early Clovers followed a Chautauquan tradition.
The New York group once needed a way to recognize a deaf man on their
stage, so members of the audience took their cue from Beethoven's apprecia-
tive audience. They fluttered their white handkerchiefs simultaneously for the
deaf man to see. This ritual became known as the "Chautauquan salute" and
is recorded several times in early Clover minutes—for example, when a presi-
dent retired or a lecturer merited special recognition.[45]

The Clovers maintained most of the Chautauqua yearly format while
gradually imposing their own variations. They adopted their own constitu-
tion and bylaws in 1894. A tradition that began that year and continued until
recently was the requirement that the president must read the club consti-
tution aloud to the membership during the first meeting of the fall. Fortu-
nately, the document is brief; it includes what we would today call a mission

statement: "mutual improvement" and "cultivation of the amenities of social life." The constitution calls for weekly meetings in members' homes. It describes the duties of the officers and the selection of members, who must "lead weekly exercises"; if they fail to do so, they will be fined fifty cents unless they have a "good and sufficient excuse."

The constitution did call for yearly dues of twenty-five cents, but of course over the years the amount increased as the club became more social and incurred more expenses. (The dues are still nominal, though.) Social events took on a yearly routine. An annual day for Cloverettes is occasionally mentioned in the minutes. Apparently some members' children accompanied their mothers to the Monday afternoon meetings and were attended by nannies, but "special" meetings were planned for the children, with decorations and entertainment for and by the little ones. Other "special days" that included husbands or other invited guests are more often mentioned in the minutes. They were evening occasions featuring "parlor lectures" (often by one of the professional husbands) or entertainments, along with meals. The club meeting most directly influenced by the Chautauqua system was known in the minutes as "closing day." It is still held, with modifications. No longer considered "graduation exercises," it remains an elegant outdoor picnic, weather permitting, and maintains a celebratory tone for the accomplishments of the program year. After research showed the value of an end-of-the-year history, the retiring president agreed to resume that practice, an old tradition newly revived.

With no joy but much emotion, the Clover Club developed a ritual by which they memorialized deceased sisters. In the early years a memorial was prepared by friends of the deceased and entered into the club records, and a copy was sent to the immediate family. Once, saying good-bye to a member began with a bedside vigil and continued with group attendance at the funeral and ongoing expressions of sorrow throughout the minutes of the following years. However, only Julia Kimbrough would inspire such an exceptional farewell.

At 2:00 P.M. every Monday afternoon, the Clover Club followed a "structure of work" similar to the Chautauqua models and spin-offs used around the country by women's literary clubs. Secretaries and class historians frequently used the words "work" and "lesson" in their accounts of the activities of the "class." The carefully preserved minutes and histories provide the format (if not often the substance) of the weekly meetings. Each meeting began with a roll call, which was answered with a response to a preannounced prompt such as "Bring a current event" or "Provide a quote from Emerson" or "Name an author who has adopted a pseudonym." According to a club historian, a roll call sometimes took up to thirty minutes.

Depending on the president, parliamentary drill sometimes followed a roll call. President Julia Kimbrough, undoubtedly influenced by her lawyer/judge husband, valued the rules of parliamentary law. She sometimes created visual aids and games to reinforce her drills. The minutes, however, do not reflect how carefully parliamentary rules were enforced. The next item on the weekly agenda was the "Critic's Report," a reflection on any errors of fact or pronunciation (or grammar) during the previous week's lesson. The role of the critic was common among women's literary clubs, and her report may have been nervously anticipated in some groups. In Santmyer's ". . . *And Ladies of the Club*," the critic's report was awaited with "trepidation."[46] However, in Clover Club the critic often had little to report, and when she did, it was benign. Typical entries in the minutes read: "The critic reported pronunciation perfect at the last meeting" and "The critic's report was taken in the good spirit in which it was intended." One interesting exception was a debate spawned in 1895 by a critic who challenged the phrase "Everybody was his children." Unable to determine the correct grammar, the women postponed a decision until the next meeting, when it was decided that grammatical agreement is achieved with the phrase "Everybody was his child."[47]

The minutes clearly reflect how little of the weekly meeting was concerned with club business. Unless new members were under consideration or a committee was at a stalemate, no business was recorded. Instead, the format called for the women who had been assigned the "work" or the "lesson" for the meeting to proceed. In the beginning years as many as six or eight women might be on the program in one long afternoon. They likely followed Chautauquan pedagogy on how to conduct a circle: explain historical allusions, correct any mispronounced words, drill on the key points.[48] Later the number of class leaders diminished to two or three for the afternoon's lesson. Modern Clover meetings likewise conduct little business but feature one leader each, and meetings rarely last over an hour.

It is not clear from the minutes whether or not discussion followed the lesson, but it is clear that socialization followed. The ladies in Santmyer's fictional Waynesboro Woman's Club eschewed refreshments, saying, "We do not want to be seduced . . . into seeing who can bake the richest cake."[49] Modern Clovers agree, serving refreshments only on "special days." However, the early Clovers disagreed. The minutes frequently record some lesser version of this statement: "not willing that the mental faculties should be developed at the expense of the physical, delicate refreshments were served by the hostess in a graceful manner." Sometimes the meals served on "special days" are on record. An example from the conclusion of a poem composed by a gentleman lecturer after an evening parlor lecture at the Kimbrough residence in 1897 reads:

Only one complaint is made by we poor sinners.
Life is real, life is earnest, but it's not all Kimbrough dinners.
Philosophy! Come to our aid: dispel this downcast look.
Alas! We cannot all be Kimbroughs and we've not the Kimbrough
 cook.[50]

The importance of food as a foundation of the fabric of the sisterhood is summarized in this statement by Julia Ward Howe, founder of the New England Women's Club: "Ladies, we must eat and drink something together or we shall never get acquainted with each other."[51]

John Vincent referred to Chautauqua as "our great life-university,"[52] but most scholars of the literary club movement conclude that the club members' efforts fell short of an actual college experience and that their study programs "evaded the mental rigors imposed by a good college curriculum."[53] During its first four years, the Clovers' "university" curriculum prescribed extensive, required reading built around a yearly theme: England, America, Europe, the classics. Required or recommended titles included *English Literature; Recreations in Astronomy, with Directions for Practical Experiments; The Word of God Opened;* and *General History of Rome.* A few scientific titles can be found on the reading lists, but they are far outnumbered by titles that suggest curricular focus on culture, literature, history, and travel (which became very popular later). Reading had long been a way for girls and women to compensate for their limited intellectual opportunities, and history had been recommended as "the proper study to unfold the intellect of woman" by Elizabeth Peabody, who added that "as Emerson has said, we can judge our own characteristics, and those of others when they are displayed on the page of history, without personal pique."[54] Besides, practically speaking, books on literature and history were quite accessible. All the books were affordable and were often supplemented with small, ten-cent paperbacks written especially for Chautauqua home readers. Some ten-cent topics included Horace Mann, Socrates, and a booklet on manners. A Chautauqua Book of the Month Club eventually developed, predating modern ones by fifty years.[55]

Later the Chautauqua reading list expanded and politicized to include the autobiography of Lincoln Steffens, Jane Addams's *Newer Ideals of Peace* and *Twenty Years at Hull House,* along with Richard T. Ely's *The Strengths and Weaknesses of Socialism.*[56] However, by then the Clovers had gone their own way and were choosing their reading lists and topics from other sources, such as the Bay Area Reading Course, *Bay View Magazine,* and related books. Eventually the Clovers turned from prepackaged curriculum materials. The Clover program committee began to select its own program theme for the

year, assign topics to individual members (sometimes over protest), and expect self-directed reading and research on the topics in preparation for solo presentations at the Monday afternoon meetings. It is not clear whether the women read their papers word for word to the club, but it is clear from the few extant texts that they were carefully composed in the flowing handwriting of the day and with admirable rhetorical skills. Clover records suggest that anxiety was a frequent problem among presenters, even though critics were seldom harsh in their comments. The system of program assignment, preparation, and presentation is still in operation, minus the critic.

A random survey of Clover Club program books from 1897 to 1930 reveals the study of England, Russia, France, Austria, South America, the history of painting, art appreciation, and western folklore. American studies focused on artists, Native Americans, and "the noblest, best women the world has ever known," including Susan B. Anthony, Clara Barton, Mary A. Livermore, Frances E. Willard, and Julia Ward Howe. Following the tradition of university curricula of their time, little attention was paid to Asian and none to African countries. The Danville Clover curriculum could be accurately described in this assessment of the literary club curriculum: it "was not as closely allied to traditional concepts of ladydom as the study of home or child care might have been, but neither was it as radical as suffrage work. Its form and content was fairly rigid and limited to particular topics which, if not entirely within the bounds of orthodoxy, surely were not extremist."[57]

Critics demeaned literary clubs for superficial study of a wide range of topics, which were rarely covered in depth. Comments by club members support these charges. Mary Lee Talbot, in her examination of Chautauqua correspondence, notes constant complaints from club members (who ironically anticipate modern college students) that too much reading was required. Blair records a club member admitting, "The subject of conversation at our teas is first Shelley, then Charley, then Mary Ann." A Clover Club secretary confirmed in her 1904 minutes that this sometimes occurred: "The repeated efforts of the President to interest the class in the German press and German art and literature utterly failed. She good-naturedly gave up and the afternoon was spent socially."[58]

Rigorous reading requirements declined. Early Chautauqua curricula demanded that twelve books be read; that number dropped to four books by 1900. The *Chautauquan* magazine, which contained articles, dictionary helps, study guides, and reports from national headquarters in New York, began to substitute for full-length texts. Magazines, in fact, were growing in popularity around the nation, and they became the "lifeline of the CLSC."[59] The increasing use of magazines by the Clover Club is easy to observe in the minutes: beginning in 1901, "Magazine Day" is often mentioned. Titles cited

include not only the *Chautauquan* but also *Century, Bookman, Harper's, Atlantic Monthly, Popular Science,* and (gasp) *Reader's Digest.* So, was there a parallel between the women's literary club and the university? Both required "sustained and structured work." However, as the literary clubs evolved, their formats and especially their curricula abandoned university standards. In the twenty-first century we accept John Vincent's enthusiastic claim of a "great life-university" only metaphorically.

BONDS OF SISTERHOOD

The bonds created by membership to any club often go beyond simply learning and growing intellectually. Like women in most sororities, those of the Clover Club found true friendship with their fellow members. The bonds of sisterhood were the foundation of the club's contribution to "the development of 'woman,'" in Julia Kimbrough's phrase. In the dusty, dead papers of the Clovers, the many expressions of love and affection that were prompted by their association together come alive and reveal what truly helped them grow together.

Historians who analyze the world of women's literary clubs rarely fail to comment on the power of sisterhood; they note that club records abound with the sisters' expressions of affection for one another and their reliance on one another to help break the barriers of tradition. After having been told for centuries not to speak up in public, to avoid politics, and to defer higher education to their brothers, American women had "been led to the conclusion that they were incapable of these things. . . . To unlearn this lesson took time and the mutual trust engendered by a newfound sisterhood."[60] Therefore, a typical club goal "was to foster fellowship leading to greater intimacy and friendship," and women met together regularly in their clubs to develop "friendship [and] confidence" as well as knowledge. Early club organizers recognized the centrality of affective ties. Mary Livermore endeavored "to cultivate the social spirit [with] 'bright and spicy papers' and 'a great deal of talk.'" Charlotte Perkins Gilman perceived that clubwomen learned more than to improve their minds: "They learned to love one another."[61]

The records of the early Clover Club spill over with expressions of sisterhood. One of the annual club historians began with apologies of inadequacy and then continued: "but my heart is full of love for each and every one of you and I know you will excuse mistakes and omissions. . . . Our club opened its [program year] at the home of Mrs. Tincher, a bright and beautiful day. I am sure this can always be counted one of our happiest days, for it is the reunion of old true and tried friends who are glad to clasp hands once more and smile into each other's loving eyes, looking forward to the weekly companionship through the long winter together." Another club historian

asked, "What would life be like without Monday afternoons?" Julia Kimbrough said in her speech of retirement from the presidency: "Now that we are about to part for our summer vacation, it is with deep regret I do so, for I have learned to love the work and the members. It would be impossible to associate together four years without becoming deeply attached to each other. No president was ever honored with a truer, nobler set of ladies."[62]

Never is the bond of sisterhood more dramatically evident than in the memorials offered to departed members. When Julia Kimbrough died in 1907, with little warning and still in the prime of life, the club members went into prolonged mourning. They took charge of receiving funeral callers in the Kimbrough household and attended the funeral as a group. They also created a memorial book in memory of her passing. In it the club historian, using her highly evolved, creative literacy to express her grief, wrote:

In the weeping month of April Death beckoned our loved member, Mrs. Kimbrough, to the beautiful beyond. Standing in the present, memory works backward and we see her:

> Standing in the new, wide-open doorway
> With the sunshine overhead,
> The house all garnished behind her
> And the plentiful table spread.
>
> She has stood to welcome our coming,
> Watching us fall in line
> On the pleasant days that brought us
> Oh, many and many a time. . . .
>
> The smile on her face is quiet,
> For her work is compassed and done.
> All the things are seemly and ready
> And her summer has just begun. . . .
>
> But we cannot think of her idle;
> She must be a home-maker still;
> God giveth that work to the angels
> Who fittest the task fulfill.
>
> And somewhere yet in the hilltops
> Of the country that hath no pain,
> She will watch in her beautiful doorway
> To bid us a welcome again.[63]

Several years later a club historian showed that Julia Kimbrough's memory remained fresh within the group. The historian described a Clover meeting at the home of Caroline Tincher, who was Julia's mother: "We were served a delicious tea, such as Mrs. Tincher is renowned for. This Mother is dear to the heart of each Clover and this home filled with the memories of the many happy times spent there with our dear Mrs. Kimbrough, and we left with a feeling of joy for having been there, and one of the sadness that she was not there."[64]

The Clover Club created a bond of sisterhood that modern Clovers still enjoy. In its blending of love and learning, the Danville literary club, like other literary clubs created by American women, crafted an important innovation: the new literacy created in the "synergy between clubwomen's literacy practices and their intimate connections with one another" and the new public persona of the clubwomen. Gere has made extensive use of the written records of literary organizations and has found that "they show clubwomen making their own history and defining their own cultural identity." She observes that clubwomen "shared gendered perspectives . . . and employed conscious strategies of community building [which] developed an ideology of literacy best reckoned by the calculus of intimacy."[65]

The search through the minutes and annual histories of Danville's Clover Club reveals no evidence of deliberate strategy, but they certainly provide evidence of a gendered literacy based on the intimacy of sisterhood. As in any literary club, Clover Club members performed with only occasional complaints. They accepted assignments from their program committees. They shared their worry about the topics and their ability to research and write about them well. The women likely shared sources with and sought advice from their sisters as they worked sometimes for months on their assigned topics and composed drafts. They agonized in nervousness over the presentation of their research, especially if it was their first solo performance. Nevertheless, they stood and read their papers to supportive listeners, and then they willingly accepted comments from the club critic. The necessary result of this collaborative process was a powerful, shared emotion.

As for the new public persona, Julia Kimbrough saw the "strength in union. While our intentions may be good enough, we find we do but little except by the spur which comes from our club meetings." Only a few of the early Clovers, such as Eliza Webster, moved on to political activity. Probably only one evolved into the ultimate clubwoman self-described above by Julia Kimbrough. While today most Clovers are politically aware and active, not many of the founders felt motivated to go beyond the new persona they were developing within their club. However, all the early Clovers had stepped out

of their kitchens and parlors, beyond their church circles, and into the public sphere. Even if they were not ready or saw no need as yet to work for benevolent causes, the temperance cause, or woman suffrage, they had publicly declared their literacy and their worth and in so doing had taken part in "the development of 'woman'" and "her evolution."

3

Board Ladies

. . . she had the ardent woman's need to rule beneficently.
George Eliot, *Middlemarch*

THE CONFINED SPHERE OF THE TRUE WOMAN of the early nine-teenth century began to expand as she moved out of her home and into her church. Here her virtues were extolled by her minister, and here she could join ladies' aid and missionary societies and engage in activities that were natural extensions of those virtues, especially piety and charity. More doors opened for antebellum women into the homes of their peers for afternoons of self-directed literary and historical study. Such activities were still within the sphere of respectability despite some criticism that the "ladies of the club" were selfishly engaged in promoting their own intelligence. The club ladies persisted in their self-directed pursuit of cultural topics, developing confi-dence, new voices, and powerful bonds of sisterhood.[1]

The knowledge and confidence they developed while participating in church activities and/or study groups such as the Clover Club were reward enough for many women in Danville, Illinois. However, for others, such as Julia Kimbrough and her Clover sister Eliza Webster, church and Clover experiences were just the beginning of their emerging public personae. Their journeys from home included a fulfillment of Jane Addams's prediction: "If a woman would keep on with her old business of caring for her house and rearing her children she will have to have some conscience in regard to pub-lic affairs lying quite outside of her immediate household."[2] Progressive women in cities across the nation were in tune with Addams's conscience. They were becoming "municipal housekeepers" who wanted to re-create the orderly, healthy, Christian atmosphere of their own homes for homeless chil-dren. Likewise, Kimbrough and Webster used their homemaking skills in the founding of a remarkable benevolent institution, the Vermilion County

Children's Home. Now known as the Center for Children's Services, the building is no longer a residence for homeless children, but its location on a spacious and prominent lot on Logan Avenue is still the same. Fortunately the vault of the center contains the history of the Children's Home as recorded in detailed minutes of the board of directors dating back to the home's founding in 1894. Another serendipitous resource is an in-house history of the center, a labor of love written in 1989 by Dan Olmsted, professional editor and great-grandson of founder Eliza Webster.

VERMILION COUNTY POOR FARM

At the turn of the previous century, Danville was a booming town with several newspapers. On March 20, 1889, the *Danville Weekly Press* ran an article by Nora Marks, an investigative reporter from Chicago. Marks rode the train around the state and provided "pen-pictures of the poor houses of Illinois." Her description of the Vermilion County Poor Farm begins with a hired man at the gate who blocked Marks's admission, saying that the superintendent was not there and "It's against orders to allow anyone to go through when he's away." However, Marks persisted and gained entrance after showing her credentials. She entered a large frame building where "a dozen men crouched about a stove." Next she saw three boys approximately nine to twelve years old, "shivering in their bare feet." They were uncommunicative, and the hired man ordered them to bed. She saw two little girls in the women's building but was not allowed to question them. The next day Marks came back with a permit from the county board and was allowed to inspect the poor farm more freely. She reported:

> Five boys were playing on the veranda, one a cripple. They were ragged and dirty, neglected and spiritless. None of them had been in school since they came to the poorhouse.
>
> "I've been here a year and was in the third reader," said a boy of 13. The two little girls were his sisters. "Mother died and my pa went to Texas." The others did not know how long they had been there.
>
> "What do you do all day?"
>
> "Play and fight."
>
> We tried the doors opening onto the veranda, but all were locked; so, piloted by the boys, we crawled under a railing and went in by the back door to a room where a number of men, old, crippled, foolish, were herded. . . .
>
> "They don't do anything, them boys, but play, fight and learn to be lazy and idle. This is good enough for us who are no account to anybody, but them boys ought to have a chance to be something besides paupers.

There's a school house not half a mile away and six children here who ought to be in it or out of this place," exclaimed one of the men.

Taking the boys by the hand, we went across to see the girls, who were a little better cared for than the boys, but this was evidently the work of a grandmotherly old woman, herself a pauper.

"Would you like to have a mamma?" I asked Annie.

"My momma is dead," she said. "Are there any more?"

"Lots of them somewhere. . . ."[3]

GRAND OPENING

In response to the need of Danville's motherless and homeless children, eleven benevolent women signed the charter of the Vermilion County Children's Home in 1894. The home opened its doors in a rented house at the intersection of Logan and Williams streets. The founders accepted their first child, a deserted two-year-old, on February 1, and by the summer of the following year, the facility was already filled to capacity and expansion plans were under way. The rented house was soon purchased and remodeled, and a grand opening of the new facility was held in 1899. According to the *Danville Daily News* on January 13 of that year: "The opening of the Children's Home yesterday was one of the most auspicious events that has ever occurred in our city . . . the reception was attended by hundreds of people. . . . The guests were received most graciously in the reception hall by Mrs. W. E. Shedd . . . assisted by about forty ladies, members of the board of the association . . . the visitors availed themselves of the privilege of admiring the beauty and comfort of the home, not forgetting the wee tot in the dainty crib in her pretty dress fashioned so beautifully by Miss Madie Woodbury."

W. R. Jewell, editor of the *Danville Daily News,* addressed the gathered crowd with words of praise, congratulating the board ladies for striving to inculcate upright, middle-class values in the city's homeless children:

> In standing in this home for homeless children it seems fitting to say, "Now abideth Faith, Hope and Charity, but the greatest of these is Charity," and to remember that "Charity abideth forever." In this place the heart is assured that charity abides upon the earth for this is practical proof of it. This home, this building and administration, is purely a work of charity. The ladies who have devoted so many years of hard work to the home, and have toiled so hard for this building the past year . . . are to be congratulated. . . . All the ladies of the board are women who have comfortable homes of their own, and could have lived at ease without taking this great burthen upon themselves; but knowing that there are homeless children in the community who were not only suffering, but who were

becoming moral wrecks, they could not rest in their comfort and plenty and not do something to help save them from suffering and moral ruin. True they are the county's poor and true the county is able to take care of them, and does do so; but the ladies did not want them to go to the county home and have the associations of that place and people, they want these children to have the associations of home and of child-life, hence have arranged their home as nearly [like] a real home as possible. . . . Many of the children that come into this home from places where they would have been made criminals and pests, if they had stayed, will become good useful citizens in a few years.

The eloquent rhetoric of W. R. Jewell was surely appreciated by the ladies who founded the home, but their charter, as stated on their certificate of corporation, offered a more practical view of their purpose: "To alleviate the conditions of destitute or dependent children, caring for them in the home, and securing for them homes in Christian families, to clothe, feed, and instruct . . . to afford a temporary home for poor children whose parents thus aided may be enabled in a short time to support them in homes of their own . . . and other charitable work as the board of directors may approve."

Skilled managers of their own households, the small group of directors oversaw every decision, thus micromanaging the home in the early years. For example, according to the board minutes of 1894, they voted to charge Mrs. Downey two dollars per week for the keep of her grandson Laurence, and "motion [was] made and carried that when children are offered to the home the member of the board to whom the application is made with two other members be authorized to use their judgment in taking them into the home." This loose system of acceptance would not last long. The "Board Ladies," as they were known to residents, were learning on the job and soon expanded their base to include more members, dividing responsibilities more efficiently and delegating them to committees.

BOARD LADIES GET ORGANIZED

Like most women's organizations at the time, the Board of the Vermilion County Children's Home had a constitution and bylaws. In delicate script the constitution begins with the language of the charter, quoted above, and then describes the membership: "Any white person may become a member of this association by paying one dollar annual dues." Further articles distinguish two levels of membership: (1) Association members, who met only once a year, mostly to approve reports, and whose numbers would rapidly increase as a wider community base was needed to support the home—248 association members are recorded in the minutes of 1912; and (2) the board of

directors, which included a select eleven members of the association, the original micromanagers, and which met frequently and had much more authority. Within two years the board expanded its membership to twenty-one members, who were to meet the last Wednesday of each month (although in the early years they sometimes met twice a month) and had the power to elect officers, fill all vacancies in the association or on the board, raise money, approve expenditures, accept or deny all applications, and otherwise manage the home. These Board Ladies were active in the public sphere, determining their own goals, planning their own agendas, controlling their own budget, and evaluating their own progress.

The board's management of funds, as called for in the constitution, was at first a curious arrangement of cross-checking. All monies came in to the secretary, who was to pay them to the treasurer and "take receipt therefore." Money could be disbursed only at the direction of the board and over the signatures of the president, secretary, and treasurer. The books of both secretary and treasurer were audited yearly. This careful financial system might have been due to the ladies' inexperience; or perhaps it manifested their conservative care of donated and public funds. Whatever their motive, the Board Ladies soon learned that they could relax their cautious, cross-checking measures.

Another curiosity of the early constitution is that all of its articles describe the structure of the association and the board except for two shifts from structure to Children's Home management. Article XI describes eligibility for entrance into the Children's Home: "Any dependent white child may be admitted to the Home, the age limit to be left to the discretion of the Board. . . . All applications for admission to the Home must be recorded as follows: name, age, sex, names and occupation of parents, habits of father and mother, cause for admission and by whom entered, except in the case of temporary children. Papers must be signed surrendering the child to the Home. Children may be taken temporarily. Children in the Home will be compelled to attend Public School." Article XIII states that visitors to the Home "may be admitted on Tuesday and Thursdays." Such policy details seem too detailed for a constitution, and they would disappear in later, more polished versions.

In the beginning, 1894, the Board Ladies micromanaged the Children's Home as a committee of the whole, but they soon learned that a subcommittee structure was more efficient. By 1895 they had established six committees: auditing, bedding and clothing, supplies, house and garden, finance, and accepting and placing. The following year the ladies apparently recognized the burden on the committee that accepted and placed the children, so a separation occurred and a new committee was added. The 1896 minutes

contain reports from the receiving committee, a separate placement commit-
tee, and an investigation committee. In 1898 (by this time the facility had
already become overcrowded) a donation committee was established along
with an entertainment committee and a visiting committee. The 1918 associ-
ation agenda shows that by then a few committees had been renamed and/or
combined but that the committee responsibilities were essentially the same,
the only addition being a membership committee.

In describing an earlier Chicago home for children, Kathleen McCarthy
points out that the women directors held "a tremendous amount of discre-
tionary power over the lives of the orphans, half-orphans, street children and
boarders entrusted to their care."[4] Nowhere was this power more focused
than in the committees that most directly affected the children. In Vermilion
County one woman's name appears over and over, not only as a founder,
twice president, and frequent officeholder but also as a continuous member
of either the receiving committee or the placement committee (sometimes
both simultaneously). Her name was Eliza Webster.

NATURAL LEADERS EMERGE

A profile of lady directors in Danville and across the nation reveals that they
tended to have connections to high society. They were married to profes-
sional, white-collar workers. They were mothers, often with children still at
home and usually with household servants. They were women of religious
faith, active in church or temple.[5] In Danville they were predominantly Protes-
tant and Republican. Danville natives in the 1890s would have recognized all
the prestigious names of the founders and leaders of the Vermilion County
Children's Home: Giddings, Deamude, Webster, Shedd, Kimbrough, Plaut,
Lewis. Most of these women had a previously shared history as sisters in
the Clover Club. Names of later Board Ladies that are still recognized and
respected in Danville in the twenty-first century include Fithian, Woodbury,
Jewell, Voorhees, and Tilton.

The first board president was Mary Giddings, whose husband was a farm
implement dealer. Her successor, Harriet Deamude, was the wife of a town-
ship supervisor and dealer in real estate. Of her successor, Eliza Webster,
more will soon be detailed. The fourth president of the board, a woman who
served four different terms in that office for a remarkable total of twenty-one
years of leadership, was Alice Shedd. Local historians record that her hus-
band owned and operated his own hardware store, and he served as a presi-
dent of the Danville School Board. Alice traveled widely when she was not
busy at home or at the Presbyterian church, the Clover Club, or the Chil-
dren's Home.[6] Although she never served as president of the board, Julia
Kimbrough was a leading fund-raiser who tried to resign for health reasons

Eliza Webster. Courtesy of Rosamond McDonel

but was convinced to stay on as a valued adviser. She and her husband, Mayor and later Judge E. R. E. Kimbrough, were generous financial contributors to the Children's Home.

In discussing newly developed women's associations, Anne Firor Scott focuses on the importance of local leadership: "When no natural leaders emerged, societies formed in an initial burst of enthusiasm often dwindled and died."[7] No such problem existed at the Vermilion County Children's Home, thanks in great part to the abilities, resources, and generosity of two-term president Eliza Webster. Her leadership is illustrated in several ways, not the least of which is the fact that this founder of the Children's Home inspired three generations of family loyalty to her favorite cause.

Although she was always "Mrs. Webster" in board minutes, her full name was Eliza Eleanor Innis Webster. Eliza had been an orphan herself, adopted at age six and reared in Ohio by Dr. James and Harriett Innis. It was a boon to the Board Ladies that Eliza was married to a wealthy wholesale grocer and lived in a gracious home on North Walnut in Danville, where she frequently hosted meetings of the board as well as fund-raising events for the Children's Home. Late in their lives the Websters built a stately brick home with Greek columns on North Vermilion Street. Their great-granddaughter Rosamond

McDonel provided much of this information about her famous family. She recalled growing up in "the aura of the Websters," even three generations removed. She described Eliza as the matriarch of the family, a small but strong and independent woman.

According to Rosamond McDonel, the Websters entertained frequently after they moved into their Vermilion Street home, especially on New Year's Eve, when Speaker of the U.S. House of Representatives Joseph Gurney ("Uncle Joe") Cannon was often in attendance, drinking port and smoking his cigar with gentlemen in a side room while the festivities proceeded in the third floor ballroom. Cannon gave the Websters a gold loving cup for their fiftieth wedding anniversary. That Eliza Webster was also a generous hostess to the Board Ladies is evident in the minutes of 1894, 1895, 1909, 1910, 1912, and 1913, which record that the annual association meeting was held in her home. Often the minutes do not mention the name of the hostess, so it is safe to assume that Eliza opened the doors of her home on other occasions as well. Minutes do record that she hosted a luncheon for the board when she stepped down as president (for the first time) in 1897. When her second presidential term ended in 1916, Eliza was made "honorary advisory president."

Eliza's powerful influence can be seen not only in her role as twice-elected president but also in her committee work. Committee membership is not always detailed in the board minutes, but in 1912 it was, and Eliza's name appears on three influential committees: placement, provision, and donations. Her place on the donations committee was likely assured by her generosity and her husband's influence among his wealthy cohorts. In bigger cities around the nation, women directors tended to increase their financial contributions as they decreased their personal participation in the running of the children's homes.[8] This was not the case for Eliza Webster, who continued both her financial support and her personal commitment to the Vermilion County Children's Home and its residents.

The minutes show that soon after the Children's Home was remodeled in 1899, Eliza Webster was an advocate for paying off the one-thousand-dollar debt. In fact, the home was debt free by 1901 and for most years of her participation. In 1901 she made her first recorded financial gift, donating one thousand dollars to establish a nursery in memory of her two deceased daughters, Emma and Katherine. Then in 1918 she and her husband donated the deed to "Lot #316 in North Tilton" to the Children's Home. Even as she increased the generosity of her donations, she still kept in touch with the home and the children there. For example, she made a motion in 1916 to provide "curtains for the house" and another motion the following year to

purchase "a $5 graduation present for Marguerite." Twice the board minutes record that Mrs. Webster's attendance for the year was perfect.

Rosamond McDonel added an intriguing side note to the generosity of her great-grandparents. In the early 1920s A. L. Webster gave one hundred thousand dollars to establish a gracious home on Logan Avenue for single women over fifty-five; there, for a one-thousand-dollar entrance fee, each would be guaranteed room and board for the rest of her life. He announced that the Webster Home for Women was a memorial to the two deceased Webster daughters. He made this generous gift without the knowledge of his wife, Eliza, who was furious when she found out about it. Family speculation abounds on the reasons for his secrecy and her fury, the most benign conclusion being that Eliza preferred that such generosity be directed toward her orphans. In any case, both A. L. and Eliza would be proud of the Lakeview College of Nursing, which now occupies the building.[9]

The bright star of Eliza's generosity and leadership helped the Board Ladies of the Children's Home navigate through several management storms. However, another influential woman, an employee whose name appears even more frequently than Eliza's in the early minutes, deserves credit for avoiding a storm often referred to at other children's homes as "the matron problem." Her name in the minutes and in the memories of countless residents of the home was "Mrs. Slusser."

THE MATRON AND UNCLE GEORGE

In big cities across the nation, women of vision were seeing the needs of homeless children and were putting their homemaking skills to benevolent use by establishing orphanages. Problems that they shared focused primarily on hiring (and retaining) matrons, raising and managing funds, and placing children out of the homes. Danville's Board Ladies were more fortunate than most in the matter of matrons. They were typical but resourceful in the matter of finances, but they clearly struggled with a placement problem.

Danville's good fortune was in the choice of matron. According to the board minutes, Miss McKeon was the Board Ladies' first choice for matron of the newly established Children's Home in 1894. However, the board received "no reply" from Miss McKeon to their offer of fifteen dollars a month plus room and board, so they made the same offer to a second choice, Mrs. Viola (George) Slusser, who accepted. What the Board Ladies got for their money was an experienced and long-term matron, who came complete with a handyman husband. Viola and George Slusser lived and worked at the Children's Home as a successful team for nearly thirty years. In 1930, when she was forced to retire due to ill health, the Board Ladies asked her to reconsider

Viola Slusser and a child from the Vermilion County Children's Home. Courtesy of Vermilion County Museum

but finally accepted her resignation. The board minutes direct that she should be sent a "chair instead of flowers."

The Slussers' granddaughters Doris Slusser and Audrey Slusser Oswalt agreed to an interview. With smiles and nods of remembrance, they shared detailed memories of their frequent visits to the Children's Home when their grandparents worked and lived there in an apartment on the second floor. They remembered that Viola and George had taken children into their private home for years before the Children's Home was established. These children had been placed with the Slussers by county probation officers and/or the Vermilion County Board of Supervisors. Up to sixteen children at a time boarded with the Slussers, who ran a home where stern discipline was the rule.

The Slussers were community-minded people who had connections in the St. James Methodist Church, as well as the International Order of Odd Fellows and Eastern Star, so that later, when they moved to the Children's Home, Viola Slusser had many useful advantages: she was experienced in child care; the county board knew and trusted her; she already knew many of the Board Ladies and was comfortable working with them; and she knew how to contact community volunteers for needed goods and services. The Slussers' daughter-in-law, Bertha Harper Slusser, mother to Doris and Audrey, was one of many volunteers in the early days of the Children's Home. She often took her daughters with her to the home when she made her weekly visits to mend the orphans' clothing. Doris and Audrey recalled that Mrs.

Slusser and Uncle George, as they were known to the residents of the home, insisted that all residents (and visiting granddaughters) had duties to perform. Girls mostly worked at housekeeping chores under Viola's critical eye, and boys mostly worked outside in the garden or on the grounds with Uncle George. According to Audrey and Doris, Grandma Slusser was "a disciplinarian from the word 'go.'" She was a tiny woman, barely five feet two inches tall, but she was a powerful personality, and when she spoke, everyone listened, even Uncle George.[10]

Many women involved in benevolence in the late nineteenth century believed that their responsibility was to share the Christian atmosphere of their own homes with their communities.[11] Certainly Danville's Board Ladies held this view, and the Slussers concurred that the children in the home should lead not only disciplined but also Christian lives. To insure a Christian atmosphere, prayers were conducted before each meal, usually by Uncle George, and unless they had a different religious preference and someone to take them to another church, residents were expected to walk down the street to the nearby Lincoln Methodist Church each Sunday. Of course, girls walked on the opposite side of the street from the boys, just as they did to school. Strict segregation of the sexes was an unchallenged rule until the mid-twentieth century. Margaret Haenel, who became a member of the board in 1960, said, "One of the first things that impressed me was a big discussion about whether it would be all right for the boys and girls to eat in the same dining room."[12]

Audrey and Doris knew that their grandmother was strict, but they had no knowledge of residents being punished. Aggie Miller, however, who lived at the Children's Home from 1927 to 1933, recalled that silence was required at meal times and that noisy children were sent from the table. She observed other children being spanked with switch or belt for disobedience. Sylvia Macy, resident from 1915 to 1925, concurred that discipline was strict but said she always avoided trouble. She remembered Mrs. Slusser as a loving and compassionate matron.[13]

Despite the long tenure of the Slussers, frequent turnover of other employees was a concern in the rapidly expanding Vermilion County Children's Home, as it was in many other such homes. Board minutes record frequent employment frustrations, and according to recollections of children who lived in the home, Mrs. Slusser was assisted by many other matrons and by domestic help, whose lengths of employment varied greatly.

One of Mrs. Slusser's ongoing duties was to appear at each board meeting to present her report on the number of residents, any unusual activities, and the bills for approval. The minutes of the association meeting held on January 21, 1903, read: "Mrs. Slusser spoke of the pitiable conditions of many of the children when received, and the gratitude and affection the little

ones never fail to show." Ex-resident Aggie Miller did not remember through such rose-colored glasses, but she concurred that she and her seven siblings were grateful for a place to live since their mother was dead and their father's mining job kept him away from home.

FINANCIAL PROBLEMS

The Vermilion County Children's Home was typical of many benevolent institutions where finances were concerned. The minutes devote a great amount of space to financial details since the board voted to allow or disallow line items. The minutes reveal a balanced and, as the number of residents grew, slowly increasing budget. Aside from well-supported, countywide fund-raisers for renovations or new buildings and frequent bequests from local citizens, most income came, in varying amounts, from the Vermilion County Board of Supervisors. The board's first recorded payment must have been a "start-up" contribution of $700 in January of 1894. Afterward the yearly amount varied, probably according to the number of residents and/or the expansion projects under way: $250 in December of 1894 (fifteen residents in the home); $300 in 1896 (fourteen residents); $1,531 in 1911 (twenty-nine residents); $3,115 in 1919 (eighty-five residents). Minutes of the Vermilion County Board of Supervisors include the following entry: "[Have been] in conference with the ladies talking over at some length the general policy and management of the Home and have only the highest praise and commendation for the noble ladies and their able administration of the affairs of the Home."[14] The gentlemen of the county board sent their checks and kept their distance. Clearly they recognized and appreciated that the Board Ladies had relieved them of their child-care burden.

In some cities, including Chicago and Galveston, the focus of the ladies who directed the facilities for orphans changed to fund-raising, leaving management of these institutions more and more to professionals. By the late 1920s even the fund-raising was led by professionals, and most women directors had little firsthand awareness of the children they served. In Danville, however, the Board Ladies continued their micromanagement until state commissions, which in the beginning were merely advisory, became more controlling. The first mention of state influence on the Children's Home in Vermilion County is in the board minutes of September 1921: "Department of Public Welfare sends notice that Home must contain 500 cubic feet per bed." The minutes record no response to that first state notice; likely none was required in the early years of the century. The Board Ladies kept up their personal involvement with both management and fund-raising until the 1960s, when the Illinois Department of Children and Family Services was created, assumed the role of overseer, and required professional management.

The minutes of the early years of the Children's Home reveal an interesting variety of fund-raising activities, from individual to board-sponsored to community-wide. One of the Board Ladies "held a fundraising supper on her lawn" in 1897 and donated the proceeds, $58.85, to the home. Later the Board Ladies gave showers, held charity balls, and opened "country stores" at the fair. In 1898 their "trolley day" netted $586.00. Despite the national trend in benevolence toward more-professional management, the Board Ladies in 1905 turned down the application of a professional fund-raiser who presented her services for a salary of $50.00 per month. Instead the Board Ladies continued their personal donations (both money and property in the case of Eliza Webster) and their successful contacts with the community, sometimes assigning lists of businessmen to the Board Ladies for solicitation of funds.

Records of orphanages in other locations often indicate that while women made the plans and did the work, at least in the early years, men were important influences where finances were concerned. The Board Ladies managed the Vermilion County Children's Home without male overseers, but local men generously provided much needed financial support. In 1895, one year after establishing the home, Board Ladies found their facility filled to capacity (fifteen) and expenses rising (the cost of child care was up to $1.50/week). Problem solvers that they were, they went first to the Vermilion County Board of Supervisors for additional funds (they were rarely refused) and then made a public appeal for support. The success of their public appeal was no doubt due to the fact that many of the Board Ladies were married to prestigious and wealthy leaders of the community. The list of the contributors reads like a Who's Who in Vermilion County: Hon. E. R. E. Kimbrough, *Danville News* editor W. R. Jewell, wholesale grocer A. L. Webster, banker William P. Cannon, haberdasher Ike Stern.

In 1897, when another expansion project became necessary, the Board Ladies went public again, holding a fund-raiser in the new City Hall. According to the *Danville Daily News,* the well-attended event was sponsored by a coalition of women's clubs including the following: North End Workers, East End Social and Literary Club, Friday Club, West End Club, Ladies of the C. P. Church, Philanthropic Section of the Women's Club, Little Do Something Club, and (how *did* they choose their name?) Desperation Club. Again the results were successful, illustrating how the Board Ladies continued to expand their base of support by forming coalitions.

As the new century dawned, the Children's Home population continued to grow. Association minutes of 1912 and 1913 include Matron Slusser's report of over 100 children admitted during the year, with between 20 and 30 in residence at the same time. Once again responding to need, and perpetuating

the strict segregation between boys and girls that had been maintained from the beginning, the board expanded its association membership from 180 to 248 members. With this new financial base plus the support of wealthy husbands and many women's clubs, board members planned and built a separate structure to house the girl residents.

PLACEMENT PROBLEMS

Permanently placing orphans out of the home was a difficult challenge to the Board Ladies, as it was in orphanages across the country. Separate committees were established for admission and placement, and the makeup of the placement committee shows that board leaders such as Eliza Webster were usually in control of this influential position. Overcrowding in the facility and spiraling costs (child care had risen to $3.75 per month per child in 1913) made "adopting out" a high priority.

The constitution stated that only "white children" would be accepted into the Children's Home. However, "colored" children were occasionally admitted on a temporary basis. The 1895 board minutes record that "a lady in Decatur has found a home for one of our colored boys." A later report on the same boy notes that he is "dishonest" and must be sent to reform school. The board voted to send another boy of color to the county poor farm.

Some private homes in Danville accepted children of color, most notably Laura Lee, an African American community leader whose home became a Danville institution. In 1915 she petitioned a judge to let her keep several homeless children, ages ten and under, in her home rather than send them to reform schools. She was supported in her efforts by Danville African American women, who in 1907 had formed a Colored Woman's Aid Club, of which Laura Lee was a member. Lee took in washing, and her husband worked nights in a garage to finance their benevolence. Members of the Colored Woman's Aid Club and Danville's black churches donated clothing, money, and food to help support the children. The county provided some financial support for the Colored Children's Home, and the community kept it going after Laura Lee's death in 1929. In 1944 the Laura Lee Fellowship House was established under biracial leadership at 212 East Williams.[15]

The Colored Children's Home was closely integrated into the African American community, according to famed entertainer Bobby Short: "Laura Lee . . . founded a home for colored orphans and children who had no other place to live, boys and girls whose fathers had disappeared or whose parents had just left the scene. As far as we were concerned, no stigma was attached to living at the Laura Lee Home, a complex of three frame buildings down in the East End, with a community dining hall and a big playground where we were always welcome to play. The children at the Home were a close part

*Laura Lee. Courtesy of
Vermilion County Museum*

of the colored community. No bureaucratic hands-off or red tape. And they were brought to Sunday School each week by an enormous, gentle colored girl named Magdalene."[16]

Thus, the Board Ladies "adopted out" children of color, and in 1913 they petitioned the county board to "remove all boys [black and white] from the home who were over ten years of age." Minutes do not reveal why these particular boys were targeted, but the crowded condition of the home plus the normal, difficult behavior of preadolescent boys seem the likely causes.

Returning children to their parents was usually the desired goal, but this was impossible if parents were deceased or absent. In keeping with their moral agenda, sometimes the Board Ladies decided against returning the child to a parent because the parent did not meet the board's standards. Recorded in the minutes of May 1894 is this: Board Ladies vote to "investigate and see if the mother can be prevented from taking Lerue away"; and in April 24, 1895: "Board decided not to give up Mrs. Wire's son to her unless she established a good character."

Aggie Miller, resident from 1927 to 1933, remembered stressful events during which the girls were cleaned up and asked to stand in line while couples inspected the lineup to select a child to adopt. She was disappointed many times at such events, but finally, as she neared age sixteen, she was selected, not for adoption but for employment as a live-in maid. She was glad to have the job offer, since all girls were expected to leave the home at sixteen. In her case, the employment led to a private home where an employer/mentor

recognized her desire for further education and helped her complete nurse's training. Former home resident Sylvia Macy recalled that she had a "guardian" who provided her with clothes and personal items while she lived in the home and up until she was fostered out in 1925. Neither young resident was aware of any influence the Board Ladies had in her placement. In fact, Sylvia Macy had little recollection of the Board Ladies except to say that they "dressed like Mrs. Astor and inspected the place."

LADY MICROMANAGERS

Whether or not the residents were aware of their presence, the Board Ladies were powerful influences on the day-to-day lives of the children who lived in the Vermilion County Children's Home. McCarthy describes the influence of the directresses in Chicago: "In order to sustain the continuity of day to day operations, board members made the clothes and bedding themselves, purchased supplies, investigated and admitted inmates, hired and fired the staff, nursed the children, placed them, taught them, mothered them, and when necessary buried them as well."[17]

Similarly, the board minutes in Vermilion County reveal that micromanagement became the ladies' specialty in the early years of the Children's Home. As they set up the home in 1894, the Board Ladies first purchased or donated items from their own homes: a heating stove from Eliza Webster, "coal for the season" from Harriet Deamude, a washing machine from Lida Helm. Later they solicited donations such as "a single iron bed" and "a washing machine and 1 box of soap." They contacted Dr. Herbert W. Morehouse to see if he would provide medical assistance. A committee was established to make covers for the mattresses. In November 1897 three Board Ladies were put on another committee to "look after Christmas for the Home." When the matron was reported to be ill, "Mesdames Powell agreed to go to the Home on Monday, Jewell on Tuesday, and Kimbrough on Wednesday."

This hands-on and day-to-day commitment continued at the Children's Home into the 1960s, when Illinois established its Department of Children and Family Services, which required professional management of children's homes. Margaret English, who joined the board in 1946, recorded the continuing, direct involvement of the Board Ladies: "I can remember going . . . to Westville just to get a cook, going from door to door." Margaret Haenel, who joined the board in 1960 and was still an emeritus member in 2007, reported: "I remember being called down to the Home in the middle of the night at least once or twice. One time one of the big boys had locked the housemother in the bathroom, and there was no way he was going to let her out. I don't remember just how we solved that one."[18]

Rose Allen, granddaughter to Eliza Webster, recalled in a 1989 interview: "What I remember is that the Children's Home has been part of my life ever since I was a little girl. I can remember my mother [Nellie Webster Hatfield] doing blue denim shirts on the sewing machine. Several times a year, before the children went to school—board members would make shirts, and I can remember that sewing machine that you push down the treadle, and that thing was just buzzing away on those blue denim shirts."[19]

In addition to putting clothes on the children's backs, the Board Ladies managed the dining room. They also studied and approved monthly grocery bills presented by the matron; for example, $34.64 was approved for July 1894. In addition, they solicited donations of food from area farmers and grocers, although thanks to Uncle George Slusser, the boy residents, and volunteers, the home was fortunately able to provision itself by raising cows and chickens in the early years. According to board minutes, one of the Board Ladies collected donations for a new cow in 1896 and was therefore voted onto the "cow committee." In 1911 "Mrs. Bump was instructed to get estimates for the chicken house." However, 1914 board minutes record that the house and grounds committee decided to keep only the best cow and chickens. A Board Lady was directed to sell the other cows, and "the rest [of the chickens are] to be used on the Home Table." Uncle George had long supervised a large garden, and Matron Viola Slusser's report to the association in January 1908 details forty gallons of beets, forty-two gallons of tomatoes, and fifty heads of cabbage for the home table. Board minutes in 1909 record that the home's garden provided all their fresh vegetables and even won prizes in a "Farmer's Institute."

The Board Ladies naturally oversaw the menu in the early years, deciding at one point to prohibit lard from the children's table and later voting that the children should be fed "pie once a week." They voted to use tablecloths and napkins. Doris Slusser and Audrey Slusser Oswalt remembered that their grandmother demanded that the girls who resided in the home learn to set the tables properly and to "eat like ladies." Resident Sylvia Macy remembered that one of her frequent chores was setting the table, but she had little recollection of the menu except that "we ate worlds of oatmeal."

Lady managers in Danville and around the nation not only mothered the children in their homes but "when necessary buried them as well."[20] The minutes recorded in Vermilion County leave no doubt of either activity. The Board Ladies' mothering instincts are illustrated in recurring references, sometimes by first name only, to young residents in the home. In 1914 one girl was apparently about ready to leave, but the February 24 minutes record a "discussion and vote on whether to keep Josephine Brewer in the home and in school until she becomes more competant [*sic*] to help herself." The

August minutes record that "Mrs. Freeman donated a membership in the YWCA for Josephine Brewer. Mrs. Freeman was asked to assist Josephine to select a course of study." Later that year Josephine was "released to her brothers in Chicago."

Other examples indicate maternal attachments to residents (most of them girls). A Board Lady is instructed to "get glasses for Mabel," and a motion is made to pay Margaret Williams's bill at Lakeview Hospital (the eleven-dollar check was returned to the board from the hospital the next month). Doris Slusser and Audrey Oswalt Slusser recalled that their grandmother took a strong maternal interest in resident Pat Bentley, who grew up to be a teenager in the home. Viola "saw potential" in young Pat and wanted her to develop it. She taught Pat not to accept the label of an orphan, a "kid from the Home," but to learn and accept responsibility for herself. After Pat left the home, she worked for some of the leading families in Danville and remained a friend of the Slusser family for the rest of her life.

If ever a board meeting had a maternal aura, it was in May 1921, when a debate ensued on where the children should be allowed to hold their ball games. Should the games be held on the "cow lot"? This possibility was voted down because it would necessitate the moving of a fence (other bovine problems are not mentioned). Should the game be allowed on the north side of the house, where the grass would be trampled? That possibility was tabled, and the Board Ladies were about to decide to leave the location up to the house and grounds committee when one of the ladies moved to allow the game on the east side of the building and not to worry about the grass "because children's pleasure means more than grass."

The most difficult task of a mother is to bury her child. Occasionally the matron's report at the end of the year summarized the health of the residents: "Sickness among the children but no deaths"; "Nurse hired for the sick baby"; "No deaths or serious illnesses have visited our little ones"; "Whooping cough going around." In 1921 these two entries appeared: "one child died this year" and "$10 approved for minister who did funeral services for Little Flossie."

"Little Flossie" was probably ten-year-old Florence N. Hilde, who died in 1921 and is buried along with seven other orphans in a lonely spot at the edge of Springhill Cemetery in Danville. The small obelisk that serves as grave marker says only "Children's Home," and until recently no orphans' names were visible. Cemetery records do not reveal who purchased or perhaps donated the section for the orphans, which has many vacant plots, but the records show that eight children were buried there from 1917 to 1966. Sometimes the exact date of birth and the names of parents are not listed in the records. Date of death, however, is always recorded, as is the result of the

Children's Home grave, Spring Hill Cemetery. Photograph by Martha Kay

coroner's inquest, with one exception: the cause of death of one-year-old Danny Cox is listed as "temporary."

When local journalist Jean Byram did a column on the Children's Home burial plot in 1991, she noted, "These are the graves of forgotten children. Flowers are not brought here."[21] However, Byram's sad description is no longer true; perhaps her article inspired the flowers that have adorned the grave in recent years. In addition, in 2007 Marilyn Blanton of Danville memorialized her sister, who loved children, by donating individual grave markers for the orphans. Each flat marker contains the name, the date of birth (if known), the date of death, and a little angel on a cloud.

FROM TRUE WOMAN TO NEW WOMAN

Danville's True Women stepped out of their front doors and redefined themselves as New Women, moving beyond the circle of their churches and the

parlors of their literary clubs and into the public sphere of benevolence. Their path from their front doors to the door of the Children's Home probably went like this: reading the local papers and listening to their ministers and their husbands who sat on the county board, the Board Ladies became aware, certainly alarmed, and perhaps ashamed of the condition of homeless children in and around Danville. They likely discussed this problem at their ladies' aid society or over tea at the Clover Club. Strong-minded women such as Alice Shedd, Eliza Webster, and Julia Kimbrough insisted that prayer and tea conversation would not solve the problem. Action should be taken, action which they felt qualified to lead due to their home-management and child-rearing experience. The Board Ladies identified a need and soon approached the county board to offer their expertise. The first reaction of the county board is not recorded, but the board's eventual, grateful endorsement of the ladies' offer is clearly in the public record. Thus, the Board Ladies perceived a need, began to assume Vermilion County's responsibility for orphans, used their moral convictions and their homemaking skills to establish a residence for children, and developed coalitions in the community to support their Children's Home and expand it when it quickly filled to capacity. They learned to work together with other women to manage public money, to hire committed professionals, and to streamline their organizational structure efficiently. The safety and security these maternal women offered to homeless children was their proudest achievement. According to founding president Mary Giddings: "The Children's Home stands as the noblest monument to the generosity and benevolence of Danville women, who have done unto the children of other women as they would have done for their own."[22]

However, even at the turn of the previous century, a dispute was brewing that continues to this day. Some historians describe women's benevolence as "an assertion of social control, an attempt to impose class-specific values on the poor."[23] Focusing on the model conditions in their own home, Danville's Board Ladies made no apologies for their insistence on good manners, strict discipline, and hard work. To them, gender and racial separation was the community norm. They were, in fact, proud of their Christian bias, believing that orphans' wandering souls deserved as much attention as their homeless bodies did.

Anne Firor Scott acknowledges a skeptical interpretation of the motives of the New Woman and her benevolence. Was the Board Lady too status conscious? Was she seeking to clarify and solidify the separation between herself and the "worthy poor"? Was she avoiding serious reform with half measures such as orphan asylums and thus maintaining the status quo? Even though everyone agreed that a child with shoes was better off than a child without shoes, as Zona Gale wrote in 1906, "no kind of philanthropy will solve the

requirements of infant welfare when poverty or labor conditions are the root of the problem."[24]

The Board Ladies of Vermilion County were not inclined to propose radical challenges to get to the "root of the problem." However, in their minds, the Children's Home could provide to orphans not only shoes but also other essentials. Most of the Board Ladies had evangelical motives, seen in the emphasis on prayer and required church attendance of home residents. They felt that they were saving children's souls and earning themselves credit in heaven. Others surely saw their benevolent activities as a substitute for the careers that were denied them. In the case of women such as Eliza Webster, "benevolent societies *were* their careers."[25]

The more direct and acknowledged rewards enjoyed by the Board Ladies lay in their newly discovered capabilities to make public appeals, organize fund drives, learn about budgets, and make other business decisions usually made by men. Working together to solve problems and learning resourcefully on the job were two abilities that the Vermilion County Board Ladies added to their already acknowledged homemaking skills. An expanded mobility, a stronger sense of confidence in themselves, and a new influence over the lives of others were additional rewards. These New Women offered no apologies for what some saw as their loss of womanliness and made no demand, yet, for equality because they were proud of their accomplishments in their separate sphere.[26] The description in a 1914 *Chicago Record-Herald* could have applied to Danville's Board Ladies: "Woman has conquered everything, has taken her rightful place in society, and behold, she is ready! Who will talk now about her narrow sphere, about the kitchen and the nursery. Woman has educated herself. She stands ready for duty—serenely confident, conscious of power and anxious to serve."[27]

4

Currents of Reform

. . . centers from which radiate electric currents of moral and political reform.

Mary I. Wood, *The History of the General Federation of Women's Clubs for the First Twenty-Two Years*

VERMILION STREET IN DANVILLE is a busy, multilane highway on which cars speed north and south through the city. Still, the blocks from 1100 to 1700 North Vermilion cannot fail to remind passersby of a quieter, more elegant past, when Danville was a wealthy center for industry and the arts. Imposing homes, often beautifully landscaped, are set above and apart from the traffic. One of these homes, the handsome prairie-style residence at 1122 North Vermilion, was built of deep brown brick with leaded glass windows outlined in cream and is fronted by a deep porch and stone urns. Inside, its enormous stone fireplace, spacious rooms, and massive dark woodwork, cabinets, and cloakroom hearken back to an era of gracious formality. Until 1993 the plaque prominently displayed in the yard proclaimed this as the home of the "Danville Woman's Club." The home and the sign evoked a time in Danville decades before, when hundreds of prominent women competed to become Danville Women's Club members to show that they had "arrived" socially. By 1993 the membership had declined and many of the remaining members could not negotiate the steep stairs in the house, so the plaque was taken down and the house sold. As the Danville Woman's Club members left their beloved home, which they had occupied since 1940, the *Danville Commercial-News* reporter most in tune with local history, Kevin Cullen, wrote a retrospective article noting the club's prominence in the past. From interviews with members and from what he described as "yellowed newspaper articles in dusty scrapbooks," Cullen noted that members had brought about many improvements in the community, including a

musical department and a study of "art, foreign languages, drama, classic books, cooking, travel, and history."[1]

Another newspaper article could only hint at the breadth of the early Danville Woman's Club activities, or what they had meant to Danville. When Sue Richter, director of the Vermilion County Museum, researched the 1910 beginnings of the Young Women's Christian Association in Danville, she found that members of the club had played a prominent role in the YWCA's beginning by offering their downtown meeting rooms for the use of working girls to eat their lunch, put their feet up, have a cup of coffee, and take part in concerts and study sessions.[2] The idea of this elite group of clubwomen reaching out to working girls was intriguing, and it suggested that the members of the Danville Woman's Club had become involved in doing something about social problems and class rigidity in their community. Historians of American women, including Anne Firor Scott and Karen Blair, had shown that clubwomen, often caricatured as card players and social butterflies, actually began their club life as community activists. The Danville Woman's Club was one such socially active group. To penetrate the real history of that visionary group of women whose plans and dreams had made Danville a cleaner, healthier, more beautiful place to live, it was necessary to draw aside the veil of social snobbery that lingered in the public perception of the Danville Woman's Club.

The story began in 1895, when educated and energetic women, filled with the Progressive spirit and determined to bring the best of its potential to their hometown, began the Danville Woman's Club. Their concerns were political and benevolent as well as intellectual and artistic. Wider in their ambitions than the literary and exclusive Clover Club or the single-cause Vermilion County Children's Home Board, the founders of the Danville Woman's Club firmly established its public identity in community activism. The women of the club spearheaded Progressive reforms to better the lives of Danville's children and to make their city cleaner and more beautiful. While their progressivism halted before structural economic changes or even advocacy of unions or woman suffrage, members of the Danville club were responsible for making the female persona more public than ever before in the community. Woman's needs and comforts, her health and opportunities, and even her history were spotlighted in the literary, philanthropic, and civic actions of the Danville Woman's Club.

Like the Clover Club, the Danville Woman's Club began in 1890 with the Chautauqua literary movement. The two Chautauqua-descended clubs took different paths, however. The Clover Club remained private, small, exclusive, and literary; the Danville Woman's Club expanded its membership, took on political and benevolent as well as literary activities, and sought and gained

a public presence. The particular Chautauqua literary circle that formed the core of the Danville Woman's Club was composed of elite women, many with connections beyond Danville and some with formal education. Looking back after forty years, club founder Frances Pearson Meeks recalled that her literary circle "became ambitious and decided to enlarge the group . . . and try to organize one of those new-fangled women's clubs, so much talked of."[3]

One reason for their idea was boosterism; after all, "was not Danville as up and coming as any town in the United States?"[4] Peoria, Springfield, and many other villages and towns in Illinois had well-established women's clubs. Another reason to organize a woman's club was the fact that a Danville club would be part of a state group and even a national group, which would give its women influence beyond their own numbers. "New-fangled women's clubs," not really so new, provided the model for Danville women in addition to the Chautauqua literary circles. Beginning in the 1860s with Sorosis, founded by a group of professional women in New York City, women's clubs had established a firm foundation in benevolent and political activities as well as the study of art and literature. Their goal was "service," and they saw their sphere as "no longer confined to the washtub, the kitchen or the parlor" but part of the "great whirling globe, with all its responsibilities and its glories."[5] In the 1870s and 1880s women founded clubs not only in Boston, New York, and other eastern cities but also in Chicago and smaller towns in the Midwest.

Rapid growth in women's clubs and the belief that much could be accomplished by "strength in unity" had led to the formation of a General Federation of Women's Clubs in 1890. The new national group held its first biennial meeting in Chicago in 1892, hosted by the Chicago Woman's Club. The Chicago club was one of the oldest and strongest of the women's clubs in Illinois. By the 1890s its activist leaders were in the forefront of Progressive reforms. The Chicago club had supported the founding of Hull House by Jane Addams and Ellen Starr on the city's Near West Side in 1889. Hull House became very well known for its social, artistic, and educational programs and other assistance to immigrants in its neighborhood. Four hundred Chicago Woman's Club members took part in congresses at the 1893 Chicago World's Fair. They set up relief systems for women and families in the 1893 depression and worked to establish kindergartens and to improve the public school system. Visiting nurses, women's trade unions, parks for recreation and beautification, clean streets, and pure food were among their greatest concerns in what became known as "municipal housekeeping." Led by a Progressive vision to create a more humane, clean, efficient, honest society, women were determined to clean out laziness, corruption, and filth in their communities and city councils, just as they fought against dirt, disorganization,

and immorality in their own homes. Convinced that unity would further their power to achieve their reform goals, women's clubs worked together in the national federation and urged members also to form state federations.[6]

With enthusiasm and energy, Illinois clubwomen met at the Chicago Woman's Club in 1894 to establish a state federation.[7] They held their first state meeting in the clubhouse of the Peoria Woman's Club in October 1895. Jane Head Fithian recalled that Peoria meeting ten years later. She was one of three delegates from Danville, whose club was just being formed. The three Danville women were struck by the power that could come from women working together. According to Fithian: "As I sat in that convention and listened to the words . . . telling of the special work in which each was engaged, and the great need of more workers and of more moral support along various lines, I had a faint realization of the idea of organization of women's clubs, that an unmistakable voice might go out to the world gathering strength and volume as it goes, saying—'I too believe in that, I too work for that; I too desire that good or denounce that evil.' It is a wonderful thing to see the birth of a great idea, and then to watch its growth."[8]

The Danville women, responding to the national federation's call for service in a wider world, chose as their motto "Not for Ourselves, but for Humanity." As they sought to expand their literary circle into a large membership that would give them strength, they used a guide from the national federation: "Unity in Diversity." Jane Croly, the founder of Sorosis in 1861, had explained that women's clubs went beyond cliques, classes, or single-goal groups. She stated that "the essence of a club is its many-sided character, its freedom in gathering together and expressing all shades of difference, its equal and independent terms of membership, which puts every one upon the same footing, and enables each one to find or make her own place. Women widest apart in position and habits of life find much in common, and [find] acquaintance and contact mutually helpful and advantageous."[9]

UNITY IN DIVERSITY

To create a club with enough members from varied backgrounds to produce both strength and diversity, the Danville Woman's Club founders had a plan. The club would need the energy of youth, the status of the prominent, the perspective of the educated, and the stability of the mature. Therefore, as recalled by founder Frances Pearson Meeks, the women "scanned the social register and looked about them to find every newcomer, every returned college graduate, every girl or woman who had 'done things' at home or abroad," and invited her to join.[10]

The recruiters were women who had themselves "done things" or were on the verge of being active in various aspects of their community. Among the

*Frances Pearson Meeks.
Courtesy of Vermilion
County Museum*

founders were Cora Abernathy, tireless in her involvement in church and community, and Mary Jewell, wife of W. R. Jewell, the publisher of the *Daily News*. Strong educational leadership came from Eva Sherman, the noted principal of Washington School; Jane Pennell Carter, the first president of the club, whose husband was superintendent of Danville schools; and Frances Pearson Meeks, a leading Danville educator and social activist for decades.[11]

Frances Pearson Meeks is well known in Danville as an avid supporter of education and the community. College scholarships are still awarded to deserving young people from funds she established. Her reputation as a benevolent educator, however, gives little sense of her as a person—an intelligent, determined, forthright founder of many organizations devoted to learning and social betterment.

In an interview with a reporter on her ninety-second birthday, Frances Pearson Meeks declared: "I have very decided opinions. I'm all for democracy, always for the people."[12] Frances Pearson was born in 1870 in California, where her colorful and adventurous father, Gustavus Pearson, had pioneered during the gold-rush days. He and his wife, Hattie, decided to return to Danville when Frances was fourteen to educate their children in the town where Gustavus had read law and where her grandfather John Pearson, a Princeton

graduate, had established himself as a lawyer and become a circuit judge. Back in Danville, Gustavus Pearson built a hotel and developed other property and also wrote history. While his daughter Frances was helping to organize the Danville Woman's Club, Gustavus was busy gathering material for *Past and Present of Vermilion County, Illinois,* a biographical history that was published in 1903.[13]

Frances reflected the intelligence and self-confidence of the Pearson family. Even in her nineties she was a strong personality. Dow Cooksey, who in 1964 was a young winner of a scholarship established in her name, recalled that she "had a presence, almost regal or aristocratic and refined . . . gracious and kind, with warmth and curiosity. . . . I fell in love with her right then."[14] Her definition of democracy centered on a belief in the best education for everyone and an adherence to high standards. After her graduation from Danville High School, she became one of the first Danville women to attend college, first at Michigan State Normal and then at Cornell University. She also did graduate work at Illinois Wesleyan University, the University of Chicago, and the University of Illinois. Pearson Meeks's Danville High School faculty picture in 1908 shows an attractive but serious and determined young woman. One of her high school students described her as "a kind looking lady . . . not pretty nor very stylishly dressed . . . [but] with a pleasing smile and a pleasant voice."[15] When Frances helped found the Danville Woman's Club, she was twenty-six years old. She served as president of the club when she was twenty-nine.[16] Her marriage in 1898 to James A. Meeks, thirty-four years old and law partner of Judge E. M. E. Kimbrough, brought her into politics and membership in the Democratic Women's Club. In the 1930s she spent six years in Washington, D.C., when James Meeks was elected for three terms to the U.S. House of Representatives. Frances devoted herself to her husband's political career and to her efforts to help the less fortunate and to invigorate the Danville community.[17]

Katherine Stapp, her friend and biographer, declares that "education was more than a word to [Frances]; it was her life."[18] While she taught high school history and other subjects, she also sought to educate the community and fostered what is now called "lifelong learning." She and James Meeks did not have children, but a reporter in 1956, when Frances was voted one of Danville's ten most influential women, noted that "she counted the success of those she helped as if it were her own."[19] Twenty years after she helped start the Danville Woman's Club, she began the first adult education class at Danville Library; helped organize the American Association of University Women and Delta Kappa Gamma, an honorary society for woman teachers; and actively supported the League of Women Voters and the YWCA, church projects, and educational associations.[20] Within the Danville Woman's Club

she served on the executive board and the education committee but was most active in leading the study of literary masterpieces, music, and physical culture. She remained a strong club leader for decades and was several times designated as "Club Mother," an honorary mentor chosen personally by new club presidents to give them advice and support.[21]

The first membership list for the Danville Woman's Club, published in 1896, shows the efforts of Frances Pearson and other club founders to combine the talents of three groups that were not part of the traditional elite—women educators, unique and accomplished women without social status, and young women with potential—and combine them with the "right sort" of socially acceptable women, whose presence would make membership prestigious and desirable. Danville's first club members were noted for their youth, and more than one-third, many of them teachers, were single. Twenty-eight of the 151 charter members were teachers, including Belle Grant, Grace Dillon, Minnie Smoot, and Mary Hawkins. Several of the teacher members were to become school principals in succeeding years, including Ollie Moore, remembered as "tall and slim, pleasant, but very dignified."[22] While some of the Danville Woman's Club literary study groups met in private homes, all general meetings were scheduled on Saturdays "to enable the teachers to participate."[23] In addition to the teachers, another professional woman, physician Annie Glidden, was invited to membership and shared her expertise with the other members on physical fitness and health issues.[24]

THE COLORED WOMAN'S AID CLUB

"Unity in Diversity" did not, however, extend to racial diversity during the club's early decades, when no African American women were invited to join. In 1894, when Ellen Henrotin, General Federation of Women's Clubs president, sponsored her African American friend Fannie Barrier Williams to be a member of the Chicago Woman's Club, the otherwise forward-looking members of the Chicago club debated fourteen months before inviting her to join, and her membership failed to set a precedent.[25] Like the Chicago and other women's clubs, the Danville Woman's Club did not welcome African American members, even though the town's African American residents included professional and business leaders who were ready to organize for the betterment of their community.[26]

African American men organized their own service clubs and fraternal orders, and Danville African American women, including Annie Bass Robinson, Arzelia Taylor, Laura Lee, Mary Harding, and Kathryne Hardin, formed a Colored Woman's Aid Club in 1902. Colored Woman's Aid Clubs were organized in several middle-sized Illinois towns with the help of an organizer from the Federation of Illinois Colored Women's Clubs, founded in 1899 as

an affiliate of the National Federation of Colored Women's Clubs (NFCW). The NFCW clubs included both literary study and social action, on the principle that one improved oneself by helping others. The Illinois group, with Fannie Barrier Williams as its first president, adopted as its motto "Loyalty to Women and Justice to Children." The motto reflected the group's concern about the negative impact of race and gender discrimination on black women's lives and their goal of defending black womanhood. It also expressed their interest in influencing the lives of the children of the black community.[27]

The Danville Colored Woman's Aid Club took the motto to heart, and thrived; in 1906 club members bought a house at the corner of Union and Cherry streets, where they located their club rooms "and a Social Center for the young people."[28] The women's work for young people continued into the 1920s and 1930s. Bobby Short, who grew up in Danville, remembered the Community Center, headed by Minnie Lee's sister Laura, which was successful at "drawing the young people off the streets" and into choral work, sports, and other activities. According to Short, "the Community Center was a great place to meet your friends and stay out of trouble."[29]

African American clubwomen in Danville also retained their connections to the Federation of Illinois Colored Women's Clubs and hosted the federation's annual meeting in 1906. In succeeding years Danville women, including Emma Waldon, Annie Beeler, Arzelia Taylor, Annie Nichols, Annie Bass Robinson, and Ella Stone, served as state officers for the Illinois federation. In 1922 the Danville Colored Woman's Aid Club counted thirty-six members and hosted the state federation again.[30] Like their sisters elsewhere, Danville's leading African American women worked together "to create race pride and solidarity and to dispel notions of powerlessness."[31]

SOCIAL ELITES

As for the social elites in the strictly white club, seven Clover Club members joined the Danville Woman's Club during its first years, including active clubwoman Julia Kimbrough. Wealth and status in the club were enhanced by daughters of the prominent Wolford, Woodbury, and Webster families as founding members, and some young women founders, including Kate Webster, were also Clover Club daughters. Others had prominent political connections. Mabel Cannon Leseure, Congressman Joseph Gurney Cannon's "stately daughter," was an active founder and hosted one of the organizing meetings.[32] Gertrude Kent Wilson's husband was the Vermilion County state's attorney, and Mildred Newlon's father was county treasurer and former sheriff. Most members came from the same neighborhoods, for example, Hazel, Walnut, Franklin, and Vermilion streets, accessible to each other by foot or

carriage. However, some, mostly teachers, came from Grape Creek and other addresses away from the socially prominent core, suggesting that an attempt had indeed been made to broaden the membership.[33]

As a group that prized "Unity in Diversity," the Danville Woman's Club did not have a fixed number of members, though in later years there was reputedly a waiting list.[34] According to its first constitution, members could be proposed by anyone already a Danville Woman's Club member. The application would be decided by a two-thirds vote of the executive board, a fairly large group consisting of seven officers and the chair and secretary of each department, erasing the threat of blackballing by a single member.[35] Danville Woman's Club officers began to include membership applications in the club's annual program books in 1904. Numbers of members fluctuated, from 151 in its first year to 218 in the third year and down to 160 in its fifth year. The membership increased to almost 300 in 1904, when the local club gained prestige and publicity by hosting the Illinois federation annual meeting. Through the ensuing years membership fluctuated from a high of 341 in 1906 to only 92 in 1915. From then the numbers of members gradually increased, counting several hundred each year in the 1940s and 1950s, until they began to decline in the 1970s.[36]

The Danville Woman's Club encouraged a large membership because its founders believed that lots of women working together would be able to accomplish more than small, homogeneous cliques. Both idealistic and pragmatic, the club founders declared in their charter that their group had been organized for "mutual sympathy and counsel and a united effort toward the higher interests of humanity."

Pragmatically, they took two steps that made it clear that their club was an organization different from private literary clubs such as the Clover Club or women's missionary and other church groups: they formed a corporation and set up public meeting rooms. The club organized in December 1895, absorbing the membership of the literary circle formerly connected to Chautauqua. Corporate directors, including Eva Sherman, Jane Head, Frances Pearson, Mabel Leseure, Alice Benedict, and Nannie Kelly Guy, agreed to stand responsible for the club's fate and fortune as they signed the incorporation papers in June 1896.[37]

Dues of three dollars per year, paid semiannually, were used to rent spacious rooms, known as Jewell Hall, on the second floor of the Daily News Building, 17 West North Street. Unlike the Clover Club, which still meets in private homes, the Danville Woman's Club's rooms downtown typified the determination of women's clubs "to assert claims to public space for their own sake," to quote Judith McArthur.[38] Location of the Danville Woman's Club rooms changed several times, but each address was downtown, easily

accessible, in a prominent public building.[39] McArthur sees these club rooms and houses as symbolic of a public privilege that was important to women: "as the female counterpart of the gentleman's club, where men had traditionally enjoyed themselves without the constraining presence of women, the increasingly common clubhouses became 'homes' in public."[40] Club rooms were used for the club's study and policy sections, but they were also sites for public lectures, art exhibits, and concerts, emphasizing the Danville Woman's Club's role as a community-based civic organization.

COALITIONS AND CONNECTIONS

As the first large, public women's organization in Danville, the Woman's Club had put itself in a position to "get things done" within the community. Results, however, required skills in dealing with the public, which men had traditionally gained by "building organizations, serving in military campaigns, even leading sports teams," according to Meredith Tax, a historian of women organizers. Tax points out, however, that as women entered the public world of reform in the late nineteenth century, they were able to draw on their own strengths, including "the intellectual ability and information to make a realistic estimate of a situation, the social sensitivity to observe when it is changing and how, and the imagination to see how one's own meager strength could become a lever to change it."[41] Women began to use their traditional skills in human relations to form coalitions. In Danville the Woman's Club demonstrated "strength in unity" by working with groups with similar goals and by constructing alliances. The club first coordinated charitable efforts and then helped form the Associated Charities, which coordinated charitable efforts of both men's and women's groups under a professional woman director. Clubwomen also helped form the Civic Federation, a business and commercial alliance working for city betterment.[42] In 1910 the Danville Woman's Club offered the new YWCA the use of its downtown rooms for the Y's meetings and instruction. In 1913 the Woman's Club, as the largest women's group in the city, helped twenty-nine smaller Danville clubs develop the City Federation of Women's Clubs, united for benevolent and civic causes.[43]

Many Danville women had visited the 1893 World's Fair in Chicago, where women's accomplishments were prominent, and had toured Hull House, the famous settlement complex begun by Jane Addams and Ellen Starr. Addams had gained public adulation for her work and was outspoken and untiring in her efforts to better the lives of working people through fostering associations and labor unions and honest, responsible government. The new Danville Woman's Club scored a coup by successfully bringing Jane Addams to Danville for a public lecture in November 1897. According to the

Danville Daily News account of the speech, Addams attracted an audience far bigger than the Woman's Club; even Mary Forbes, never a clubwoman, noted in her diary that she and a friend had gone to hear Addams speak.[44] Addams did tell of her accomplishments at Hull House, but the purpose of her presentation was more visionary. According to her writings and other speeches of that period, Addams was working out the principles of a philosophy of experiential social ethics. She believed that the fortunate classes in America should recognize that in modern industrial society all were interdependent; the old code of personal morality was no longer practical because without the advancement of all, no one could hope for lasting improvement in one's social and moral condition. Addams also warned in her writings that the sin of "excessive self-regard" came from "limiting our circle of acquaintances to others who share our beliefs." She challenged her audiences to deliberately seek out those whose experiences were different from their own. Through learning to see the world through the eyes of others, Americans could transform "the democratic belief in the worth and dignity of all human beings into a social ethics."[45]

The *Danville Evening Commercial* gave the lecture perfunctory coverage, complimenting the large crowd but describing the oft-told story of Hull House as "the most interesting feature of the address." However, in the *Danville Daily News*, editor William Jewell perceived that Addams's address was more far reaching. He recognized that Addams advocated putting her social ethics into practice; he concluded that she showed great evidence of thought and study as she "insisted on a newer and almost radical social movement to elevate the social and moral life of the working classes."[46]

Whether or not her "refined and cultured" Danville audience, as it was characterized in newspaper accounts, agreed with her, her address was well received, and "all felt well repaid for their attendance."[47] In bringing Addams to Danville, the Woman's Club members had established their credentials as serious, thoughtful, and successful.

The Danville Woman's Club gained further prominence and stature when its members hosted the annual meeting of the Illinois Federation of Women's Clubs in 1904, and the Danville community got an education in the Progressive agenda. The five-day meeting required cooperation from all the members of the club and influential community figures and was attended by hundreds of the most talented women in the state, including a large contingency from Chicago. Together with the Clover Club, most actively represented by its president, Julia Kimbrough, the members of the Woman's Club provided room and board, meeting rooms, tours, entertainment, and lectures from community leaders. Jane Head Fithian, president of the host club, delivered the welcoming speech. Eva Sherman coordinated arrangements, Helen Webster

Straw took charge of music, Julia Kimbrough found locations, and Josephine Straus handled the decorations. Kimbrough and Kate Heath helped prepare the program, complete with quotations from Shakespeare, Emerson, and Kipling. Presentations featured famed sculptor Loredo Taft and Isabel Bevier, founder of "Household Science" at the University of Illinois. Local talent included Judge Kimbrough, who introduced a prestigious panel debating civil service reform, and local musicians, including Rigdon's Boy Band.[48]

Although the 1904 federation meeting participants discussed art and defended the study of literature, it was obvious that the federation's focus was political. Members debated reform of the marriage and divorce laws, protection of the California redwoods and Arizona cliff dwellings, the Peace Conference in Boston, creation of a National Children's Bureau, and completion of the St. Charles Home for Boys and the Geneva Home for Girls. The delegates voted to promote state legislation to raise the age of consent for girls from fourteen to eighteen to facilitate prosecution of sexual predators;[49] to license trained nurses, both for the protection of the public and improved status for the nurses; and to establish a Commission of Forestry. The group discussed civil service reform and the child labor bill and nominated Julia Lathrop, an authority on labor conditions and a Hull House resident, to represent the Illinois federation at the national Conference of Charities. The federation climaxed this Progressive agenda with a vote of 74–34 in favor of action to bring about suffrage for all adult women.[50]

Despite the notoriety gained for the Illinois federation by these national and state Progressive issues, the Danville Woman's Club preferred to focus on local reforms. Members encouraged the study of literature and the arts and engaged in public benevolence and community activism within their own town.

FROM LITERATURE TO LAW

Danville's sizable and influential club did satisfy its members' desire for quality studies. From its beginning, the Woman's Club challenge was to establish a program that would persuade an active and thoughtful group of women that their memberships were worthwhile. Since the club began as a literary circle, the study of art and literature was prominent in its program. The size of the membership made it possible for club leaders to offer a variety of topics. In 1896 members could sign up for Homer, Dante, James Russell Lowell, Shakespeare, the history of Greece through the Peloponnesian War, and china painting. Mary Jewell, "an enthusiastic student and a skillful teacher," acted as literary leader and held her position for years, "giving course after course of interest and value to the section."[51] The music section studied German classical composers. In those early years the Danville Woman's Club

also offered fitness activities. A section on physical culture, led by Dr. Annie Glidden, reflected the youth and vigor of the founders and the popularity of gymnastics at the time. Under the guidance of an instructor from Chicago, members could practice calisthenics, apparatus work, and Indian clubs. Also offered was fencing instruction, in which "great interest was shown" by some members.[52]

Several of the club's literary and historical study groups examined women writers and women through the ages, at a time when formal education focused almost exclusively on men's achievements. In 1905, for example, the history section studied Catherine the Great, Maria Theresa, Queen Victoria, Elizabeth Frye, Florence Nightingale, Clara Barton, Mary Livermore, Susan B. Anthony, Elizabeth Cady Stanton, and Frances Willard. In 1904 Julia Kimbrough led the forty-nine-member "Current Events" section in discussions of the Panama Canal, the Philippines, the Russo-Japanese War, America's open-door policy, and surprisingly, "Labor vs. Capital—Trusts and Great Corporations, Trades Unions." In 1914 clubwomen began to study "New Law" with regard to women through workshops led by lawyers and prominent politicians. In 1916 Nellie Coolley, an activist for woman's right to vote and also a Danville Woman's Club member, led a study of "The Suffrage Question," a longtime concern of Danville women and in 1916 a national cause and controversy.[53]

Despite the club's tentative examination of social criticism, its reading list was less venturesome than those of some other women's clubs. Chicago's clubs, with their Progressive leadership, chose some of the more radical literature of the day. Even in conservative Texas, according to Elizabeth Turner, Galveston's Wednesday Club members "turned in their volumes of Shakespeare" for examinations of the marital state, such as Mary E. Wilkins Freeman's "The Revolt of 'Mother,'" and presented papers on "Women in Industry" and "The Problem of Woman" with quotes from Edith Abbot, Olive Shreiner, and Charlotte Perkins Gilman on woman's feeble economic power.[54] Danville clubwomen dipped into Progressive literature but failed to ask the large questions about their own place in a rapidly changing world.

CHILDREN IN NEED

When Jane Addams reminded her Danville listeners of the obligations that the fortunate classes owed to the less fortunate in an interdependent, modern industrial society, she struck a familiar chord in the community. Danville residents were already active in benevolence through groups such as the church aid and mission societies and the Board of the Vermilion County Children's Home. Where the Danville Woman's Club could use its strength in numbers was to expand and politicize benevolent activities and to work for

other political goals. Mary Wood, historian of the early General Federation of Women's Clubs, noted that concern for children's learning was "deep-rooted in the hearts of clubwomen."[55] Leaders of the Danville club's philanthropy section immediately focused on the needs of children in the public schools, reflecting both the traditional middle-class benevolence toward the poor and the Progressive belief that even children from poor backgrounds, given the benefits of community-supported education, could adopt middle-class values and conquer poverty.

Danville Woman's Club members were driven by their determination to improve the schools to make their first foray into politics. During the second year of the club's existence, its members claimed responsibility for electing a "lady member of the School Board" (Margaretta Mabin, a club member), and the third year they claimed success when a club member, Franc (probably Frances) Slocum, was appointed as a truant officer.[56] Their emphasis on females in these positions underscored their belief that women would bring particular understanding of the needs of children to their work and a fresh perspective to a school system that they believed had become stagnant and ineffective.

Dividing the city systematically by school districts, club members worked with Truant Officer Slocum to identify over four hundred children in need. As Addams had suggested, working directly with the children led to a greater awareness of the reality of their poverty. The club members' ultimate goal was to teach needy children skills to "help themselves," but their "immediate physical wants and suffering" had to be alleviated first. The fact, uncovered by the Woman's Club and the truant officer, that four hundred children in Danville did not have enough clothes for school attendance must have been an eye-opener for the middle-class clubwomen. They responded with both direct action and political scrutiny: they made clothes for the children so they could stay in school, as had the Board Ladies of the Children's Home, and they also appointed delegates to visit the schools "at intervals" and to report to the school board on those that were overcrowded.[57]

Club members held mothers' meetings so that parents could study "Child Life in its Home and School Relations." This study led to the establishment of the first kindergarten in Danville, at Douglas School, in 1899. Kindergartens were a popular Progressive reform, "not just educational experiments for the young but the first battleground in winning the child to the progressive middle class perception of life," according to Elizabeth Turner in her study of women's philanthropy in Galveston. Kindergartens, in Danville as elsewhere, reflected the belief of reformers that "if they could reach underprivileged children early enough, teach them in kindergarten habits of cleanliness and industry and channel their innate curiosity into wholesome

learning, educators would be 'saving' the next generation of working class citizens."[58]

The Danville Woman's Club outreach to the poor reflected both the humanitarian and the practical aspects of progressivism. In an age before antibiotics or pediatricians, mothers literally held the lives of their children in their hands.[59] Teaching parenting to mothers and skills to children could save lives. When the Woman's Club promoted kindergartens, less crowded schools, and parks with supervised playgrounds, they had safety as well as middle-class values and enhanced learning in mind.

Victoria Buckingham, philanthropy chair in 1904, forthrightly declared that "practical charity does not consist in giving food and clothing to the shiftless poor, but rather in teaching them how, and helping them, to better their condition by cleanliness and industry."[60] As soon as she had put this worthy goal on record, however, the club was forced by hunger and cold in Danville to coordinate relief measures. Christmas baskets fed 350 people, and in a very cold January, club members found themselves organizing a public appeal for warm clothes and making "maternity bags" because infants needed wraps. As Buckingham had said, though, clubwomen did prefer to work for the long term to help the poor help themselves. One of their self-help projects was a sewing school. If the club members could sew for these children, they reasoned, how much better to give the children the tools for self-improvement. In 1906 the sewing school reported that an average of eighty girls attended on Saturday mornings and, with the assistance of eight Danville Woman's Club teachers, had successfully sewn their own petticoats. The club also stationed traveling libraries in schools throughout the city for the use of children and adults, and in 1910 members assisted public school children with eye examinations and eyeglasses.[61]

The Shoe and Stocking Fund was one of the Woman's Club's most notable projects for Danville's children in need. Projects came and went, but the Shoe and Stocking Fund commitment was kept by several generations of Woman's Club members. Like other philanthropy projects, the fund's goal was a combination of humanitarian benevolence and practicality: to keep children healthy, to aid the unfortunate, and to improve the morality and competence of the next generation by keeping the children in school. In recommending a "shoe fund" in 1904, Buckingham pointed out that "there is so much sickness among children, during the winter months, caused by wet and cold feet"; furthermore, the sickness and the lack of shoes prevented children from attending school.[62] The fund began in 1906 with $61.35, most of it donated by smaller clubs at the request of the Danville Woman's Club. Under the leadership of Pauline Muir and Nannie Guy, the fund went public in a major way in 1910. With an advisory board of teachers from the six Danville elementary

schools, the club members distributed 111 pairs of shoes and 184 pairs of stockings to keep needy children in school. They raised the money to buy the new shoes from individual donations; in addition, in October 1910 they held a shower, where members donated 100 pairs of stockings, and they hosted a card party in February 1911. A few dollars were also collected from school-children, starting a practice that was to continue as the Shoe and Stocking Fund grew.[63]

Even as the Danville Woman's Club undertook other long-term projects, the Shoe and Stocking Fund continued and expanded. In November 1914 children from Washington and Douglas schools serenaded the club members at an open meeting, which "inspired us to greater effort" to help "these needy little ones in our city schools."[64] Myrtle Goldsmith was the driving force behind the fund from 1912 until 1924, when she became club presi-dent. During those years the Woman's Club, supported by schoolchildren's contributions, money-raising events, and private donations, collected enough to distribute over one hundred pairs of shoes and dozens of pairs of stockings each year. Even during 1918, when the club focused on Red Cross bandage making and other war-related activities, the Shoe and Stocking Fund col-lected and distributed new shoes, rubbers, and stockings.[65] The club worked through the teachers, who would notify Myrtle Goldsmith and other com-mittee members of children who needed shoes and stockings in order to stay in school. Then, on Saturdays, the teachers would arrange for the children to meet with club members, who would take them shopping.

In the 1920s the weight of responsibility for contributions to the Shoe and Stocking Fund shifted to the children themselves. Each schoolchild was to bring a dime on a designated school day, usually early in November, as the weather began to get cold. (Most shoes and stockings were purchased from December through March.) In 1921 schoolchildren gave $540 to the fund, which was supplemented by $200 raised by the Danville Woman's Club.[66] During the next four years, donations were listed by school, probably in an attempt to encourage competition between them. (Washington school, one of the wealthiest, always donated the most.) The club held card parties and accepted other donations to supplement the children's contributions.

Not surprisingly, the Shoe and Stocking Fund reached its highest level of donations during the Depression. In the late 1920s and early 1930s, Hattie O'Toole, the attendance (truant) officer, evaluated requests for aid. A news reporter featured O'Toole and told of the "stories of want, suffering, and trouble" that inundated her investigations. According to O'Toole, when she measured the children for new shoes, many times the old shoes were "so nearly gone and the stockings so wet and ragged, that new stockings must be put on before shoes can be fitted." Woman's Club members obtained the

children's sizes, purchased the shoes, and delivered them to school. However, even during the early years of the Depression, the stigma against handouts was so strong that many children asked to carry their new shoes home in bags instead of wearing them home from school, "in order that the other pupils may not know that he or she has been forced to accept charity."[67]

In 1928 the Danville Woman's Club also began to participate in another poignant program called the "Open Air Room." Located in Douglas school, this room, which could hold up to twenty-five students, was for those who were at least 15 percent underweight and, it was feared, vulnerable to tuberculosis. Here they were given fresh air, special feeding, and rest; as they reached normal weight, they were returned to regular classes, with each returned child's place taken "by some other child" needing the special care. The program became part of the New Deal's National Recovery Plan, and a Douglas teacher remembered that Eleanor Roosevelt came to the school to see the Open Air Room in operation.[68]

Woman's Club members did not examine the reasons why Danville consistently had families that could not afford to feed their children or furnish them with shoes and stockings, just as the clubwomen seldom examined the topics of economic systems and inequalities in their study circles. The state and national federations took more notice of these deeper economic issues. In 1898 the General Federation of Women's Clubs introduced resolutions on the "industrial problem," because "women of larger opportunities should stand for the toilers who cannot help themselves." The resolutions included banning child labor by those under fourteen years of age and under sixteen years for work in the mines, and an eight-hour maximum working day for women and children.[69] The General Federation and the Illinois Federation of Women's Clubs worked for decades for a ban on child labor, but this effort was never included in the causes adopted by the Danville Woman's Club. Similarly, in 1910 John Mitchell spoke to the General Federation of Women's Clubs about the "Death Roll of Industry," exposing the fact that thirty thousand American workers had died and more than two million were injured in industrial work in one year alone.[70] The Danville Woman's Club took no official notice, even though Illinois and Vermilion County coal mine fatalities were among the worst in history that year.[71]

FROM DOMESTIC SCIENCE TO COMMUNITY HEALTH

The Woman's Club's considerable accomplishments in improving Danville may have had the support of the "movers and shakers" among the male population because its projects improved the city without questioning the existing power structure and inequalities. Club members' husbands, in many cases, may have encouraged their wives' forays into the public realm because

the women were, in effect, partners, helping business and real estate by beautifying the community. However, those club accomplishments that focused on women and children would probably never have taken place had the reforms been left to the men, no matter how civic-minded. The domestic-science movement, for example, was a reform embraced almost solely by women's clubs. The goal of domestic science was to achieve greater health through knowledge and efficiency, both in the women's own homes and in the community at large. The Danville Woman's Club embraced the movement. At the urging of Jane Pennell Carter, one of the club founders, the Woman's Club helped sponsor a domestic-science teacher in the public schools in 1903.[72] The clubwomen also undertook their own education in domestic science. As club president Blanche Adams said in 1911, "all successful reforms must be preceded by a revised public opinion, so let us inform ourselves conscientiously and thoroughly and then disseminate information upon such subjects as make for public good—such subjects as social hygiene, and public health, clean streets, clean groceries and pure food."[73] Domestic science, later titled "home economics," has been suspect as part of women's history because, as Judith McArthur has said, "its thrust has seemed to be to keep women preoccupied with food preparation and cleaning to prevent them from entering male domains or looking seriously at the economics of home consumption and maintenance." However, as McArthur points out, in its beginnings domestic science was a catalyst for women's activism that "encouraged middle-class women to cross boundaries between private and public space and claim new roles without violently offending gender prescriptions" as they tackled the problems of pure food and milk and food spoilage and encouraged self-reliance and wise buying in an age of increasing commercialism.[74]

Members of the Danville Woman's Club's study group on domestic science in 1903, for example, did do table decorations, but they also studied basic sewing, care of the sick, cooking for the invalid, and "waste through injudicious buying." The members were also treated to a "demonstration dinner" that could be prepared by "the woman without help."[75] By 1905 the women were studying "household expenses and economics," the training of children in domestic duties, and "sanitary plumbing, heating, and ventilating," though one lesson did consider "indigestibles—cakes, puddings, pies."[76] A yearly "Pure Food Day," which included serious discussion on the topic of adulterated milk, was part of the domestic-science study group, as the movement to pass the Pure Food and Drug Act became a national cause both for Progressive reformers generally and for women's clubs in particular.[77]

These projects, carefully summarized by Danville Woman's Club committee chairs year after year, might seem to be mundane and even time-wasting in the perspective of the twenty-first century; but one hundred years ago,

when club members studied "scientific and practical" cooking and cleaning, there were no packaged foods, nutritional listings, vitamin supplements, or antiseptic household cleaners. Women's earnest attempts to improve the health of their families were vital. McArthur points out that gastroenteritis as well as tuberculosis killed many infants, which explains the "almost obsessive concern with proper baby feeding." There were few or no medical authorities to advise mothers; as one woman newspaper columnist declared, "women held life and health in their hands."[78] Woman's Club members seriously undertook their studies, for their own families and for others.

Domestic science moved naturally to a concern with health not only at home but also in the community. The Danville Woman's Club became the stimulus for "municipal housekeeping" in its broadest sense, both targeting the need for a cleaner, more healthful city and fighting to control disease. Despite their lack of the vote, club members vigorously pursued the traditional woman activist's goal of applying the cleanliness, efficiency, order, and usefulness of a well-run home to the needs of the community. Turner points out that this was a power play, "disguised in the rhetoric of woman's sphere." Women may not have had official power, but "they had the power of righteous indignation, muckraking publicity, and extended notions of citizenship on their side."[79]

The civic committee of the Danville Woman's Club, turning its attention to the city's needs in 1905, promised in a traditional guise "not to do aggressive work, but to co-operate with the powers that be." Their tools were petitions, private lobbying, and trying "to create public sentiment" for improvements; their accomplishments depended on persistence.[80] However, moderate actions were not enough, and they quickly turned from the tactic of persuasion to demands for enforcement of the laws. After mildly worded petitions in 1905 requesting that "the expectorating ordinance be more rigidly enforced" and that "some action be taken to avert a repetition of the recent pollution of the city water," the civic committee became more assertive.[81] Members called personally on the mayor to enforce the ordinance against spitting on the sidewalks. Most effectively, they collected one thousand signatures on a petition "for the early consideration of collecting and disposing of the city garbage." Impressed, the mayor and city council appropriated fifteen hundred dollars for garbage removal.[82] The club also collaborated with other groups "to prevent the scattering of waste paper on streets and sidewalks, also in yards" and participated in a 1908 "clean-up day" in Danville, during which eighty teams worked for two days to remove seventeen hundred loads of rubbish from the city streets. Dr. Annie Glidden, civic committee chair, reported that the club, through the city council, also saw to the purchase and placement of eighteen public wastepaper cans.[83]

Persuasion and public exposure, the women found, were effective tactics in tackling the city's diseases and dirt. In 1909 the civic committee of the Danville Woman's Club prepared and presented a petition to local grocers "asking them to use more sanitary methods in displaying fresh fruits and vegetables in front of their stores" (the flies can only be imagined). The grocers used the petition to get the city council to pass an ordinance for uniform observance of this sanitation issue.[84] In 1913 the club sponsored a visit of the state pure-food inspector to examine all the groceries and bakeries in the city.[85]

The Woman's Club had succeeded in making Danville more sanitation conscious and now turned to a concern with disease. Josephine Snyder, president of the club in 1913, recommended that the club and the city pay greater attention to "medical inspection in our schools, a proper regulation of minor contagious diseases among children, sanitation, social hygiene, and a visiting nurse." Due to the club members' persistence, the mayor and city council agreed in 1916 to hire both a public health nurse and a social welfare nurse.[86]

The Woman's Club also adopted national campaigns when they were important to Danville citizens. The General Federation of Women's Clubs had an active, energetic membership in the U.S. Public Health Department in 1910–12. Its tuberculosis subcommittee urged local clubs to spread information and educate communities about this national crisis. In broad terms, the national committee stated that "the crusade for the prevention and extermination of tuberculosis was the capstone of the entire arch of preventable, infectious filthy diseases," requiring the mobilization of "all social forces, public and private, official and voluntary."[87] Tuberculosis had reached epidemic proportions in Danville in 1918, when twenty-seven died of the disease. The club acted by gathering statistics from the visiting nurse for tuberculosis care, expanding the public health nursing staff, and working with Dr. W. C. Dixon, the new and active city health commissioner. While the Vermilion County Board of Supervisors financed tuberculosis care and paid a county nurse, the club petitioned successfully for the city to hire a nurse as well. The club worked with Dr. Dixon to stock the county dispensary and to work for a "cleaner Danville."[88]

Tuberculosis continued to be an issue that involved the Danville Woman's Club, especially when it also touched on education. In 1923, "with the introduction of milk into our public schools," the club began to carefully examine the local milk supply. Anna Christman, chair of the pure food committee, led a campaign to ensure that dairy herds were tested for tuberculosis. From a discussion with the Vermilion County Farm Bureau, the club estimated how much would be needed to test all the cattle in Vermilion County for tuberculosis, with the cost to be borne in equal thirds by the federal government, the

state, and the farmers. The Woman's Club worked quickly and successfully with the county and the Farm Bureau to get thirty-five hundred dollars in state money to help with the testing. The preliminary tests showed that about 8 percent of the herds in the county were tubercular, 100 percent in one herd, proof that the testing served an important purpose. Anna Christman, proud that the women had pushed the issue, concluded that "it is surely a relief to know that the children of our public schools are being supplied with tuberculin tested milk."[89]

The Danville Woman's Club was deeply involved in these matters of tuberculin testing and public grants, functions that would be fulfilled by the county health department today. This was in part typical of a decline in Progressive regulation in the 1920s, when either private agencies did it or it did not get done. Danville, though, seemed particularly prone to relying on volunteerism for its social welfare. A 1926 state survey of public health in Illinois towns indicated that of fifteen cities surveyed, "Danville and one other city were the only two that spent so little for public health service." The city spent fifteen cents per capita, while other sources, in other words volunteer individuals and private agencies, spent twenty-one cents.[90] The vigorous work by the Woman's Club and other volunteer organizations had accomplished much, but the vagaries of reliance on volunteer support for a necessary community function such as public health were obvious. Another disturbing issue was the death rate in Danville, which "averaged considerably higher than that for the State."[91] Solving problems about this high death rate, related to the industrial structure, alcohol abuse, and prostitution endemic to the city and the economic and physical deprivation of many of its residents, was beyond the capabilities of volunteerism.

EXCLUSIVELY FOR WOMEN

Members of the Danville Woman's Club brought about woman-centered civic reforms that were unlikely to have been considered by the male power structure. Their outreach to working women and "women adrift" through the YWCA and the "social disease awareness" movement will be discussed in chapter 6. In 1915 the elite club members also reached out to help area women beyond their own class when they created a waiting room, called the "Rest Room," in the Vermilion County Courthouse, to be used primarily by rural women coming to the city to shop, working women, and women with small children. The Rest Room also served as a welcome center to Danville, especially for job-seeking women who came to town and had no living accommodations and needed advice on where to get employment and shelter. The Woman's Club helped furnish the room with comfortable chairs and stocked it with magazines, papers, and directories of all the city's charitable

organizations. Minta Harrison, chair of the "Rest Room" committee, reported that twelve hundred women and girls made use of the Rest Room during its first week of operation.[92]

A few months later, at the club's urging, the city hired and paid a day matron to help with these women's services. The Woman's Club added a salary for a night and weekend matron because working women needed a space to rest between work and nighttime activities and because rural women traditionally came to Danville on Saturdays to shop or do business and needed a place to rest or to feed and nap their children. By staffing the Rest Room for these extended hours, the Woman's Club made the courthouse "a veritable REST ROOM not only for the women and girls of Danville, but for the whole of Vermilion County."[93] After a year of sponsoring a night and weekend matron, the committee reported that "many girls, and women with little children, both from town and country find these rooms a great comfort while waiting for outgoing and interurban cars, or while waiting for evening entertainments. There are times when the capacity of the rooms is inadequate to meet the demands." The thousands of women and children who used the rooms, as reported by the matrons during the summer of 1916, showed that a serious need had been met.[94]

Danville Woman's Club members also encouraged women to take professional and political roles in the city. In addition to their campaigns to get the city to hire women truant officers, police matrons, and public health nurses, a change in the club's membership roles reveals increasing prestige given to women professionals. In the first years, "Honorary Members" were listed after the active member roster and signified members who had moved out of the community, whether to Indiana, California, New York, or even France, Germany, or Chile, and could no longer attend meetings. The lone professional given "Honorary" status in those early years was Josephine Durham, head librarian of the Danville Public Library. Women were proud of the position Durham had achieved, though it kept her from active membership in daytime clubs. In the 1910–11 yearbook, however, a significant change took place; the "Honorary" members who had moved away were replaced by an "Honorary" category exclusively of women professionals, Durham and four others. By 1914 seven women were listed by their occupations: Durham; Miss Amy Brant, secretary of the Associated Charities; police matron Laura Parisoe; Harriet Tenney, executive secretary of the YWCA; Sadie Virden, probation officer; and Mabel Redden and Susan White, reporters for the two major Danville newspapers.[95] The club's listing of "Honorary" professional women as members continued through the 1920s, as the number of these professionals increased.[96] While most Woman's Club members were not employed outside the home (the number of teacher members never became

sizable), the "Honorary" designation indicated the clubwomen's respect for women professionals in public positions.

ORGANIZING FOR WAR WORK

When the United States entered World War I in April 1917, the Danville Woman's Club became the central organization around which the community's women organized for war work. Club members had already been working with the Red Cross on their fight against tuberculosis and quickly joined in specific activities to help the soldiers, including rolling bandages, making hospital garments, and knitting "helmets, sweaters, wristlets, scarfs, and socks."[97] Much of their Red Cross work, though, was in raising money and organizing war efforts. They worked with teachers to establish Junior Red Cross units, were in charge of selling Red Cross seals throughout the county, raised money with variety shows and concerts, and organized the county drive for Liberty Loans.[98] With the war and the tuberculosis crisis, the clubwomen had to face the problem of multiple money-raising appeals: as Martha Dow, head of the Red Cross seals appeal, noted, her sales campaign "was undertaken in the midst of a veritable sea of 'Drives' going on at the same time."[99] The year 1917 was also the worst in Danville for deaths from influenza, and the wider influenza pandemic of fall 1918 brought more needs for public health services, confronting the public health staff and the Red Cross with additional demands. During the flu epidemic the Red Cross was open for twenty-four-hour days and the Woman's Club and other groups established public kitchens, made hospital gowns and pneumonia jackets, and found temporary homes for children whose parents were stricken.[100]

The Woman's Club also supported and coordinated war efforts through the Illinois Woman's Committee (a shortened version of its official title, the Illinois State Division of the Woman's Committee of the Council for National Defense). Organized as a standing state committee and as part of the Council for National Defense created by the president of the United States to coordinate the nation's war effort, the Illinois Woman's Committee was dominated by Chicago women but did its best to organize all the state's women for the war effort. In her research on the Council for National Defense's activities on the Illinois home front, Virginia Boynton has found that Illinois women were more comprehensively organized than women in most states were, and that overall "the state produced exceptionally active local Woman's Committees." The committees attempted to register all adult women in the state for war work; they disseminated information from the government about the war effort, and they led efforts to grow, harvest, and preserve food. They also used the opportunity to improve life in their communities by

holding classes to broaden women's occupational opportunities and improving the health of local children.[101]

Danville's branch of the Illinois Woman's Committee was one of these "exceptionally active" local groups chronicled by Boynton, and its leadership came from the city's Woman's Club. Members of the Illinois Federation of Women's Clubs figured prominently in the local and state women's committees of the National Council for Defense. Local leaders were most often the leading clubwomen in their communities.[102] In Danville, Florence Dillon, the Woman's Committee chair, was a longtime member and past president of the Danville Woman's Club. Dillon enlisted other club members in her local Woman's Committee, including Anne Wolford Ridgely, Dr. Annie Glidden, Myrtle Goldsmith, and Martha Dow, as well as several community men and women who were not club members.[103] Katherine Haworth served as both the civic chair of the Woman's Club and a representative of the Woman's Committee, so she was able to coordinate the efforts of both. The activities she reported to the club members provided ideas about what the local branches of the Illinois Woman's Committee were expected to do—for example, "organizing of Vermilion county boys and girls canning clubs," raising funds for food conservation, putting patriotic literature in the schools, holding a "Corn Club Contest," and encouraging better food production through exhibits at the Illinois and Indiana (I&I) Fair.[104]

Some Illinois women interpreted war work in broadly Progressive terms. Many who headed the Illinois Woman's Committee had worked for Progressive causes, and they insisted "that child conservation is a war measure of the highest importance, and should rank with work for the Red Cross, Liberty Loan, and other patriotic endeavors." Their goal was to save infants' lives "so that at least 100,000 of the 300,000 children under five years old who annually die in America, mostly from preventable causes, might be saved."[105] The child welfare program proved "immensely popular among the women," and most counties set up their own child welfare committees. The two specific state efforts were to register all infant births and to weigh and measure all children under six years old. Communities established "baby welfare weeks."[106] As part of this effort, the Danville Woman's Club established its first Baby Welfare Station in June 1918.[107] Conserving children, always a goal of women in association, was now given renewed energy because it was essential to the community's war effort.

In Danville the war emergency thrust Frances Pearson Meeks, Woman's Club founder, educator, and public personality, into the spotlight. Pearson Meeks was in charge of education for the Danville branch of the Illinois Woman's Committee, a charge she interpreted broadly in the spirit of its

Progressive women leaders. By June 1918 Florence Dillon reported that the Danville unit, headed by Pearson Meeks, had organized classes in English, French, and telegraphy. The Council for National Defense had urged lessons in English as a step toward more quickly Americanizing immigrants, so the English classes could be rationalized as a demonstrable war measure. The other classes, French and telegraphy, related less directly to national defense; they were efforts to broaden occupational opportunities for women, taking advantage of possible use of new skills in a prolonged war. In an effort to expand women's job opportunities, Pearson Meeks had also sent two young women to Chicago for training in "Re-Education of the Handicapped soldiers and sailors,"[108] a defense project that was planned to provide education and employment for young women and also to help the healing and productivity of those men gravely injured in the war.

Frances Pearson Meeks later became Vermilion County chair of food production for the Illinois Woman's Committee, a duty she performed with her usual thorough and meticulous energy. Her letter to Nora Dunlap, state chair of food production, was full of detail and enthusiasm, demonstrating the skill in coordinating broad efforts for which she and the Woman's Club were well known. In the letter Pearson Meeks declared that "we feel that co-ordination and co-operation of men, women and children in this serious problem [food production] is [sic] essential." She had enlisted the farm adviser, boys' and girls' clubs directors, the county superintendent of schools, and managers of the Illinois and Indiana fairs to share and coordinate their plans. In addition, she had asked the food administrators "to name an efficient woman for the work" in each township. (Cora Abernathy, "an experienced gardener," was the food production chair for Danville Township.) Pearson Meeks's purpose was "to enlist every citizen in the garden army." She recruited women as speakers to community centers and other gatherings "to arouse interest or furnish help in the planning and work now paramount."[109] Nora Dunlap, in turn, designated Vermilion County as one of four counties that deserved special mention in food production.[110]

Pearson Meeks was also the first woman chair in the state to respond to Nora Dunlap's experimental idea for a girls' reserve army, to give teenage girls an opportunity to help with farming just as the Women's Reserve Army was doing. To create this army, Pearson Meeks introduced the "Illinois Girls' Working Reserve." She established a five-member planning committee: herself, representing the Illinois Woman's Committee; Mrs. Harvey Sconce, wife of a leading farmer; Kate Haworth, the wife of the county superintendent of schools; a *Danville Commercial-News* reporter; and a girls' club worker from the YWCA. Their purpose? "To help those overworked country women to save the food that is produced in such quantities on the farms." Pearson

Meeks sketched out her plan: "In any year—the poorest year—there are thousands of quarts and gallons of material that has been lost because of failure to have enough help to care for it. But we are having this plan: the girls will give one day a week or go out in teams for a day whenever they receive a call. When the gooseberries or currants are ready to be prepared they will go in teams to the country, whether to pick the berries or to preserve the fruit, so they will work from two to four days a week, or work a week or a month or more, just as the call comes for this work."[111]

The girls had to be fifteen before they could join, but the upper age limit was flexible; Pearson Meeks enrolled someone her age, forty-eight.[112] The war ended before the girls' reserve army could expand, but again Pearson Meeks had proved her ability to get things done and her belief in the power of women to do them.

On May 20, 1918, Frances Pearson Meeks rode proudly in a Red Cross parade representing the Danville branch of the Illinois Council for National Defense, along with the Boy Scouts, the Soldiers' Home Band, the Military Girls of the YWCA, draftees and the National Guard, and schoolchildren.[113] Women's efforts in this war had not been ignored; due to their hard work and their assertiveness, women were now community partners in public efforts. When the war ended, the first reaction of the Illinois Woman's Committee was to keep on fighting. As a committee officer stated: "Signing of the Armistice has only affected our women in that it has made them carry on their work for the Woman's Committee with renewed energy. There has been no inclination on the part of any of the women to lay down their arms. They are all eagerly awaiting our program of reconstruction which we will send out as soon as we receive our orders from Washington."[114]

No orders came, so the Illinois Woman's Committee disbanded in March 1919. However, before it did, its officers held a final conference to celebrate its accomplishments. Florence Dillon, Danville's Woman's Committee chair, was given the honor of being the first of many speakers at the conference. Dillon was introduced as "one of the best workers in the Woman's Committee" who had "always been on the job." The story was told that Dillon had "refused to rest from her work even during the weeks she was ill in the hospital," holding lengthy conferences from her hospital bed.[115]

CHANGING THE DEFINITION OF "HOME"

Florence Dillon's talk revealed much about the transition from True Woman to New Woman, a transformation that had probably occurred in her own life even before her Danville Woman's Committee work. Dillon was a Missouri native who had married a civil engineer from a prominent family in Georgetown, just south of Danville. His engineering work led them to spend five

years in Nicaragua before he came home to become the Vermilion county surveyor, which gave Florence Dillon eye-opening experiences with another culture.[116] In her address to the Illinois Woman's Committee in 1919, Dillon sketched in broad terms the transformation she had seen in women's lives, a transformation quickened in pace and exacerbated by war emergencies. She spoke about "home" and the fact that woman's work "used to be done within the realms of the home[, whereas] now . . . woman was supposed to run a bakery, a creamery, a shirt and underwear factory, and a woolen factory, a factory for ready-made clothes and a hospital." In order to do all that, a woman's sphere had to be private: "in order to be womanly and modest she must stay at home."[117]

However, Dillon went on, by 1919 the definition of "home" had changed:

> Today our work is not done within the realms of the home as it used
> to be. A great deal is taken out and done in public factories. That does not
> relieve us of the responsibility, if we are the right kind of women, we will
> still want to know that bread that comes to our door ready to eat has been
> kept clean and wholesome all the way from the wheat to the table. We
> want to know that the butter has been kept clean all the way from the cow
> to the table. We want to know when we receive our clothes ready to wear
> that no one has suffered in the making; that they have been paid a liberal
> wage, worked reasonable hours and under favorable conditions. Most of
> all we want to know when our sick are taken from our homes to a hospi-
> tal that there, in addition to all advantages of modern science and all
> advantages of modern appliances, they will still have the same consid-
> eration and kindness that they would have had with us.[118]

To do all of this, Dillon continued, "we must go out of our homes; must in-terest ourselves in public conditions; must help to create sentiments that con-trol the laws." She could no longer understand how a woman "can surround herself with the comforts and luxuries of a modern home, how she can work for that home 24 hours out of every 24 hours and close her eyes to the uni-versal cry of the world today for home."[119] Dillon, at the climax of women's war efforts, made social housekeeping a universal mission for women.

Exhaustion often follows a crisis, however. After the war-time spirit de-clined, the spirit of universalism and progressivism expressed in Florence Dillon's words also began to decline. The Danville Woman's Club changed too. In the first two decades of the twentieth century, the club had embodied "public woman" as a learner, a community activist, and an arbiter of public taste. As an example of the latter, members of the education committee had investigated and reported on moving-picture shows in 1912 and found that the pictures shown were of three classes: "the ludicrous, the dramatic, and

the instructional." The women went on to say that "the standard might be raised as to moral tone, and yet . . . as a means of education much may be done by encouraging the use of high-class films."[120]

In 1921 the Danville Woman's Club made a similar attempt to arbitrate cultural behavior, as members endorsed a resolution "that the mothers in the Club persuade, instruct or compel their daughters to change the style of dress so there be some evidence of modesty."[121] However, cultural roles for women had changed in the 1920s, and so had the position of the Woman's Club. Though its literary study, philanthropy, and community action continued, the club began to lose its place at the center of public activities for women. Achievement of suffrage in 1920 and the increasing numbers of women in the professions led to the formation of service clubs for specific groups in Danville, including the League of Women Voters, Altrusa, the American Association of University Women, and Delta Kappa Gamma service sorority for women in education.

The Danville Woman's Club changed its motto temporarily in 1926 from "Not for Ourselves, but for Humanity" to "Not for Ourselves, but for Others," probably a result of the cynical 1920s embarrassment with the high-sounding slogans of the 1890s but also indicative of the loss of the idealism, activism, and inclusiveness of an earlier age.[122] Club members no longer held open meetings on Saturdays for the convenience of working women. Its membership, though it remained sizable, lost its earlier diversity and came to embody social status, reflecting the public image of its members as "women in furs" and "wives of doctors and lawyers," which it retained for decades.[123] The women distanced themselves from direct interaction with the needy. For example, in times of hardship in earlier decades Woman's Club members had fed and clothed the needy, but in 1931 they helped the Depression's unemployed by holding a card party to raise money for them.[124]

When the Woman's Club dwindled in membership and sold its imposing Vermilion Street home in 1991, its impact on the Danville community was remembered in specific accomplishments, which justified a national speaker's praise for women's clubs as "centers from which radiate electric currents of moral and political reform."[125] In the early years of the Danville Woman's Club, members had persuaded the city council to appoint the first women truant officers, school board members, jail matrons, public health nurses, and social welfare nurses. The club was responsible for the first kindergartens and supervised playgrounds in Danville. Club members had begun mothers' clubs, sewing classes, traveling libraries, and domestic science and social hygiene education. They had provided eye examinations and glasses, the long-lasting Shoe and Stocking Fund for needy children, and as part of their work in World War I, the first baby clinics. They had reached out to women beyond

their social class to establish a "Rest Room" in the courthouse for working women and rural women and their families, and they had helped initiate the YWCA for working women. Club members had raised the community's awareness of the value of art and literature. All of these achievements in the early years of the Woman's Club brought women and women's issues into the mainstream of public consciousness in Danville. The "new-fangled woman's club" that Frances Pearson Meeks and others had envisioned and brought to reality in 1896 had given the women of Danville a forum and an opportunity for action.

"A Robust, Gritty Crew"

> *. . . a robust, gritty crew. . . . they bought their own bread and grew
> some roses, too.*
>
> Catherine Clinton, introduction to
> Joanne Meyerowitz, *Women Adrift*

GLADYS WALKER, ENERGETIC AND feisty in an interview on the eve of
her 101st birthday, was a working woman. Born in 1902, she was the daugh-
ter of a fireman, Robert Pugh, a sweet and loving man, and his wife, Lillie,
strong-minded and frugal. Gladys seems to have escaped her mother's dom-
inance by turning her energy and optimism to helping others. Joining clubs,
giving a helping hand wherever needed, and volunteering for good causes
came naturally to Gladys, according to her son. She became both a career
working woman and a clubwoman, managing work, a home, and an active
community life.[1]

As a teenager, Gladys lived with her parents and sisters Hazel, a teacher,
and Mildred, a clerk, in a modest home on Bryan Street. Her widowed aunt
ran a boardinghouse across from their home.[2] Like her sisters, Gladys went
to Danville High School to prepare for the workplace, taking typing, short-
hand, and other business courses. Her 1917 senior picture in the DHS year-
book shows a poised young woman with short, wavy hair, a sweet smile, and
intelligent eyes. During her high school years she found outlets for her energy
and sociability. She played basketball, participated in variety shows, and
served as treasurer for the Girls' Student Club, affiliated with the YWCA,
which alternated Bible study, meetings at the Y, and charitable activities.

Gladys found her life's work as an office clerk for the Central & Eastern
Illinois Railroad. She married a coworker, accountant Loran Walker, and they
had a son, Wesley. Unlike the majority of women workers in the 1920s and
1930s, Gladys kept her job while raising her family and was employed by the

Gladys Walker,
Danville Commercial-
News *Woman of the
Year, 1968. Courtesy
of Wesley Walker*

railroad for forty-three years. With the support of her husband, who took care of Wesley many nights while she was out, Gladys maintained her work with the YWCA for her entire adult life, enjoying and contributing to the sociability and support of her sisterhood of working women.[3]

Danville women inherited a tradition of pride as workers outside the home. As early as the 1890s women were employed in clerical and techno-logical positions, as professional teachers, and in traditional domestic work. During the twentieth century Vermilion County counted an unusually high percentage of women in its labor force—the highest rate in the state.[4] Through the 1890s and early 1900s, as Danville's economy matured, women entered the public world of employment in ever greater numbers. New types of skilled work attracted ambitious working-class women and, especially after World War I, women of the middle class. Their emergence into the public world of work added a new dimension to women's public persona. The im-personal and often harsh workplace presented challenges, but most women were able to meet them. Surviving on pitifully small salaries, they created "work cultures" for sisterhood and survival, and their standards, values, and behavior helped to shape the images of women in the new century.[5]

These women moved out of their houses into the public world of work and thus made their major contribution to the growing numbers of women in the public arena. Like their elite sisters, working women also wanted fellowship and sisterhood, growth and self-improvement, and a chance to help those less fortunate and the community as a whole. They lacked the time and resources of upper- and middle-class women to achieve these goals and left a smaller paper trail, but they did make great efforts to come together. Danville's working women were particularly assertive in using community resources to create their own sisterhood, and a few, with support of their sisters, were able to use their abilities and ambition to take advantage of opportunities for advancement.

Danville's increasing numbers of employed women in the first decades of the twentieth century reflected a trend shown in national statistics. From 1880 to 1930, as Joanne Meyerowitz calculates, "the number of women gainfully employed grew almost twice as fast as the adult female population."[6] The first rapid increase came in the bigger cities in the 1880s and 1890s. In small cities such as Danville, women became part of the labor force in large numbers after 1900. In 1895 an estimated 9 percent of the female population identified themselves as paid workers in the Danville city directory, but by 1920 five times as many women were on employment rolls in that city, comprising 20 percent of the workforce. Almost one-fourth of the women in Danville worked for pay in 1920. (See appendix a.)

Women entered the paid workforce in increasing numbers because of sweeping changes in the national economy and technological transformation. As the result of industrial and urban growth, increased use of labor-saving devices in the home, and the inability of small farmers and businesses to employ all the women in the family, growing numbers of young, single women sought jobs outside the home. Mobility provided by railroads and streetcars enabled these women to leave farms and small towns for the cities or to commute daily to work. Technological changes in office work, accounting, and communication opened opportunities for women who had acquired skills needed in these rapidly growing areas of employment.

Danville and Vermilion County's growth reflected these national trends. The years from 1900 to 1920 were Danville's biggest boom time ever. The city doubled in population in those twenty years, and the country grew 25 percent. The county led the state in coal production in 1900, and Western Brick, Hegeler Zinc, the Malleable Iron Works, and the Holmes Foundry opened on the outskirts of Danville in the first years of the century. The major industries spawned a greater need for rail transportation. Three major lines, the Wabash Railway Co., the Big Four (later the New York Central), and the Chicago & Eastern Illinois, converged just northeast of Danville in an area

known as Danville Junction, which saw the transfer of thousands and thousands of passengers as well as untold tons of freight. The railroads gave Danville a national connection too: the Chicago & Eastern Illinois ran through Louisville, Tennessee, and Georgia into Florida. The Wabash ran on a Detroit–St. Louis axis. The Chicago & Eastern Illinois built its roundhouse and shops in Danville, employing seventeen hundred in 1920, including women office workers.

Numerous smaller businesses expanded and exploded in the city. Cars and bicycles, clothing and shoes, flour, cigars, and beer were all produced in Danville. The Illinois Printing Company, drugstores, steam laundries, hotels, restaurants, banks, and lawyers' offices all expanded to service the growing population, as did the bigger and bigger department stores, including Meis Bros. and Cramer & Norton. The Gas, Electric Light, and Street Railway, established in 1890, expanded its streetcar service to facilitate the movement of Danville's people from home to work.

Women took advantage of opportunities in expanding industries for various reasons. Many of these women had to work. Young women's incomes were needed to contribute to family support, and impoverished women had always worked out of the need to support themselves and their families. Other women, usually young, left their homes to escape abusive relationships or excessive restrictions. Even so, the ideology of the home as the proper "woman's sphere" permeated their consciousness. The new workers and those who had always worked felt the need to justify themselves in leaving the home for employment and demonstrated these justifications in their employment patterns. Lisa Fine, who studied women office workers in Chicago, explains that women who left "the security of the world of hearth and home" and their roles as "true women" for the world of impersonal business usually relied on certain explanations for their activity.[7] These justifications are illustrated in the 1890s employment of Danville women, whose work patterns established a model for the city's subsequent working women and continued while employment patterns changed into the 1920s.

"FEMINIZED" EMPLOYMENT

Women who needed paid employment could maintain the traditional work of the home by doing it for others for pay, "usually within a closely monitored 'family' setting," in Fine's words.[8] More paid women workers in Danville in 1895 identified themselves as "domestics" than as any other category, though surprisingly their numbers totaled only a fifth of Danville women workers. An additional third identified themselves as laundresses. This traditional domestic and laundry work hardly needed justification in 1895.

Women who needed to work and who had no other skills or opportunities had few other choices.

In the early twentieth century women who could find other jobs left domestic service; its long hours, isolation, and lack of freedom and control over their lives made it the least attractive of employment options. Interestingly, though, in Danville the number of women engaged in domestic work persisted as the number of paid women workers grew. Employment of women servants in Danville declined only slightly by 1920. A large population of single male workers brought to Danville by mining, railroad, and foundry employment continued to provide domestic employment opportunities for women who wished or were forced to be self-supporting.[9] Oral histories and available data suggest that African American women gradually took over domestic jobs formerly held by working-class white women in Danville. By 1907, the only year in which the Danville city directory specified residents by race, the overwhelming number of African American women who identified themselves as paid workers listed their jobs as domestic service.[10]

The number of laundresses actually increased in Danville by 1920, according to census data. The continuing demand for laundry service in a growing community was met by individual women who took in washing to increase their incomes but also by an increasing number of commercial laundries, which also employed women. Founded in 1894, Model Star Laundry was the first steam laundry west of the Alleghenies. It did a large retail business and also serviced many of Danville's hotels. Model Star employed forty women at the maximum. According to Lou O'Brien, son of the founder, these employees were young, single, German women who lived in Rabbit Town, on the east side of Danville, and rode the trolley cars to work. (The founders were Irish, but the hiring was done by a German forewoman, "Aunt" Louise Huckstadt.) The women sorted, folded, and ironed. Their working hours were 7:30 A.M. to 4:00 P.M., and they made twenty-five cents an hour in the 1890s. Men did the huge, heavy batches of laundry and were also the mechanics and drivers. Lakeview and St. Elizabeth's hospitals had their own laundries, which also employed women.[11]

In addition, Danville's Old Soldiers Home provided employment for women in traditional female occupations. A political plum procured for Danville by the influence of U.S. House Speaker Joseph Gurney Cannon, the Old Soldiers Home opened in 1898 and by 1910 housed an average of twenty-seven hundred retired veterans. Most of the work to maintain such a large operation was done by the veterans themselves to supplement their small incomes. However, in 1910 the payroll also included fifty-two civilians, many of them women who worked in the home's laundry, waited tables, or worked

in the cafeteria, kitchen, or bakery. Waitresses and other women employees were housed in the upper level of the cafeteria building.[12]

Other work that was considered a natural extension of traditional female functions in the home included that of seamstresses and milliners, or "the needle trade," numbers of which equaled that of domestic servants in Danville in 1895. Millinery and dressmaking were among the few businesses run by women in 1895. These jobs still employed women in the early decades of the twentieth century, but a smaller percentage were paid servants, dressmakers, and milliners in 1910 and 1920 than had been the case in 1900.[13] Danville women still found work, however, in other extensions of homemaking. In addition to domestic and laundry services, they kept lodging houses, ran restaurants, cooked, and waited on tables. Some of them served as housekeepers—really house managers—supervising staffs in hotels or in the great homes of Danville's wealthy. Mary Williams was a housekeeper for Spring Glenn, a large estate on North Vermilion Street, which is now Schlarman High School.[14]

Feminized employment (that is, work customarily done by women) also included work in factories that produced items connected with the traditional women's sphere, such as food, shoes, clothing, and textiles. In Danville many women went from commercial laundry work, which required them to stand all day, to the needle trades because they could sit down at the sewing machines.[15] A large number of the women who worked in American factories at the turn of the century were daughters of European immigrants. Few of the newcomers to Danville at that time were foreign born, but many were the children of immigrants, particularly those who had come to work in the mines: Belgian, German, Italian, and eastern European. In Danville, as is shown by recollections of two of these immigrant daughters, young women often worked out of the home to supplement their families' incomes.

Elizabeth Pitlick was the daughter of Hungarian parents (father from Buda, mother from Pest) who moved from New York to Tilton, Illinois, and then to Danville when Libby was thirteen. She was the oldest girl in a family of eleven children and went into the work world after she graduated from eighth grade, though her younger sisters went to high school before they took jobs. Libby was petite; when she tried to get a job, she was fifteen and looked much younger, so most employers would not even talk to her. Eventually she was hired by an optometrist across from her church. She did the filing and bookkeeping, washed windows, and cleaned sidewalks—all for three dollars a week in 1928. When she was sixteen, she tried for a better job and got one at a shoe factory in the stockroom, at seven dollars a week. She recalled that then she "worked in every sewing factory in town" and eventually returned to the shoe factory as well. Quiet and shy, she learned to speak up and defend

herself when someone accused her of not doing her job at the shoe factory. Libby never dated or married; when she was nine years old, she saw her mother suffering in childbirth and vowed then and there that no man would ever touch her. "And no man ever has!" she said proudly when interviewed. She explained that she worked at many different factories because she often left her job to help out families, sometimes as long as six months. Usually these were cousins or siblings who needed help with someone sick or a new baby. A few were not even members of her family. She considered this her Christian duty and did not charge them for her help. Libby chose to play both roles attributed to the single woman: the traditional role of supplementing family work when needed, and the modern role of earning money for herself and her family. She remained sharp, active, and energetic in her nineties.[16]

Rose Fava was the daughter of parents from Italy's northeast coast who immigrated to Westville, just south of Danville, so her father could work in the coal mines. Some of Rose's sisters worked in a Westville clothing factory, owned by family friends, where they assembled dresses, jeans, and shirts. Another sister clerked at a dry goods store run by two women (whose father had begun the store but died, and so they carried on). Rose had quit school to do housework, but her teacher Mr. Howerton came to her home to encourage her return to school, which she did, graduating from eighth grade. Then she went to work. She washed dishes at a restaurant and filled in for the cook occasionally, although not always successfully (she remembered covering all the soft pies with coconut, regardless of their flavor). Rose's regular employment was at a cooperative store owned by a group of miners. She clerked, cut meat, and stocked and delivered groceries, proud that she drove a horse-drawn delivery wagon all over town—all for $3.50 a week. Her mother, Mary Fava, took in boarders, and one of them, Vester Merlie, started courting Rose. She married him at age eighteen. After they married and had two children, Rose went to the clothing factory intending to get a job. She came home without applying, however, after deciding that the factory was "too noisy" and that she had enough to do raising her children and caring for her miner husband.[17]

THE FAMILY BUSINESS

Women often entered public employment to help out their families, either by taking on temporary work or by working directly in the family businesses, which came in many varieties. In 1895 twelve Danville women, at least, including Sadie Simpson, Mary Hurley, and Mary Boynton, ran lodging houses or hotels, where their children also boarded or worked. Other boarding-houses were listed under the names of husbands employed outside the home but were undoubtedly run by their wives.[18] The Hacker brothers and sisters,

including Minnie and Carrie, partnered in a dry goods store, a grocery, a dress shop, and eventually Hacker's Fair, which combined all three and became a staple in downtown Danville for decades.[19]

African Americans numbered over eleven hundred in Danville in 1900, and their population in the city more than doubled by 1920. There was no strict residential segregation, but the main African American settlement and stores were in what was called "the bottoms." Old-timers remember mom-and-pop grocery stores, including Carter's grocery, run by Joseph Williams's grandmother and grandfather. Other black entrepreneurs, women and men, would sell goods from Chicago on the streets. African American women whose husbands listed themselves in the 1907 city directory as insurance agents or saloon or restaurant owners may have been workers in the family businesses as well. Danville's black community was seldom without a doctor or a dentist after 1900, and while these were usually male, they employed African American women, often relatives, in their offices.[20]

In Danville it was acceptable for a well-off woman to work in the family business. In 1895 Lucy Woodbury, of the famous Danville founding family, was employed in the family's business as manager of the book department (though her sister Flo did not work for pay). Maggie Conron, Mary Partlow, Mary Depke, Marcia Daniels, and the Menig sisters were among those who managed or clerked for their families' real estate, insurance, furniture, or woolen mill businesses.[21]

Many Jewish women too took part in mom-and-pop businesses and sometimes lived over their stores, a practice long acceptable in Europe and then transferred to America. After an immigrant family, relatively penniless, moved to America, they would rent a store and the meager sleeping rooms above it. Both man and wife worked in the business, most often in tailoring or shoe repair or dry goods. This practice often occurred among eastern European families. German Jews, who were the earlier Jewish immigrants, had often begun as peddlers and then found locations where the demand was great enough to start "stalls" or shops. By the 1890s and early 1900s German Jews owned about thirty stores on Main, Hazel, and Vermilion streets. Their wives stayed home and ran the households and took care of social and charitable obligations.[22]

PROFESSIONAL WOMEN

Professional employment for women in the early twentieth century centered on extensions of traditional women's work: teaching, nursing, social work, and library work. Josephine "Josie" Durham was the first librarian for Danville Public Library and, after the opening of the new library building initiated by a donation from Andrew Carnegie, worked with women's groups

in the community to expand the library's reach.[23] Many more women were teachers, including almost 14 percent of those in the 1895 Danville workforce. The number of teachers increased as Danville grew in the next twenty-five years, but the percentage of paid women workers who were teachers declined. Teacher salaries remained low, working conditions challenging, and employment dependent on the whims of local school boards, while other opportunities for employment that presented themselves did not demand years of post–high school training. Still, to many women, teaching remained a calling; teachers listed themselves as professionals, and many proudly named the schools they were identified with, whether Jackson, Washington, or St. Mary's Academy for Girls, where Sisters Clarissa and Inezetta were teachers. Later, after Jackson had become an all-black school, African American women teachers found employment, beginning with Helene Smith, a graduate of Kansas State Teachers College, and Myrtle Johnson Robinson. Helene Smith was a community leader for decades and helped establish Laura Lee Fellowship House and Carver Park. Myrtle Robinson was born in Danville, graduated from Indiana State Teachers College, and later taught in New Jersey, where she received a doctorate from Seton Hall University.[24] A few women, even in 1895, were school administrators, including Mary Hawkins, assistant principal of Danville High School, and Eva Sherman, principal of Washington school. By 1913 six of the eight elementary school principals were women.[25]

Most teachers remained in the classroom and had to overcome hardships from meager community support. In an unpublished autobiography written for her family, Vera O'Connell Janes reminisced about teaching in the early twentieth century in the Danville area. Born into an Irish Catholic family in Grape Creek, she always wanted to be a teacher and after her graduation from Danville High School in 1920 was hired "for the fabulous salary of $85.00 a month for eight months" in a rural school northwest of Danville. She had no training for her school of thirty-nine children, ages five and a half to fifteen years, and recalled, "I felt as if I were on a merry-go-round trying to get a daily schedule outlined and then getting every lesson assignment covered every day." There was little equipment in the school; she used grains of corn for the children to form letters and designs on desks until the corn attracted nesting mice. Janes later taught at better-equipped schools, but her experience showed why many women sought employment in fields other than teaching.[26]

Women also taught privately. The Danville city directory of 1907 lists twenty-four music teachers, all but five of whom were women. Women still comprised two-thirds of that field in 1910 and 1920.[27] While their jobs required training, of course, music teachers' employment opportunities could

better be compared to those of milliners or dressmakers than those of public school teachers. Largely self-employed, these women had prospects that could range from sporadic and precarious to stable and successful. Bertie Braden was one of the successful music teachers. She taught lessons in her house located at a desirable North Vermilion address for decades, advertised herself in city directories, and was active in club and service work.[28] Elocutionists and private art teachers earned equally precarious or prosperous livings, depending on their circumstances. Danville had an active theater life, and while professional actors and actresses most often passed through on a touring circuit, they no doubt inspired the development of local talent, a heritage made famous by the many theater, movie, and television stars who grew up in Danville, including Helen Morgan, Bobby Short, Dick and Jerry Van Dyke, and Gene Hackman. Until radio and the movies existed in the 1920s, talent shows and plays featuring scores of local speakers, dancers, and singers were regular fixtures for entertainment in Danville and furnished a continuing local demand for lessons.[29]

Nursing grew rapidly as employment for women as hospital care was professionalized and feminized in the late nineteenth and early twentieth centuries. Including Amelia Hunger, head nurse at Vermilion County Hospital, only seven women identified themselves as nurses in Danville in 1895, but by 1920 there were ninety-nine, including eight nurses at the Old Soldiers Home.[30] Nurses also worked in private homes and in the two local hospitals, St. Elizabeth's, founded by German Franciscan nuns in 1882, and Lakeview, founded by the Protestant Hospital Association in 1892. Lakeview trained its own nurses in its Danville Training School for Nurses, established in 1894. Its two-year program accepted women ages nineteen to thirty with two years of high school, sound physical health, and good teeth. Each woman was required to bring a recommendation from her minister and was put on three years' probation to assure strict moral conduct. By 1905 the Danville Training School, later renamed Lakeview School of Nursing, had graduated twenty-nine nurses. St. Elizabeth's was operated by members of religious orders (forty sisters were on duty in 1918), but in 1920 it opened its own school of nursing to fill its growing need.[31]

The expectation that women were "naturally" nurses and midwives, even without training, persisted, though; thirty-two women in 1910 and sixty-one women in 1920 described themselves for the censuses as nurses and midwives without professional training.[32] Few women were physicians. Only Addie Barnes, widow of another physician, identified herself as a doctor in 1895. Five more, Rachael Cooper, Effie Current, Maggie Downs, Ella May, and Anna Natho, identified themselves as physicians in 1907. Maggie Downs was in partnership with her husband, but the others had their own offices.

On a 1907 list of seventy-one physicians, these six were the only women. Two of the five osteopaths and one of the four undertakers listed in the city directory were women. In 1909 the wife of Dr. Thomas Lake advertised her services in the *Danville Banner* as a "Divine Healer," particularly skilled at healing female complaints; in the ad she appears as a dignified, middle-aged, African American woman with a reassuringly professional demeanor.[33] The line between certified and uncertified healers was being more defined in the early twentieth century, and in 1910 several men and women in Danville were charged with "impersonating a physician."[34]

Social workers, members of another feminized profession, were also employed in Danville as early as 1895, when Eliza Taylor served as the matron for the Woman's Faith Home and a crew of five Salvation Army women led by Capt. Ama Houton and Lt. Cana Fenton engaged in needed work among the large transient population. By 1911 the YWCA and Associated Charities expanded the opportunities for women trained in social welfare leadership. Other jobs opened for police matrons and truant officers to deal particularly with women and girls. Cora Abernathy, the church lady profiled in chapter 1, and Franc Slocum were among the first to take these positions.[35]

SALESWOMEN

In addition to working with their families or in feminized employment, Fine cites a third reason that made work acceptable for traditional women: the common assumption that they were working "until" marriage. While this assumption made it more and more acceptable for young single women to work outside the home, many women did not follow this pattern.[36] Most of Danville's women who listed themselves as paid workers in the 1890s were career single workers, by design or circumstance. In Danville many of these were saleswomen. The numbers of department and clothing stores and the growth in consumer services attracted women to retail jobs, which provided opportunities for them to engage in "genteel" occupations while wearing nice clothes. The popularity and opportunities for women as sales clerks were established in Danville in the 1890s, when large stores began to fill Main Street. Fifteen percent of women in paid labor in 1895 worked as sales clerks or "salesladies," and while the numbers of women in this field burgeoned later, the percentage of employed women remained the same. Women who described themselves as "sales clerks" in 1895 often named the Golden Rule, a large variety store, as their place of business, and women identified as "salesladies" named as their employer the biggest Danville department store, Straus-Hecht.[37] A difference in status was implied in these terms of identification, although saleswomen were at a disadvantage no matter where they worked.

In *Counter Cultures: Saleswomen, Managers, and Customers in American Department Stores, 1890–1940,* Susan Porter Benson points to the low status of women's sales work within the department store. Bullied by the floor-walker and the store manager to push sales items, saleswomen had to put up with low salaries made lower by the cost of the "nice clothes" they were required to wear and pay for.[38] However, the other, poorer options for work in the 1890s made sales a desirable opportunity and generated decades-old loyalty among women who worked for the best-known stores. Women and men who worked for Meis-Baer department store, which opened in 1897 and later became Meis Bros, recalled it as "a good place to work" and later recalled that management was "ahead of the times" in employee relations. Respect and opportunities for advancement for women at Meis were demonstrated by the fact that five of the eight department heads named when the store opened were women: Minnie Hacker, Alice Combs, Gertrude Tucker, Maggie Norton, and Mary Laurence.[39] As large chain stores such as Woolworth's challenged the family department stores, employment in sales became less attractive because of the impersonality and inflexibility of rules for employees, but more jobs became available. The number of Danville women clerks and saleswomen tripled from 1895 to 1910. By 1920 women made up almost half of Danville's salespeople, and sales had become one of the biggest fields of employment for women. While most women maintained entry-level positions in stores, thirty-six Danville women were managers or supervisors in 1920.[40]

CLERICAL JOBS: A "NEW FRONTIER" FOR WOMEN

Young women in Danville, as elsewhere, found the greatest number of attractive new jobs in the clerical field, which was dominated by men in the nineteenth century and could not be defended as "naturally" extending from the domestic sphere. As Fine points out, "there was nothing inherently feminine in filing, typing, or taking stenographic copy." The introduction of the typewriter and the dramatic increase in job opportunities as stenographers-typists may have reduced the possibility of accusations that women were stealing men's jobs.[41] However, facility with language was a required stenographer skill in which many women excelled. Girls were likely to stay in schools longer than boys and were therefore able to take the necessary skills training in high schools and/or business colleges. Clerical work became women's work in the twentieth century. Danville, where the number of women clerical workers almost tripled from 1910 to 1920, illustrates this trend. In 1920 office clerks were still predominantly male, but almost all of Danville's stenographers-typists and two-thirds of Danville's bookkeepers and cashiers were women.[42]

Even as early as the 1890s, Danville women had already established their abilities in clerical and office work. Forty-one Danville women listed themselves as bookkeepers, cashiers, stenographers, and/or "typewriters" (typists) in 1895. Mamie F. Baldwin advertised her skills as a "stenographer, typewriter and notary public." Other women had shown that they were not afraid of skilled technological jobs. Illinois Printing Company had employed skilled women technicians since it was founded in 1874, and its women employees proudly listed their skills in 1895: Kate McFall and Maud Esslinger, binders; Lina Marble, a feeder; Mamie Burk, a "ruler."[43] These few clericals and technicians were, of course, only precursors to the flood of those who performed clerical jobs in the early 1900s, but they did establish female skills in this field and pride in these skills.

The office world also provided opportunities for career women of exceptional ability and drive: a fourth category of women who worked to achieve and accomplish their personal ambitions. Mary Jones, for example, began as bookkeeper for the Illinois Printing Company and later became the secretary-treasurer and a major stockholder and manager of the company.[44] Other nontraditional women included Mabel Redden and Susan White, reporters for the two major Danville newspapers in 1914. A few held local government positions: the deputy circuit clerk's job was filled by Sophia Adams in 1895 and Maud L. Baum in 1907.[45]

Exceptional women also took advantage of the opportunity to train the new women clerical workers. Danville High School and, eventually, other area high schools increased their commercial courses, which included typing, shorthand, and bookkeeping. Danville Business College and Brown Business College were among the institutions that assisted women, many of whom had not been able to attend high school, to acquire and improve their clerical skills.[46] Cleona Lewis showed how far these new opportunities could take a woman of exceptional ability, drive, and timing. Born in 1885 in a rural community, Lewis graduated from Danville High School and began teaching in a one-room school before 1910. Danville High School hired her as a secretary, and she also began teaching business courses at the high school. Forced to take some college to keep her job, she attended the University of Chicago, where her brilliant work as a student led her to a position in the American Peace Commission at the end of World War I and an illustrious career as an economist at the Brookings Institution.[47]

Most women who took clerical positions, though, did not develop illustrious careers. In fact, their salaries and opportunities for advancement declined as the profession feminized. The entry of large numbers of women employees into offices "posed a direct threat to a number of Victorian prescriptions for respectable behavior," as Fine points out, particularly to the belief that

"it was morally dangerous for unrelated men and women to work together in the same physical space."[48] In order to accommodate the reality and the economic advantages of women office workers, clerical positions were gradually "feminized" in the public image. Business journal writers and sociologists stressed the advantages of female qualities such as "refinement, morality, decorum, and neatness" that women brought with them to the office.[49] Women were praised for working long hours, attention to detail, punctuality, and enthusiasm. They also had the "advantage" of working for lower salaries and not expecting career advancements. Nineteenth-century men had taken clerical jobs with the expectation that these provided an opportunity for moving up the ranks within an office, but many men had given up on these jobs after the economic hard times of the early 1890s. As women took the abandoned clerical jobs, gender in the office separated into two tracks: men were on an upward track to management, while women remained in the same positions for decades. For most of the public, this image of the separation of male and female spheres, no matter what relationships may have been in the real world of the office, made it acceptable for men and women to share the same space.[50]

The separate tracks for men and women also made acceptable the fact that female office workers almost universally made less money than male office workers did. The majority of women clerical workers were young, ready to try out their skills learned in high school commercial courses or business colleges, and proud to be on their own or helping out their families. The public and employed women themselves accepted the myth that women in offices as well as factories were expected to be "until" workers: single women employed "until" marriage, or married women employed "until" a temporary financial crisis was over or "until" support of an aged parent ended. Certainly this myth was not reinforced by reality. Many women, such as Danville's Gladys Walker, held office positions through marriage and child raising. Her earnings put Gladys's brother, husband, and son through college, but she stayed in the same job for forty-three years. She saw the men around her get raises and promotions withheld from her. Her son remembered this, and he recalled his general sense that his parents discussed the unfairness of her situation.[51]

Needless to say, however, Gladys and other office workers did not organize for fairer treatment. While a few women joined unions or founded their own in large cities, women workers did not form unions in Danville, despite the fact that Danville was a strong union town for men. The only exception was the Women's Union Label League, a union support group founded in 1913. The league, dedicated to buying union-made products wherever they were available, met the second and fourth Wednesdays each month in

Danville's Union Hall, owned by the Danville Trades and Labor Council.[52] The Women's Union Label League was headed by Phoebe Fox Walker, daughter of a strong union family from Mason, Illinois, and wife of labor leader John H. Walker (no relation to Gladys Walker). The Walkers were a strong union presence in Danville from 1911 to 1919. John Walker, born in Scotland, was a coal miner who had gone from being president of Danville's United Mine Workers (UMW) to president of the UMW of Illinois. From 1913 to 1930 he was also president of the Illinois Federation of Labor.[53] Walker was known as "Cooperative Jack" for his efforts to help miners bypass company stores by establishing their own cooperative stores. In 1916 he proudly counted "over 30 stores in mining towns employing nothing but union men and women" and selling "all the union-made goods that can be gotten,"[54] which tied in with the Women's Union Label League organized by his wife. Westville miners operated one of these cooperative stores, and Rose Fava was one of the "union women" who worked there.[55] The number of miners' cooperative stores in Illinois expanded to eighty by 1919 but began to decline after that, and the Walkers moved from Danville.[56] Working women in the area remained unorganized into labor unions, though they later organized into clubs to better themselves and their communities.

ELIZABETH STEWART, CLERICAL WORKER

It is difficult to find out what these young workers did in offices and after work, how much they were paid, and how they thought about their lives. Few left written records or recollections of their pioneer office work in the early twentieth century. Elizabeth Stewart, however, who lived and worked in Brazil, Indiana, not far from Danville, industriously chronicled her daily life during 1913 and 1914.[57] Elizabeth was twenty years old, lived with her mother and father over their grocery store, and worked in an office of architects struggling to establish their business. She was often alone in the office, or had little to do, while the architects were out making contacts and bidding on contracts. She liked her bosses but hated being alone. Like diarist Mary Forbes, profiled in the prologue, Elizabeth was affected by the weather, as she reported on November 7, 1913: "Unhappy, dismal day. . . . I had nothing to do all morning. Felt mean, dissatisfied, hateful and everything else. It Rains—Rains—Rains." On December 2, 1915, she turned to needlework to have something to do: "Bought a pillow top to work on at the office this afternoon, and you'd [like] to see them gawk. Don't care." Then, as work increased in March 1914, she was swamped, as she stated on March 17 and 19, 1914: "Am working like killing snakes at the office this week. . . . Have worked so hard and so steady today that I had the regular hysterics tonight. Just wanted to scream and laugh and cry all at the same time." She prepared and produced

specifications (sixty-four sets) in a few days for one job and more for another. She also wrote business letters, answered the phone, and kept long hours, mentioning evening as well as daytime work, though she also took time off for short trips with family and friends. For her work, as of September 13, 1913, she was paid a weekly wage of $6.00.

Elizabeth handled her meager finances carefully. She bought herself a piano on payments of $5.00 a month and had several teeth filled, many with gold, for a total of $9.50, which she also had to pay in increments. When her salary was raised $2.00 a week in October 1913, she began to pay rent of 50¢ a week to her parents. As for clothes, she noted on September 22, "Stayed home after taking my old hat up to get fixed over. Almost [finished] my waist. Fixed my old skirt. Cleaned my gloves, shoes, trimmed over my hat." When she did pick out a new dress, she had to borrow the $5.00 from her friend Lizzie to pay for it, because on payday, November 18, "no one [was] in the office. Didn't get my check."

In April 1914 Elizabeth's brother arranged for her to work in the office where he was employed in Indianapolis, for a bigger salary of $60.00 a month. She decided to try it, but after two weeks she noted, on April 26, "I got homesick, tired, and almost sick. No mama, no Lizzie, no own little room all by myself." She returned to her old job, where her grateful bosses raised her salary to $8.00 per week. She was also less lonely because the firm hired two more women. "Mac [her boss] said it looked like a Young Ladies Seminary in there," a revealing May 13 observation of male uneasiness over the gender transformation of office work.

Elizabeth's return home from Indianapolis indicates how important her personal life was, compared to her office work. She had liked the work in Indianapolis, but there she had to live with her brother and his family, and, above all, she missed her friends. Her diary in 1913 is full of the fun she and her friends had going "uptown" several nights a week: to movies at the Sourvine and Arc theaters (one of her friends had complimentary tickets through her work), to carnivals and circuses, and on picnics and buggy rides on weekends. Like a typical twenty-year-old, Elizabeth often stayed out at night until 11:30. Parties were a big part of the working girls' social lives, and Elizabeth described them in detail, including her "mash party" for Halloween, complete with costumes, and a "hard time party" with "ridiculous" dresses. She gleefully chronicled her surprise birthday party September 18, 1913, for her close friend Lizzie. She invited Lizzie for what seemed to be a two-person party. "We [she and Lizzie] had quite a time singing and playing" when "about 8 oclock here came in all the girls, seven in all and L[izzie] just had spells." The girls "had boughten [*sic*] a cake, ice cream, salted peanuts and flash light powders and maybe you don't think we had a circus. I laughed

so much my jaws ached. Had lots of music, too. . . . Lizzie said she never had a better time in her life."

By the second decade of the twentieth century working women were modeling their lives after those of the wealthier classes, including woman's clubs. Significantly, Elizabeth and her friends formalized their relationship as sisters by forming a club in October 1913 with Elizabeth as president. They held regular meetings that included initiations, business, music, refreshments, and more birthday celebrations. Despite her parents' meager income, Elizabeth had been able to get some musical training. She sang in the church choir, and many of their good times included singing around the piano, which she must have played ably. She began to give lessons to pay for her piano, and she acquired a beau, "Mr. Poling," who shared her love for music and bought a violin so they could play duets. As part of their formal courtship Arlie Poling brought her chocolates, sheet music, and "lots of candy and gum" on their regular Sunday dates, as she reported on March 16, 1914. Elizabeth later married Arlie, but in her 1913–14 diary she saved her enthusiasm and affection for her good times with her girlfriends.[58] Her diary supports many general observations about working girls: their skilled work and low pay, their enthusiasm for entertainment and good times, their desire for self-improvement, and the centrality of female companionship in their lives.

"WOMEN ADRIFT"

Elizabeth Stewart returned to her small hometown after a brief stint in the big city of Indianapolis. However, many other women left their homes for good, moving from farms and villages to larger towns or cities. "Women adrift" is Meyerowitz's appropriate term for these young women, who moved away from their homes to avoid family restrictions or abuse or to escape boredom or find new opportunities.[59] According to Meyerowitz, a special 1900 census of women workers in twenty-eight cities showed that 19 percent of urban wage-earning women lived apart from family and relatives. Chicago's "women adrift" comprised 21 percent of the city's wage-earning women.[60] Danville's multifaceted development made it an attractive job market for women, so it undoubtedly had its share of newcomers among women workers.

Young women moved to the cities because of the "pull" of job opportunities and a desire for independence and excitement. Sarah Brewster captures their optimism in *Relatives*, a 1916 fictional account of working women, when her heroine proclaims: "I want to work because I've the ability to work. What's the use in wasting my energy? It's thought shameful of a young man to loaf around. . . . My own idea is that it's just as shameful for a girl to fool away her time when she's capable of doing good work."[61] Meyerowitz also points to the "push" factor that impelled young women to leave

their homes: economic hardship and lack of work at home, disruption of the family by death or divorce, "unhappy and abusive relationships" with step-parents or guardians, expulsion from the family because of the girl's sexual activity or unwed pregnancy, or simply unduly restrictive treatment as the "daughter of the house."[62]

Meyerowitz does not intend for the term "women adrift" to have a nega-tive connotation. She admires the women, almost all of them young and entry-level workers, who had to create their own lives. They had to find places to live, work that would support them, and leisure-time activities that would make up for their difficult, monotonous workdays. Most of them hoped also to find husbands, economic partners who would make their "until" working status a reality. Unfortunately, pay for their entry-level work was inadequate, places to live were scarce, and there was a paucity of leisure activities that could provide the fun and excitement they craved.

"Women were pinned into sex-segregated jobs and paid as if their wages were pin money," as Catherine Clinton puts it.[63] Testimony at an Illinois Senate investigation in 1913 from spokesmen for the Illinois Manufacturers' Association; banks; Sears, Roebuck; and Marshall Fields revealed that most major employers paid women workers from $5.00 to $8.00 per week, with some wages as low as $2.75. Employers claimed that "the girls" could live on that. Several women workers objected to this claim in letters to the senate. A welfare worker protested that the working woman's "bare necessities . . . will average more than $10 a week." A working girl had to pay for rent, even for "a cubbyhole or a larger room shared with another girl"; meals, even a skimpy breakfast and lunch and a 25¢ boardinghouse dinner; laundry, tooth powder and brush, soap, powder, and face cloths ("even poor girls powder their noses and wash their teeth"); a small amount of dental and medical work per year; and a little entertainment. By that time her wages were gone, without anything for clothes or extras. The welfare worker came into con-stant contact with girls "who are eking out that shortage in wage by occa-sional delinquency."[64]

It is easy to see these girls as victims, as did the welfare worker, who said that she "would rather watch a girl dying by inches."[65] However, Meyerowitz sees them as pioneers in a new urban culture. As she says, "few women alone starved or committed suicide." Instead, they found "resourceful ways to live in the city. They created substitutes for family life, and they cooperated with and depended on their peers, stretching, pooling, and supplementing their wages."[66] Meyerowitz further believes that these young, single workers pro-vided the middle class with a model of rebellion and freedom that evolved into the flappers by the 1920s. Her point makes some sense, but while the working girls' bravery and independence are admirable, it was also obvious

that women adrift did need help, not only in a big city but also in a town such as Danville, with its low wages, its scarce affordable housing, and its thriving liquor, sex, and gambling industry.

The next chapter will show how Danville elite women developed ways to assist those who might drift away from safety and respectability in their town. They created a branch of the Travelers Aid Society and a long-lasting and popular branch of the YWCA. We have seen how Danville had a rich tradition of proud women workers, even in the blooming clerical field, before the "women adrift" began to arrive in Danville for jobs. Danville's large number of women workers cut across class lines to some extent, easing the transition of middle-class women into work outside the home in the twentieth century. Building on this heritage, Danville's working women were proud and assertive. The following chapter will show how Danville's branch of the YWCA, originally designed to protect "women adrift," was used by the working women to achieve many of the goals that had been achieved in other ways by elite women. Working women attended the Y's religious vespers when they craved spiritual fellowship; their clubs donated and raised money for the less fortunate, in the spirit of the Board Ladies of the Children's Home; they asked for self-improvement classes and organized small clubs for close sisterhood in the manner of Clover Club and Woman's Club study groups; and they initiated small clubs for those women workers hard to reach by the Y. Gladys Walker, a working woman who remained in her own hometown and had a supportive husband, was one of those who had experienced the benefits of sisterhood and who extended a helping hand to other young working women to create their own "work culture" within Danville's social milieu.

"Sin City" and Its Reformers

. . . women have found that they are not safe out in a community.
. . . their sense of values is distorted, there is danger of their losing their
bearings.

National YWCA president, 1913

DANVILLE'S REPUTATION AS A MAGNET for fun, good music, and
entertainment was already decades old by the Roaring Twenties, and it pro-
vided employment for those women who were drawn by talent or inclination
to the entertainment world of theaters, bars, and nightclubs. Bobby Short,
born in Danville in 1924, began his illustrious career performing as a child
in Danville's bars and supper clubs. In *Black and White Baby,* the autobiog-
raphy of his years in Danville, he describes his hometown as a "sin city" for
the surrounding area, where miners, factory workers, and college boys from
nearby Urbana could find "bars where you could drink all night; girls . . .
available, if you knew where to look, and gambling even legalized at one
point."[1]

As a river town and then a major railroad intersection, Danville had long
provided entertainment for travelers and residents. Its theaters, including the
Lyric and the Grand, offered concerts, serious plays, musical extravaganzas,
circuses, and Wild West shows. The theaters offered "ladies' matinees" in
addition to family programs. They also provided entertainment for the re-
tirees who lived at the Old Soldiers Home after the 1890s and received—and
spent—their pension checks in Danville, and the hundreds of railroad pas-
sengers who passed through Danville Junction in the 1890s. The Junction
was a small town in itself, according to Don Richter, historian of the railroad
scene in Danville. Its several blocks included "hotels, restaurants, saloons,
the nearby railroad shops and, most important of all, the human element that
is necessary to make any place successful and interesting."[2] As many as fifty

passenger trains a day stopped at the Junction and deposited up to a thousand or more passengers. Added to these were several hundred railroaders who worked at the shops and on the different lines. In *The History and Romance of Danville Junction,* Cary Clive Burford recalls its excitement in the eyes of a small boy in the 1890s: "I was speechless with delight. I was awed, fascinated, dumbfounded with what I beheld before me—Danville Junction at its busiest and noisiest. . . . hotels, lunch counters, sleek traveling men, troupes of actors and actresses, bustling baggagemen, tugging at ponderous trunks, and trundling station truckloads of drummers' trunks and scores and scores and scores of 'valises.'"[3]

Women as well as men found jobs serving this multitude in hotels, saloons, restaurants, and other enterprises. Burford recalls with sentimentality some of the women who ran hotels, including Regina Hoff of St. Louis House, known as "Mother Hoff," with her "kindly grayish blue eyes, her dignified expression and her face which reflected goodness personified." The Summit House's "Aunt Jennie" Pickering was known for her kindness to railroaders: "no 'boomer' down in his luck was ever refused shelter by Aunt Jennie." Hoff and Pickering were among those who raised their families at the hotels while creating a homey atmosphere for transients and laborers.[4]

Most of the many women who made their livelihoods as actresses, singers, and musicians merely passed through Danville, as did the women of the Monte Carlo Big Burlesque Company who played the Grand Opera house in 1911 and Sarah Bernhardt, who toured with a play in Danville in 1917,[5] though their performances may have inspired Danville women to follow their profession. Only LaPearl's Railroad Show, a circus, was located permanently in the city in 1895. LaPearl's was a family business: Herbert Swift was its "showman," Miss Alice Swift a slack-wire performer, and Miss Eva Swift an aerialist. Also in the realm of entertainment was Jennie Weigel, a "mind reader" who added to the income of her plumber husband. Other clairvoyants included Jessie Carr, an African American woman, and Madame Iola, a white woman. In later years this occupation must have been considered on the edge of the law: clairvoyants were not listed under "occupations" in city directories; and two fortune-tellers were arrested by Danville police in 1910.[6] Jennie Weigel, however, "better known as Madame Jeanette the clairvoyant," persisted and succeeded; she celebrated her sixty-first birthday in 1915 with a supper for twenty-five guests at her home. The food, presents, and decorations were extensively described in the *Commercial-News.*[7]

Not all entertainers listed themselves in the city directories, however. Bobby Short recalled colorful women entertainers in the bars and nightclubs of the early 1930s, women who had long been part of the musical scene in Danville. Clubs he was familiar with, such as the Edgewater Club on the

Perrysville road, the Pullman Club, Burke's Tavern, the Hottentot, Jimmy Harold's, the Panama Tea Garden, and Louis Knake's Café, were not necessarily part of the "respectable" Danville scene, though even the Hotel Plaza and the Hotel Savoy had "taprooms" that also featured entertainment.[8] Women famous for their musical talent who performed at these clubs included Bernice Hassell, "a colored woman who played a natural jazz piano and . . . could turn on a roomful of people"; Ruth Barnett, "famous around town for her torchy versions" of popular standards; and the Three Shades of Brown—Maudie Morton, Isabelle Stone, and Bertha Burnett. The Edgewater Club featured Ellyn Treadwell, a local pianist and "the party girl of all time," accompanied by a saxophone, drums, and an occasional trumpet on big nights, "while the crowd danced their heads off and wailed and hugged and drank and whooped it up." She also sang; "she had a husky voice that wrung the last drop of heartbreak" out of such tearjerkers as "My Man" and "The Man I Love" and an always-requested, risqué number titled "Yas, Yas, Yas," which she belted out "while the crowd screamed and clapped. More! More!"[9]

Bobby Short also remembered the distinctive Hazel Myers, who had gone into show business early in the 1920s and achieved success as a blues singer. Myers, dressed in black, "her hair glossed straight back, like Bessie Smith's," had an enormous "powerful and dramatic voice that filled the hall without any mikes." Hazel Myers made records and was often mentioned in the jazz journals of the day. She eventually came home to Danville and sang in her church's choir.[10] Helen Morgan, who was also raised in Danville but left for success and fame as a torch singer and movie star, did not come back; while still a relatively young woman, she dissolved into addiction and an early death. The entertainment scene offered a glorious but hard life. In Danville women on the edge tried to survive without sinking into the city's underbelly of vice and corruption.

DRINK, GAMBLING, AND SEX

Danville's notoriety as a "sin city" dates back at least to 1900, and women charged with keeping houses of ill fame ran into trouble with the law before that.[11] Gobin Gulch had a longtime seamy reputation,[12] and a prostitute named Bessie Dodge made headlines when she was convicted of having participated in the infamous lynch mob and riot in downtown Danville in 1903. Bessie lived (and presumably engaged in her trade) at the northwest corner of North and Gobin streets. A tall, red-haired woman in her thirties, she had moved to Danville from Urbana in 1902 when her husband was sentenced to prison. In *Here Stands the Law,* his history of the Danville riot and its aftermath, Donald Richter states that Dodge was "attractive and once might have been described as being beautiful before age and her life style cast a hardness

on her features."[13] Bessie was a bold racist who probably reflected the antagonism between the largely white vice district of Gobin Street, where she lived, and the vice district of neighboring Lemon Street, mostly African American. During the 1903 riot, she thrust herself into the mob yelling for the lynching of an accused black man being held in the county jail. Climbing on a wagon, she even urged the mob to "Lynch the sheriff!" as well as the black man.[14] The sheriff, however, prevailed, the accused remained in jail, and Bessie and others were arrested. Richter says that "Dodge's spirits remained high as she was walked the few blocks to the county jail, but she became noticeably quieter when the steel jail door slammed behind her."[15] The first woman in Vermilion County to be charged with inciting a riot, Bessie Dodge was "so pale and nervous there was general speculation no jury would convict her." A majority voted for her acquittal in the first jury vote, but the final vote declared her guilty along with eleven men. She was given an indeterminate sentence at the prison for women in Joliet.[16]

Danville's red-light district was not confined to one place in the early 1900s, but newspaper accounts of arrests for prostitution and its related charges, such as disorderly conduct or pandering, usually occurred on streets in two areas: south of Main Street on Washington, College, and Commercial; and north up the Wabash Railroad line to Lemon and Gobin, north of Stony Creek.[17] In addition, George Woolsey advised interested readers of the *Danville Banner* in 1909 to "watch closely the public square" and the "neighborhood of the interurban station," where "from early in the evening until a late hour in the night the 'catchers-on,' both men and women, congregate in the vicinity" to watch for customers from the in-coming and the out-going cars.[18] Woolsey also called attention to drinking and vice in the "Cherokee strip" just north of Kellyville "along the north side of the Catlin road in Danville township" and in the recently settled town of Belgium, both of which were located outside Danville's and Westville's Sunday drinking laws. According to Woolsey, on the Cherokee strip "on Sunday nights, especially immediately after the Soldier's [sic] Home pension days, there are more prostitutes, pickpockets and holdup men to the square foot in this territory than any other place I ever saw. . . . Sunday afternoons crowds of Danville toughs, prostitutes, and the merely thirsty, journey to the village [of Belgium] and by night a greater number are drunk. Then the fighting and robbing begins."[19]

Kevin Cullen, who gathered documents and oral histories about Danville's red-light district, and Vic Pate, who grew up in the neighborhood, identified more than twenty former brothels that operated from the 1930s to the 1950s in two square blocks bordered by Green, Washington, Commercial, and College streets. Popular strip bars also operated in Belgium just south of the Danville city line.[20]

Danville's reputation as a regional sin city was earned in its bars, gambling, and commercial sex. Women found employment in all three, but notoriety in the latter. What Meyerowitz calls the "sexual service sector"[21] saw opportunities to make profits servicing Danville's large population of single men with money to spend: salesmen and other travelers, railroad workers, miners, veterans from the Old Soldiers Home, and later, students from nearby Champaign, Charleston, Purdue, and Normal. Women worked full time as prostitutes in their own apartments and hotel rooms or in "resorts," as they were called, run by pimps and madams. From surveys in other towns and cities, including a 1911 investigation in Chicago, it seems that some women also worked as "occasional prostitutes," holding jobs in stores, offices, factories, and restaurants during the day and on occasional nights exchanging sexual favors for gifts or extra money, supplementing their meager daytime salaries.[22]

Women also earned money in other aspects of sexual service. Clubs and bars hired attractive, personable women as entertainers or as shills to attract male customers, paying bonuses if the girls got men to spend more money. Bobby Short describes a Danville dice game called "26" that could be played in any corner bar: "The '26' girls, who worked the bars and got a cut of the winnings, rolled the dice with you." Winners received chips that could be cashed in for drinks; the girls got a little extra money toward paying their rent.[23] According to Meyerowitz and others, "gold diggers" honed commercial use of female charms down to a science; they wheedled and accepted the most gifts and money from men that they could "but finagled to avoid giving them sexual favors."[24]

Therefore, as Ruth Rosen points out in *The Lost Sisterhood,* prostitution could be seen as a continuum—from white slavery, where a woman was held against her will to perform sexual acts for the profit of others, to routine and casual forms of sexual service "in which a woman might participate because prostitution might have appeared a better means of survival than other available choices." Even in the 1990s prostitutes interviewed by a sociologist as to "why they were there" gave answers about men who had actively forced, seduced, or betrayed them into prostitution; escape from bad home conditions; and low wages or economic necessity. Others wanted "easy money" or "more money" or were "tired of drudgery." A summary of the interviews concluded that "prostitution represented an integral part of culture determined by poverty."[25]

Meyerowitz and other chroniclers of working women in the early nineteenth century have shown that working girls, even "women adrift" from family and small-town control, were creative and resourceful in making their new lives, even if some of them chose sexual service to supplement or replace

other, meager sources of income. Anne Butler, however, warns contemporary scholars not to exchange one stereotypical image of the prostitute for another: to avoid exchanging the image of the "fallen angel" for "the professional who chose her job after carefully crafting her career plans!" In her study of prostitutes in the American West, *Daughters of Joy, Sisters of Misery*, Butler concludes that "an unending stream of violence and grief brought an aura of physical and psychological misery to the world of prostitution. Immersed in a routine of unmitigated chaos and social rejection, prostitutes had few opportunities to develop into balanced, stable persons."[26]

Sociologist Joanna Phoenix has come to the same conclusion after her systematic study of contemporary prostitutes in England, Scotland, and Wales, which she published in 1999. According to Phoenix, "against the backdrop of diminishing options and opportunities, involvement in prostitution came to signify both an opening of opportunities and a closing of opportunities. Within the context of lives shattered by the effects of poverty, violent and brutal relationships, homelessness and destitution, social censure and ostracism, involvement in prostitution signified a way forward and a strategy by which the women could improve their options and opportunities for material and social survival." However, as Phoenix continues, "in the context of the hassle of street life, the risks of violence, destitution and homelessness, the difficulties of being arrested, fined and potentially imprisoned[,] opportunities and a strategy for survival . . . backfired and trapped the women."[27]

Phoenix's study recognizes the outside forces that made prostitution dangerous. This hostile climate was also present at the turn of the last century in cities and small towns in the Midwest. In Danville in the early 1900s, prostitutes were vulnerable to arrest and helpless to avoid exposure of their lives in the newspapers. Danville's major newspapers covered their skirmishes with the law and their tragedies with a mixture of sympathy, amusement, and cynicism. The Prohibition Party organ, the *Danville Banner*, reported a tragedy and attached moralizing: "Flossie Martin, an inmate of Stella Wilson's resort on Van Buren Street, attempted suicide last Thursday morning by swallowing carbolic acid. This is the third attempt made by this woman in the past few years to kill herself by swallowing poison. Verily the way of the transgressor is hard."[28]

Emma Dee's death in 1911 was chronicled by the *Danville Press-Democrat* as a "general break-down physical and mental": "Flesh and bones will not stand the strain of a very long period of sporting life and its accompanying dissipations. Doubtless the woman would have lived many years had she not been what she was. She had reached that pitiful stage in the life of every woman—middle age—when good looks and attractiveness have flown. But

she had not been a good woman and she paid the price with her life at the near side of middle age. . . . For years she had been a police character, a woman who while not a violator of the laws of the land, except for drunkenness and disorderly conduct, had broken the moral laws that bind the weak and the poor. She was living on the wrong side of life and she knew it, but she had gone there in youth and she had known nothing else." The paper's reporter noted two other telling facts about Emma's life: that, picked up for intoxication several years before, she had been the first to ride in the police patrol wagon, which was from then on known as the "Emma"; and that "invariably when Emma was arrested," Henry Fugate, a veteran, was with her, "for they were almost inseparable."[29] These items highlight aspects of the prostitutes' lives; their almost symbiotic relationship with the police, who could be protectors or bribe takers or scourges; their addiction to alcohol; and their dependent relationships with men who shared their world.

Several reports chronicled the unhappy story of Martha (who used several aliases), who attempted to commit suicide after the police "had raided a resort" on Lemon Street at 3:30 A.M. and found her there. "She had been arrested several times while in the company of Negroes." After the suicide attempt, Martha was arrested once more for "loitering" with another young woman. In each case someone paid her fines and she was released. Eva was less lucky; "white wife of a Negro and an old police court character," she was fined five dollars and costs for loitering and was unable to pay. She was released but was arrested again two weeks later, again for loitering. The magistrate levied a ten-dollar fine this time, "so she may have to serve 21 days because she was unable to pay," the paper reported with seeming satisfaction.[30] When informing the public of these arrests, newspapers repeatedly called attention to racial intermingling, particularly of white women and black men; the underlying message was, of course, that racial integration was linked to vice and crime.[31]

Prostitutes were often portrayed as preying on men. An Old Soldiers Home resident, for example, had collected his pension and bought a railroad ticket to Louisville but stopped off before going to the train "to sleep" at a home on Lemon Street. In the morning his cash and ticket were gone. (The two women in residence, Ella and Pearl, accused each other, and Ella was finally indicted.) Prostitutes had little leverage in court. Stella, an "alleged keeper of a resort on College Street," brought charges against her lover Abraham Willus for attempted murder, but he responded by having actual or pretended D.T.'s in court when charged. These items, and many more, were published with names and addresses in the *Commercial-News*.[32]

Danville's red-light district was not particularly sinister to the people who lived in the neighborhoods, judging from their recollections. Commercial, College, and Green streets bordered St. Joseph's Catholic Church and school, and some of the women who lived in "resorts" attended church and went to St. Elizabeth's Hospital when they were ill. Growing up in the neighborhood as a boy, Vic Pate would see some of the women going shopping, and they would exchange greetings with him. The only reason he knew who they were was because they were better dressed than other neighborhood women shoppers. Pate remembered that houses in the district were brightly painted and well kept, and they had large screen doors so the women could scrutinize their customers; and yes, many of the houses sported red lights. Elizabeth "Libby" Pitlick attended St. Joseph's school on the corner of College and Green streets. Across the street were several houses of prostitution. Libby was warned never to cross the street. Her mother, however, told her that "if you see any of [the prostitutes], say hello. They're human beings just like us."[33]

To many people in Danville, the houses of prostitution furnished opportunities for profit. Keepers of "resorts" hired local Danville people as cooks and housekeepers. They used employment agents to aid them in staffing their places of business. They also used the services of physicians. Dr. John S. Curtis, who remembered Danville as a "wide open city" when he was a young practitioner, made house calls to some of the "resorts." He treated one woman for alcoholism with a tranquilizer and others for syphilis and gonorrhea with injections manufactured by Parke-Davis (penicillin was not yet available). While most customers paid three dollars for a house call, Dr. Curtis received five dollars each for his visits to brothels.[34]

The women must have had money to spend, according to peddler Mary Maloley, an "itinerant merchant of fine embroideries and dresses," who was arrested for peddling without a license in 1911 when she was apprehended in the district. Maloley stated that she came from Terre Haute, where she owned property; slipped into Danville; and sold her goods in the middle of the night to "inmates of resorts," her best customers "being women of the underworld." She readily paid her twenty-five-dollar fine and costs and disappeared.[35]

PROSTITUTION AND CORRUPTION

Many stories of Danville prostitutes were published in Danville newspapers in spring 1911 as part of an anticorruption campaign. Both newspapers were trying to persuade voters to reform a corrupt Danville city government by voting in a city-manager system. Their campaign failed, and complaints about the blatant "sin city" continued. During the same spring a Vermilion

County grand jury indicted eleven women for "keeping a house of ill repute," but there is no record of any trials.[36] Reformers' efforts to close down prostitution failed almost everywhere, not just in Danville; as one scholar concludes, "the evil effects of prostitution could not be segregated from the everyday life of city residents or the society at large."[37]

As the economy of prostitution became more organized and rationalized, however, Progressives fought its increasingly dehumanizing effects on women and its damaging effects on the political system. In her 1912 book *A New Conscience and an Ancient Evil*, Jane Addams clearly outlines the ways in which commercial sex operated and was closely connected, along with liquor and gambling, to the political and law-enforcement systems. Her analysis certainly applied to Danville:

> The situation is enormously complicated by the pharisaic attitude of the public which wishes to have the comfort of declaring the social evil to be illegal, while at the same time it expects the police department to regu-late it and to make it as little obvious as possible. In reality the police, as they themselves know, are not expected to serve the public in this matter but to consult the desires of the politicians; for, next to the fast and loose police control of gambling, nothing affords better political material than the regulation of commercialized vice.
>
> First in line is the ward politician who keeps a disorderly saloon which serves both as a meeting-place for the vicious young men engaged in the traffic and as a market for their wares. Back of this the politician higher up receives his share of the toll which this business pays that it may remain undisturbed.[38]

As if to support Addams's analysis, a Danville old-timer who had served as a policeman before World War II recalled that "there's no doubt there were payoffs." He claimed that one of the mayors even owned two of the houses, and the police chief answered to the mayor. If police got a complaint about a disturbance, "we'd take the whole house. They'd pay their fine—usually $10 and $2.50 costs, and be back in business."[39]

Danville reformers made one attempt after another to fight the web of corruption spun between government and vice, but Danville's "business as usual" continued. Despite another crackdown on prostitution in 1918, a rapid rise in reported cases of venereal disease in the city in the 1920s showed the continued persistence of sexual commerce in Danville.[40] Many of the bars and brothels were still located in the same areas in the 1940s and 1950s until 1956, when Danville was declared "off-limits" to personnel from Chanute Air Force Base because of its illegal temptations and resulting venereal dis-ease and drunken driving accidents.[41]

SOCIAL PURITY AND SOCIAL HYGIENE

The Danville reform movements in 1911 and 1918 were based on the Progressive drive for morality and efficiency in government. These reformers saw prostitution as a peripheral vice linked to their major targets, crime and corruption. Another aspect of reform, though, focused on prostitution itself. Women and men who saw the rapid increase of commercial, large-scale prostitution in the late nineteenth century as a dehumanizing evil and a form of slavery organized to do something about it, with the restoration of "social purity" as their goal.[42] Some of the literature of the social-purity movement was romantic, featuring Victorian culture's belief "that women were inherently pure and passionless" and portraying "men as sexual predators and women as prey."[43] In a humorous paragraph in his autobiography, Bobby Short tells the familiar story, a tale that persisted long into the twentieth century: "Everybody knew what happened to a girl who slipped from the straight and narrow with a smooth-talking stranger. That was The Downfall. He introduces her to a lovely lady in silks and satins, and the next thing she knows she's sitting in a parlor with other broken blossoms. In no time at all, it's drink and dope and her hair falling out, and she dies of disease. The end."[44]

The social-purity movement included social conservatives "who focused on depraved female sexuality as the source of pollution in American society"[45] and blamed all women leaving the home for public pursuits, whether they be jobs or club work, as the source of social immorality. This strain of social-purity reform is exemplified by a minister's admonitions to young women as referenced by the Woman's Christian Temperance Union in the June 3, 1909, *Danville Banner*:

> Don't flirt—don't even try. . . . Flirting is unwomanly, unchristian and undermining of all that is lovable and sweet in the young life. Don't correspond with young men unless your mother consents and not then without an understanding that she is to read all letters.
>
> Don't hail the stranger by smile, gesture or waving of the handkerchief. Please don't. Those that ruin your young life accept such advances as evidence that you lack in those characteristics that make you proof against their evil designs.
>
> Don't take strolls out into the highways and byways of the town or city; nor take the buggy ride far into the country, and especially far into the night. Don't unless the relative, the brother, the father be near you. What shadows gather about the midnight buggy ride! Don't forget this, girls.
>
> Don't accept at the hands of any young man, the glass of wine, or any intoxicant.

Not all members of the social-purity movement blamed women for the increase in commercial sex. The movement against prostitution also included those termed "social purity feminists," who "sought justice for women."[46] They focused less on controlling the behavior of young women and more on the structural evils that allowed large-scale prostitution to operate. Social-purity feminists advocated the abolition of prostitution but also "the censorship of pornography, reformation of prostitutes, sex education, prosecution of prostitutes' customers, and establishment of women's right to refuse to have marital sex."[47] The General Federation of Women's Clubs echoed the concern with the "double standard of morality" and in 1910 turned its attention from social purity to social hygiene in order to emphasize the dangers and far-reaching effects of venereal diseases.[48] The Danville Woman's Club adopted the federation's example and in 1910 invited a woman doctor, Josephine Milligan of Jacksonville, Illinois, to give a public lecture on "Social Hygiene" in the club meeting rooms. The women distributed literature on the topic to teachers in the public schools. The next year a doctor from Northwestern Medical School gave a similar lecture to Danville club members and their invited guests, the mothers' clubs from the city schools.[49]

An Illinois Senate vice committee conducted hearings in 1913 on the root causes and extent of prostitution and the white slave trade in the state. The hearings were prompted by what has been called the "white slavery scare" in the United States. The shocking issue of white slavery united both conservatives for social-purity and Progressive reformers behind the easily identified and understood evil of prostitution. While reformers of the 1910s targeting white slavery often promoted a racial and nativist message, they were also fighting a real evil of modern prostitution. Scholar Brian Donovan points out that "coercion and violence became an all too common fact of life for prostitutes as increasing numbers of middlemen profited from the vice trade," including brothel owners, procurers, politicians, and saloon owners.[50]

During the Illinois Senate hearings, Danville was described as one of those cities where "federal white slave officials" found the existence of houses of prostitution.[51] Specific examples of coercion by predators appeared in stories in Danville daily newspapers. While these stories were obviously attempts to capitalize on the white-slave scare, guaranteed to sell newspapers, they also served as reminders of the profits to be made in the sex trade and the people eager to make this money by exploiting naive or helpless women, even in a relatively small sex market such as Danville's.

The *Danville Banner* for January 27, 1910, included this item: "A fifteen-year-old child was taken from a resort over a saloon last Sunday. The child was taken to police headquarters and questioned. She said that she was brought to this city from her home in Champaign by a bartender in a Danville saloon.

The man claimed to have a subpoena for her as a witness in a case to be tried in a Danville court, and that she came to this city with him and was taken to an alley saloon. She was welcomed at this resort by a woman who hugged and kissed her affectionately. She soon tired of this den and was transferred to another resort over a saloon where the police found her and rescued her and returned her to her parents."

The *Danville Press-Democrat* reported that another fifteen-year-old was befriended by two men and a woman, taken to a saloon where she drank beer and "much pop," and then taken to a room; the three were charged with "forcibly restraining a female in a room for fornication." Another direction of news stories was to warn young women to beware the attractive stranger. The *Commercial-News* related the story of a "traveling salesman" who made several friends among the young women of Gifford, a small town between Danville and Champaign, and wrote them "assuring some of them if they would meet him in Danville he would secure them good positions and also insure them a good time."[52] Notices such as these led an impressionable fourteen-year-old, Zay Wright, who lived near Champaign, to dedicate her life "to redeem[ing] girls debauched by the white slave trade" when she grew up.[53]

PROGRESSIVE REFORMS OF THE COMMERCIAL SEX INDUSTRY

Progressive reformers spearheaded legislation to curb forced prostitution. As a result of vigorous Progressive campaigning, the Illinois legislature made pandering a state offense in 1908. In 1909 U.S. congressman James Mann of Illinois sponsored the legislation that made him famous, the Mann Act, which made it a federal crime to transport women across state lines for purposes of sexual activity.[54] A Danville arrest illustrated this crime. In 1913 Lulu Shumaker, proprietress of the Danville Hotel at Washington and North, was charged for violation of the Mann Act. Dorothy Johnson, a young woman from Indianapolis, told a detective that she was persuaded by Nellie Shane, employed by Shumaker, to come to Danville for a great job: "light and cheerful employment, short hours, and plenty of money." According to Shane, "girls who were working at her shop frequently made as high as seventy five and eighty dollars weekly, wore the finest of raiment, did little but attend the theatres, ride in taxi cabs and enjoy themselves." Whether or not Johnson was naive to believe this, she did agree to take a job in Danville. However, in the two weeks after she arrived, she "had virtually been kept a prisoner in a room at the hotel." The charges against Shumaker declared that she had "already prepared a place for the girl, knew she was coming here and for what purpose she was being brought."[55] Even after the reform passion over prostitution peaked, prosecutions of violations occasionally surfaced. In Vermilion County in 1920, for example, two persons were charged with

"contributing to the delinquency of a female child" and "taking indecent liberties with a female child."[56]

Jane Addams spearheaded the most comprehensive action against forced prostitution. In her book on the sex trade, Addams wove together all the strands of the reforms against prostitution. Addams was criticized by some Progressives for a "sentimentality in her anecdotes about frail and innocent victims of prostitution rings" that reflected the white-slavery scare and the attitudes of the social-purity movement. Addams, though, also attempted to portray poor women in Chicago as "mobile, intelligent, experimental, pugnacious, and imaginative,"[57] and she showed her usual common sense in outlining the economic hardships that faced working women, who were often not paid enough to support themselves and therefore were tempted into sexual service. In addition, she was practical enough to acknowledge that working girls were starved for entertainment, and that unless cities provided outlets for this hunger, women would be drawn to "cheap theatres and dance halls," where they could be recruited for sexual service, or to "penny arcades, slot machines, candy stores, ice-cream parlors, [and] moving-picture shows," which would take their meager spending money and leave them more impoverished than before.[58]

Addams summarized practical Progressive remedies for these needs. She recommended that women workers be more widely incorporated into labor unions for better pay and working conditions. She also advocated "increased social control" through better public health, crusades against sexually spread diseases, and "a much wider and more thorough education of the public in regard to the historic connection between commercialized vice and alcoholism."[59] Addams, who had led a 1911 march to the Springfield state capitol to successfully urge the adoption of woman suffrage in the state, also gave illustrations to support her claim that where women could vote, the age of consent had been raised, and aroused women had broken the link between vice and corrupt politicians.[60]

In 1913, the peak of progressivism in Illinois, twenty-two Progressive legislators were added to the Illinois legislature and influenced the tone of reform. When the Illinois Senate conducted a systematic inquiry into the status of vice in Illinois in 1913, its report, published in 1916, reflected the Progressive outlook and the influence of organized women, not coincidentally reflecting the partial suffrage that women of Illinois won in 1913. The Illinois Senate vice committee traced the extent of the social ills connected with prostitution and evidence for its causes, stressing the low wages paid to women, the parasitic relationship between the vice industry and the political system, and the lack of civil and legal rights for women.[61] The committee concluded its hearings by appointing a Women's Legislative Congress composed

of four hundred women whose names were suggested by women's organizations. The congress was led by Jane Addams and many other women well known in the state, including Mary Payne, an active member of both the Danville Woman's Club and the Danville WCTU. At the conclusion of its December 1914 assembly, the Women's Legislative Congress recommended a broad menu of remedies for vice in Illinois, including a political system more responsive to the people, a minimum wage, better support for vocational training in the public schools, and the elimination of child labor for those under sixteen years old. As for the elimination of prostitution, the women recommended that instead of paying fines, prostitutes be committed to a shelter or home for vocational training and treatment of addictions. The age of consent should be raised to eighteen for girls, and similar protective measures should be taken for boys. While these and other recommended reforms were not immediately passed, they did indicate the general awareness by thoughtful and concerned people that the social problem of vice had broad and complex causes.[62]

HELPING "WOMEN ADRIFT" IN DANVILLE

Danville women's responses to the needs and vulnerability of girls, like those of women statewide, were broad and practical. The Board Ladies of the Children's Home provided a refuge for young girls who needed care and supervision, and the Woman's Club led a petition drive to have juvenile court closed to the public. The women argued that "open sessions of the court and the publicity given the cases in which young girls are concerned, permit persons who prey upon young girls to learn the names of the girls and frequently seek them out." Several women noted that continually in the courtroom were four or five men "who learn who these girls are and pass out this information to others" or follow the girls themselves. County judge Thomas A. Graham agreed to work out a way to shield first offenders and other vulnerable children from open court sessions.[63]

Danville also began a Travelers Aid Society, under the leadership of Mary Du Bois Giddings. Travelers Aid Societies aimed to protect and help women at risk, although they did not rule out helping men and children as well. Initiated in 1888 as a branch of the YWCA, Travelers Aid sent agents to meet incoming trains to help travelers unfamiliar with the city find lodging and information on available jobs. Its initial focus was to deflect the influence of those men and women who tried to befriend the "woman adrift" on the train or at the station in order to entice or force her into a red-light district, and this activity intensified with the white-slave scare. The success of Travelers Aid and other efforts to help "women adrift" were copied in smaller cities, including Danville.

Which Shall It Be ?

Travelers Aid Society of Chicago leaflet, c. 1920. The Travelers Aid matron saves the innocent girl from the city slicker. Courtesy of the University of Illinois at Chicago, Richard J. Daley Library, Special Collections

According to a *Danville Commercial-News* account, Mary Du Bois Giddings, wife of an attorney from a well-known Danville family, was motivated to begin the Travelers Aid Society by a personal experience. She was approached in 1910 by a "foreign-born Danville man" for assistance in finding out why his niece had failed to arrive from their native country as planned. Giddings, an active member of the Danville Woman's Club, was familiar with the work of Travelers Aid in Chicago, so she contacted that organization. According to a newspaper account, "the missing girl was traced, rescued from white slavery and returned to Danville." Giddings, convinced of its value, became a life member of the National Travelers Aid Society and decided that a branch was needed in Danville. She persuaded Grace Shields and Mary Payne to assist her, and the three of them went to Hull House for help. They returned to establish a Danville Travelers Aid Society and hired the society's first two secretaries from Hull House. Support for the society came from "50 patrons and patronesses" and contributions of a dollar a month from each of the community's churches. Later the Vermilion County Board of Supervisors and the Danville City Council also supported Travelers Aid, which continued for decades to fund an office at the train station.[64]

Travelers Aid, though, was a small precursor to Danville's most ambitious social agency for women, the YWCA. Organized nationally out of the social-purity movement, the Y's original purpose was protection, particularly protection of woman's traditional morality. However, under Progressive influence, the YWCA also became concerned with economic needs of working women served by the program. Danville's YWCA began during this later phase. It was organized and governed by traditionally prominent women who founded the YWCA to fulfill its original social-purity goals, but its target population of young working women, who eagerly embraced what the Y had to offer, wanted the Y to fulfill their needs for opportunity and sociability. Another group, which included Y professionals and trained community volunteers, acted as a "third tier," mediating between the board and the members to attempt to achieve the goals of both and to put the YWCA in the center of community life in Danville.

DANVILLE'S YWCA: OUTREACH TO WORKING GIRLS

Danville's local YWCA began with a Presbyterian effort during the pastorate of the Reverend W. E. Parsons, 1893–1904, to offer a place for downtown Danville working girls to eat their lunches at a time when the only lunchrooms available were in the rough and rowdy local taverns. Effie Parsons, the minister's wife, and Kate Leverich started a tearoom in the parlor of the church, offering the girls coffee or tea and a place to rest during the noon hour. This practice was extended by the wife of the next minister, Mary Shawhan, and the women of the Pastor's Aid and Improvement Society, who under the leadership of Emma Collison added weekly programs and hot soup on Saturdays to the parlor lunch hour and "made it a homey place for the girls." Soon scores of working girls were enjoying the benefits of the "Rest Club," as it was then called, bringing their lunches to the Presbyterian parlors and enjoying music, reading, and other planned programs.[65]

By February 1910, seeing the enthusiastic response from working women and energized by an evangelical crusade, a group of church and community women leaders decided that the time had come to formalize their aid to women workers as a Young Women's Christian Association. The YWCA's state secretary and state president met with the Danville women, who began the organization of their local YWCA. The organizers, like the Children's Home Board Ladies, did it all themselves at first. They relocated the "Rest Club" to the spacious rooms rented by the Woman's Club on the second floor of the Fera building, on the corner of Walnut and North; collected dues to pay gas and janitor charges; hired a matron; and offered coffee to the girls for a charge of five cents a week. Sunday evening vesper services were also held in the club rooms.[66]

The YWCA founders, though, quickly moved on to involve a wider spectrum of the community in their efforts. By the time the Danville YWCA was officially organized on April 18, 1910, the women had done their work, canvassing their friends, neighbors, church members, and local businessmen so that the new YWCA counted 784 members, 530 of them active, and over one thousand dollars in membership dues.[67]

Danville's Young Men's Christian Association was also revived and activated. A YMCA had existed in Danville since the early 1890s, but the Presbyterian Men's Bible Class, probably energized by the same evangelical crusade that sparked the YWCA founders, began a building drive in 1910. A new YMCA building was dedicated in 1915 at the corner of Madison and Hazel streets.[68] Since the YWCA was also rapidly growing at that time, it is obvious that the two efforts energized each other, to their mutual benefit.

THE YWCA BOARD

Although men as well as women helped raise and manage the money, the entire Y board was composed of women. Many of these were prominent and active in other social and community efforts. Elegant, "quiet and dignified" Nellie Coolley identified herself with the cause of the YWCA from its beginning. Nellie was a tireless club member and worker for good causes and a strong advocate of woman suffrage. For its first fifteen years, Nellie was the most consistent, reliable leader of the YWCA board, serving as board president several times and spearheading the drive for the new Y building completed in 1923.[69]

Other members of the founding board of the YWCA reflected the newer, larger industries in town. Olive Rankin was the wife of the secretary-treasurer of Western Brick Co. She served as the first president of the board and opened her country estate to the Y's working women members for meetings and recreation. Josephine Hegeler represented the well-known family that established an important zinc mine and industry in South Danville in 1905; she was also active in the Salvation Army, the Children's Home, the philanthropy section of the Woman's Club, and numerous other organizations that focused on the needy.[70] Jennie Straus's family owned one of the biggest department stores in town. Mary Reed Cannon was the wife of Danville's most famous citizen, "Uncle Joe" Cannon, U.S. congressman and Speaker of the House.[71]

Laura Whitlock, another Y founder, was the wife of Hardy Whitlock, who had gained national attention in 1903 as the Vermilion County sheriff who protected an accused black man from a lynch mob in downtown Danville and later testified against mob leaders. Laura had refused to leave her husband as he faced down the mob, and after the riot was over, she had her own

personal experience with women in unfortunate circumstances. While prostitute Bessie Dodge screamed for the crowd to "Lynch the sheriff," Laura shielded her children from flying bullets in their apartments above the county jail. Later, when Bessie was arrested for participating in a riot, there were no women deputies, so Laura was assigned to take care of Bessie's needs as a prisoner. Newsmen reported that Laura provided Bessie with a few comforts, including a mirror, and "one of her better dresses for her court appearance." When Bessie was found guilty and given an indeterminate sentence at the women's prison at Joliet, Laura walked over and consoled her.[72] Perhaps Laura's relationship with Bessie led her to help organize a YWCA, which was dedicated to help girls and women find a different life from that on the streets.

The YWCA board went beyond women of prominence as members were sought, however. Because of the Y's affiliation as a Christian organization, the YWCA movement attracted women previously active in missions and religious education. Cora Abernathy, for example, religious and community activist and Sunday school teacher, was one of the first YWCA board members. Because of the organization's original Presbyterian connections, Presbyterians dominated the Danville YWCA board at first, but both the board and its corresponding religious-work committee also included Methodists, Baptists, and Episcopalians. In fact, the board established an informal quota system: two Presbyterians, two Methodists, and so on. Board member Jennie Straus was Jewish; the local community made an unofficial practice of having one Jewish representative on each social welfare and social club board, and as in many other communities, the Christian base for the YWCA was ecumenical in nature.[73]

The board's social base was broader than that of the Clover Club or Children's Home boards. While the YWCA board was and is dominated by "board lady" types, new board members did not have to be voted in, so there was a breadth and variety not found in other charity and social boards in Danville. Several women professionals, including piano teacher Bertie Braden; Helen Payton, clerk for a wealthy widow; and several young women students and office workers, served on the original board.[74] Still, the board members seemed to share an outlook that reflected the organization's origins in the social-purity movement, so their primary goal was to restore traditional morality by channeling the behavior of working girls toward genteel conduct.[75]

WOMEN WORKING FOR WOMEN

Undoubtedly the YWCA founders, as represented by its first board members, were successful in fund-raising and membership because prominent members

of the community saw the influx of young working women as creating problems, particularly at the height of the white-slave reform movement. After its founding in the 1870s, a recurrent theme of the YWCA was that young women and girls "need the protection and encouragement of Christian surroundings"; despite some concern with the women's "life of low wages, long hours, seasonal unemployment and loneliness," the overriding concern was sexual morality, at danger especially from "scheming men." A YWCA national speaker put the dangers in broad terms in 1883: "Everything that woman has been doing has moved out of the home; education first, then most of our religious institutions, and now all our little infant industries have gone out of the home and women have followed, and in a very profound sense of the word our women are 'away from home.' . . . First women have found that they are not safe out in a community. They find they have to become adjusted to a new order, their sense of values is distorted, there is danger of their losing their bearings."[76]

The YWCA, however, was structured to change as the circumstances of women did, and by the time Danville women founded their YWCA in 1910, the Y's theme was empowerment of working women as well as their protection. Change was built into the YWCA operations because its founders were among the first to proclaim their gender consciousness and to declare that "an independent organization of women working for women" should not be governed tightly from the top down but should govern by consensus. Therefore, there was little standardization of programs in the YWCA. Its national organization, at least, prided itself on crossing class lines and aimed "to bridge the gulf that divides the favored from the less fortunate."[77] Organizers of associations learned to follow the wishes of the young women they served, offering those programs that were most popular, including self-improvement classes, gym activities, lunches, and "other features which girls always know they want."[78]

Scores of Danville's working women responded to the YWCA's initial "Rest Club" outreach, and the Y thrived because it continued to meet workers' practical needs. Young women, as well as the whole community, needed affordable food and a safe place to eat lunch, and the Danville Y's most popular offering was a practical solution, a lunchtime cafeteria. The cafeteria, first located at the rear of one of the two rooms used by the YWCA on North and Walnut streets, was so popular in the city that its cooks served nineteen thousand meals during its first year. At a time when a working woman's lunch expense was estimated at ten or twelve cents, the cafeteria served tomato soup, salmon salad, mashed potatoes, and raspberry pie for five cents each and baked ham or scalloped oysters for eight cents. The Y's famous Sunday dinner could be obtained in 1914 for thirty-five cents. A longtime community

tradition developed in Danville of rushing from church to stand in line for dinner at the Y cafeteria, particularly after the YWCA opened its new building and cafeteria in 1923. The cafeteria's ads claimed "good food, good service, cheery quarters, absolute cleanliness," and community members obviously agreed.[79]

Young women coming into Danville were looking for work, and so the Y, under the leadership of Cora Abernathy, began an informal employment service. These women needed a place to stay, so the Y board first began a room-locating service for boarders and then, by 1915, a residence house for twelve women in the Gillette home on the southeast corner of Hazel and Harrison streets. Spiritual guidance was answered with Bible study and Sunday vesper services, held in the Woman's Club rooms instead of any particular church so as to be ecumenical. According to a newspaper account, the young women who attended gained "spiritual strength and fellowship" from these services.[80]

Most popular among young working women, next to the cafeteria, were the Y's program of social events and classes, "thrilling activity to young women in Danville who had few amusements."[81] By the time the Danville Y was founded, national organizers recognized that the women's need for fun and friends, excitement, and self-growth would lead them "astray" if respectable alternatives were not available, so the Danville YWCA began immediately to offer first aid, storytelling, stunt shows, sewing, and hat making. Best attended were the physical education classes held in the YWCA gymnasium, a small area in the back of the Woman's Club rooms. Reflecting the national enthusiasm for "physical culture," the Y teacher led members in the use of dumbbells, calisthenics, and gymnastics. Young working women quickly bonded at the gym, remembering later that "many nights there were slumber parties on the hard gym floor."[82] Their good times and sociability quickly led to a desire for more structure and bigger plans, this time shaped and spearheaded by the working women themselves.

THE Y OF THE WOODS

The early members of the YWCA counted as a great accomplishment their creation of a summer camp, the Y of the Woods. In November 1911, in the Y's second year, twenty of the Danville Y women formed a club: the Paladian (also spelled Palladin) Club, whose purposes were "to lend a helping hand, promote good fellowship, help in Association work" but also "to work toward a summer camp for the Association," as a way for women to get out of the oppressive heat of the summer when working hours were over.[83]

The Paladian women's plan was to impress the board by raising money on their own. In February 1912 the women sponsored a circus (a touring professional group) and netted $225. The board members then added $150 and

YWCA women at the Y of the Woods, c. 1918. Courtesy of Your Family Resource Connection, Danville, Illinois

gave their permission to establish a camp. After a discouraging search for a feasible campsite, James Woodbury agreed that the women could set up their camp on his farm, on a ridge of land above the Vermilion River, "one of the most picturesque views imaginable" and with the practical advantages of a fresh spring of water and location just at the end of the streetcar line (now at the end of Maywood Avenue). The women canvassed local lumber suppliers

for material to build a cook-shack and a dining room with a canvas top (given height by dry-goods boxes stacked by the women). They borrowed big battery tents from the National Guard, "one with floor for sleeping and one without floor for dressing." Charging 15¢ for supper, 10¢ for breakfast, and 10¢ for lodging, the women made enough to pay their expenses and gain a profit. The water company manager had a big flatboat built for the women, and another donation enabled them to clear and net a tennis court. They also had permission to use a privately owned swimming hole along the river.

Later YWCA Y of the Woods camps were, of course, better built and organized, but the women recalled the excitement and fun of those first years and how much it meant to working women to get away from the hot city streets. One remembered, "arriving in camp, civilized clothes would give place to middies and bloomers, and a row on the river would sweep away every trace of the hot tired day."[84]

The good times, pride, and accomplishment that the women felt after their summer camp success extended into other YWCA areas. Social occasions, such as the Halloween party, the New Year's reception, and the Valentine party given during the Y's first year, were initiated by the board but were well attended and successful; as a national Y leader admitted, "an entertainment is the snare we spread to catch the birds."[85] The young women who came to a party very often came again for clubs, classes, or gym. The YWCA parties offered not only fun but also a chance to socialize with the opposite sex in a protected environment. Social occasions enabled the women to entertain their young men in refined and decorous settings established by the genteel board ladies. Every Y had a "Beau Parlor," where young men could be "received"—but with the protection of the setting and the presence of a matron and, later, a buzzer system to "warn courting couples of elapsing time."[86] Even in social occasions, though, the exuberance of working-class culture made itself known in the YWCA, as in this 1916 appeal obviously written by the young working women: "All business girls of the city, who are live wires and full of fun are wanted to register at the Y. W. C. A. Rooms at once for this banquet. No quiet girls need register for this is to be one of the biggest and best affairs. . . . Good cheer and good fellowship will reign over the cafeteria that evening and the old walls will resound with yells led by the efficient cheer leader as never before in the history of the organization."[87]

The Girl Reserves, the high school branch of the Y, held an annual "Kid Party," where the girls dressed as children and played children's games, a curious activity that was beloved of adult women workers as well.[88] However, Y social events also reflected working women's aspirations for a genteel life. The organization's numerous clubs held teas and banquets, whose decorations and awards were faithfully reported for the newspapers. Both the

raucous activities and the interest in genteel practices were initiated by the first working women members, the stenographers and other office workers. They took many of the first leadership initiatives and in turn recruited the women who worked in the five-and-dimes and clerked in dress shops. Last to join were the factory women, who were sometimes allied with the business-women and other times were recruited as a group within a single industry (with the permission and encouragement of management). White domestic workers were also early Y joiners in Danville. Eager to reach the younger generation, the Y offered high school and grade school girls the opportunity to form clubs under Y supervision.

African American women did organize as part of the Danville YWCA, but in segregated clubs. On the national level, the YWCA had merged its white and black organizations in 1906 and took national stands against lynching and in favor of interracial harmony. On the local level, as a historian of the YWCA in the South observed, "on occasion the wall between the races was acknowledged and discussed in the Y even if it was never scaled."[89] In Danville, in most ways a segregated city, the YWCA recognized separate "colored" branches of its Girl Reserves in grade schools and high schools, incorporated a club of African American women workers into its structure, and became one of the first Danville organizations to include both black and white women in leadership training—though not without resistance from the board.

Practically the only groups not included among the YWCA's working women clients were the daughters of immigrant families who came into Vermilion County to work in the coal mines. Their names are not found in early Y chronicles. A brief effort was made to organize a branch of the Danville YWCA in Westville, but Belgian, French, Italian, Lithuanian, Polish, and other ethnic enclaves in south Danville and Vermilion County monitored their young women's activities themselves and centered them around family, work, and the Catholic Church.[90]

GLADYS WALKER VENTURES FORTH

Gladys Pugh Walker's years of YWCA leadership illustrate the opportunities available to an ambitious working girl who "ventured forth" (her term). "Glad," as she was also known, joined the Y as a student in high school, where the YWCA had helped organize the Girls' Student Club. She and her friends, who took the business curriculum in high school and already planned on careers as office workers after school, were attracted to the Y by the opportunity to join a hat-making class and to make their own Easter bonnets.[91] As a high school senior, Glad served as treasurer for the Girls' Student Club and helped run its "Kid Party," where the high school girls could "return to

childhood, with its jumping ropes and stick candy"; a Christmas party for a hundred needy boys and girls; and a spring minstrel show.[92] After graduation, and with her first job, Gladys embraced the Y of the Woods, enjoying escape from the hot summer after the workday and the delights of intense fellowship with other young women. She recalled that at camp "we were just having our first jobs then, all of us, and we would come out there and stay all night and on weekends—our families just about disowned us."[93]

Having learned the joys of sisterhood at camp, Gladys joined with other young stenographers and office workers to form the Do Shi Kai club for businesswomen in 1917. Elizabeth Wilson, the YWCA's first historian, observes that "the democracy" in which women planned their own good times in connection with classes "led on to the club, where working together made a short cut to a new life."[94] Leadership was built into the Y program. Conventions expanded the worlds of the young women at a time when few working women had had an opportunity to travel; they were held in the summer, usually at wooded lake resorts, to combine fun, fellowship, and leadership training. The first Danville women who attended one of these, at Lake Geneva, Wisconsin, in 1912, returned to found the Geneva Club. By 1913 members of that club had published their first newspaper giving working women a voice, the *Association Lever*.[95]

Because they were initiated and governed by the young women themselves, clubs in the Danville YWCA opened, split, merged, or declined, depending on the desires and circumstances of their members. In the early years board women began clubs to encourage the newest members, including the Rain or Shine Girls, begun in 1913 with Nellie Shedd as adviser. Specific interests were facilitated by the Choral and Glee Club and the Storytellers League, organized in 1914. For a while an effort was made to organize girls by their work, such as the LUBA (Let Us Be Happy) club in 1915. Initially known as the "maid's club," designed for domestic workers, the LUBA club declined in the 1920s as more women left domestic service. Several clubs were organized within companies—for example, the Chuckles Candy Club.[96]

Patricia Murolo, who has studied working women's clubs extensively, concludes that working women "clearly cared a great deal about the social issues" that they were encouraged to embrace, "and they were by no means simply an amen chorus for sponsors."[97] Her conclusion is supported by the many activities in which Danville YWCA clubs engaged as their members did good works, educated themselves, and celebrated their sisterhood. The high school Girl Reserves "sewed for the County Dispensary," sent "Good-Will Bags to Mexico," collected toys for "one hundred poor kiddies of the city," and held mother-daughter teas and banquets.[98] The Do Shi Kai club sewed for Lakeview Hospital and the women at the Vermilion County Poor Farm,

made comforters for needy families, and raised money for summer conferences. For self-development, the Do Shi Kai women invited members to come "right after work every Thursday evening"; put on their "bloomers, middy and tennis shoes"; and engage in "Sociability, Supper, Songs, Stunts" and then "Charm Talks" on dress, health, hair, personality, dancing, entertaining, and spirituality. Additional classes were held on parliamentary law, salesmanship, and dramatics.[99]

WORKING WOMEN VS. THE BOARD

The clubs within the YWCA were something on which women from all ranks of life could agree, but their autonomy also exposed tensions between the goals of the working women members and those of the women of the YWCA board. The board women had benefited from their own experiences with club life, which had brought them into the public world through their own personal friendships and civic goals. The working women who joined the YWCA were ambitious to advance in their work and also in social graces; they took classes in manners, style, and deportment, and in their club work they duplicated the teas, music, literary presentations, and social service projects conducted by the more exclusive Danville Woman's Club. The problem was that the working women took advantage of the opportunities to choose and plan projects and parties themselves, as when they invited all business girls who were "live wires and full of fun" to their gatherings, and this opportunity unleashed energy and vision not expected by the Y board women. For example, the Do Shi Kai club, organized by a handful of Y businesswomen, including Gladys Walker, endured as an active and long-lasting club that reached out to others: after a few years members encouraged younger workers by mentoring a club for them, the Ek-O-Lee-Lahs, and later mentored the Entre Nous Club and then the Femmes Charmants, clubs for African American office workers. Recalling her Y activities years later, Gladys Walker remembered fighting against some board resistance to the project with the Femmes Charmants, a resistance that enraged her and encouraged her to work more forcefully toward integrating black women into the local YWCA.[100] Integration was strongly encouraged by the national YWCA by that time, but not by the local Y board women.

As a leader and organizer, Gladys felt proud of any accomplishment "her girls" would make to show their abilities; her pride showed in efforts to narrow the gap between women across class lines in the YWCA. She fondly recalled that in the early Y years "her girls" decided to hold a public Easter breakfast, complete with program: "Our girls were the speakers; some had never done this before in their lives . . . some of them wore corsages, their husbands were dressed up, and they felt like they were somebody." The board

and staff came, to the gratification of Gladys and the women, "and realized the girls gave the whole program—took charge of the whole thing." Gladys concluded, "Oh, I was so proud of them."[101] As Gladys implied in her recollections, the Y board women were a group apart, surprised to see initiative and talent in working women but able to give them credit when appropriate. However, though working women often welcomed the guidance of middle-class ladies "who offered to instruct them in the ways of 'true womanhood,'" they also retained what one called an "I'm as good as you are" feeling. The working women were just as interested in gaining and maintaining some authority over their Y activities as they were in meeting "genteel standards of femininity."[102]

The elite women who set the tone for the YWCA board represented different economic goals from those of the working women Y members, of course. The board women and their husbands were the employers. They wanted prompt, well-trained, reliable workers and expected the YWCA to do its part to produce them. The working women wanted job opportunities, steady employment, decent salaries, and chances to better themselves. The YWCA, nationally and locally, tried to satisfy both groups, emphasizing protection, supervision, moral education, and proper behavior in order to reassure the board women but also encouraging self-growth, self-confidence, and leadership among the working women. To highlight the latter, for example, Danville's YWCA education department aimed "to meet the needs . . . for a better equipment for economic independence."[103]

The YWCA board women, who represented the managerial class in Danville, could hardly have been pleased with another of Gladys Walker's projects. As one of the relatively fortunate women who had a job in business, and convinced of the benefits of the Y, she determined to "venture forth" to recruit more Y members among saleswomen. As she recalled, "my group got out and hit around the bushes, [recruiting] poor working girls like those from the ten cent store who had never been to a business meeting." Gladys carefully scheduled club meetings to coincide with the streetcar schedules so that women would not miss their rides home. She even reported one of the downtown stores to the health department because the manager forced its women employees to use a single room both for a toilet and for a lunchroom. The store manager was unhappy about this, but Gladys became popular with the women who worked there and gained some Y members from the incident.[104]

Working women's YWCA clubs did not study union organization or how to file grievances against their employers—the Y had a tacit agreement with businesses on that—but they did strengthen and advance their careers and their personal lives. The business and industrial club women toured mines and studied citizenship as well as hair styles, appropriate business wear, and

public speaking. Gladys Walker initiated classes on personal law, estate planning, and taxes. She got no encouragement from the Y board; the opportunities for working women to learn may have gone too far, in board members' perspective, when women sought to know more about the law. Still, Gladys persisted; she contacted a lawyer she knew and quietly arranged for him to give classes in law to the women in her clubs.[105]

BRIDGING THE GAP

A "third tier" of women involved in the YWCA helped bridge the gap between the working women and the Y board ladies. Working women professionals, including teachers and librarians, volunteered as instructors at the YWCA. They worked alongside the women members, and as volunteers, they had no decision-making authority, only encouragement. They were non-threatening models for middle-class behavior and values. Katherine Stapp, Vera Diffenderfer, Irma O'Connell Giese, Dorothy Livesay Sturm Duensing, and Mildred Glindemeier were among these women. Stapp was an award-winning English teacher and a local historian; Diffenderfer also taught in the public schools and later at Danville Junior College. Giese, a "marvelous athlete," had grown up in an Irish Catholic family in Grape Creek. As a girl she had participated in Y activities, especially swimming and basketball, and she continued her passion for health education as an adult, "always willing to lend a hand to working women," especially for athletics and camping.[106] As a newcomer to Danville, Dorothy Sturm "joined the Y at once" to get acquainted and, with her new teaching degree, was immediately welcomed. The Y also helped Sturm overcome the class barriers she sensed in Danville's society. She taught night classes in Spanish, French, and bridge to working women, YWCA dorm residents, and a few teachers.[107] Mildred Glindemeier was one of the best loved and best remembered of the professional women volunteers. A career home economics teacher at Danville High School (DHS) and an "Outstanding Teacher" designate, Glindemeier was well known for her smile and cheerfulness and her ability to relate to and inspire her young women students and her YWCA protégées. One Y administrator recalled that "the women just loved her."[108] Glindemeier, as a nutritionist, was concerned about general ill health in the Danville community because of poor eating habits, and she was responsible for bringing knowledge about nutrition and food preparation into the public schools. In addition, she worked across racial lines; she was the sponsor for the Phillis Wheatley Club at DHS, a YWCA Girl Reserves unit for African American girls.[109]

While helping and guiding working girls was its primary goal in its early decades, the YWCA also provided Danville with a central focus for its many community social projects, from those administered by numerous men's

service clubs to the single-purposed Children's Home board. The Y was well equipped to do this with a board composed of community leaders and a professional staff, which gave the Danville community the benefits of its organizing and proselytizing experience. The staff members were headed by a general secretary who acted as hostess, organizer, and evangelist. The YWCA, proud of its gendered independence, was among the first women's associations to establish training schools for its workers. The national organization sent out staff members with rigorous education and a broad vision that came from association with women with a national and international perspective.[110]

Mary Hayes Watson of Bloomington, the first general secretary of the Danville YWCA, did not stay long, but during her few months' tenure she positioned the YWCA as a facilitator of community social welfare groups. In 1911 Watson, working with the Woman's Club, was instrumental in calling together representatives of Danville's major clubs and charity boards to form the Associated Charities. The Associated Charities, which met at first in the YWCA rooms, acquired its own office and executive director, who coordinated charity efforts and responded to emergency needs.[111]

Harriet Tenney served as the Danville YWCA's general secretary for a much longer period, from 1915 to 1924, and helped shape the Y's years of challenge and growth with her considerable promotional powers and strength of purpose. Tenney had attended the national Y training school, conducted in an elegant New York City residence, before her call to become Danville's chief staff person. She was an effective spokesperson for the YWCA's social gospel message, which reassured its Christian base but sought to give it the breadth that the social gospel movement and its successor, the "abundant life" movement, promoted. YWCA women later recalled Tenney's life as a message: "she scattered goodness—and kindness—and Christianity wherever she went."[112]

During Tenney's tenure, the Danville YWCA expanded its professional staff; in 1916 the board added a secretary for the Girl Reserves and for the health program, and later an industrial program secretary was added. The health program was a key facet of the Y, considered integral to expanding women's horizons and building their confidence. The board hired women with quality training, indicating the popularity of physical education at that time. Lenora B. Davidson, camp director for the Y of the Woods in 1915, for example, was a graduate of the Sargent school of gymnastics in Cambridge, Massachusetts, and had taught physical education at Oberlin College. She was known as a leader in all outdoor sports and an excellent swimmer. In 1916 Ruth Melin became the new physical education director. She was a graduate of the Chicago Normal School of Physical Education and had

directed programs at Ft. Wayne, Indiana, and Everett, Washington, before coming to Danville. Her initial public demonstration included dumbbells, tumbling, dance, folk dancing, and basketball. Basketball quickly gained popularity, and the Danville women's team played a regular schedule through the 1920s, to popular acclaim.[113]

Physical activities appealed to a public audience, and so did entertainment. The YWCA organized community shows planned and directed by professionals but using local talent from all sections of the community. The "Wishing Ring," for example, in December 1915 called on over two hundred Danville citizens of all ages, including prominent women such as Nellie Coolley, Rebecca Levin, and Mary Reed Cannon, and working women, including Gladys Pugh (Walker). A stunt show in 1916 that incorporated 475 Y members and friends included masques and burlesques; in one the working-girl Y members burlesqued a YWCA board meeting and the board members burlesqued a gym class. The 1917 talent show, best attended of all, included a famous "plantation jig" performed by Flo Woodbury, which was a big hit to the racially insensitive white audience of the time.[114]

COMMUNITY LEADERSHIP

The YWCA reached an early pinnacle in community leadership in 1916. Using the vehicle of the national jubilee celebrating the YWCA's fifty years, Nellie Coolley and Harriet Tenney promoted the Danville YWCA as a leading community group and also initiated its ambitious building project. Nellie and Harriet led the Y's month-long jubilee, which included a kickoff party for Y members, vesper services, four informal "at homes" for churchgoers from various denominations (including mainstream Protestants but also Catholics and Christian Scientists), public physical education demonstrations and basketball games, Campfire Girls' demonstrations, special offerings from the Storytellers League, and a Japanese tea for high school girls. The Y held a series of banquets, chaired by Nellie: one for all Danville District 118 teachers and principals; one for business girls; and one for the Danville Musical Cycle, with piano teacher and Y activist Bertie Braden as toastmistress and one of the performers. An elegant banquet, chaired by William R. Jewell, honored one hundred welfare workers in Danville and featured talks on the Y's special mission to businesswomen and factory workers by Nellie Coolley, Harriet Tenney, and the Y's new industrial secretary. Speakers represented other Danville benevolent organizations: Florence Dillon for the Woman's Club, Alice Shedd for the Children's Home, Dr. J. D. Wilson for the Sunday school council, Mary Payne for temperance, and others. The most popular speaker, according to the event's reporter, represented Travelers Aid, an urgent issue in the community with an obvious link with the YWCA.[115]

The YWCA's jubilee year climaxed with a Danville banquet for the men who led the community: members of the chamber of commerce, the rotary, the city council, and the Young Men's Christian Association. Nellie Coolley was the toastmistress, a task she performed expertly, according to a *Commercial-News* reporter, who described her as "charming [and] unassuming." The reporter added that "her commingling of the lighter vein with the more serious side of the business was all that might have been expected of a veteran after-dinner speaker."[116] Nellie pulled out all the stops: she saw to it that a charming girl, "little Miss Louise Chapman," was on the program to present an "intelligent, detailed account of the meaning and work of the Campfire girls." Harriet Tenney spoke with "clever witticisms" and serious instruction about the need for more space for the Y's 899 members. Finally, Nellie revealed the reason, in addition to the jubilee celebration, for all the festivities. Having demonstrated the importance of the YWCA to the community, she unfolded a scroll "fifty feet long and bearing the signatures of nearly three thousand women and girls of Danville" asking the community for a new building. The men of the city council, Rotary, YMCA, and chamber of commerce all responded (by design, of course) with promises of support and acknowledgments of the value of the YWCA to the community.[117]

Danville's involvement in World War I eclipsed the YWCA's building plans for a time, but after the war Nellie Coolley revived the building project. She recruited Frank Wolford to lead a money-raising and building campaign in 1920. Businessmen donated $100,000 to kick off the campaign. While the working girls and middle-class men and women were involved, the board ladies used their connections most effectively in planning and fundraising. By 1923 they had raised $307,000 and were able to celebrate the erection of their new three-story building. It was handsome and easily accessible to the community in a choice location across from the Wolford Hotel, complete with rooms for forty-five boarders plus short-term shelter for transients, a parlor where the women could entertain gentlemen friends, a gymnasium and a large swimming pool, meeting rooms that could be open to public use, and a cafeteria that served three meals a day and Sunday dinner for the community. At its opening, Nellie proclaimed, "we have here a building that seems to us now almost ideal" and predicted that it would serve as a model for other communities. A telling comment was made almost in amazement; as community leaders gazed up at the massive building at its opening, the male chamber of commerce representative admitted that "people sometimes think that I am stretching the truth when I tell them we have such a building for *young women*" (emphasis added).[118]

The new YWCA building marked the pinnacle of community concern for Danville's working women. Danville soon forgot that the YWCA was

originally founded to provide protection, shelter, and social and professional growth for young working women who might otherwise "drift" into vice. World War I, with its upheavals and deprivations, fostered a new wave of forced prostitution in Europe and a new focus on white slavery, but the United States did not share this concern in the 1920s. After a brief spurt of reform activity in 1918, Danville seemed to tolerate rather than fight the prostitution and illegal alcohol that persisted in its vice district. Danville's Travelers Aid Society continued its work, but with less focus on "women adrift" and more on all strangers in need.

The status of working women as a separate class began to blur as the daughters of middle-class families joined the workforce. The YWCA became more of a community facility than one focused on opportunity and protection for young working women, though its dormitory remained a welcome, inexpensive shelter for those women who could tolerate its matron's strict supervision.[119] The new pool served as an initiation to the Y for all ages and social classes, though the Y stalwarts, including Gladys Walker, got to initiate the pool first.[120]

The boisterous "work culture" of the early YWCA women, with their "Kid Parties," their Y of the Woods initiative, and their self-improvement classes, was forgotten. Do Shi Kai and other YWCA business and industrial clubs more and more resembled the social and professional clubs of upper- and middle-class women. The crossing of social class lines was symbolized when Gladys Walker became a member of the YWCA board in 1929.

In the 1930s and 1940s Gladys continued her work with her YWCA clubs and her volunteer work with Y activities. She recalled that her husband obligingly left the house when her "women only" Entre Nous Club met there.[121] She entered her son, Wesley, in Y programs when he was seven; since he was an only child, he found the Y to be a gigantic support group for kids, and he became a career executive with the YMCA as an adult. Gladys was an efficient, loving mother, who made sure to have a hot meal on the table every night, but Wesley remembered being cared for by his father, Loran, many evenings. His father's daily diary of events (for years 1950, 1953, and 1954) includes a frequent phrase, "Glad out," usually for a YWCA activity.[122] Gladys's husband, a quiet accountant, gave her the support she needed as she maintained her office work and what was also important to her, her work as a volunteer and clubwoman. In recognition, Gladys Walker was designated "Danville Woman of the Year" by the *Commercial-News* in 1968.

Despite the changes in the YWCA and women's roles through the decades, the tensions between Y members and the board and staff did not disappear; Gladys remembered, for example, her work in the 1930s to integrate Y clubs and her efforts to integrate the swimming pool against the reluctance of the

general secretary and the board. (The pool was quietly integrated in 1945.)[123] When she was interviewed at the age of 101, Gladys still felt that the YWCA had been vital to the development of the Danville community. She remained extremely proud that, as a result of Y opportunities, "we've had a lot of growth among girls who never would have dared by themselves."[124]

"Forces to Be Reckoned With"

In their corsets, shawls and "fussy dresses with illogical and irrelevant ruffles, tucks, pleats, and panels," they gave the impression of being old-fashioned, meek and passive. But their sharp minds, keen wits, and wide-ranging skills made them forces to be reckoned with. Their small groups quickly became organizers for change.

May Estelle Cook, quoted in Poplett,
The Woman Who Never Fails

THIS DESCRIPTION OF EARLY SUFFRAGISTS in Oak Park, Illinois, applies just as well to Danville's temperance and suffrage activists. As they did for other community problems, Danville women joined the temperance and suffrage movements to bring about needed social and political changes. Alcohol abuse was a serious social problem and was quite visible in Danville and Vermilion County. Danville women and men worked together to fight the liquor interests and the political corruption they fostered, and these people found that their goals could not be accomplished without women's votes.

The national temperance and suffrage movements began separately but by the 1890s became entwined in a symbiotic relationship. This was seen on the local level, as Danville branches of the Woman's Christian Temperance Union (WCTU) and the Illinois Equal Suffrage Association (IESA) claimed many of the same members and goals in that decade. By then most women who may have been attracted to temperance for conservative or religious reasons came to realize that liquor would not be banned solely by attempts to change traditional male behavior, whether in the tavern or in the voting booth.

Historians of suffrage commonly see a decline in the impact of temperance on the woman suffrage movement in the early twentieth century, as progressive reformers and woman's club elites took the limelight and organized

the campaign for women's voting rights. Danville's example, though, illustrates the persistence of temperance as a motivation for the great mass of female and male supporters of woman suffrage. In their first opportunities to vote, after Illinois women had gained partial suffrage in 1913, Danville women made alcohol sales illegal in the city and supported reformers in their fight against city corruption financed by liquor interests. Throughout the battle for change, both temperance and suffrage supporters were challenged by a common enemy, the alcohol industry, which came to recognize the power of women not only to close a saloon but also, with their votes, to close all saloons across the nation.

DANVILLE'S CARRY NATION

Carry Nation was the most notorious of the antisaloon activists at the turn of the century, but the Danville area had its own woman saloon-buster, as described by the *Danville Press-Democrat* ("She Emulated Carrie [*sic*] Nation") on April 8, 1909, on page 3:

> There was something doing a few days ago in one of the saloons up in the Cherokee Strip when Mrs. Lon Sloan, wife of one of the barbers in this city, entered the place in real Carrie [sic] Nation fashion and picking up a pint pop bottle hurled it with terrific force against the big mirror that faces the long bar.
>
> Although the crashing noise was heard all over the room, strange to say the mirror was not broken, and neither was the woman roughly handled. Her recreant husband, however, was hustled out of the place double quick and his wife went with him.
>
> It seems that Sloan was seated in the saloon deeply interested in a game of checkers when his wife entered with their small babe in her arms. She spoke to her husband and urged him to come and go home with her, but he was too much absorbed to pay any attention to her request. She again asked him to go, but he still made no effort to move except to shuffle a checker off to the king row. This angered the woman and stepping over the bar she picked up an empty bottle and "bing" it went against the mirror. That proceeding was sufficient and the game of checkers was unceremoniously broken up.

So an angry wife and mother created her own spectacle in a small community just south of Danville, a mining village known for its Catholics and its saloons. Mrs. Sloan may have been inspired by the real Carry Nation, who was reported to have visited Danville. According to Guy McIlwaine Smith in *The History and Romance of Danville Junction,* "Nation and her hatchet alighted from a C. & E. I. train one sizzling hot noon in 1904 at the

Junction." As a highlight attraction of an Elks street carnival, Carry smashed a brewery exhibit.[1]

The fate of Mrs. Sloan and her family is unknown. However, the national problems of alcohol and women's determination to solve those problems were well reflected in Danville's active "dry" movement, including the Woman's Christian Temperance Union. Women across the nation as well as in Danville were the leaders of the movement to prohibit the sale and use of alcohol, and their commitment and success in this arena radically enlarged the sphere of women's influence.

THE NATION'S SALOONS

In colonial America the use of alcohol was widely accepted, and the tavern was often an important social center for respectable men of the community. As the nation developed and alcohol became widely available because the ingredients were abundant and it was easy to manufacture and transport, concerns about the abuse of alcohol began to surface. Women were always among those who saw the dangers, especially as those dangers affected their homes and their children. In the late eighteenth century the Methodist Church was the first to warn officially of the dangers of distilled liquor. During the early nineteenth century other male-dominated organizations began to target the dangers of excessive drinking. Women were welcome to join in the cause and "were expected to work but not to have opinions," so women separated from the male group called Washingtonians and formed Martha Washington Societies in the 1840s. Susan B. Anthony, in fact, first entered public life as a Daughter of Temperance after learning that she would not be allowed to speak at a Sons of Temperance meeting.[2]

Pre–Civil War temperance agitation resulted in some legal coercion against the use of alcohol: the state of Maine was the first to enact statewide prohibition of the sale of liquor in 1851, and thirteen states and territories had prohibition laws by 1860. During this time a few women suddenly began to use civil disobedience to publicize their antisaloon sentiments. Women activists were considered quite respectable and even had male support. Lawyer Abraham Lincoln defended nine temperance women for disturbing the peace in a Marion, Illinois, trial by making analogies to the Boston Tea Party.[3]

Early Illinois law required licensing of saloons, and the revenue gained became a growing interest of county and city government bodies. The earliest form of local option, that is, granting the right of cities and counties to determine for themselves the legality of sales of alcohol, went into effect in Illinois in 1839 but was repealed two years later. Illinois tried to follow Maine with a statewide prohibition in 1851, but that act was rejected by the courts. Another attempt followed in 1855, supported by Abraham Lincoln,

but this time the voters, all males, rejected statewide prohibition. Despite the setbacks, several organizations sprang up to keep the temperance movement alive: the Maine Law Alliance, the Good Templars, the Sons of Temperance, and the Templars of Honor—some secret and all under the leadership of men.

After the Civil War, when alcohol consumption was on the rise, temperance activities in Illinois increased, and a Prohibition Party was established in 1868. However, because of the experience and confidence they had gained in their war-time efforts, women began to take charge of their own causes. Both women and men desired to restore order to the nation after the upheavals of wartime. Joseph Gusfield and some other sociologists place the temperance movement in the context of a rapidly changing society where urbanization, industrialization, and immigration were presenting frightening challenges to middle-class Protestants and their focus on self-control, industriousness, and sobriety.[4] While this may have given background motivation for the temperance movement, historians such as Ruth Bordin argue that alcohol was indeed a national problem: "Americans were heavy users of strong drink. . . . Drunkenness was widespread in the United States in the nineteenth century."[5] Catherine Gilbert Murdock agrees that "public drunkards were a pathetic, everyday spectacle in villages and cities throughout America. Drink really did kill men and ruin families."[6] The women committed to temperance began to work separately from men, and their activities accelerated during an Ohio crusade against liquor in 1873–74.

"DO EVERYTHING"

The term "temperance" sounds deceptively mild and moderate, but to the women of the Woman's Christian Temperance Union, it translated more severely: "total abstinence from all things harmful."[7] Their crusade against drunkards, saloons, and retail liquor suppliers began almost spontaneously in Ohio in 1873–74 and swept the Midwest "like a prairie fire."[8] Crusades across Illinois, Ohio, Michigan, and New York quickly followed. The image of self-directed matrons singing and praying on their knees in front of saloons was accurate in the beginning, but the WCTU got organized at the Methodist-sponsored Sunday school convention in Chautauqua, New York, during the summer of 1874.[9] The women of the WCTU were already networked in their Protestant churches, especially those evangelical denominations that had grown so successfully on the frontier: Presbyterian, Methodist, and Baptist. The organizational skills of the ladies' aid societies and missionary societies were quickly put to use. Specialized departments of work cut across state boundaries and reflected the WCTU's broad agenda for social reform.

Frances E. Willard, the WCTU's second president, shaped this broad agenda in her long and influential career. In her introduction to *Woman and Temperance,* Ruth Bordin explains Willard's success with the following descriptive terms: "charismatic . . . messianic . . . mobilizer of American womanhood . . . superb organizing skills . . . manipulation of public opinion . . . ability to inspire devotion."[10] Willard's family home in Evanston, Illinois, is now a memorial maintained by the WCTU and is open to the public on a limited basis. The two-story frame house with high-ceilinged, dark rooms has walls filled with books and pictures of family members and awards. A walk-through suggests additional descriptive terms for the woman who lived there with her parents and siblings. She was comfortably middle class, devoutly Christian, well read, and acquainted with powerful men such as Teddy Roosevelt, whose hunting-trophy gift adorns a wall. Today Willard's upstairs office looks as well organized as was her union, but a photograph reveals that when she worked there, her office was cluttered. WCTU librarian/archivist Virginia Beatty said that Willard was a "piler, not a filer." On her desk is a picture of a powerful woman who was a lifelong friend, Susan B. Anthony.[11]

Willard's broad vision guided the WCTU into a philosophy she termed "Do Everything," as described by historian Janet Zollinger Giele:

> Organizing fell to such departments as juvenile work, the young woman's branch, and the support of lecturers and organizers. Outreach was the purpose of work among colored people, foreigners, Indians, lumbermen, miners, railroad employees, and soldiers and sailors. Publicity and education were advanced through scientific instruction, state and county fairs, temperance literature, and the Woman's Temperance Publishing Association. Departments for alcohol substitution changed their names over the years, but at one time or another included friendly inns and reading rooms, unfermented wine, and anti-narcotics. Finally a number of departments were dedicated to personal and social reform: prison and jail work, evangelistic work, social purity, temperance legislation, franchise, and relation of temperance to labor and capital.[12]

Willard inspired not only respect from powerful leaders but also devotion from women of many backgrounds. The Woman's Christian Temperance Union became a powerful instrument of women's consciousness-raising and political awareness. The wives and mothers who had once been confined to home and church gained confidence in the public sphere, and as a result, the WCTU got things done. This sisterhood that wore white ribbons believed as did their leader that all their reforms were bringing the nation to Christianity. They closed saloons, influenced local option elections and other legislation, changed school curricula, changed the perception that alcohol was

medicinally necessary, and encouraged countless thousands to sign their pledge: "I hereby solemnly promise, God helping me, to abstain from all distilled, fermented and malt liquors, including wine and cider, and to employ all proper means to discourage use and traffic in the same." By 1892, after a rapid rise in membership, the WCTU had over two hundred thousand members, making it the first mass movement of American women.[13]

DANVILLE'S CRUSADERS

Danville's branch of the WCTU evolved from growing temperance sentiment in the city in the 1870s, influenced by the midwestern crusades. On March 12, 1874, when the Ohio crusade was under way, the *Danville Commercial* headlined "The Coming Crusade," and the story claimed that 70 had gathered in Lincoln Hall, "the majority of whom were ladies." Newspaper publisher William R. Jewell was among the speakers. He said that America was ready for this crusade now that slavery was abolished. (Many advocates of temperance and suffrage began their public lives as abolitionists.) A reported 397 people signed the pledge that day. Two weeks later, March 26, the *Commercial* reported that church services were cancelled in order that congregations could attend a "Grand Temperance Mass Meeting" in the Danville Opera House. Elder Phillips of the Methodist Episcopal church declared: "The whole portion of mankind has utterly failed to accomplish anything permanent in the cause of temperance and now it only remains for the women, leaning on the arm of God, to see what they can do."

Anti-alcohol meetings continued in 1874 and 1875, bolstered by newspaper accounts of the evils of alcohol: whiskey blamed for a robbery, for a woman who fell from the upper window of her house, and so on. On June 7, 1877, the *Danville Commercial,* noting the growing temperance movement in Ohio, Michigan, and Indiana, concluded: "Danville is ripe for the organization of the red ribbon movement. Who will take the matter in hand and prepare the way?" The answer, headlined in the *Commercial* on June 28, was an organization that called itself "Dare to Do Right." Members were to sign the pledge and wear ribbons, red for men and white for women. They promised nonviolence and the use of moral persuasion. All the leaders were men. Later in the year a temperance convention was held in the Opera House with representatives from Danville, Rossville, Alvin, Maryville, Indianola, and Georgetown.

One year later, on June 13, 1878, the *Danville Commercial* reported that the Danville Temperance Union, meeting at Temperance Hall to discuss their growing financial difficulties, put forth a proposal and welcomed the assistance of the Woman's Christian Temperance Union, the first acknowledgment of the separate women's group.[14] By 1878 in Danville temperance advocates

were wearing ribbons of many colors to announce that they had signed the pledge, men's groups were forming and floundering, and the WCTU was gaining its foothold.

Nothing speaks more directly to the early success of the Danville WCTU than that they hosted the state convention in 1892. The *Union Signal* summarized the Illinois convention for its national WCTU readers, beginning with "Never before did the white-ribbon army of Illinois march up to their annual Harvest Home with heavier burdens or with stronger faith than they did on the third day of October, when they set their faces toward Danville, the seat of the state convention."[15] Nearly four hundred delegates gathered to renew their unity and pledge action. The *Danville Evening Commercial*, October 4–7, observed that "many of the most notable women of the state [are gathered] . . . the hospitality of the citizens is being extended with that free generosity that has given our little city an enviable name all over the state." The meeting was held in the First Methodist Episcopal Church, not surprisingly since Methodists were leading temperance advocates.

Danville's WCTU women in 1892 were notable public persons. Profiles reveal them as less traditional than might have been expected given today's conservative image of the WCTU. Local WCTU president Mary Woods, a sharp and forceful orator, titled herself "Mrs. M. V. S. Woods," not "Mrs. Hiram Woods," which was the traditional title of that time. She may have taken her first name for title instead of her husband's because she ran her own millinery shop for more than ten years, in a business separate from her residence. Hiram, a preacher, may have been in ill health; Mary was widowed by 1901. Mary Woods was later active in the Danville Woman's Club and advocated suffrage as well as temperance, as did many of her fellow WCTU leaders.[16]

Frances Pearson represented the Ladies' Temperance League, an organization for young women, at the WCTU convention. Pearson was a twenty-two-year-old high school teacher in 1892 when she welcomed the WCTU delegates to Danville. She was soon to help found the Danville Woman's Club and, as Frances Pearson Meeks, would become one of the foremost community leaders in Danville's history. Lizzie Kyger was a paid employee of the WCTU. She directed its industrial school as a mission for homeless girls in Danville. Kyger was a widow with experience in the hotel business; her family also operated the Kyger House, a well-known Danville Junction institution. As a convention delegate and also district treasurer of the WCTU in 1892, Kyger reported the Danville WCTU membership at fifty-five and the Ladies' Temperance League membership at twenty-two.[17]

Two other prominent Danville women focused their considerable energies on the WCTU and took part in the 1892 state convention. Emma Lytle,

whose husband was a corporation officer for the Oriental Flour Company, was district financial secretary in 1892 and later served as Danville WCTU president. She was also a founding member of the Danville Woman's Club, where she successfully promoted WCTU policies for the club's first few years. Lusanna Shea was a newcomer to Danville in 1892 but a longtime WCTU promoter and "one of the hardest workers in the cause."[18] Her husband, a native of Ireland, became president of Danville Brick and Tile Co. in 1892. Lusanna was a Clark from West Virginia, with family connections to Massachusetts and the Mayflower. The Sheas had lived in Decatur before coming to Danville, and Lusanna had been WCTU president there. She quickly became a leader in Danville's WCTU and became its president in 1894. Among her other activities, she helped encouraged a white-ribbon group for the young temperance children.[19]

The agenda of the state WCTU meeting in Danville in 1892 included prayer, devotions, hymnal music, memorials to departed sisters, an address by the state president, an evening public-speaking contest, and every day, reports and more reports by the many superintendents of the union's departments. The state minutes clearly support the fact that the "Do Everything" philosophy of national president Frances Willard was endorsed by the state of Illinois and District 15, of which Danville was a member. The following is excerpted from the District 115 report by President Kate Goldman of Hoopeston:

> House-to-house visitation . . . Evangelistic work . . . More gospel meetings than any previous year . . . Superintendent of Sabbath Observance reports many sermons preached upon the subject [of temperance] . . . Sunday-school Work, . . . three hundred pages of literature, wall-packets and reading rooms . . . interest in the department of Hygiene and Heredity has been awakened. . . . In the Legislative Department considerable petitioning has been done. Under the head of Fair work, through the watchfulness of our efficient Superintendent, Mrs. Lizzie Kyger, the law relative to gambling has been enforced, in some instances . . . much good has been accomplished in our department of Railroad work. . . . We now have thirty L.T.L.'s [Ladies Temperance Leagues]. Superintendent of Social Purity has been zealous. . . . Much has been done in the Department of Flower Mission. Over 400 visits to the sick. . . . 1,000 bouquets were distributed funeral pieces, scripture cards, literature and flowers have been sent to the poorhouses, hospitals and jails. . . . Y.W.C.T.U. report 320 meetings. . . . Over 1,600 dollars have been raised in the Y Unions. . . . We have recently adopted the Department of Systematic Giving. [20]

The district report does not usually specify which of these diverse activities were carried out in Danville, but other activities were specifically credited

to Danville in the state minutes and the *Union Signal*. Danville WCTU members demanded a matron for women prisoners, worked continuously with railroad men, maintained three reading rooms (with the YMCA), organized a Christian Temperance Union at the Old Soldiers Home, ran a mission/industrial school, organized many Ladies' Temperance Leagues, held parlor meetings and receptions, published a county directory, held speaking contests, and raised money to help build the temple in Chicago.[21] Even if the Danville union did not "Do Everything," members' activities were broad and tailored to the needs of their community.

TEMPERANCE AND VOTES FOR WOMEN

Another Danville report at the 1892 WCTU state convention provides the first evidence in the city of the relationship between the WCTU and the movement for woman suffrage. Danville WCTU members reported that eighteen hundred Danville women took advantage of their recently acquired right to vote in school elections: "The contest was an exciting one as the women had determined to remove a saloon-keeper from the school board and put on a Prohibitionist. They carried the day by a majority more than twice as large as the whole vote had ever been before, and now for the first time in a number of years the school board is without a saloon keeper upon it."[22]

Gaining woman's rights to vote in school board elections in Illinois, including Danville, had been a triumph for Frances Willard and the WCTU and a gratifying development for the group long focused on women's political rights, the Illinois Equal Suffrage Association. Willard's forays into politics when she first became WCTU president had failed. She was able to gather 180,000 signatures in 1879 to petition the Illinois legislature for women's participation in temperance votes, but the petition went nowhere. She began to perceive that until women voted, they would have no leverage with the legislators, a realization confirmed when another petition with 30,000 signatures, this time asking that the state constitution be reworded so that women could vote, was also ignored. However, both of these efforts helped move Willard's frustrated petitioners from their previous conservative moral persuasion "into a more overtly political stance, and one that would eventually include advocating woman suffrage."[23]

Until Willard changed their minds, the WCTU members had been reluctant to endorse suffrage for fear of alienating its conservative members, especially those in the South. In addition, the Illinois Woman Suffrage Association, which would become the Illinois Equal Suffrage Association in 1885, had been reluctant to endorse the temperance platform of the WCTU for fear of alienating those in its membership base who wanted to retain alcohol sales. However, the two groups shared many leaders, members, and goals.

Neither could accomplish its goals without the other, and they shared a need to challenge traditional male behavior, and at the same time work with male supporters, in order to succeed.

CIVIL RIGHTS AND VOTES FOR WOMEN

The civil rights momentum—the conviction that democracy is open to women as well as men—had propelled the early nineteenth-century women's movement and the 1848 convention at Seneca Falls, New York, which resolved that women should have political rights, including suffrage, equally with men. The role of Illinois in this civil rights crusade began on February 12, 1869, when Susan B. Anthony and Elizabeth Cady Stanton visited Chicago and inspired the formation of the Illinois Woman Suffrage Association. The next spring that association met in Springfield, just across the street from the delegates to the state's constitutional convention. The suffragists sent the constitutional delegates a petition totaling over 1,600 signatures and asking that woman suffrage be placed as a separate question on the ballot when the constitution was proposed to the voters. At first the delegates agreed; then, a month after the prosuffrage petition, the opponents of woman suffrage got organized. They sent a petition of 1,381 signatures, followed by several smaller antisuffrage petitions, some playing on the planted rumor that suffragists were preaching that "men are out of their places in legislative halls, and on the judicial bench—that these places should be wholly given to women, and the men to go to the fields and workshops."[24] More common was the insistence that women's "domestic cares and present field of action is broad enough and large enough to engage their whole time and attention, and we cannot afford to spare them from its sacred and solemn duties" for such a task as voting. Still, the vote to table the question of woman suffrage passed, but only by a 33–28 margin. Despite this defeat, the sentiment for votes for women was surprisingly strong in Illinois.[25]

Women leaders for the vote were determined not to let the suffrage issue die with their constitutional convention near miss. In 1877 Susan B. Anthony embarked on a lecture tour throughout the state, delivering a well-publicized address at the Danville Opera House on February 5, 1877. Danville newspapers' responses to Anthony varied. One paper, the *Danville Daily News*, reviewed her person and words unfavorably, ridiculing her as an "old maid, with glasses, smooth hair, and plain clothes, made in an old-fashioned style" and calling her speech "dry and unlogical."[26] The other paper, the *Danville Commercial*, praised her message as "full of good sense and sound reasoning," credited her for "opening of many new avenues to women to fight the battle of life on an equality with men," and called her one "to whom the women of America owe a debt of gratitude they scarce can ever repay."

Anthony, despite the mixed reaction, earned money for the cause in Danville with the fifty-cent admission she charged for her talk, and she revived a public discussion of the issue of women and civic equality.[27]

The Illinois Woman Suffrage Association (IWSA) continued its efforts in the 1870s and 1880s with strong leadership but meager results. Its two strongest, most competent, and most colorful leaders were Elizabeth Harbert and Catherine McCullough. Harbert, the voice of the movement as president of the IWSA and editor of the *Inter Ocean* and other suffrage journals, was highly talented and versatile, a "renaissance woman," according to Steven Buechler, historian of the Illinois woman suffrage movement.[28] When she participated in a state suffrage meeting in Danville in 1894, a local reporter described her as "of slight build, striking face, her gray hair combed plainly back, plainly dressed," though "her voice is clear as silver." Catherine Waugh McCullough appeared to the Danville reporter "as brilliant as a diamond; her raven hair is combed straight back, her black eyes flash rays of good humor, she is handsome and is an excellent speaker."[29] McCullough was the tactician of the IWSA. A lawyer in partnership with her husband, and therefore labeled "our little Portia" by a national suffrage president,[30] McCullough had experienced the prejudice against women professionals and passionately worked to keep the woman suffrage issue in front of the legislature; she assumed that the legislators would eventually see that it was fair and right to let women as well as men make the state's political decisions. She reminded the public that Abraham Lincoln had considered women as citizens, as when he stated in 1823, "I go for all sharing in the privileges of the government who assist in bearing its burdens, by no means excluding women."[31] In "The Bible on Women Voting," McCullough succinctly stated the essential tenets of the civil rights goals for woman suffrage: "Women should be joint guardians with their husbands of their children. They should have an equal share in family property. They should be paid equally for equal work. Every school and profession should be open to them. Divorce and inheritance should be equal. Laws should protect them from man's greed by limiting the hours of women's labor, and protect them from man's lust by punishing severely, vile assaults on women. . . . All these desirable reforms can come through the vote of women and such laws have passed where women vote."[32]

Despite their lack of the vote, Harbert, McCullough, and other activist suffragists lobbied successfully for advances in civil and political rights for Illinois women before the 1890s. Illinois was the first state to prohibit discrimination against women in employment in 1872 as a result of lobbying by women who had received law degrees but were denied the right to practice law. By court ruling, women were also allowed to hold school offices in 1872; nine women became county superintendents of schools immediately after that

ruling. In 1875 women gained the right to become notaries public, and in 1873 women gained the crucial right to equal guardianship of children after divorce. The civil rights goal was foremost when, under Elizabeth Harbert's leadership, the Illinois Woman Suffrage Association changed its name to the Illinois Equal Suffrage Association in 1885.[33]

The vote was a more elusive goal than other civil rights for women, though. Every year after 1893 until its passage in 1913, McCullough introduced the bill for Illinois women to vote in presidential and local elections (women's votes in state elections would have required amending the state constitution). She lobbied legislators incessantly and, in desperation, organized the unfurling of giant "VOTES FOR WOMEN" banners when the legislature came into session. Harbert's rhetoric and McCullough's parliamentary and publicity tactics, though, failed to win any major votes until they joined with the WCTU to lobby the legislature. The WCTU won a notable victory for its tactics in 1891. In that legislative session, the Illinois Equal Suffrage Association tried to get a bill enacted calling for an amendment to the state constitution enfranchising women. The effort got some support but failed. The WCTU prepared a much more limited bill to enable Illinois women to vote in school board elections, which passed. The "school suffrage" bill granted women little practical voting power, since many school officers were appointed rather than elected, but it was "significant in its technical and symbolic implications for future agitation."[34] Even though the WCTU introduced the bill, its favorable passage helped to revive the Illinois Equal Suffrage Association.

In 1894 Danville women demonstrated the new partnership between the WCTU and the Illinois Equal Suffrage Association when they hosted the state IESA convention. The suffrage association, whose membership had dwindled in the 1880s, was attempting in the 1890s to broaden its appeal beyond civil rights advocates. Its cooperation with WCTU women was paired with a campaign to convert influential clubwomen and "well-heeled men as well as society women" to the suffrage cause. This outreach had met with success in Danville, where the Illinois Equal Suffrage Association's hosting of its state convention was welcomed by prominent citizens and temperance leaders. Danville's newspaper gave the convention extensive and positive coverage. William R. Jewell, a longtime supporter of temperance, revealed his support for woman suffrage in his newspaper's greeting to suffrage delegates:

> We welcome heartily to our city the Illinois Equal Suffrage Association. All our citizens welcome you and will show you every courtesy.
> The news believes that woman is the equal of man before God, and for that fundamental reason should have equal rights under our flag.

Let the plea for suffrage be broad, not confined to any political party or religious sect. Be as national as our population.

Boast not what you will do when you get the ballot. First get it, and then, like we poor, plodding men, do the best you can.

Great good always comes from the fullest exercise of rights and from bearing the burthen of responsibility.

We can trust our mothers, wives, sisters and sweethearts with the ballot and be the better governed for it.[35]

Eliza and A. L. Webster, among the wealthiest and most prominent of Danville's civic leaders, and their daughter Kate hosted a reception for the suffrage delegates the night before the convention began. The *Danville Commercial* reported that the Websters' "spacious house was crowded, was simply packed and jammed." The Websters and members of the local suffrage association "made all cordially welcome and the social was hearty all around."[36]

The Websters often served port wine, at least, at parties in their home.[37] It is almost certain, however, that no alcoholic beverages were served at their reception for the IESA because most of the local suffrage officers were also leaders of the WCTU. Lusanna Shea was president of both the Danville WCTU and the Danville Equal Suffrage Association. She served on the IESA nominations committee alongside Catherine Waugh McCullough. Lizzie Kyger, state WCTU officer and Danville WCTU president in 1895, was credentials chair for the IESA convention. Mary Woods (Mrs. M. V. S. Woods), former Danville WCTU president, took a prominent and public role in the IESA convention. She began the meeting by presenting the IESA with a new U.S. flag with two enlarged stars representing Wyoming and Colorado, the only two states that had complete suffrage for women in 1894. According to the *Danville Daily News* on March 2, Woods's sharp words "flashed like a Toledo blade" as she recounted the history of the setbacks of suffragists, the victories in two states, and the certainty of victory in the others. "It was a strong, brave address." At the conclusion of the pageantry, poetry, music, and stirring speeches, the local Equal Suffrage Association gained thirty new Danville members.[38]

In the November 3, 1894, *Woman's Journal,* the national magazine of the National American Woman's Suffrage Association, Harbert, McCullough, and Illinois Equal Suffrage Association president Mary Holmes reported on the "interesting and varied programme and attractive social functions" in Danville. According to their account, however, the greatest excitement at the convention was beyond its host city; suffragists were buzzing with the expectation that women were getting closer to the vote. Just before the convention

Colorado had approved woman suffrage, and in Illinois women had played major leadership roles at the Columbian Exposition in Chicago as board members and World Congress participants. Most exciting of all, Illinois women were going to get to vote for the first time in a statewide election a few days after the convention. The Illinois Supreme Court had ruled that since women had been granted the right to vote for local school boards in 1891, nothing prohibited them from also voting for University of Illinois trustees.[39]

Although a single statewide vote does not seem like much, especially when the position of university trustee was largely peripheral to state politics, "it can never be said in Illinois that the women do not want to vote, when they make so much of so little," as the IESA state president pointed out. They did make a great deal of this single vote. A *Woman's Journal* writer explained its significance: "Illinois women are now seriously facing the responsibilities of a political life. They . . . are dealing fairly and squarely with the option of their admission into the political area."[40] The *Chicago Evening Post* published five columns quoting leading Illinois women who intended to vote in the trustee election. Since women were voting for these offices for the first time, McCullough helped persuade the men of each political party to nominate women candidates: Lucy Flower for the Republicans; Julia Holmes Smith for the Democrats; and Rena Michaels Atchinson, the secretary of the IESA, for the Prohibition Party. Flower won the 1894 election, but all three women, even the losers, received more votes than the men on their party tickets.[41] Obviously Illinois women, voting for the first time on a statewide basis, relished voting for women candidates.

PROGRESSIVISM AND VOTES FOR WOMEN

On the national, state, and local scenes, women's drive for the vote, watered for decades by a steady trickle of outspoken and steadfast reformers, gained the momentum of a rapidly flowing river in the 1890s and early 1900s. The revived movement was fed by two streams: the temperance movement and progressivism, both reflected by Danville's public women. Progressives "demanded that government—from municipal to federal—*take action* on a variety of fronts" including protection of workers and consumers, public health, child labor, parks and playgrounds, juvenile court, and improved and compulsory education. To take all these actions, government needed reform to "make it more responsible, accountable, and free of corruption."[42]

Progressivism aided the drive to woman suffrage for two reasons. First, women were among the strong advocates of Progressive reforms, which touched their lives, communities, and children. Hundreds of thousands of women lobbied and acted to gain playgrounds and juvenile courts, improve

schools, and inform the public about health concerns. Second, both men and women believed that if women gained the vote, a large number of voters would support Progressive political goals because they would be more interested in investing in the welfare of society than in corporate welfare and national defense. Jane Addams, in an examination of the evolution of the modern city, explained the problems if city administration were left to men: "A city is in many respects a great business corporation, but in other respects it is enlarged housekeeping. If American cities have failed in the first, partly because office-holders have carried with them the predatory instinct learned in competitive business . . . may we not say that city housekeeping has failed partly because women, the traditional housekeepers, have not been consulted as to its multiform activities? The men of the city have been carelessly indifferent to much of its civic housekeeping, as they have always been indifferent to the details of the household."[43]

Addams realized that public Progressive women such as those in the Danville Woman's Club did much of the detailed work of city cleanliness, public health, and humanitarian duties, but women who campaigned and lobbied for Progressive reforms were frustrated and felt powerless when politicians ignored or opposed them. Both men and women believed that their Progressive movement would be much more effective if women had the lever of the vote, rather than relying exclusively on moral persuasion.[44] As stated by Addams, if woman "is permitted to bear an elector's part, . . . she would bear her share of civic responsibility, not because she clamors for her rights, but because she is essential to the normal development of the city of the future."[45]

DANVILLE'S WOMAN'S CLUB AND SUFFRAGE

Illinois women were clearly interested in exercising any political power they could, and the suffrage campaign continued to be fostered by the WCTU as well as the IESA. WCTU women helped found the Danville Woman's Club in 1895 with the expectation that it could, along with other worthy purposes, be used as a vehicle to promote woman suffrage, which would in turn help the cause of temperance. Several charter members of the Woman's Club, including Mary Woods, Ella Zerse, Jennie Whitehill, and Lusanna Shea, were also active leaders in the WCTU. Emma Lytle, a WCTU local and state leader, headed the "Political Equality" study group in the Woman's Club and saw to it that the Danville club sent "over four hundred names" for the 1897 WCTU petition in support of amending the state constitution to allow women to vote. The Political Equality section also sponsored a lecture for the entire club on the legal status of women and, in a clear connection with the WCTU, financially supported a bill "providing for the scientific teaching

of temperance in our public schools."[46] At that point, however, the Political Equality section of the Woman's Club went out of existence, and Lytle dropped her Woman's Club membership (though other WCTU members continued). Perhaps the Woman's Club leadership preferred not to promote temperance so actively or to take such a vigorous prosuffrage stance. The General Federation of Women's Clubs had determined not to take a stand on suffrage so that it would not alienate antisuffrage members. The Danville club may have preferred this policy. The club certainly was involved in political activity in the schools and the community. Other Woman's Club projects, such as sponsoring a community appearance by Jane Addams in 1897, suggest that progressivism was the guiding spirit of the club in the late 1890s and early 1900s.

Addams and many other Chicago Progressives dominated the Illinois Federation of Women's Clubs, of which the Danville Woman's Club was a member. The Illinois federation worked actively for Progressive causes such as those involving conservation, child labor, and working conditions for working women. Their commitment to social and political reform led them toward support for woman suffrage. In 1902 delegates to the state federation meeting voted for a measure to support the vote for those Illinois women who paid taxes. In 1904 Danville hosted the state federation convention, where woman suffrage was debated again and a crucial vote was taken on the issue. Early in the 1904 convention, speaker Judge Richard Tuthill lit the flame of resentment that led to action; he concluded his speech on the Juvenile Court Law with the traditionally pious recommendation that the women work through the men and that way "be sure the prayer would be answered."[47] Many women at the federation meeting were dissatisfied with praying and depending on male politicians and were ready to act as voters themselves.

The state federation had been working for a more active, progressive state government, and at its Danville convention, delegates voted to urge legislators to enact civil service reform, a child labor bill, licensing for trained nurses, and reform of marriage and divorce laws. The impatience of women who had worked for this legislation but had no political rights came to a head at the Danville meeting. After days of debating and resolving political issues, and after a lengthy evening discussion on civil service reform by several male judges, government officials, and civic leaders, Eugenie Bacon, the federation president, lost her temper. She declared that "the recital of this evening fills us with pain and humiliation for the State of Illinois. We regret that the audience is not composed more largely of the voters of this state [in other words, women] who could change these conditions directly." She went on to say that "it was my misfortune, as President of the [Illinois] Federation, to visit the state legislature five times in the interest of the child labor and the compulsory

education bills. We have been told that politics are too corrupt, perhaps too much so for the dainty and delicate womanhood of the State, but sometimes we feel we would be less humiliated if we could have some more direct way to bring our influence to bear."[48]

The sentiment of the Illinois federation delegates was clearly, but not totally, in favor of woman suffrage. During the intense discussion over whether the federation should support suffrage for all women, not just tax-paying women, two strands of the prosuffrage argument were evident. Harriett Van Der Vaart, Consumers League and Neighborhood Settlement House activist,[49] argued that suffrage was necessary because it could bring about the desired Progressive goals to make the society a better place: "When we worked for the Child Labor Bill we worked under great difficulties because we had no direct voice in the matter, we worked through the men and spent a great deal of time and energy that could have been spent in influencing other people to work for us. It will be easier to work in the future if we can have a direct voice. It seems to me that this is the opening to prepare the way for us to do efficient work."[50] Delegate Everett added, "It is because I am interested in . . . helping the distressed, raising humanity, caring for the unfortunate, that I would like women to put themselves on record as being able to record their votes as well as petitioning others."[51] Dr. Cornelia DeBey echoed the argument that suffrage was needed to effect Progressive goals, but she focused on the powerlessness of working women: "There is no argument for the Suffrage Bill, which does not concern us so much, but [does concern] the working woman tremendously. Those women are at a tremendous disadvantage because they have no value in the scales of election. Take our department stores—if there is a little over-work to be done it is thrown upon the women. I might go on for a half hour and tell you how the women, throughout the country, who are forced to earn their living, are put to a tremendous disadvantage because they cannot march up and say 'I too have a voice in this matter.'"[52]

Delegates Watkins and McGovern voiced the civil rights, or equality, argument, which had been espoused by early suffragists and for decades by Catherine McCullough and the IESA: "Hundreds of thousands of women in this country are supporting themselves, in this State, and have to pay taxes in business, then why should we not be willing to help those women to help themselves. If not, then I think we had better disband. I stand in the position, not so much as a working woman, but most unfortunately a property owner, and it is a question of taxation without representation." Catherine McCullough, who had presented the bill for discussion, used both arguments: that women as well as men should make the decisions, and that the Progressive issues were important enough to make the effort to bring in women as voters.[53]

The Woman's Club debaters did not include another argument for suffrage—that the vote would make restrictions on alcohol sales easier to pass. Not all the club leaders on the state level were temperance advocates. However, responding to the Progressive arguments for suffrage, and despite objections that some of the speakers had "raised . . . voices to the key where they sound irritated," the majority were persuaded. The vote was 74–34 in favor of calling for suffrage for all women.[54] It was a divisive vote, however. Danville's Clover Club ceased to be part of the federation after the convention, and although individual Woman's Club members were involved in the suffrage movement, the Danville Woman's Club took no part as an organization in subsequent suffrage work, even after the national federation took a stand in favor of suffrage in 1913.[55]

The Woman's Club did not give up its suffrage advocacy on the state level. In the years following the 1904 vote, the Illinois Federation of Women's Clubs published suffrage pamphlets, publicized suffrage gains, and regularly worked with suffrage forces. The Illinois Equal Suffrage Association in those years was concentrating not on building up its own membership but in reaching out to alliances with other groups. These alliances were often successful in achieving political gains. Club and suffrage movements had combined to pass, in 1901, a bill that made mothers as well as fathers guardians of their minor children. A law limiting child labor passed in 1903 with the help of the Illinois Federation of Women's Clubs, suffrage organizations, and women's labor unions. However, by contrast, the IESA was unable to get a straightforward woman suffrage bill or an amendment to the state constitution through the state legislature. Before Susan B. Anthony died in 1906, she had commented privately on the lack of unity and coherence in the suffrage movement: "it seems impossible for all to *unite* to get *one thing* at the *same time.*"[56]

THE ANTISUFFRAGE DEBATE

The suffrage debate was enlivened and its responses sharpened by a series of pamphlets critical of votes for women that had been issued in the thousands by the Illinois Association Opposed to the Extension of Suffrage to Women. The association had been organized and was headed by Caroline Elizabeth Corbin, a writer and essayist who had moved from the East Coast to Chicago.[57] Corbin and other antisuffrage spokeswomen, according to research by Susan Marshall and Manuela Thurmer, were well if traditionally educated, commonly daughters of lawyers, bankers and financiers, and to a lesser extent ministers, educators, and military officers. They were also often connected to politicians, and they made good use of their privileged positions to maintain the status quo. Marshall points out that "as members of the American aristocracy they played an important role in social status maintenance

that became a valuable resource for antisuffrage mobilization."[58] Ironically, though, other antisuffrage spokeswomen were career women identified with the Progressive movement. These women, including reform journalist Ida Tarbell, pointed out all the accomplishments that women had made without the vote, and they questioned whether the vote would really make women more effective as social reformers.[59]

Corbin's bulletins for the Illinois Association Opposed to the Extension of Suffrage to Women were written from an office on North Dearborn Street in Chicago. Despite the fact that the organization had a list of officers, Corbin wrote most of the bulletins herself and saw to their distribution. She used the arguments described above and also exploited the fear of socialism and its doctrine of equality, as in a bulletin entitled "Socialism and Sex": "All civilization is built upon the existing forms of male and female and the way in which they act and re-act upon each other. A world of all men or all women is an absurdity . . . and that is precisely what Socialism is trying to do; to endow women with 'equal political rights' is as impossible in the long run as all the other absurdities. It is upon such an unstable and dangerous foundation as this that the doctrine of Woman Suffrage bases itself. It is from Socialism that it sprung in the first place, and towards Socialism that it tends."[60]

Corbin repeatedly emphasized "the eternal difference in the characteristics of sex, as maintained from the days of Adam and Eve down" and even from "prehistoric protozoa." Women are specialized as the "mother of men," and therefore "woman does not need the ballot to make her equal with man." In fact, according to Corbin, women gaining political rights would take from men "much of the dignity and honor which truly belongs to them" and which they need even to approach the pedestal on which traditionally women are enthroned. To upset the order of gender in the universe would also lead to the abolition of classes and will result in "race deterioration and decay," a familiar race suicide argument based on the assumption that women with education, money, and political rights had fewer children than did other women.[61]

Corbin joined with a few Progressive women who argued that women had made advances without the vote. Corbin described "the progress which has been made during the last decade in the pursuits of the domestic arts and sciences, in the care and proper upbringing of children [and] in the regulation of the hygienic and moral conditions in our schools."[62] Just the opposite happened in states that allowed woman suffrage, she insisted, referring to a *Ladies' Home Journal* article in which the writer argued that those states where women could vote showed a steady decline in morals and an increase in juvenile crime and illiteracy. Corbin assumed, therefore, "Whatever good has been accomplished by women in any suffrage state, has been gained by

influence quite as much as by votes and the sum of it has not been greater than that which has been achieved in other States by the old-fashioned way. In no State has the ballot brought to woman an equal power or influence to that exercised by men."[63] This "demoralizing effect of Woman Suffrage" was an obvious reason that, Corbin protested, "the great majority of women [do not] want to vote."[64]

None of the officers of the Illinois Association Opposed Opposed to the Extension of Suffrage to Women was a Danville woman; nor have any documents surfaced to this date from Danville women opposing suffrage. As mentioned earlier, the Clover Club left the Illinois Federation of Women's Clubs shortly after the federation approved votes for women: this may have been due to the Clovers' distaste for public positions or broadly Progressive issues —or perhaps a real opposition to suffrage. Undoubtedly there must have been a "silent" group of women who resisted votes for their gender, but the authors have found no paper trail from them in Danville.

Danville's foremost political leader, Joseph Gurney Cannon, certainly expressed himself vocally against votes for women. In a 1913 speech after Illinois women were granted partial suffrage, "Uncle Joe" Cannon, who had been voted out of office for the first time in twenty years in the wave of Progressive sentiment, expressed his skepticism that women really wanted the vote. He estimated that "if the proposition were put to a vote of the women it would be lost by 50,000 votes in this state," and he attempted to trivialize the vote: "Now that we are going to have it [woman suffrage] in Illinois, it will be a great time for an awfully handsome man to run for office." Woman suffrage would make little difference, though, Cannon declared, because the True Woman already made the decisions: "You women determine the character of the future men you nurture and more than likely their policies will be settled your way, no matter what the old man thinks." The crowd cheered.[65]

BOOMING LIQUOR BUSINESS

Whether or not any of Danville's women were actively against equal suffrage, Danville's liquor interests certainly feared votes for women as a real threat to their livelihood. Since the early years of the twentieth century, liquor distributors and saloon owners had been fighting off attempts by temperance advocates and prohibitionists to pass laws to make Danville "dry," that is, to prohibit the sale of liquor within the city limits. News analysts traced the beginning of municipal corruption to the bitter referendums in 1909 and 1910, which the "wets" were widely assumed to have won by buying votes and bribing the election commissioners and other city officials.

Newspapers played up the connections between alcohol, prostitution, and corrupt government, none more colorfully than the *Danville Banner,* a

political organ of the state Prohibition Party. George Woolsey was its editor, and while the paper focused on national and state issues, readers could quickly pinpoint local problems that related to alcohol, including alcohol-related crime and violence, thefts of merchandise by women presumed to be feeding alcohol habits, and the suicides and attempted suicides of Danville prostitutes who used drugs and alcohol. Woolsey's colorful descriptions of the "wild life" in Danville emphasized, of course, the link between alcohol and other types of vice: "Drunkenness and licentiousness are the two greatest evils that are growing rapidly every day in this city without any apparent effort to check them. . . . Our streets are thronged with harlots from early in the evening to early in the morning seven nights in the week, and it is not an uncommon thing to see police officers holding confidential conversations with these scarlet women on the public streets, not only in the night, but frequently in the day time."[66]

Owners of bars, according to Woolsey, fought enforcement of Danville's ordinance against saloons operating "bawdy houses" on their premises because "the two evils are inseparable, and if the bad women are compelled to vacate their haunts over the saloons it will decrease the saloonkeepers' income to a considerable amount." Women would go elsewhere, men would follow, and so would the whisky and beer, "and the saloonkeepers know it. The saloonkeepers are 'pimps' for many of these bawdy houses and in return for their services the women buy their supply of drinkables from the saloonkeeper who can steer the greatest number of men into their dens of vice."[67]

Circuit court records and city council minutes give substance to the impression that in Danville the liquor business was indeed booming. Repeated indictments before the court from 1894 to 1920 provide a glimpse of Danville's problems with alcohol. The most frequently repeated indictments involved liquor: selling without license, selling to minors, selling to inebriates, selling in "anti-saloon territory," opening a "tippling house" on Sunday. An examination of dram-shop licenses shows that the number of saloons in Danville increased along with the population and peaked in 1907. In 1895 the city council issued forty-one dram-shop licenses and began issuing licenses to wholesale beer distributors. By 1905 the number of dram-shop licenses had increased to seventy-two. Numbers of dram-shop businesses were on the rise until 1907, when ninety-five licenses were applied for and all but two were approved.[68]

Woolsey's alarm at the expanding liquor scene increased after a fight to make Danville dry lost decisively in 1909. Woolsey editorialized "that the present administration of Danville is the rottenest thing this side of the infernal regions." The mayoral election that followed the failure of the prohibitionist referendum by several months was bitterly fought. Louis Platt was

considered the reform choice, and druggist W. F. Baum was seen as the expansionist choice (advocating saloon expansion). Baum's election, according to Woolsey, would "allow the saloon keepers and gamblers to select the successful candidate."[69]

Granted, the *Danville Banner* had a prohibitionist agenda, but other print sources corroborate that corruption was real in Danville. Headlines from the *Danville Press-Democrat* up to the 1909 Platt vs. Baum election included the following: "Baum Managers Violating Law," "Are You Satisfied with Gang Rule in Danville?," and "Charge Men with Stealing Ballots."[70] In the age when newspapers freely editorialized on their front pages, the *Press-Democrat* suggested links between liquor and Mayor Baum and his friends Chris Leverenz and Magnus Yaeger, also known as his "managers" or his "gang," as in the following:

> . . . state officers of the Liquor Dealers' Association were here recently . . . the [votes of] the Soldiers' home are now safely stored in their vest pocket with the flap buttoned. . . . (April 8, 1909, p. 4)
>
> . . . bullragging and threats . . . intimidation . . . police vengeance. . . . "Alderman's stepson" fired his revolver over the heads of Negro friends of Mr. Platt in an effort to intimidate them. (April 17, 1909, p. 4)
>
> Next Tuesday the politcal garbage cans will be dumped and the old party machine thrown on the scrap pile. (April 17, 1909, p. 4)
>
> Saloons . . . were watched all day and one man was arrested on the charge of keeping open on Sunday. At the same time the three Leverenz saloons were doing business unmolested. (April 20, 1909, p. 10)

On April 17 a front-page political cartoon depicted Chris Leverenz, one of the mayor's "gang": "Vell, vell, I chust bet dat vas der key to mein saloons 'dot I lost four years ago. Dis politics game vas great if der richt man vins."[71]

The newspapers' outrage at the corruption in the city reflected the disgust felt by the voters. Louis Platt was elected mayor in 1909 after pledging during his campaign to attack the liquor and gambling interests. Platt denounced prostitution in his inaugural speech and began to enforce a city ordinance against "resorts" being located in the same building as taverns.[72] However, Danville still had more active saloons than at any other time in its history.

Once again the Danville WCTU, prohibitionists, and other temperance activists succeeded in bringing the wet/dry controversy to a vote in 1910. They hoped that the spirit of reform and disgust against corruption, reflecting the national Progressive movement, would carry the vote. However, despite the fact that neighboring towns, including Champaign and Urbana, remained dry, the resolution to make Danville dry failed by one thousand votes.[73] There were many accusations of corrupt vote buying by the liquor

interests. The *Danville Banner* reported that the wets spent eighty-five thousand dollars on the campaign. Later observers of the Danville scene believed that the wet/dry votes of 1909 and 1910 were what brought big money, mostly liquor money, into Danville's electoral system. Woolsey implied as much in his May 1910 editorial after the vote: "The balance of power in Vermilion County is in the purchasable vote in Danville township. . . . The monopolies furnish the money that purchases these votes. To preserve the vote buying Machine, the System does not overlook the fact that supervisors name the grand jurors, the sheriff serves the papers and the States Attorney leads the prosecution of these outlaws."[74]

Reformers continued their outcry over bribery of Danville officials by the liquor interests in 1911, a peak year for Progressive campaigns against corruption in government, prostitution, and other social evils. A Danville grand jury sat for several months in early 1911 and conducted an extensive investigation into corruption in the city of Danville. Both the *Danville Press-Democrat* and the *Commercial-News* sanctioned and publicized the investigation and also campaigned strongly for a change in Danville government from a mayoral to a city-manager system, a Progressive reform adopted in many cities at the time. The 1911 vote for a city-manager system failed, but the grand jury came out with a blistering report, declaring that "a most astounding state of political corruption prevails in Vermilion County and especially in Danville township." The jury report described the use of vast sums for bribery and vote buying. Election commissioner W. C. Brown was singled out for particular blame, but the county sheriff and his assistants were condemned for blocking, not aiding, the investigation. The jury report even declared that "men prominent in political and business circles" had tried to get the jury to abandon its investigation. The grand jury indicted twelve men for gambling and eleven women for prostitution and pandering, all with their names published in the newspapers. However, court records show no indictments of Danville officials resulting from the grand jury recommendations.[75]

Clearly, the power of the political and liquor interests in 1910 and 1911 had protected a corrupt government system from being reformed. The language of reformers was desperate, and many of their appeals were to women, who were not yet voters but were increasingly active in church work, benevolence, temperance, and Progressive issues. At an advantageous point in 1913, Illinois women and men were able to achieve partial suffrage for women, a vote which would make the difference in Danville.

DANVILLE WOMEN VOTERS SAVE THE DAY

At the peak of Progressive sentiment in the state and after a long struggle by the Illinois Equal Suffrage Association, in June 1913 the Illinois legislature,

enhanced by the votes of new Progressive party legislators, passed the Illinois Presidential and Municipal Suffrage Law. The law permitted women to vote for all national offices and virtually all municipal, county, town, and village offices (but not state officers, because the word "male" in the Illinois Constitution prevented them). The vote was significant in several ways: Illinois was the first state east of the Mississippi and the first state "to break down the conservatism of the great Middle West and give suffrage to its women."[76] Looking back later, North American Woman Suffrage Association (NAWSA) president Carrie Chapman Catt declared: "New York women never could have won their great suffrage victory in 1917 if Illinois had not first opened the door in 1913, and the winning of suffrage in New York so added to the political strength of the suffrage movement in Congress that it made possible the passage of the Federal Suffrage Amendment in 1919, so the work in Illinois was fundamental and as vitally important to the women of the whole nation as it was to the women of Illinois."[77]

The national suffrage organization recognized the significance of the Illinois vote immediately; the headline in its June 21, 1913, *Woman's Journal* read "ILLINOIS WOMEN WILL VOTE FOR PRESIDENT." However, the most immediate results of woman suffrage in Illinois were on the municipal level. Since women in Illinois had gained only limited voting rights in 1913, they often had separate ballots, allowing gender vote recording in the Election Abstracts. Using these election records, political scientist Joel Goldstein analyzed the gender differences in Illinois voting from 1914 to 1921. Most of Goldstein's statistics related to Chicago, but he did some statewide analysis also. He concluded that women voted more readily on local than national elections, but that their voting numbers grew in all elections as they became more accustomed to the ballot. Women were more likely than men to vote independently of party loyalty. Goldstein concluded that women "introduced a large segment into the electorate who were willing to support types of public policies which were not clearly in the majority prior to its [woman suffrage's] adoption." The measurable differences between men and women voters were on social reform issues, Sunday blue laws, and above all, prohibition.[78]

The women's votes made a difference in many Illinois towns, according to the *Woman's Journal:* Rosiclare women outvoted men and elected a "dry" candidate for city clerk; River Forest women made the village a park district, heading off commercial/industrial development; Dixon women extended the town's waterworks franchise; Champaign women carried the vote for seventeen thousand dollars for modern fire-fighting equipment; and, after years of effort by Mary McDowell, Chicago garbage was finally collected in the dumps and stockyards—immediately after women got the vote.[79]

Danville women voters began to make changes with their first municipal votes, according to the *Illinois State Progressive,* published in Danville as the voice of the state Progressive Party. In October 1914 the editor of the *Progressive* summarized the longtime control of county and township offices by "a crooked gang of politicians" or by those who "either from lack of nerve or from lack of desire to work allowed the lawless element to control elections just as they choose."[80] The editor noted the change with women's votes in city elections:

> After 1913, a new deal was started: a move to get the better element of voters of all parties [women] to join in a movement to clean up political conditions in the county.
>
> The first election was the township election. [A reform ticket was formed] not on party lines but on lines which it was planned would break up the gangs in possession of the township offices. The result was that the people voted right and the township ring was broken.
>
> Next came the city election and again the plan was laid to break up a combination of city aldermen which had been the back bone of the corrupt gang for years. A fusion ticket was used to do it. The result was, only one of the old gang's representatives was elected, and for the first time in years, the citizens of Danville had a city council not controlled by a gang.[81]

Fortunately, voting records are available in the Vermilion County Board of Elections office to indicate how Danville women actually voted in some of the elections after 1913. Most of the results parallel Goldstein's findings for the whole state. A November 1914 election for U.S. representative and county officers indicated that only a few women cast votes in Danville, as Joe Cannon defeated Elmer Burt Coolley in the primary and was narrowly restored to his seat as congressional representative for the Eighteenth District.[82] However, the citywide election of March 1915 brought out six times as many women as in the previous election. The mayoral candidates were William Lewman, the Republican incumbent; Lincoln Payne of the Citizens Dry Party; and Louis Platt, listed as "Independent." Candidate Platt reminded the public that his two-year service as mayor, 1908–10, had seen a wise regulation of the saloons and the stamping out of gambling. He accused Mayor Lewman of allowing all-night and Sunday operation of saloons and "the "red-light district" and gambling to run rampant.[83] A higher percentage of women's votes than men's went for Platt and the dry party candidate. According to the October 22, 1914, *Progressive,* women also voted out corrupt city aldermen and a majority of women voted for a "Sunday law" to ban Sunday theater, although male voters carried the vote and theaters remained open on Sundays.[84] The women's reform and dry votes, in the first election

in which they could participate, foreshadowed the impact their votes would make in the future.

Danville's temperance advocates had tried to make the city dry in 1909 and 1910 but had failed without the women's vote. In the first local option vote to make the city dry after the women gained the vote, though, the gender tally clearly showed that women supported local prohibition. However, more men than women voted, and more men voted *no*. The *Danville Morning Press* announced the next day: "Danville City is wet by 1518 [votes]."[85]

Although Danville was still wet in 1915, the writing was on the wall. Thirty-three Illinois towns had voted to become dry in the first election after the introduction of limited woman suffrage. Danville liquor interests knew what was to happen. Sixty-two licenses were applied for and approved at a special May meeting of the city council in 1916, just before another vote for local option was expected in 1917. For the first time in the city council minutes, the saloon addresses were included, offering a flashback of Danville's downtown pub-crawl in 1916. Twenty-nine (almost half) of Danville's saloons were clustered along ten blocks of East and West Main streets. Other prime locations were downtown, the east side of town (location of the Old Soldiers Home), and Danville Junction (where rail lines converged).[86]

When the election was about to come before Danville's voters in 1917, the wets bought full-page ads in the *Commercial-News* that appealed to diverse voters across the city: "Women of Danville! Save Our City!," "Business Men! Don't Paralyze Danville!," "Prohibition Will Hurt Labor!," "Vote No!," and "Taxes Will Hit the Sky if City Goes Dry."[87] However, the wets could not buy the local option election of 1917. Danville elected another reform mayor, George Rearick, and by a close margin answered *yes* to the question once again on their ballots: Shall Danville become Anti-Saloon Territory? In this election the voter turnout was slightly smaller, but more women voted, and their wishes for temperance prevailed. The *Commercial-News* headline told the story: "Day Saved by the Women / Their Votes Made Danville Dry Cause Win."[88] With the women's vote, Danville joined many other towns and cities, such as Champaign, Urbana, Rockford, Decatur, Elgin, Bloomington, Jacksonville, Freeport, Waukegan, Springfield, and Evanston, by moving into the dry column before the Nineteenth Amendment brought Prohibition to the entire nation in 1919.[89]

One year after the Danville dry vote, when the city council held its first May meeting, the minutes record that Mayor Rearick took the opportunity to comment on Danville's antisaloon status, promoting the wisdom of the women's vote: "Danville's first dry year has demonstrated beyond fear of contradiction several facts, notably that the city can be run without saloon license money; that the prohibitory law can be enforced; that business has

not suffered, and that moral conditions are bettered. That a business so per-nicious and so wasteful and destructive should have been so long tolerated is now a matter of wonder. The general feeling is that the saloon has gone to stay. It is to be regretted that the clean-up did not extend to the whole county. Had this been so, the difficulties of law enforcement would have been much lessened."[90]

Most historians of woman suffrage consider the impact of temperance on the suffrage movement to have declined in the early twentieth century, as Progressive reformers and women's club elites took the limelight and organ-ized the suffrage campaign. Danville's example shows how temperance and prohibition continued to motivate the great mass of women and men who supported woman suffrage and also indicates the considerable impact of women's votes on temperance. Prohibition Party and WCTU members had led several efforts to abolish liquor sales in Danville before women got the vote, but they had always failed. Danville, like many other Illinois cities, went dry after women gained suffrage in local and presidential elections.

DANVILLE ACTIVISTS ZELLA MAE LAURY AND NELLIE COOLLEY

Zella Mae Brown Laury epitomizes the determination, moral character, and strength of temperance and suffrage women.[91] A small, bright-eyed woman with a charming and direct manner and an air of competence, Laury was a born reformer. She signed the WCTU pledge when she was twelve, according to her daughters, Joan Ring and Susan Freedlund. A resident of Bismarck, a small suburb north of Danville, she likely belonged to the union in Hoope-ston, Rossville, or Danville and all her life supported its views. Born in 1902, Zella Mae Brown taught Sunday school for years at Bismarck United Metho-dist and eventually married a Methodist minister. Her parents had no formal higher education but proudly sent Zella Mae to DePauw University in Indi-ana, where she graduated Phi Beta Kappa in 1925. She taught high school English and French briefly before her marriage to Rev. Raymond Laury and then ran the parsonage and reared five children, returning to teaching after her children were grown. When she was age seventy, the school board at East Lynn informed her that she must retire. She sadly turned away from public education only to begin a new career as director of the newly established Ver-milion County Museum. Zella Mae told her daughters that the "second hap-piest" day of her life (her wedding day being the first) was when school board members came back to her "hat in hand" and asked that she return to East Lynn because it would take two teachers to replace her. By then, though, she was too busy with her new career.

This very public woman not only signed the pledge and wore the white ribbon of the WCTU, but when she was sixteen, she put on a white suit and

Zella Mae Laury at age twenty. Courtesy of Joan Ring and Susan Freedlund

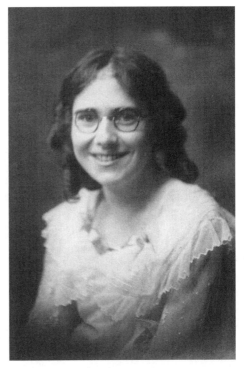

marched in a suffrage parade in Danville. Never flagging in her concern and enthusiasm for temperance, suffrage, and other political causes, Laury announced during the 1960s that she wanted to go south and march with Dr. Martin Luther King Jr., but her family dissuaded her. Instead she resumed her temperance activities, going door to door to keep her township dry, which it is to this day.

When Zella Mae Brown Laury marched in Danville in 1917, she was probably part of the last state suffrage convention parade. Danville was given the honor of hosting the 1917 Illinois Equal Suffrage Association convention in recognition of the suffrage work by another Danville activist, socialite Mary Ellen "Nellie" Fowler Coolley. Nellie Coolley was the most public and prominent of Danville's suffrage advocates in the second decade of the twentieth century. Born in 1872 to one of the largest landholding families in Vermilion County, Nellie had married a country doctor, Dr. Elmer Burt Coolley, when she was nineteen. After their two sons were born, the Coolleys relocated to 112 Pine Street in Danville, where he expanded his practice and both of them threw themselves into community leadership.[92]

Nellie's only granddaughter, Marilyn Coolley Carley, who was five when her grandmother died, had an impression that the Coolleys had lived a

Nellie Coolley and her son Marion. Courtesy of Marilyn Coolley Carley

"wonderful life." E. B. Coolley raised and raced fine horses; Nellie was an avid clubwoman and an aspiring writer, as well as a concerned mother. The Coolleys were active in society and established the Coolley Duplicate Bridge Club, which still exists.[93] Both Coolleys also led in efforts to better the community. Dr. Coolley's response to his sons' illnesses was to become involved in public health in the county and city. He led the move to build a tuberculosis sanitarium after his elder son's death from that disease.[94]

Nellie Coolley was an attractive woman, a "presence," dignified and strong-willed, with lots of energy. Her granddaughter remembered her "swooping in" to visit them and the family's efforts to prepare the house as if for an inspection.[95] Her pictures show her as serene and self-possessed, dressed in style and ready to take charge. As described in a previous chapter, Coolley was a founding mother of Danville's YWCA and effectively ran the campaign for the Y's impressive new building. She swept into the cause of votes for women with the same overwhelming commitment as she had for the YWCA founding. As a Danville Woman's Club member she led suffrage discussions to persuade its members to work for the vote. Another of her notable suffrage efforts was to initiate a Woman's Citizenship Club in early 1917. Its purposes were, in Coolley's words, "to bring to women a surer knowledge of public affairs," to "develop the extempore speaking qualities of many women" through debates and discussions, and above all "to make the club one of the livest [sic], most progressive and most interesting organizations in the entire city." The club was nonpartisan and enlisted Woman's Club founders Jane Fithian to conduct parliamentary-procedure workshops and Eva Sherman to take charge of instruction about civil government. Coolley conducted the "department of enfranchisement of women," to "inform women of most important events which are happening in the locality and to give them a broader view in regard to their enfranchisement."[96]

THE IESA RETURNS TO DANVILLE

Meanwhile, the celebration of woman's rights to vote in national and local elections in Illinois was incomplete. Women in Illinois could not vote for state offices, and most American women could not vote at all. The Illinois leadership divided on tactics: Catherine McCullough turned all her efforts toward amending the U.S. Constitution, while Grace Wilbur Trout, the IESA president and effective leader of the 1913 campaign for the vote, preferred an effort to rewrite the Illinois Constitution to provide woman suffrage in state elections. Trout believed that an Illinois-initiated federal amendment would never get past the male voters of the state. Promoting a constitutional convention, though, would give the IESA automatic allies, reformers who had been trying to get a new constitutional convention for thirty years.[97] Working with her allies, Trout aimed to establish centers in all of the 102 Illinois counties, where the population could be educated about the need to call a convention to write a new Illinois Constitution. Reflecting war-time spirit, Trout created a military-type structure and language for her "troops," which she designated the "Women's Emergency League," declaring, "we must fight . . . with the same method [with which] armies are organized." She appointed

three field agents for Chicago and three for downstate, and each of these agents appointed ten "division generals."[98]

Nellie Coolley was one of the most successful "generals" for the Women's Emergency League. She raised fifteen hundred dollars in pledges and recruited many new members for the league.[99] Despite the entry of the United States into World War I in spring 1917 and the diversion of suffrage efforts to war work, the Women's Emergency League held over a thousand meetings in the summer of 1917, promoting a call for a new Illinois Constitution.

In appreciation of Nellie Coolley's hard work for the Women's Emergency League, the IESA held its 1917 convention in Danville.[100] By 1917 the IESA, which had attracted only thirty-five participants to its 1894 meeting in Danville, had a membership of over two hundred thousand women representing every congressional district in the state.[101] Hundreds of these members converged on Danville in late October with the assuredness that votes for women were a certainty in the near future. A measure of their confidence came in a small incident. As a special Chicago train for members arrived at 4:00 P.M. on November 1, Representative Joseph Gurney Cannon was leaving the station on another train. As their paths crossed, Cannon "was surrounded by the suffragettes before he could enter his coach." The women gave him a "volley of greetings" and urgently requested him to stay and address the meeting, but the nimble Cannon escaped onto his train to Washington without committing himself on suffrage. The confrontation with bold and assured women may have unnerved him, especially since the *Danville Press-Democrat* headlined that day that SUFFRAGETTES TOOK THE CITY.[102]

Danville women conducted the opening ceremonies of the 1917 IESA meeting admirably. YWCA executive director Harriet Tenney delivered the opening prayer. A song, composed especially for the occasion, was rendered by Ida Stevens and Rebecca Levin and was adopted as the official song of the association. Its lyrics suggest the serious intent of women fighting for citizenship in a time of war:

> Children of liberty
> Heirs to equality
> Bound in fraternity
> Rise in your might.
> Greed let us immolate
> Wealth let us dedicate
> Life let us consecrate
> To keep our right.
> Down with autocracy
> War lords and Tyranny

Friends of democracy
For these we fight.[103]

Stevens and Levin's song had a militancy that matched the spirit of the nation in 1917. Americans were fighting to save the world, and women were partners in the fight. In her articulate and inspirational presidential address to delegates in Danville, Trout elucidated this partnership distinctly: "There has been a superhuman effort on the part of society and governments to separate humanity when it comes to politics into competent parts, divided along sex lines. This has proven a failure, as it is contrary to nature's great plan, which designed humanity as a perfect and concrete whole. . . . Humanity, with one side partially paralyzed and only half functioning, has been unable to demonstrate either efficiency or beauty."[104]

Because of the war, delegates to the 1917 convention were "not here for amusement," so the parties and receptions that Danville had provided for the Equal Suffrage Association convention held there in 1894 were muted in 1917, except for a program at Washington School that included a combination of the old and the new: living tabloids of Danville history, motion pictures, speeches, and music. Net proceeds were given to the fund to provide "Christmas cheer for Vermilion County soldiers." Otherwise, business held at the Woman's Club rooms in the Adams building was conducted quickly, ending by noon on the convention's second day.

Nellie Coolley was clearly the "star" of the Danville contingent and was named to the IESA state board of directors. In charge of the committee on arrangements, Nellie had seen to it that her neighbors, friends, Woman's Club sisters, and, presumably, sister suffragists Martha Tilton, Annie Glidden, Bertie Braden, Josephine Hegeler, Minta Harrison, Ruth Curry, and Nellie Shedd were assigned to various committees.[105]

Suffrage was a bipartisan issue; the Coolleys were Republican, but Nellie Shedd was a Democrat. In fact, she was a vigorous and articulate suffragist who emphasized partisan issues in the suffrage fight. In 1916, after a march of five thousand rain-drenched women in Chicago had failed to get the Republican convention to adopt a woman suffrage platform, Shedd warned Danville women not to support the Republican candidate Hughes but rather to vote for Woodrow Wilson. She noted, quoting a state suffrage leader, that under Wilson's first term, "more hearings have been held, more votes taken in senate and house, more favorable reports made by committees, and more recognition given to suffragists by the president than in the forty preceding years." Shedd declared that "the women of Danville, understanding the situation, will not be deceived and will not turn their backs on the really grave issues of this campaign to follow after the will-o-wisp reasoning of the

Republican adherents." With women voting in their first presidential election, Vermilion County, usually Republican, went for Woodrow "He Kept Us Out of War" Wilson in 1916 with 13,864 votes to 10,320 for Charles Evans Hughes.[106]

WORLD WAR I AND THE WOMAN'S VOTE

Trout's reminder at the 1917 IESA convention that humanity's "efficiency" and "beauty" required the efforts of both men and women struck a chord that resonated in wartime. While men made the decisions and sent young men to war, the war required efforts of all citizens, men and women. World War I changed the debate over woman suffrage; as Judith McArthur points out, "home front mobilization completed middle-class women's conquest of public space, fatally weakening the old separate spheres argument against female voting." Few could argue that woman's place was in the home when she was selling war bonds and thrift stamps, collecting money and marching in parades for the Red Cross, or organizing gardening, canning, and bandage making.[107]

Suffrage leaders used their organizing and speaking expertise for the war effort, which reflected favorably on the suffrage cause. Grace Wilbur Trout was appointed as a member of the executive committee of the Illinois Woman's Committee of the Council for National Defense, and Catherine McCullough served on the Illinois committee's state council.[108] Progressive leaders, including Louise de Koven Bowen, Mary McDowell, and Dr. Alice Hamilton, spearheaded the executive committee, which was dominated by Chicago women, but downstate women proved to be activists in the organization and execution of Woman's Committee goals.[109]

The Illinois Woman's Committee, as it was commonly known, aimed to register and mobilize all the state's women for the war effort. Ostensibly a war measure so that a "regiment" of women could be marshaled for war work when needed, the registration held obvious potential for identifying probable women voters. With a local leader in each community, the Woman's Committee succeeded in registering at least one-third of the adult women over sixteen years old in Illinois, over six hundred thousand women, by mid-1918.[110] Members of Danville's Woman's Club, the city's leading war-work organization, proudly announced that they had undertaken the registration of all women in the Sixth Ward, where many of them lived. The implications of the Woman's Committee registration project were significant for woman suffrage. Women who had never before taken a public role now registered, not with their husbands or families but as themselves, and were mobilized as valuable citizens in a world war.[111]

THE FINAL SUFFRAGE BATTLES IN ILLINOIS
AND THE UNITED STATES

The war effort had unleashed women's energies and transformed their outlook, and the end of the war left them still energetic. Turning their enthusiasm to winning suffrage was an obvious transfer, and a large number of men showed their gratitude for women's war efforts by ceasing to oppose votes for women. Most European nations, including Great Britain, Austria, Germany, Poland, and the Netherlands, granted votes to women immediately after the war was over in 1918. The United States, however, lagged behind, and the suffrage fight was finally won only with difficulty, due to the opposition well financed by the liquor interests and other businesses that thrived on the inequalities of the traditional system.

In Illinois, Nellie Coolley and other of Trout's suffrage "generals" completed their Women's Emergency League work when the constitutional convention resolution was passed in November 1918. Delegates were elected to the Illinois convention to write a new constitution (Dr. Elmer Burt Coolley was elected by the biggest vote among Vermilion County delegates). When the delegates met in 1919, they quickly paid their debt to the Equal Suffrage Association by adopting an article stating that full suffrage to Illinois women would be incorporated into the new constitution.[112] While the delegates were still meeting, however, the Nineteenth Amendment to the U.S. Constitution granting full suffrage to all American women was in the process of being ratified, first by the Illinois legislature in June 1920 and last by Tennessee on August 26, 1920. Danville papers celebrated the occasion, and women voted enthusiastically in elections for state as well as national elections that year.

The National American Woman Suffrage Association did not wait for ratification; its members held a victory celebration in February 1920, symbolically in Chicago because of the significance of Illinois's votes for women in 1913. Attending were the illustrious women leaders of Hull House and Chicago progressivism, the Illinois Equal Suffrage Association and the NAWSA, including Jane Addams, Carrie Chapman Catt, Julia Lathrop, Florence Kelley, Mary McDowell, Catherine McCullough, and Grace Wilbur Trout.[113] Nellie Coolley's name is not listed as a speaker on the program, but it is likely that she attended. The League of Women Voters was organized at the same meeting, and Coolley was named to be one of its first Illinois directors.[114] According to the program for this celebration, the serious suffragists celebrated their long struggle with a cheer: "V – I – C – T – O – R – Y / Victory! Victory! Victory! Aye!"[115]

Women voters made their influence felt immediately. Even before the last states ratified the Nineteenth Amendment, women's votes on the local level had helped make thirty-one states dry, and the Eighteenth, or Prohibition, Amendment had become law. This accomplishment was short-lived, however, as the Prohibition Amendment was repealed just thirteen years later. Despite women voters' support for Progressive reformers, the spirit of progressivism declined in the 1920s, and corruption seems to be with us always. However, to Danville women, the symbolism of the vote was greater than specific accomplishments. As they were interviewed and looked back over the significant events of their lives and their mothers' lives, women regularly mentioned their pride or their mothers' pride in being able to vote. Rose Merlie's mother, Mary Fava, born in Italy and a private woman, was thrilled about getting to vote for the first time, and Rose remembered her mother's excitement eighty years later. Elizabeth Pitlick took her vote seriously; before her first vote, she researched the political parties and determined that "my voice should count too." According to her son, Gladys Walker was a regular and independent voter. Zella Mae Laury had strong political opinions and never missed a trip to the polls. Doris Zook, whose diary is featured in the epilogue, was an active voter and supporter of her political party all of her life. Nellie Coolley was active in politics as a supporter of her husband's campaigns. Her son Marion became a political consultant.[116] The women of Danville who led efforts to make life better for themselves, their families, and their communities were personally empowered by their opportunity to take part in their political system. Danville women shared the joy and relief felt by all those in the Equal Suffrage Association who had worked so hard for suffrage, and in their last newsletter they proclaimed: "The political liberty of the women of the United States is forever established—WE ARE CITIZENS!"[117]

Epilogue THE DIARY OF DORIS ZOOK

Some folks say the world is round
But I believe it square
For so many little hurts we get
From corners here and there.

<div align="center">Diary of Doris Zook,
January 1, 1921</div>

IN THE PROLOGUE TO THIS VOLUME, widow Mary Forbes serves as an introduction to the True Woman of Danville in the 1890s. Burdened by sorrow and loneliness, she used her diary as therapy, describing in detail the daily life of a domestic and pious woman forced to enter the world of business affairs. Her diary illustrates the True Woman poised to move from the private sphere to the public sphere of the New Woman.

The New Women of the 1890s to 1930 were the people most examined and celebrated in this book: the earnest, capable ladies who came out of their homes to reach out to the world through their churches, to assist the unfortunate, to form bonds of sisterhood through study, and to bring beauty and health to their neighborhoods through persuasion and then through the vote. However, as Dorothy Brown points out, "New Woman" was an extremely flexible term. The coming of the New Woman had been "announced, heralded, and denounced since 1900," and by 1930 she took many guises: "veteran reformers, victorious suffragists, powerful athletes, pioneering scientists, Marxists, bohemians, and aviators."[1] Women, according to psychologists, were "claiming the right to dispose of themselves according to their own needs and capacities." Woman's new assertiveness, according to G. Stanley Hall, "carried the promise and potency of a new and truer womanhood."[2]

The arrival of this "new and truer woman" is illustrated by the diary that chronicles the very public lifestyle of twenty-one-year-old Doris Elizabeth

Zook. In her diary, begun in 1921, she promised a daily entry for five years (a promise she would not keep). She went on to her active life outside her home: movies, dances, and late evenings with friends; office skills and jobs; regular overnight train trips; occasional drinking and smoking; and preoccupation with boyfriends. Zook's granddaughter Mary Coffman suggests that Doris was Danville's version of the "flapper."[3]

Coffman's apt characterization of her grandmother Doris is right on target. Historians of the 1920s generally consider the flapper culture an upper-class phenomenon, but scholars of working women, including Joanne Meyerowitz and Lisa Fine, insist that the flapper lifestyle was part of a way of life created by young working women themselves. According to Fine, working women had as much to do with relaxing restraints as did upper-class flappers: "The continued entrance of women . . . into the ranks of the white collar labor force . . . coincided with, and was encouraged by, the loosening of many of the social, economic, and political restraints experienced by the nineteenth century woman."[4]

The young, single, white-collar woman of the period after World War I was an important transitional figure, both personally and historically, in other ways also. Meyerowitz observes that after World War I working and "middle-class women . . . discovered a new morality through self-support and self-expression."[5] No longer did elites set the standard for all women: church and charity work, literary study, club work, political outreach. The spirit of progressivism was no longer dominant; the working women who in their clubs had reached out to the less fortunate had changed their direction. Females "no longer wanted to work to express the ideals of 'love and service,' but to get ahead."[6] Women of the 1920s focused on their own welfare and struggled with their identities in a world of change.

Doris Zook's diary reveals a young woman caught in this transformation of the culture of the American woman. She was obsessed with good times and her own independence, but she also retained much of traditional life. She lived at home and assisted her stern mother, she was involved musically in her church, and she sought to solve her problems with her mother and her boyfriends with a traditional solution: marriage. Doris was almost a prototype of the young woman of the 1920s, both rebellious and traditional.

According to her daughter, Carolyn Coffman, and her granddaughter Mary Coffman, Doris made her home with her mother and father at 519 Harmon until Mr. Zook left them sometime after 1921 and went to Texas.[7] Mrs. Zook then took in laundry not only to support them but also to pay for Doris to have piano lessons. Determined that her daughter would become a concert pianist, she supervised Doris's music practice, slapping a ruler on the piano to keep time. She spared her daughter heavy household duties in order

Doris Zook at age eighteen. Courtesy of Mary Coffman

to protect her delicate hands. In her diary Doris seldom mentions her parents except to say, in the January 6, 1921, entry, in an offhand manner, "Mama had a nervous breakdown"; no details are provided. She records that her mother challenged her to choose between her home and her beaus. She mentions light household duties such as washing, ironing, and sewing, but it is clear that most of her interests lay outside the sphere of her home:

Beatrice and I and Jerry Carr and Walter McAdams went to dance at Brocton. Got back to hotel 12:30. Boys stayed until 2:30. Bed 2:45. Perfectly wonderful time. In fact, best time of my life.

Ed and Bun came in John's roadster. Went down after Beatrice White. Out to Bun's cabin. . . . Left cabin at 12:20. Ed and Bun left my house at 1:30. "Wonderful kids."

"Bun" is short for "Bunny," a nickname that Henry Valentine Miller was given when he was a child "because he was so cute." In her diary Doris Zook records Bun's patient rivalry for her attention with several beaus, most notably Ed Canady. From March 13 through July 23, 1921, Doris listed seventeen beaus by their names in the back of her diary, with Ed at the top of the list:

> Ed and Bun called and both came up at 7:30. Bun didn't know Ed was coming. Bun left right away. Ed stayed. We went driving. Got home 11:50. "Experienced in love."
>
> Went to K of P Hall to dance. Home at 12 o'clock. Bun left 1 o'clock. Didn't have very good time without Ed.
>
> Went to town. Be, Bun and myself went to dance at Court of Honor. Home at 11:45. Ed couldn't go. Had a wonderful time. Be peeved because I danced so much with Bun. Bed 12:20. "Good night."
>
> Got marcel [the popular pressed waves of the 1920s] at 4 o'clock. . . . Bought new evening dress. Went to Delta Kappa Alpha dance in evening with Bun Miller. Bed 1:30.
>
> John Casebeen and myself went to Paris. Had some good wine. Got home 12:45.

According to Mary Coffman, Doris's mother was a prohibitionist, so the wine was likely part of Doris's flapper rebellion. Mary said that her grandmother was not a serious drinker but did make sweet, fruity wines in her home. Sometimes she would tease her granddaughters into wine tastings in the kitchen that left the girls "tipsy." When younger, Doris used tobacco, and she states in the diary entry for March 11, 1921: "Almost got pinched for throwing a cigarette in a car."

Free-spirited Doris and her friends frequently attended movies at the Fisher and later at the Palace Theater. Her diary entry for March 9 reads: "Saw 'The Girl with the Jazz Heart' at the Fisher. . . . Also 'Lying Lips.'" In addition, they attended dances and other events at city parks such as Lincoln and Douglas. They went to fairgrounds, "bathing" in the Wabash River, canoeing, and riding. They liked to make candy and play games such as Flinch and checkers.

However, the life of Danville's flapper was not all parties and free-spirited fun. In the early entries of her diary, Doris mentions Ed and Bun as a pair of buddies who spent time with her and her girlfriend Beatrice. Soon, however, it becomes evident that she prefers Ed's company but that his attentions wander, as evident in entries from January 30 through April 25, 1921:

> Ed and Bun met us. Came home and stayed. Be and Bun left at 11:45. Ed left at 12:30.

Ed and Bun met me at 9. Ed very unthoughtful. Breaks my heart.

Mama up and told me I could decide between Ed and Bun and home. Ed will be my decision. "Love."

Saw Ed in front of Sears. He didn't speak. Got a drink at Feldkamps. Caught 11:30 car home. Ed and Bun passed me up while waiting for car. Nearly broke my heart. Bed 12:15.

Ed came and we agreed to disagree me taking all blame. Ed left at 8:10. Thought I could not breathe again. . . . Ed considers not and therefore I suffer. "Goodbye, my Love."

Home all eve. "Ed even though I am not worthy I crave your love."

Weinie roast at Bun's cabin at 8 o'clock. Played games until 11:30. Came home with Bun. Had wonderful day and Bun a fine fellow. Bed 12:30.

Be, Bun and I went to the Fisher. Bun talked of marriage. "Ed my only love."

Rumor out that Bun and I are married.

The life of our flapper had its little hurts, but Doris Zook did not retreat into the seclusion of her mother's home. She records going to a "women's meeting" but does not include any details in her diary. She also attended a Literary Society, and her granddaughter recalled that when "Nana" was older, she read widely but mostly was interested in nonfiction. She was a proud and conscientious voter all her life; she kept up with current events by reading and watching news so that she would have an informed vote, and she always voted Republican. In addition to attending occasional women's and literary meetings, Doris was an active member of the United Brethren Church. She records regular Sunday school and church attendance in her diary, and she shared her musical talents at the piano in her church and other churches as well. In fact, Doris's most steady job in 1921 was giving music lessons, perhaps in her church and for a while out of a hotel in Hume, Illinois. She commuted there on the train, sometimes giving up to twelve lessons a day; partied with her friend Beatrice and with boys after the lessons were over; spent the night; and traveled home the next day. Her daughter, Carolyn Coffman, remembered that Doris did not enjoy giving music lessons. She was impatient with her young students and often exclaimed, "There's no point wasting time over this!"

Doris completed Brown Business College's two-year program in six months. She had employable skills of typing and stenography but did not seem to have steady employment in 1921. In her diary she mentions a job at a wholesale house and "seeing about a job" at Lakeview Hospital. Mary Coffman recalled that Doris was proud of her office skills, especially since

she won awards in school for the speed of her typing. Speed, in fact, was part of her lifestyle. She typed fast; she played the piano fast; she played euchre fast. She told Mary, "If a thing's worth doing, then it should be done fast." Doris was also proud of her driving skill, and while Mary did not remember her grandmother driving *too* fast, she did recall that Doris drove with one foot on the gas and the other on the brake and could therefore "make the car dance," a jerky and possibly dangerous experience that delighted her granddaughters. In fact, when asked why her grandmother's memory is still so vivid in her mind, Mary Coffman replied, "She was just so much fun." Carolyn Coffman recalled, "She could make going to the grocery store sound like a trip to Paris." Apparently Doris never lost her fun-loving, independent spirit and the rapid pace of her flapper days.

The rumor over Bun and Doris's marriage eventually came true. When Bun first talked of marriage in April 1921, Doris was still smitten with Ed, but apparently due to Ed's wandering attention and Bun's patience and persistence, she accepted a diamond from Bun in August and began to see him exclusively:

> August 26: Talked to Bun on the phone. Tells me his mother knows all.
> August 30: Bun is an ideal gentleman.
> August 31: Made arrangements to be married Sunday.

However, on the following Sunday, Doris went to Sunday school and church and later to Bun's cabin and then for a "ride with Harold. Ten of us in all. Home 11:30." On September 27 she wrote: "Home all day. In evening played at Lincoln Church. Then Lucille and Harold and Bun met me and we drove to Covington. It was at 10:10 that I was ———ed. Then went to Dixie and then home. Bed 12:15." Apparently later, in a different ink color, Doris inserted in the top margin of the September 27 entry: "Married in Covington, Indiana."

Doris kept her marriage secret until she told her outraged mother on October 18, the day she was supposed to leave for music school in Chicago. Banished from home, Doris moved in with her Aunt Florence while "looking for rooms" with Bun, but the rooms never materialized. Doris's granddaughter Mary told the story that Doris did not put in her diary but that she often told to family in front of her husband: the two couples who went to Covington dared each other to get married. Doris accepted the dare (her granddaughter thinks this was the opportunity her patient and persistent grandfather had been waiting for), but the other couple "chickened out" after Doris and Bun were already married by a justice of the peace.

Doris does not reveal her reasons for marriage in her diary. She may have married on a dare or on the rebound from Ed Canady. She may have been

tired of playing the field, or she may have wanted to escape her stern mother. If the latter was her motive, it was not a successful strategy. Much later she told her granddaughter that it was like "jumping from the frying pan into the fire" as she spent the next few years living with her in-laws.

Although Doris taught music lessons and had part-time jobs, she and Bun had little income when they were married. He was an excellent mechanic but was too generous with his time in helping others. Financial strain plagued their marriage until their daughter, Carolyn, grew up and Doris was able finally to use her secretarial skills and go to work outside the home. At Industrial Glove she did payroll, operating one of the first bookkeeping machines and a Dictaphone. She was secretary to Mayor George Rearick and office manager at General Motors. As Doris matured, she accepted her family responsibilities and put her energy and skills to use as she stepped into the working world. Mary said that "Nana" considered herself a career woman.

Doris apparently lost interest in her diary after she got married. Her entries become briefer, fewer, and farther apart. They often say only, "At Mama's," but occasionally a few details emerge, such as playing for a church revival, Bun's birthday, his inability to buy her a Christmas present, his job driving for Cable Piano Company, and the birth of Carolyn Elizabeth on Sunday, November 26, 1922.

Doris Elizabeth Zook Miller was married for nearly fifty years and lived into her nineties. She was deeply mourned by her entire family, including her daughter, Carolyn Elizabeth, and her granddaughter Mary Elizabeth, and others when she was buried beside Henry "Bun" Miller in 1995.

Working Women in Danville:
Statistical Comparison 1895, 1910, 1920

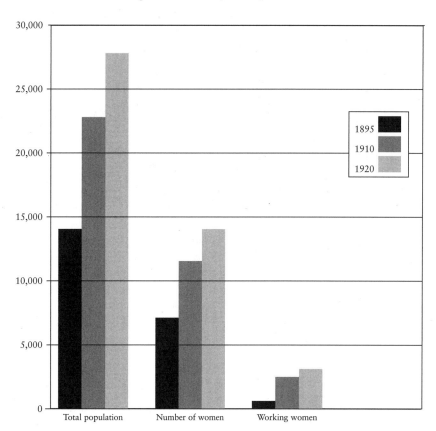

Women of Danville, 1895–1920

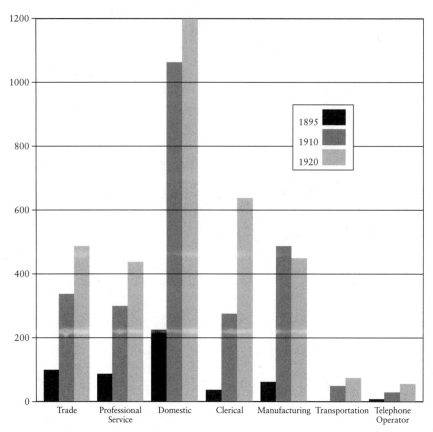

Occupations of Danville Women, 1895–1920

Sources: Danville City Directory, 1895; U.S. Bureau of the Census, *Thirteenth Census of the United States: Total Persons 10 Years of Age and Over Engaged in Each Specified Occupation, Classified by Sex, for Cities Having from 25,000 to 100,000 Inhabitants* (1910), 220–25; U.S. Bureau of the Census, *Fourteenth Census of the United States: Total Persons 10 Years of Age and Over Engaged in Each Specified Occupation, Classified by Sex, for Selected Cities Having from 25,000 to 100,000 Inhabitants* (1920), 260–63.

APPENDIX B

Suffrage Time Line: National, State, Local

1869: National Woman Suffrage Association is founded by Susan B. Anthony and Elizabeth Cady Stanton. American Woman Suffrage Association is then formed by Lucy Stone, Antoinette and Henry Blackwell.

1869: Illinois Woman Suffrage Association is established with Mary Livermore as president. Bill passes granting married women control over their own earnings.

1870: Illinois Woman Suffrage Association holds its first annual convention in Springfield. It fails to get the franchise for women included in the new Illinois Constitution.

1872: Illinois act is passed prohibiting discrimination in employment because of sex, the first such law in the country.

1872: Susan B. Anthony is arrested in New York, with fifteen other women, for casting a ballot. She is tried and fined one hundred dollars, which she refuses to pay.

1873: Illinois law is passed recognizing women's eligibility to hold school office.

1874: Ten women in Illinois are elected county superintendents of schools.

1877: Susan B. Anthony speaks in Danville on February 6.

1879: 180,000 Illinois people sign petitions in favor of woman suffrage in a campaign spearheaded by Frances Willard and the WCTU.

1886: The Illinois Woman Suffrage Association becomes the Illinois Equal Suffrage Association.

1890: National and American Woman Suffrage Associations merge: now NAWSA. Wyoming is admitted to the Union, first to grant women the full vote.

1891: Illinois women are granted the right to vote in school board elections.

1892: The Illinois Woman's Christian Temperance Union, a strong advocate of woman suffrage, holds its annual meeting in Danville.

1893: The World's Columbian Exposition in Chicago includes women as members of the Board of Directors, as members of World Congresses, and in charge of the Woman's Building.

1894: The Chicago Woman's Club establishes the Chicago Political Equality League.

1894: The Illinois Equal Suffrage Association holds its annual convention in Danville.

1894: Illinois women participate in the election of University of Illinois trustees, their first statewide vote.

1897: Caroline Corbin of Chicago forms the Illinois Association Opposed to the Extension of Suffrage to Women.

1904: The Illinois Federation of Woman's Clubs, meeting in Danville, votes in favor of suffrage for all women of the state.

1912: Grace Wilbur Trout is elected president of the Illinois Equal Suffrage Association.

1913: The Presidential and Municipal Suffrage Bill passes in Illinois and is signed on June 26. Illinois becomes the first state east of the Mississippi River to grant women the right to vote for president of the United States.

1914: The General Federation of Women's Clubs, meeting in Chicago, endorses full suffrage for women.

1915: Alice Paul and Lucy Burns establish the Congressional Union, later known as the National Woman's Party.

1916: Five thousand women march into the Republican National Convention in Chicago to support a suffrage plank. The party endorses the concept but leaves the decision to the states. Trout leads a massive voter-registration and voter-turnout campaign for the November elections.

1917: The United States enters World War I. Trout spearheads a coalition to obtain passage of an Illinois constitutional convention resolution. She also works for a federal suffrage amendment.

1917: Danville hosts the Illinois Equal Suffrage Association annual meeting as a tribute to Nellie Coolley's hard work for woman suffrage.

1918: The Illinois Constitutional Convention referendum passes. The convention adopts a woman suffrage plank as its first addition to a new constitution, but the constitution produced by the convention fails to be adopted by the voters in 1922.

1919: Congress passes the Susan B. Anthony Amendment granting full suffrage to women and submits the amendment to the states. Illinois ratifies on June 10 and reratifies on June 17, due to a typographical error.

1920: The Susan B. Anthony Amendment is ratified by thirty-six states. NAWSA and IESA disband and establish the League of Women Voters.

1923: The Illinois Equal Rights Bill, which would have guaranteed legal equality for women, is pushed by Susan Lawrence Dana and the Illinois National Woman's Party. The bill fails.

Sources: Carolyn O. Poplett, *The Woman Who Never Fails: Grace Wilbur Trout and Illinois Suffrage* (Oak Park, Ill.: Historical Society of Oak Park and River Forest, 2000), 57–59; Illinois State Archives, *Illinois Women: 75 Years of the Right to Vote* (Chicago: *Chicago Sun Times*, 1996), 16–19.

NOTES

INTRODUCTION

1. General information on Danville is from Pearson, *Past and Present of Vermilion County, Illinois;* Lottie Jones, *History of Vermilion County,* vol. 1; *Heritage of Vermilion County,* the journal of the Vermilion County Museum; *Danville Commercial-News; Danville Press-Democrat;* Wright, *Danville: A Pictorial History;* and Danville city directories, 1887, 1891, and 1895.

2. John Hallwas, presentation to the Illinois State Historical Society, Nauvoo, Illinois, April 25, 2003.

3. Mary Hartwell Catherwood, "Spirit of an Illinois Town," 45.

4. For biographical essays, see Lottie Jones, *History of Vermilion County,* vol. 2.

5. Wright, *Danville;* Lottie Jones, *History of Vermilion County;* Richard Cannon, "Vermilion County History," Continuing Education, Danville Area Community College (unpublished, 1992).

6. Danville city directories; Cannon, "Vermilion County History"; Wright, *Danville;* diary of Mary Forbes; *Atlas of Vermilion County, Illinois.*

7. Welter, "The Cult of True Womanhood, 1820–1860," 2–4; Nancy Wolock, *Women and the American Experience,* 168.

8. See, for example, Scott, *Natural Allies.*

9. Telephone conversation with Luise Snyder, October 20, 2002.

10. Richard M. Cannon, "A Sociological View of Danville, Illinois, Black Communities" (unpublished, 1970), 28; interviews with Morris Hunter, Rev. Eugene Brandon, Irene Weaver, and Carla Dumas for the Danville Area Community College Diversity Project, spring 1996. All interview were conducted by Danville Area Community College students under the direction of Janet Cornelius, Mary Coffman, and Melissa Gouty, and all are available at the Danville Area Community College Library and the Danville Public Library.

11. Wright, *Danville,* 66–68, 74; Burford and Smith, *The History and Romance of Danville Junction; Twelfth Census of the United States* (taken in 1900).

12. Donald Richter, "Railroads and People of Vermilion County, Part Three," 12–13; Robert Sampson, "Incident at Grape Creek."

13. Donald Richter, *Here Stands the Law,* 31.

14. Scott, *Natural Allies,* 121; Theodora Martin, *The Sound of Our Own Voices,* 3, 33, 67.

15. U.S. Bureau of the Census, *Thirteenth Census of the United States. Total Persons 10 Years of Age and Over Engaged in Each Specified Occupation, Classified by Sex, for Cities Having 25,000 to 100,000 Inhabitants* (1910), 220–25 (hereafter *Thirteenth Census*); U.S. Bureau of the Census, *Fourteenth Census of the United States. Total Persons 10 Years of Age and Over Engaged in Each Specified Occupation, Classified by Sex, for Cities Having 25,000 to 100,000 Inhabitants* (1920), 258–63 (hereafter *Fourteenth Census*).

16. Meyerowitz, *Women Adrift,* 44, 48.

PROLOGUE: THE DIARY OF MARY FORBES

1. Lottie Jones, *History of Vermilion County,* 2:602.

2. *Danville Evening Commercial,* January 9, 1895, 7.

3. Lottie Jones, *History of Vermilion County,* 2:522.

4. Ibid., 522–23.

5. *Danville Commercial-News,* March 26, 1935, 1.

CHAPTER 1: CHURCH LADIES

1. Scott, *Natural Allies,* 85.

2. "Woman, 86, Sunday School Teacher Since 1900, Writes Her Life Story," *Danville Commercial-News,* October 24, 1937, 10.

3. Turner, *Women, Culture, and Community,* 67.

4. Ahlstrom, *A Religious History of the American People,* 860.

5. Mark 12:41–44 and Luke 21:1–4; Pastor Dale Krueger and Doris Krueger, interview by Martha Kay, May 11, 2003.

6. Interview with Margaret McElwee, December 10, 2003.

7. St. Elizabeth's Hospital, *100 Years Together: "People Helping People"* (1982), 4.

8. Mervis, "The History of the Jewish Community in Danville, Illinois," *Heritage of Vermilion County* (Winter 2001–2): 14.

9. Interview with Ivadale Foster, January 20, 2006; Hendricks, *Gender, Race, and Politics in the Midwest,* 31.

10. *Fiftieth Anniversary of the First Presbyterian Church of Danville, Illinois, 1879.*

11. Nelms and Yeomans, *The History of First Presbyterian Church, Danville, Illinois,* 43–45.

12. Telephone coversation with Linda Corley, office manager, First Presbyterian Church, April 20, 2007.

13. Nelms and Yeomans, *The History of First Presbyterian Church,* 20.

14. Ibid., 19–20.

15. *Seventy-Fifth Anniversary of the First Presbyterian Church* (1904).

16. *One Hundredth Anniversary of the First Presbyterian Church* (1929).

17. Nelms and Yeomans, *The History of First Presbyterian Church*, 20.

18. *Blazer*, August 1910, 10. The *Blazer* was a monthly in-house publication, circa 1905–19, that featured sermon extracts, letters from missionaries, recognition of church activities, news about church members, and an occasional poem. Not many copies are extant.

19. Yohn, *A Contest of Faiths*, 4, 18, 34.

20. Verdesi, *In but Still Out*, 70.

21. Yohn, *A Contest of Faiths*, 108, 10.

22. Verdesi, *In but Still Out*, 71; James, ed., *Women in American Religion*, 23; Yohn, *A Contest of Faiths*, 7.

23. Nelms and Yeomans, *The History of First Presbyterian Church*, 18.

24. Ibid.

25. Assorted Women's Missionary Society (WMS) yearly program books stored in church archives.

26. Nelms and Yeomans, *The History of First Presbyterian Church*, 35.

27. Ibid., 18.

28. Krumreig, *History of the First Baptist Church of Danville, Illinois*, 17, 23, 49.

29. Ibid., 51.

30. Beaver, *American Protestant Women in World Mission*, 98.

31. *113th Annual Report of the American Baptist Foreign Mission Society* (1926–27), 65.

32. Pastor Jerry L. Cummins, interview by Martha Kay, January 2003.

33. Lillian Whitten, interview by Martha Kay, January 2003; Marty Burns, "A Timeline of Missions at FBC" (unpublished, 2204, First Baptist Church, Danville).

34. Moore, *History of St. James United Methodist Church*, 1.

35. Mary Jones, *The Women Who Pioneered St. James*, 1.

36. Scrapbook item dated 1949, First Methodist Church papers.

37. Mary Jones, *The Women Who Pioneered St. James*, 2.

38. Moore, *History of St. James United Methodist Church*, 2.

39. Mary Jones, *The Women Who Pioneered St. James*, 2.

40. Hill, *The World Their Household*, 48–49.

41. James, ed., *Women in American Religion*, 19.

42. Hill, *The World Their Household*, 50–51; Robert, *American Women in Mission*, 302–3.

43. Robert, *American Women in Mission*, 303.

44. Norwood, *The Story of American Methodism*, 334.

CHAPTER 2: SISTERS OF THE CLUB

1. Luise Snyder, "History of the Clover Club" (unpublished, 1985), Clover Club papers. Clover Club papers are in the possession of the current president. They include minutes and histories, from 1890 to the present; past and current program books; news clippings; pictures; and miscellaneous items.

2. In Champaign, Illinois, a club with many similarities to the Clover Club began in 1894. Its genesis was not the Chautauqua movement but the National Council of Women of the United States, which was founded in Washington, D.C., in 1888 at the suggestion of Elizabeth Cady Stanton in the interest of woman suffrage. According to its constitution, available in the archives of the Urbana Free Library, Urbana, Illinois, the object of the Champaign Social Science Club, later known as the Social Science Club of Champaign/Urbana, was to discuss "current topics of the day."

3. Scott, *Natural Allies,* 111.

4. Turner, *Women, Culture, and Communty,* 151.

5. Blair, *The Clubwoman as Feminist,* 4, 58, 71.

6. Clover Club papers.

7. Scott, *Natural Allies,* 111.

8. Gere, *Intimate Practices,* 145.

9. Talbot, "A School at Home," 7–8.

10. Ibid., 3–4, 7, 27–28; Morrison, *Chautauqua,* 50, 57; Case and Case, *We Called It Culture,* 12, 15–16; Luise Snyder, "History of the Clover Club" (unpublished, 1985); Clover Club minutes, May 10, 1896.

11. Lottie Jones, *History of Vermilion County,* 1:338, 369–70, 334–35; Wright, *Danville,* 66–67.

12. Authors' visit to Chautauqua, July 2003.

13. Clover Club minutes, October 5, 1895, and October 29, 1894.

14. John Vincent quoted in Talbot, "A School at Home," 130.

15. Talbot, "A School at Home," 129–30, 193–95.

16. Lottie Jones, *History of Vermilion County,* 1:392; Williams, *History of Vermilion County,* 1:448, 457.

17. Clover Club minutes, November 10, 1890.

18. Gere, *Intimate Practices,* 6; Snyder, "History of the Clover Club."

19. Jennie Whitehill, Clover Club history (unpublished, 1904–5); Clover Club minutes, November 5, 1894, January 14, 1895, March 23, 1896, October 25, 1897.

20. Julia Kimbrough, presidential address (unpublished, 1896), Clover Club papers.

21. Ibid.

22. Lottie Jones, *History of Vermilion County,* 2:501–4; obituary for Julia Kimbrough, Clover Club papers, April 29, 1907.

23. Julia Kimbrough, "Modern Life and Future Generations" (unpublished, 1896), quoted in Snyder, "History of the Clover Club"; Whitehill, Clover Club history; Danville Woman's Club yearbook, 1900–1901; minutes of the annual meeting of the Illinois Federation of Women's Clubs (IFWC), Danville, 1904, IFWC papers, Illinois State Library.

24. Snyder, "History of the Clover Club"; May Howard, Clover Club history, 1905–6; Lottie Jones, *History of Vermilion County,* 1:373.

25. Clover Club minutes, November 3, 1902; Travelers Aid Society, vertical file, Danville Public Library.

26. Jennie Lindley, Clover Club history, 1909–10.

27. Dora Hogan, Clover Club history, 1918–19; interview with Rosamond McDonel, Webster descendant and Clover Club member, July 2000.

28. Effie M. English, Clover Club history, 1922–23.

29. Snyder, "History of the Clover Club."

30. Unsigned, Clover Club history, 1901–2.

31. Theodora Penny Martin, *The Sound of Our Own Voices*, 67.

32. Scott, *Natural Allies*, 153.

33. Williams, *History of Vermilion County*, 2:456.

34. Gere, *Intimate Practices*, 47.

35. Unsigned, Clover Club history, 1901–2.

36. Observations of Clover Club practices and interviews with members, 2000–2005. The authors of this book are members of Clover Club.

37. Lottie Jones, *History of Vermilion County*, 2:154–56, 501–4, 181–83; interview with Rosamond McDonel; Clover Club membership rolls.

38. Clover Club papers.

39. Pearson, *Past and Present of Vermilion County*, 56–60; Lottie Jones, *History of Vermilion County*, 2:337–38, 126–30, 627–28; unsigned, "Far from the Madding Crowd," *Heritage of Vermilion County*, 29:3, 4–7.

40. *Atlas of Vermilion County, Illinois*, 87, 90.

41. Danville city directories, 1889, 1895, 1902; Clover Club membership rosters; Snyder, "History of the Clover Club"; interviews with Clover Club members; Mervis, "The History of the Jewish Community in Danville, Illinois," 9.

42. Turner, *Women, Culture, and Community*, 160; Lottie Jones, *History of Vermilion County*, 1:339.

43. Scott, *Natural Allies*, 120.

44. Santmyer, ". . . And Ladies of the Club," 75.

45. Gere, *Intimate Practices*, 29; Scott, *Natural Allies*, 119–20.

46. Talbot, "A School at Home," 27; Clover Club minutes, February 2, 1896.

47. Santmyer, ". . . And Ladies of the Club," 494.

48. Clover Club minutes, January 14 and 21, 1895.

49. Talbot, "A School at Home," 198.

50. Santmyer, ". . . And Ladies of the Club," 494.

51. Clover Club minutes, April 5, 1897.

52. Gere, *Intimate Practices*, 46.

53. Vincent quoted in Talbot, "A School at Home," 252; Morrison, *Chautauqua*, 60.

54. Blair, *The Clubwoman as Feminist*, 4.

55. Elizabeth Peabody quoted in Theodora Penny Martin, *The Sound of Our Own Voices*, 86.

56. Morrison, *Chautauqua*, 61.

57. Ibid., 62.

58. Blair, *The Clubwoman as Feminist*, 57.

59. Talbot, "A School at Home," 7–8, 155–58; Blair, *The Clubwoman as Feminist*, 71; Whitehill, Clover Club history, 1904–5.

60. Talbot, "A School at Home," 155–58.

61. Theodora Martin, *The Sound of Our Own Voices,* 131.

62. Turner, *Women, Culture, and Community,* 159; Blair, *The Clubwoman as Feminist,* 4; Gere, *Intimate Practices,* 45.

63. Helen Webster Hatfield, Clover Club history, 1916–17; unsigned, Clover Club history, 1901–2; Clover Club minutes, May 13, 1898.

64. Memorial book for Julia Kimbrough; Clover Club minutes, April 29, 1907, Clover Club papers.

65. Lindley, Clover club history, 1909–10.

66. Gere, *Intimate Practices,* 14.

CHAPTER 3: BOARD LADIES

1. Woloch, *Women and the American Experience,* 120; Gere, *Intimate Practices,* 10, 48.

2. Jane Addams quoted in Scott, *Natural Allies,* 141.

3. Nora Marks, "Living in Poorhouses," 14–15.

4. McCarthy, *Noblesse Oblige,* 9.

5. Turner, *Women, Culture, and Community,* 148–49; McCarthy, *Noblesse Oblige,* 11; Scott, *Natural Allies,* 80–81.

6. Lottie Jones, *History of Vermilion County;* Williams, *History of Vermilion County;* Danville city directories 1893, 1895, 1909, 1910.

7. Scott, *Natural Allies,* 15.

8. McCarthy, *Noblesse Oblige,* 30.

9. Interviews and correspondence with Rosamond McDonel, March and September 2005.

10. Interview with Doris Slusser and Audrey Slusser Oswalt, June 2001.

11. Scott, *Natural Allies,* 81.

12. Olmsted, *In Their Own Words,* 19.

13. Minutes of the Vermilion County Board of Supervisors (1900–1903), 522.

14. Stapp, *Footprints in the Sands,* 81; Davis, *The Story of the Illinois Federation of Colored Women's Clubs,* 11, 124; Hendricks, *Gender, Race, and Politics in the Midwest,* 26; minutes of the board of directors, Laura Lee Fellowship House, 1945 (courtesy of Gladys Davis).

15. Short, *Black and White Baby,* 35–36.

16. McCarthy, *Noblesse Oblige,* 8.

17. Olmsted, *In Their Own Words,* 17.

18. Ibid., 19.

19. McCarthy, *Noblesse Oblige,* 8.

20. Jean Byram, "Only a Number on Their Graves," *Danville Commercial-News,* March 17, 1991.

21. Mary Giddings quoted in the *Danville Sunday Press,* March 21, 1897.

22. Ginzberg, *Women and the Work of Benevolence,* 2.

23. Scott, *Natural Allies,* 16, 159.

24. Ibid., 24.

25. Blair, *The Clubwoman as Feminist,* 119.

26. Ibid., 114–15.

CHAPTER 4: CURRENTS OF REFORM

1. Kevin Cullen, "Sad to Leave Home," *Danville Commercial-News,* March 5, 1993.

2. Susan Richter, "Y.W.C.A. Danville, Illinois," 2–9.

3. "Literature Club Outstanding in Study Work for 40 Years," December 9, 1933, Danville Woman's Club scrapbooks, Vermilion County Museum.

4. Ibid.

5. Wood, *The History of the General Federation of Women's Clubs,* 100.

6. Scott, *Natural Allies,* 142–43.

7. "National Federation of Women's Clubs Formed in Chicago in October 1894" (n.d.), Danville Woman's Club scrapbooks, Vermilion County Museum.

8. Jane Head Fithian, president's address, *Program of the Tenth Annual Meeting, Illinois Federation of Women's Clubs,* Danville, Illinois, October 17–21, 1904.

9. Wood, *The History of the General Federation of Women's Clubs,* 21–22.

10. "Literature Club Outstanding in Study Work for 40 Years."

11. *First Calendar of the Woman's Club of Danville* (Danville Woman's Club yearbook), 1895–96.

12. Stapp, *Footprints in the Sands,* 80.

13. Ibid.

14. Interview with Dow Cooksey, August 14, 2003.

15. Vera Janes, "A Heritage of Love: An Autobiography" (unpublished, circa 1973), 3.

16. Stapp, *Footprints in the Sands,* 80; Danville Woman's Club yearbooks, 1900–1901, 4; 1899–1900, 2.

17. Stapp, *Footprints in the Sands,* 80; Danville High School *Medley,* 1908; Danville Woman's Club yearbooks, 1900–1901, 4; 1899–1900, 2.

18. Stapp, *Footprints in the Sands,* 80.

19. Ibid.

20. Obituary for Frances Pearson Meeks, *Danville Commercial-News,* April 5, 1966.

21. Danville Woman's Club yearbook, 1895–1924; interview with Betty Goff, September 20, 2003.

22. Danville city directories, 1895, 1901, 1907; Danville Woman's Club yearbook, 1895–96; Janes, "A Heritage of Love," 1.

23. "Literature Club Outstanding in Study Work for 40 Years."

24. Danville Woman's Club yearbook, 1896–97, 10, 13.

25. Mary Jo Deegan, introduction to *The New Woman of Color,* edited by Deegan, xxxi–xxxii.

26. Richard Cannon has noted that after the turn of the century the Danville community was rarely without a black physician and a black dentist; see Cannon, "A Sociological Overview of Danville, Illinois, Black Communities" (unpublished,

May 29, 1970), 28. Danville African Americans had stores, postal stations, fire stations, and churches; African American children attended Collett School in the early twentieth century and later the all-black Jackson school as well as other Danville schools. Information is from interviews with Morris Hunter, Rev. Eugene Brandon, Irene Weaver, and Carla Dumas for the Danville Area Community College Diversity Project, spring 1996.

27. Davis, *The Story of the Illinois Federation of Colored Women's Clubs,* 11; Hendricks, *Gender, Race, and Politics in the Midwest,* 26.

28. Davis, *The Story of the Illinois Federation of Colored Women's Clubs,* 124; Hendricks, *Gender, Race, and Politics in the Midwest,* 58. A national goal of the federation was "to reform the moral behavior and attitudes of the young men and women of their race through education and voluntary efforts"; see Odem, *Delinquent Daughters,* 28.

29. Short, *Black and White Baby,* 35.

30. Davis, *The Story of the Illinois Federation of Colored Women's Clubs,* 124, 128. Danville African American women's social, religious, and civic clubs proliferated in the 1920s and 1930s. Among them was the Colored Women's Civic Club, whose members included Edwarda C. Martin Foulks, Helene Smith, Burtella McDougal, and Magnolia Glover. The club was responsible for getting the city to create Carver Park playground in 1940 and the housing project added later. Information is from interview with Ivadale Foster, January 20, 2006.

31. Turner, *Women, Culture, and Community,* 232.

32. Lottie Jones, *History of Vermilion County,* 2:668; "Literature Club Outstanding in Study Work for 40 Years."

33. Danville Woman's Club yearbook, 1896–97, 12–15; Danville city directories, 1895, 1897.

34. Cullen, "Sad to Leave Home."

35. Danville Woman's Club yearbook, 1896–97, 7.

36. Ibid., 1896–1915, 1945, 1955.

37. Ibid., 1896–97, 6; 1900–1901, 3.

38. McArthur, *Creating the New Woman,* 76.

39. Cullen, "Sad to Leave Home"; Danville Woman's Club yearbooks, 1897–1930, 1940. The Woman's Club sold its house in 1993, as membership declined and many members could not climb the house's steep stairs. Still active in Danville, the Woman's Club meets at Harrison Park Clubhouse, the former residence of Minta Harrison, a club member.

40. McArthur, *Creating the New Woman,* 76.

41. Tax, *The Rising of the Women,* viii.

42. Danville Woman's Club yearbooks, 1906–7, 12–13; 1912–13, 6; 1914–15, 9; 1915–16, 17; *Danville Press-Democrat,* January 8, 1911, 2.

43. Danville Woman's Club yearbooks, 1913–14, 9; 1914–15, 9, 12–13.

44. Diary of Mary Forbes, November 4, 1897.

45. Addams, *Democracy and Social Ethics.*

46. "Jane Addams," *Danville Evening Commercial,* 1; November 5, 1897; *Danville Daily News,* November 3 and 5, 1897.

47. *Danville Daily News,* November 5, 1897.

48. Program of the IFWC tenth annual meeting, Danville, Illinois, May 1904.

49. The Illinois IFWC movement was part of a nationwide effort to provide young girls with some legal protection from sexual predators. Illinois did change the age of consent from ten to sixteen before 1920; see Odem, *Delinquent Daughters,* 8–16.

50. Proceedings of the IFWC tenth annual meeting.

51. Danville Woman's Club yearbook, 1897–98, 9; "Literature Club Outstanding in Study Work for 40 Years."

52. Danville Woman's Club yearbooks, 1896–97, 9–10; 1897–98, 9.

53. Ibid., 1904–5, 9–10; 1914–15, 9; 1917–18, 14.

54. Turner, *Women, Culture, and Community,* 162–63.

55. Wood, *The History of the General Federation of Women's Clubs,* 142–43.

56. Danville Woman's Club yearbooks, 1898–99, 17; 1899–1900, 18.

57. Ibid., 1898–99, 17; 1899–1900, 16–17.

58. Ibid., 1899–1900, 18; Turner, *Women, Culture, and Community,* 146.

59. McArthur, *Creating the New Woman,* 50.

60. Danville Woman's Club yearbook, 1905–6, 29–30.

61. Ibid., 1905–6, 31, 13; 1906–7, 23; 1910–11, 10.

62. Ibid., 1906–7, 31. The Illinois Woman's Alliance had achieved a compulsory school law for Illinois in 1889, but many loopholes allowed parents to exempt children for family labor and other circumstances; see Tax, *The Rising of the Women,* 76–77.

63. Danville Woman's Club yearbook, 1910–11, 8, 14.

64. Ibid., 1914–15, 15.

65. Ibid., 1918–19, 9; 1920–21, 8.

66. Ibid., 1921–22, 8.

67. "Shoe and Stocking Fund Helps Relieve Distress," clipping, circa 1931, Danville Woman's Club scrapbooks, Vermilion County Museum.

68. "Open Meeting of Woman's Club Is Held at Y.W.," clipping, October 3, 1928, Danville Woman's Club scrapbooks, Vermilion County Museum; Janes, "A Heritage of Love," 15. The project was also known as the "Open Window Room." Douglas school's brief history describes the Open Window Room as an attempted treatment for tuberculosis (vertical file, Vermilion County Museum). Perhaps the two descriptions could be reconciled; underweight children were vulnerable to tuberculosis.

69. "Open Meeting of Woman's Club Is Held at Y.W."

70. Wood, *The History of the General Federation of Women's Clubs,* 261–62.

71. *Danville Press-Democrat,* January 13, 1911, p1, 8.

72. Danville Woman's Club yearbooks, 1903–4, 6; 1904–5, 20.

73. Ibid., 1911–12, 7.

74. McArthur, *Creating the New Woman,* 52.

75. Danville Woman's Club yearbook, 1903–4, 12–13.

76. Ibid., 1905–6, 10–11.

77. Ibid., 1907–8, 10; Wood, *The History of the General Federation of Women's Clubs,* 183, 210.

78. McArthur, *Creating the New Woman,* 36.

79. Turner, *Women, Culture, and Community,* 205.

80. Danville Woman's Club yearbook, 1905–6, 28.

81. Ibid.

82. Ibid., 1906–7, 14.

83. Ibid., 1907–8, 15.

84. Ibid., 1909–10, 20.

85. Ibid., 1912–13, 7.

86. Ibid., 1916–17, 13.

87. Wood, *The History of the General Federation of Women's Clubs,* 283.

88. Danville Woman's Club yearbook, 1920–21, 12–13.

89. Ibid., 1923–24, 11–12.

90. Ibid., 102–3.

91. Ibid., 105.

92. Ibid., 1915–16, 18.

93. Ibid., 19.

94. Ibid.

95. Ibid., 1911–12, 28; 1914–15, 30.

96. Ibid., 1925–26, 31; 1929–30, 33.

97. Ibid., 1917–18, 21; 1918–19, 17.

98. Ibid., 1918–19, 14, 16–17; 1919–20, 10.

99. Ibid., 1918–19, 18.

100. Margaret Martin, "Red Cross: The Vermilion County Chapter," 7; Rawlings, *The Rise and Fall of Disease in Illinois,* 105, 106.

101. Boynton, "'Even in the Remotest Parts of the State': Downstate 'Woman's Committee' Activities on the Illinois Home Front during World War I," *Journal of the Illinois State Historical Society* 96 (Winter 2003–4): 318.

102. Ibid., 319.

103. Danville Woman's Club yearbook, 1918–19, 16; minutes of meetings of the Illinois Woman's Committee, Council for National Defense, Illinois Division, March 22, 1918.

104. Danville Woman's Club yearbook, 1918–19, 14.

105. Report of the Child Welfare Department of the Illinois Woman's Committee, Council for National Defense, Illinois Division, March 1918.

106. Boynton, "'Even in the Remotest Parts of the State,'" 331–33.

107. Danville Woman's Club yearbook, 1918–19, 20–21.

108. Report by Vermilion County chair Mrs. W. S. Dillon, minutes of meetings of the Woman's Committee, June 20, 1918.

109. Frances Pearson Meeks to Mrs. H. M. Dunlap, Danville, April 18, 1918; Illinois Woman's Committee of the Council for National Defense, Papers, Illinois State Archives.

110. Minutes of meetings of the Illinois Woman's Committee, April 23, 1918.

111. See, for example, the notice of the "Woman's Farm and Garden" conference, featuring one woman's effort to manage a farm for the Women's Reserve Army,

"Farmers Can Make or Break Country," *Danville Press,* October 14, 1917, 2. Records of conferences, Illinois Woman's Committee, June 4, 1918.

112. Records of conferences, Illinois Woman's Committee, June 4, 1918.

113. Margaret Martin, "Red Cross Parade and Wonderful Spectacle," 7; *Danville Commercial-News,* May 20, 1918.

114. Records of conferences, Illinois Woman's Committee, March 4, 1919.

115. Boynton, "'Even in the Remotest Parts of the State,'" 321.

116. Lottie Jones, *History of Vermilion County,* 2:634–35.

117. Records of conferences, Woman's Committee, March 4, 1919.

118. Ibid.

119. Ibid.

120. Danville Woman's Club yearbook, 1912–13, 9.

121. Ibid., 1921–22, 12.

122. An interview with Marlene Cannon, May 2005, provided evidence of increased racial and religious exclusiveness among Danville's elite in the late 1920s.

123. Cullen, "Sad to Leave Home."

124. Danville Woman's Club scrapbook, 1931.

125. Wood, *The History of the General Federation of Women's Clubs,* 99.

CHAPTER 5: "A ROBUST, GRITTY CREW"

1. Interview with Gladys Walker, May 2002; *Danville Sunday Press,* March 13, 1955; *Danville Commercial-News,* March 22, 1964; Danville city directories, 1895 and 1897. Gladys Walker died at the age of 102.

2. Danville city directories, 1915 and 1901.

3. Clipping, Jean Byram, "50-Year YWCA Member Finds Challenge in Youth," *Danville Commercial-News,* 1963, YWCA papers; Danville city directories, 1915, 1921, 1927, 1931.

4. Correspondence with labor-market analyst Richard Cannon, University of Illinois, March 2006.

5. Catherine Clinton, introduction to Joanne Meyerowitz, *Women Adrift,* xxii.

6. Ibid., xvii.

7. Fine, *Souls of the Skyscraper,* 53.

8. Ibid.

9. See appendix a. While a large number of Danville women were employed as domestic servants in 1920, they were only 14 percent of employed women, a decline of one-third from 1910. See *Thirteenth Census,* 220–25; and *Fourteenth Census,* 260–63.

10. Danville city directory, 1907–8. Many more African American women may also have been in domestic or laundry work. If they were married, only their husbands' occupations were listed.

11. Interview with Lou O'Brien, January 27, 2006.

12. *Illustrated History of the National Home for Disabled Volunteer Soldiers, Danville Branch;* "History of the Veterans Administration Hospital, Danville, Illinois," 28. The upper level of the cafeteria is now the second floor of the Clock

Tower Building at the Danville Area Community College and houses liberal arts offices and classrooms.

13. Danville's employment censuses bear this out. Almost 10 percent of employed women in Danville were dressmakers in 1910, but that percentage was reduced to 3 percent in 1920; see *Thirteenth Census* and *Fourteenth Census*.

14. Sue Richter, "Yesterday's Recipes," *Heritage of Vermilion County* 29 (Autumn 1993): 12.

15. Interview with Lou O Brien, January 27, 2006.

16. Interview with Elizabeth Pitlick, age ninety-two, November 7, 2005.

17. Interview with Rose Merlie and her granddaughter Melissa Merli, February 20, 2000. Rose Merlie was 100 years old when she participated in the interview. She died at the age of 105.

18. Danville city directory, 1895; Burford and Smith, *The History and Romance of Danville Junction,* 112.

19. Danville city directories, 1895 and 1897; "Hacker's Fair, Everyone's Stores," *Heritage* 26 (Autumn 1992): 13–16.

20. Cannon, "A Sociological Overview of Danville, Illinois, Black Communities," 14, 28; interviews with Joseph Williams, James Withers, Agnes Luttrell, and Eugene Brandon for the Danville Area Community College Diversity Project, 1996.

21. Danville city directory, 1895.

22. Correspondence with Sybil Mervis, June 2007.

23. Mervis, "The Danville Public Library: The Twentieth Century," 3; Clover Club membership rolls, 1894–1900, Clover Club papers.

24. Stapp, *Footprints in the Sands,* 90; obituary for Myrtle Johnson Robinson, *Danville Commercial-News,* December 7, 2002.

25. Danville city directories, 1895–1913; *Thirteenth Census,* 224–25; *Fourteenth Census,* 258–59.

26. Janes, "A Heritage of Love," 7–8.

27. *Thirteenth Census* and *Fourteenth Census.*

28. Danville city directory, 1907; minutes of the Young Women's Christian Association (YWCA), February 3, 1910.

29. Danville city directories, 1895, 1901, 1907; news clippings, December 8 and 9, 1915, April 15, 1916, YWCA scrapbook.

30. *Fourteenth Census;* "History of the Veterans Administration Hospital, Danville, Illinois," 27.

31. *Lakeview: 100 Years of Caring* (1994); St. Elizabeth's Hospital, *100 Years Together: People Helping People* (1982). The two hospitals merged in 1988 as Provena Covenant Hospital. The St. Elizabeth portion of the hospital has been closed.

32. *Thirteenth Census* and *Fourteenth Census.*

33. Danville city directories, 1895 and 1907; *Danville Banner,* August 5, 1909, 3.

34. Vermilion County Court, Recognizance Records, 1910.

35. Danville city directories, 1895, 1911, 1915; Danville Woman's Club yearbooks, 1897–98, 1901–2.

36. Fine, *Souls of the Skyscraper,* 53.

37. Danville city directory, 1895; *Fourteenth Census.*

38. Benson, *Counter Cultures,* 134–39.

39. Donald and Sue Richter, "The Great White Store," *Heritage of Vermilion County* 23 (Winter 1986–87): 6.

40. Danville city directory, 1895; *Thirteenth Census* and *Fourteenth Census.*

41. Fine, *Souls of the Skyscraper,* xvi, 22.

42. *Thirteenth Census* and *Fourteenth Census.*

43. Danville city directory, 1895.

44. Louise Mills, "The Jones Family," 17.

45. Danville Woman's Club yearbook, 1915; Danville city directories, 1895 and 1907.

46. Danville High School *Medley,* 1908, 1910, 1915; Danville city directories, 1895 and 1907.

47. "Cleona Lewis: Farm Girl to Economist," 10–11.

48. Fine, *Souls of the Skyscraper,* 53.

49. Ibid., 74.

50. Ibid., 51, 168.

51. Interview with Wesley Walker, July 2003.

52. Danville city directories, 1913, 1914, 1915, 1917.

53. Keiser, "John H. Walker: Labor Leader from Illinois," 76, 92.

54. John Walker to G. Woodhouse, May 16, 1916, John Walker Papers, Illinois Historical Survey.

55. Interview with Rose Fava Merlie, February 20, 2000; Keiser, "John H. Walker," 91.

56. Keiser, "John H. Walker," 93; Danville city directory, 1919.

57. Diary of Elizabeth Stewart. We are indebted to Brenda Voyles for calling this diary to our attention.

58. Ibid.; Vigo County Marriage Records, October 5, 1916.

59. Meyerowitz, *Women Adrift,* xvii.

60. Ibid., 4.

61. Sarah Brewster quoted in Bremer, introduction to Elia W. Peattie, *The Precipice,* xxi.

62. Meyerowitz, *Women Adrift,* 15–17.

63. Clinton, introduction to Meyerowitz, *Women Adrift,* xvi.

64. *Report of the Senate Vice Committee Created under the Authority of the 48th General Assembly, State of Illinois,* 709, 714–15, 725, 729, 827–28, 835.

65. Ibid., 828.

66. Meyerowitz, *Women Adrift,* 41.

CHAPTER 6: "SIN CITY" AND ITS REFORMERS

1. Short, *Black and White Baby,* 79.

2. Donald Richter, "Railroads and People of Vermilion County, Part Three," 1, 4, 5.

3. Burford and Smith, *The History and Romance of Danville Junction,* 18–19.

4. Ibid., 106–7, 112; Danville city directories, 1895 and 1907.

5. *Danville Commercial-News,* February 4, 1911, 9, and *Danville Press,* October 16, 1917, 16.

6. Danville city directories, 1895, 1901, 1907; Vermilion County Court, Recognizance Records, 1910.

7. *Danville Commercial-News,* September 28, 1915.

8. Short, *Black and White Baby,* 86.

9. Ibid., 80–81. Danville city directories of the 1920s and early 1930s designated residents by race. Several African American family members carried the same last names as the entertainers, but none listed in city directories had those first names during that period.

10. Short, *Black and White Baby,* 81. In 1930 Hazel Myers lived in the National Soldiers Home, where she was a clerk; see Danville city directory, 1930.

11. Vermilion County Court, Recognizance Records, 1880, 1881, 1891.

12. "Hell's Half-Acre," *Danville Banner,* August 5, 1909, 1. Two women identified themselves as residents of Gobin Gulch in the Danville city directory for 1907–8.

13. Donald Richter, *Here Stands the Law,* 14.

14. Ibid., 53.

15. Ibid., 87–88.

16. Ibid., 156, 166; Vermilion County Court, Recognizance Records, 1903. Bessie Dodge's later whereabouts are unknown.

17. *Atlas of Vermilion County, Illinois,* 86, 90; *Standard Atlas of Vermilion County, Illinois,* 11.

18. Editorial, *Danville Banner,* March 11, 1909, 4.

19. Ibid., August 5, 1909.

20. "Prostitution Phenomenon," *Danville Commercial-News,* August 3, 1991, 3A; interview and survey of the neighborhood with Vic Pate, September 20 and October 5, 2005. For local news coverage of Danville being declared "off-limits" to Chanute airmen, see *Danville Commercial-News,* March 19, 20, 22, 23, and 28, 1956.

21. Meyerowitz, *Women Adrift,* 39.

22. Ibid., 104; Hobson, *Uneasy Virtue,* 106.

23. Short, *Black and White Baby,* 79.

24. Meyerowitz, *Women Adrift,* 104.

25. Rosen, *The Lost Sisterhood,* 146–47; Hobson, *Uneasy Virtue,* 104.

26. Butler, *Daughters of Joy, Sisters of Misery,* 154, 27.

27. Phoenix, *Making Sense of Prostitution,* 75.

28. *Danville Banner,* January 28, 1909, 4.

29. "Emma Dee No More to Face the CAD!: Has Passed to Realm Where She Must Plead before Highest Tribunal in the Universe," *Danville Press-Democrat,* January 14, 1911, 8.

30. "Eight Captured in Police Raid," February 22, 1911, 2; "Eva was Fined," February 16, 1911, 9; "Arrested Woman on Charge of Loitering," February 13, 1911, 31, all in *Danville Commercial-News.*

31. "Woman Arrested for Violating Parole." *Danville Commercial-News*, February 14, 1911, 9.

32. "Arrested White Women for Larceny," *Danville Commercial-News*. February 2, 1911, 10; "Is Abraham Willus Feigning Insanity?," *Danville Commercial-News*, February 5, 1911, 1.

33. Interviews with Vic Pate, Sept. 20 and Oct. 5, 2005; interview with Elizabeth Pitlick, July 18, 2006.

34. Interview with Dr. John Curtis, June 21, 1999.

35. "Wealthy Woman in Police Court," *Danville Commercial-News*, February 23, 1911, 5.

36. "Grand Jury Has Finished Sifting," *Danville Press-Democrat*, March 15, 1911, 10.

37. Hobson, *Uneasy Virtue*, 149.

38. Addams, *A New Conscience and an Ancient Evil*, 18.

39. Kevin Cullen, "Danville's Brothels," manuscript in his possession, March 8, 1991.

40. Vermilion County Court, Recognizance Records, 1918; Rawlings, *The Rise and Fall of Disease in Illinois*, 106.

41. "City Must Prove Itself, Chanute's General Says," *Danville Commercial-News*, March 18, 1956, 21.

42. Rosen, *The Lost Sisterhood*, 52.

43. McArthur, *Creating the New Woman*, 84.

44. Short, *Black and White Baby*, 52.

45. Rosen, *The Lost Sisterhood*, 11.

46. Pivar, *Purity and Hygiene*, xiii.

47. Rosen, *The Lost Sisterhood*, 11.

48. Wood, *The History of the General Federation of Women's Clubs*, 266–67.

49. Danville Woman's Club yearbooks, 1910–11, 9; 1912–13, 8.

50. Donovan, *White Slave Crusades*, 20; Rosen, *The Lost Sisterhood*, 123; Wood, *The History of the General Federation of Women's Clubs*, 266; Cordasco, with Pitkin, *The White Slave Trade and the Immigrants*, 3.

51. *Report of the Senate Vice Committee*, 42.

52. "White Slave Traffic in Danville," *Danville Banner*, January 27, 1910, 1; *Danville Press-Democrat*, March 4, 1911, and *Danville Commercial-News*, January 24, 1911.

53. Trevor Jones, "An Ordinary Life in Illinois," 228. Zay Wright lived in Champaign County.

54. Vermilion County Court, Recognizance Records, 1911.

55. "Serious Charge Filed by Girl," *Danville Commercial-News*, June 27, 1913, p. 1.

56. Vermilion County Court, Recognizance Records, 1920.

57. Katherine Joslin, introduction to Addams, *A New Conscience and an Ancient Evil*, x.

58. Addams, *A New Conscience and an Ancient Evil*, 69, 71–72.

59. Ibid., 84–85.

60. Ibid., 87.

61. *Report of the Senate Vice Committee*, 709–29, 827–28, 835.

62. Ibid., 935–37.

63. News clipping, May 24, 1924, Danville Woman's Club scrapbooks, Vermilion County Museum.

64. "Traveler's Bid," *Danville Commercial-News*, September 28, 1941, July 15, 1951, and December 16, 1951, vertical file, Danville Public Library.

65. Nelms and Yeomans, *The History of First Presbyterian Church*; "Danville's Appeal," January, 1, 1916, YWCA scrapbooks.

66. Minutes of the Danville YWCA, 1910, YWCA papers.

67. Ibid.

68. YMCA vertical file, Danville Public Library. The YMCA erected another new building, at 1100 North Vermilion, in 1972; the YWCA, now Your Family Resource Center, remains in the Hazel Street building erected in 1923.

69. Tribute to Nellie Coolley (unpublished, 1944); rosters of YWCA board officers; dedication ceremony for YWCA building, 1923—all in Danville YWCA papers.

70. Sam Levin, "Joseph Cannon," *Heritage of Vermilion County* 1 (Summer 1965): 2–9; minutes of the Danville YWCA, 1910–12; minutes of the YWCA Religious Work Committee, 1915–17; Lottie Jones, *History of Vermilion County*, 2:755, 299–300; Danville city directories, 1909 and 1911.

71. Lottie Jones, *History of Vermilion County*, 2:176–78; Danville city directories, 1909 and 1911.

72. Donald Richter, *Here Stands the Law*, 53, 23, 41, 87, 110, 167.

73. Minutes of the YWCA Religious Work Committee, 1915–17; Mrs. C. L. Bennett, "Centennial History of the YWCA" (unpublished, February 3, 1955), YWCA papers.

74. Minutes of the Danville YWCA, 1910 and 1911; Danville city directory, 1911.

75. Interviews with former Danville YWCA directors Carolyn Miller Coffman and Ellen Morris, December 31, 2002, and November 14, 2001, respectively.

76. Meyerowitz, *Women Adrift*, 48, 49. Meyerowitz analyzed the YWCA materials from the 1880s and 1890s and concluded that, since the YWCA's overarching theme was the fear of sexual danger, its rhetoric portrayed women as weak, innocent, passionless, naive, and dependent, in need of not only protection but also parental guidance. Her analysis is period-specific, however. Studying the YWCA of a later period, Fine concluded that the YWCA was the organization most changed by its membership; she chronicles its development of "services oriented to the economic and personal needs of the business woman" (Fine, *Souls of the Skyscraper*, 184). Danville's Y experience resembles Fine's description.

77. Fine, *Souls of the Skyscraper*, 184.

78. Wilson, *Fifty Years of Association Work among Young Women*, 61.

79. Minutes of the YWCA, 1915; Susan Richter, "Y.W.C.A. Danville, Illinois," 6; interview with Lee McGrath, age ninety-six, May 31, 2001. McGrath was a YWCA board member and executive director from 1954 to 1970.

80. Minutes of the YWCA, 1910, 1911; minutes of YWCA Religious Work Committee; "YWCA: A Center of Learning" (1956) and "After 50 Years, Girls Still Call YWCA 'Home'" (1965), news clippings, YWCA papers.

81. "YWCA: A Center of Learning."

82. "The Y of the Woods" (unpublished, circa 1915), YWCA papers.

83. Ibid.; minutes of the YWCA, 1913.

84. "The Y of the Woods."

85. Minutes of the YWCA, 1910, 1911; Sims, *The Natural History of a Social Institution,* 90.

86. Susan Richter, "Y.W.C.A. Danville, Illinois," 2–9.

87. Newspaper clipping, February 7, 1916, YWCA papers.

88. Danville High School *Medley,* 1915; Fine, *Souls of the Skyscraper,* 161.

89. Roydhouse, "Bridging Chasms: Community and the Southern YWCA," 3.

90. Interviews with Rose Fava Merlie, February 20, 2000, and Elizabeth Pitlick, July 18, 2006. A branch of the YWCA was briefly attempted in Westville in 1916.

91. Interview with Gladys Walker, May 2002.

92. Danville High School *Medley,* 1917.

93. Interview with Gladys Walker, May 2002.

94. Wilson, *Fifty Years of Association Work,* 87.

95. Minutes of the YWCA, 1913; Susan Richter, "Y.W.C.A. Danville, Illinois," 3–4.

96. News clippings, February 11 and 22, 1916, YWCA papers; Danville YWCA programs and reports to the board of directors, 1925–28, YWCA papers.

97. Murolo, *The Common Ground of Womanhood,* 29.

98. News clipping, December 20, 1915, YWCA papers.

99. YWCA reports, 1925; news clippings, 1924, YWCA scrapbooks.

100. YWCA reports, 1925, 1926; interview with Gladys Walker, May 2002.

101. Interview with Gladys Walker, May 2002.

102. Murolo, *The Common Ground of Womanhood,* 128–29.

103. News clippings, n.d., YWCA papers.

104. Interview with Gladys Walker, May 2002.

105. Ibid.; YWCA reports, 1925–28.

106. Interviews with Lee McGrath, May 31, 2001, and Carolyn Miller Coffman; Janes, "A Heritage of Love," 2; Janes and Irma McConnell Giese were sisters.

107. Interview with Dorothy Sturm Duensing, summer 2001.

108. Interview with Lee McGrath, May 31, 2001.

109. Interviews with Carolyn Miller Coffman, December 31, 2002, and Dorothy Sturm Duensing, January 26, 2002; "Danville's Outstanding Women of 1963 Selected," *Danville Commercial-News,* March 22, 1964.

110. Scott, *Natural Allies,* 105.

111. "Associated Charities Finally Launched under Y Leadership," *Danville Press-Democrat*, March 7, 1911, 10; Danville city directories, 1913 and 1915.

112. Bennett, "Centennial History of the YWCA" (unpublished, February 3, 1955); Danville YWCA bulletin, 1923; Sims, *The Natural History of a Social Institution*.

113. News clippings, April 28, 1916, September 22, 1916, and 1924, YWCA scrapbooks.

114. Bennett, "Centennial History of the YWCA"; Woodbury, scrapbook 2, Vermilion County Museum.

115. YWCA papers, February 21, 1916.

116. "Thousands of Women Ask for Building," *Danville Commercial-News*, February 28, 1916.

117. Ibid.

118. Dedication ceremony for the YWCA building (unpublished, 1923), YWCA papers.

119. Interview with Lee McGrath, May 31, 2001.

120. Interview with Gladys Walker, May 2002.

121. Ibid.

122. Interview with Wesley Walker; Loran Walker's diary, courtesy of Wesley Walker.

123. Interviews with Gladys Walker, May 2002, and Carolyn Coffman, December 31, 2002; minutes of the Laura Lee Fellowship House, 1945, courtesy of Gladys Davis.

124. Interview with Gladys Walker, May 2002.

CHAPTER 7: "FORCES TO BE RECKONED WITH"

1. Burford and Smith, *The History and Romance of Danville Junction*, 176.

2. Scott, *Natural Allies*, 44–45.

3. Ibid., 45.

4. Gusfield, *Symbolic Crusade*, 3.

5. Bordin, *Woman and Temperance*, 5, 161.

6. Murdock, *Domesticating Drink*, 4.

7. Woman's Christian Temperance Union Web site, wctu.org (June 2004).

8. Bordin, *Woman and Temperance*, 15.

9. The Chautauqua movement began as a Sunday school conference, served as the site for WCTU organization, and then moved on to promote individual and group education. By the 1900s nationwide Chautauqua educational assemblies were sponsored by temperance and prohibition groups, and their messages heavily emphasized temperance goals.

10. Bordin, *Woman and Temperance*, xvi–xvii.

11. Interview with Virginia Beatty, July 12, 2004, WCTU National Library, Frances Willard home, Evanston, Illinois.

12. Giele, *Two Paths to Women's Equality*, 87.

13. Minutes of the WCTU annual national meeting, 1896.

14. *Danville Commercial* editor W. R. Jewell had also thanked the WCTU for helping the men's blue ribbon group (*Danville Weekly News,* March 29, 1878).

15. Minutes of the WCTU annual state meeting, 1892.

16. Danville city directories, 1889, 1891, 1895, 1901; Danville Woman's Club yearbook, 1911.

17. Minutes of the WCTU annual state meeting, 1892.

18. *Danville Commercial,* March 2, 1894.

19. Danville city directories, 1891, 1895; Danville Woman's Club yearbooks, 1896–99; *Danville Banner,* August 8, 1909; Pearson, *Past and Present of Vermilion County,* 370–71.

20. Minutes of the WCTU annual state meeting, 1892.

21. Ibid.

22. Ibid.

23. Buechler, "Social Change and Movement Transformation," 362; Bordin, *Woman and Temperance,* 120.

24. Cornelius, *Constitution Making in Illinois,* 71.

25. Ibid. Cook County consistently opposed putting woman suffrage on the ballot during the constitutional convention deliberations. No other region of Illinois showed a pattern of voting against woman suffrage.

26. "Susan B. Anthony," *Danville Weekly News,* February 5, 1877, 4.

27. "Susan B. Anthony," *Danville Commercial,* February 1 and 8, 1877, 1 and 1.

28. Buechler, *Transformation of the Woman Suffrage Movement,* 108.

29. "IES Association," *Danville Daily-News,* March 2, 1894, 7.

30. *Woman's Journal,* November 3, 1894, 348. The *Woman's Journal* was the magazine of the National American Woman's Suffrage Association.

31. *Woman's Journal,* September 22, 1900, 303.

32. Illinois State Archives, *Illinois Women: 75 Years of the Right to Vote,* 34.

33. Wheeler, *The Roads They Made,* 53–54; Buechler, "Social Change and Movement Transformation," 324.

34. Buechler, "Social Change and Movement Transformation," 310, 501.

35. "IES Association," *Danville Daily-News,* March 1, 1894.

36. Ibid., March 1, 1894.

37. E-mail correspondence with Rosamond McDonel and Dan Olmsted, members of the Webster family, September 2005.

38. "IES Association," *Danville Daily News,* March 2, 1894, 7.

39. *Woman's Journal,* November 3, 1894, 348.

40. Ibid. and October 13, 1894, 322.

41. Belden, *A History of the Woman Suffrage Movement in Illinois,* 37; *Woman's Journal,* October 13, 1894, 322, and November 3, 1894, 349.

42. Victoria Bissell Brown, "Jane Addams, Progressivism, and Woman Suffrage," 180.

43. Addams, *The Modern City and the Municipal Franchise for Women,* 4.

44. Victoria Bissell Brown, "Jane Addams, Progressivism, and Woman Suffrage," 180.

45. Addams, *The Modern City and the Municipal Franchise for Women,* 16.

46. Danville Woman's Club yearbooks, 1897–98, 8; 1899–1900, 18.

47. Minutes of the annual convention of the Illinois Federation of Women's Clubs (IFWC), 1904.

48. Ibid.

49. Schultz and Hast, eds., *Women Building Chicago, 1790–1990,* 634.

50. Minutes of the annual convention of IFWC, 1904.

51. Ibid.

52. Ibid.; Schultz and Hast, eds., *Women Building Chicago,* 214–16.

53. Minutes of the annual convention of IFWC, 1904.

54. Ibid.

55. Harper, ed., *History of Woman Suffrage,* 160.

56. Buechler, "Social Change and Movement Transformation," 551.

57. Buechler, *The Transformation of the Woman Suffrage Movement,* 172–73.

58. Marshall, *Splintered Sisterhood,* 51.

59. Thurmer, "Better Citizens without the Ballot," 206, 212–15.

60. Illinois Association Opposed to Woman Suffrage, *Bulletin,* no. 6 (December 1910).

61. Ibid., no. 7 (March 1911); no. 10 (December 1911).

62. Ibid., no. 7 (March 1911).

63. Ibid., no. 4 (June 1910).

64. Ibid., no. 7 (March 1911).

65. "Doesn't Believe Women Want Vote," *Danville Commercial-News,* June 14, 1913, 6.

66. "The City Campaign," *Danville Banner,* March 4, 1909, 4.

67. Ibid., July 8, 1909, 4.

68. Vermilion County Court, Recognizance Records, 1894–1920; minutes of the Danville City Council, 1895–1915.

69. *Danville Banner,* January 28, 1909.

70. *Danville Press-Democrat,* April 9, 18, and 22, 1909, 12, 1, 12, respectively.

71. Ibid., April 8, 17, and 20, 1909, .

72. Untitled, *Danville Banner,* July 8, 1909, 4.

73. Danville Didn't Go Dry," *Danville Banner,* April 7, 1910, 1.

74. The Vote Buying Machine," May 10, 1910, 1.

75. "Mr. Voter," *Danville Commercial-News,* February 14, 1911, 1; "Grand Jury Has Finished Sitting," *Danville Press-Democrat,* March 15, 1911, 10. One official, Vermilion County treasurer Hardy Whitlock—who had strongly criticized political corruption in Danville—was later indicted. The grand jury commended Judge E. M. E. Kimbrough, who "has stood alone among the public officials of Vermilion County" in aiding the jury's investigations. The judge was the widower of Julia Kimbrough.

76. Trout, "Side Lights on Illinois Suffrage History," 107.

77. Ibid.

78. Goldstein, *The Effects of the Adoption of Woman Suffrage,* 232.

79. *Woman's Journal,* June 21, 1913, 143; August 9, 1913, 156; October 4, 1913, 313.

80. *Illinois State Progressive,* October 22, 1914.

81. Ibid.

82. Vermilion County Board of Election Commissioners, Election Abstracts, November 3, 1914.

83. "Only Two Sides," *Danville Press-Democrat,* April 3, 1913, 1.

84. Vermilion County Board of Election Commissioners, Election Abstracts, April 20, 1915.

85. *Danville Morning Press,* April 7, 1915.

86. Minutes of the Danville City Council, May 1917.

87. *Danville Commercial-News,* April 12–15, 1917.

88. Ibid., April 19, 1917.

89. Pickett, ed., *Cyclopedia of Temperance, Prohibition and Public Morals,* 87; Cherrington, ed., *Standard Encyclopedia of the Alcohol Problem,* 2:1288.

90. Minutes of the Danville City Council, May 6, 1918. Oral interviews, Vermilion County Recognizance Records, and other information indicate that Danville may have been legally "dry" from 1917 to 1932 but that liquor was available, abundantly and publicly, just outside the city as well as within the city.

91. Information obtained from interviews with Laury's daughters, Joan Ring and Susan Freedlund, spring 2003 and fall 2004.

92. Lottie Jones, *History of Vermilion County,* 2:299–301.

93. Telephone interview with granddaughter Marilyn Coolley Carley, September 28, 2004; clippings from Marilyn Carley. During the 1930s and 1940s Nellie Coolley wrote a regular column for the *Commercial-News* combining bridge instruction and social notes. Carley remembered her grandmother laying out bridge hands with her when she was four years old.

94. "Tuberculosis Death Rate in County Is High, Doctor Tells Local Rotary Club," *Danville Commercial-News,* June 10, 1929, 4.

95. Interview with Marilyn Coolley Carley, September 28, 2004; interview with Lee McGrath, May 31, 2001.

96. *Danville Commercial-News* and *Danville Press-Democrat,* January 10, 1917; YWCA Papers.

97. Trout, "Side Lights on Illinois Suffrage History," 111–12; Buechler, *The Transformation of the Woman Suffrage Movement,* 662.

98. Trout, "Side Lights on Illinois Suffrage History," 112.

99. "Mrs. Trout Reelected," *Danville Morning Press,* November 2, 1917, 10, 16.

100. Ibid.

101. Trout, "Side Lights on Illinois Suffrage History," 113.

102. "IESA," *Danville Morning Press,* November 1 and 2, 1917, 12.

103. Ibid., November 2, 1917.

104. Ibid. The *Danville Morning Press* printed Trout's entire speech.

105. *Danville Morning Press,* November 2, 1917, 10.

106. Ibid., November 3, 1916, 12; Vermilion County Board of Election Commissioners, Election Abstracts, November 1916.

107. McArthur, *Creating the New Woman*, 134.

108. Minutes of meetings of the Woman's Committee, Council of National Defense, Illinois Division, May 15, 1917.

109. Boynton, "Even in the Remotest Parts of the State," 318.

110. Ibid.

111. Ibid., 337; minutes of the Woman's Committee, Council of National Defense, Illinois Division, April 23, 1918.

112. Trout, "Side Lights on Illinois Suffrage History," 113; Cornelius, *Constitution Making in Illinois*, 109–10.

113. Program for the 1920 convention of National American Woman Suffrage Association (NAWSA) and the Congress of the League of Women Voters.

114. Illinois League of Women Voters, board of directors, 1921.

115. Program for the 1920 convention of NAWSA.

116. Interviews with Rose Fava Merlie, February 20, 2000, Elizabeth Pitlick, July 18, 2006, Wesley Walker, July 12, 2003, and Mary Duitsman, daughter of Maybelle Hill Michael, January 2003; telephone interview with Barbara Johnson, daughter of Zella Mae Laury, July 18, 2006; diary of Doris Zook; interviews with Zook's granddaughter Mary Coffman, 2004 and 2005; telephone interview with Marilyn Carley.

117. Buechler, *The Transformation of the Woman Suffrage Movement*, 182.

EPILOGUE: THE DIARY OF DORIS ZOOK

1. Dorothy Brown, *Setting a Course*, 29.

2. G. Stanley Hall, quoted in ibid., 32.

3. Interview with Mary Coffman, July 10, 2006.

4. Fine, *Souls of the Skyscraper*, 139.

5. Meyerowitz, *Women Adrift*, 125.

6. Fine, *Souls of the Skyscraper*, 156.

7. Interview with Carolyn Miller, November 20, 2005; interview with Mary Coffman, July 10, 2006.

BIBLIOGRAPHY

ARCHIVAL MATERIALS

Chautauqua Association Archives, Chautauqua, New York: miscellaneous papers and correspondence

Chicago Historical Society: program for the 1920 convention of the NAWSA and the Congress of the League of Women Voters

Danville Clover Club: miscellaneous papers

Danville Public Library: Danville city directories, Vermilion County manuscript censuses, vertical-file information

Danville Woman's Club: yearbooks

Danville Young Women's Christian Association (now Your Family Resource Center): miscellaneous papers

First Baptist Church: in-house publication and miscellaneous papers

First Presbyterian Church: in-house publication and miscellaneous papers

Illiana Genealogical and Historical Society Library: obituaries, miscellaneous papers

Illinois Historical Survey: *Bulletins* of the Illinois Association Opposed to Woman Suffrage; John Walker papers

Illinois State Library: Illinois Federation of Women's Clubs papers

St. James United Methodist Church: scrapbooks and pictures

Vermilion County Children's Home Board minutes and miscellaneous papers

Vermilion County Museum: Danville city directories, Danville Woman's Club scrapbooks, miscellaneous diaries, vertical-file information

Woman's Christian Temperance Union National Library, Evanston, Illinois: WCTU annual minutes, Illinois WCTU annual minutes

GOVERNMENT DOCUMENTS

Danville, Illinois, City Council. Minutes. 1894–1920.

Fifth Circuit Court, Vermilion County, Illinois, Recognizance Records. 1880–1920.

U.S. Bureau of the Census. *Fourteenth Census of the United States. Total Persons 10 Years of Age and Over Engaged in Each Specified Occupation, Classified by Sex, for Cities Having 25,000 to 100,000 Inhabitants.* 1920.

———. *Twelfth Census of the United States, Taken in the Year 1900.* New York: Norman Ross, 1997.

———. *Thirteenth Census of the United States. Total Persons 10 Years of Age and Over Engaged in Each Specified Occupation, Classified by Sex, for Cities Having 25,000 to 100,000 Inhabitants.* 1910.

Vermilion County, Illinois, Board of Election Commissioners. Election Abstracts. 1914–20.

Vermilion County Board of Supervisors. Minutes. 1900–1903.

Women's Committee, Council of National Defense, Illinois Division. Minutes. 1918–19.

———. Records of Conferences. 1918–19.

NEWSPAPERS AND PERIODICALS

Danville Banner
Danville Commercial
Danville Commercial-News
Danville Daily News
Danville Evening Commercial
Danville Morning Press
Danville Press
Danville Press-Democrat
Danville Sunday Press
Danville Weekly News
Danville Weekly Press
Heritage of Vermilion County
Illiana Genealogist
Illinois State Progressive
Journal of Illinois History
Journal of the Illinois State Historical Society
Woman's Journal

BOOKS, ARTICLES, THESES, AND DISSERTATIONS

Addams, Jane. *Democracy and Social Ethics.* Cambridge, Mass.: Harvard University Press, 1977.

———. *The Modern City and the Municipal Franchise for Women.* New York: National American Woman Suffrage Association, 1911.

———. *A New Conscience and an Ancient Evil.* New York: Macmillan, 1912. Reprint, Urbana & Chicago: University of Illinois Press, 2002.

Ahlstrom, Syidney E. *A Religious History of the American People.* New Haven, Conn. & London: Yale University Press, 1972.

American Baptist Foreign Mission Society. 113th Annual Report, 1926–27.

Atlas of Vermilion County, Illinois. Danville, Ill.: E. S. Boudinot, 1907. Reproduction, Evansville, Ind.: Illiana Genealogical and Historical Society / Unigraphic, 1977.

Beaver, R. Pierce. *American Protestant Women in World Mission: History of the First Feminist Movement in North America*. Grand Rapids, Mich.: Eerdmans, 1980.

Belden, Gertrude May. "A History of the Woman Suffrage Movement in Illinois." Master's thesis, University of Chicago, 1913. Typescript copy, Illinois Historical Society.

Benson, Susan Porter. *Counter Cultures: Saleswomen, Managers, and Customers in American Department Stores, 1890–1940*. Urbana: University of Illinois Press, 1986.

Blair, Karen J. *The Clubwoman as Feminist: True Womanhood Redefined, 1868–1914*. New York: Holmes & Meier, 1980.

Bordin, Ruth. *Woman and Temperance: The Quest for Power and Liberty, 1873–1900*. New Brunswick, N.J.: Rutgers University Press, 1981.

Boynton, Virginia R. "'Even in the Remotest Parts of the State': Downstate 'Woman's Committee' Activities on the Illinois Home Front during World War I." *Journal of the Illinois State Historical Society* 96 (Winter 2003–4): 316–20.

Bremer, Sidney H. Introduction to *The Precipice*, by Elia W. Peattie. Urbana: University of Illinois Press, 1989.

Brown, Dorothy M. *Setting a Course: American Women in the 1920s*. Boston: Twayne, 1987.

Brown, Victoria Bissell. "Jane Addams, Progressivism, and Woman Suffrage: An Introduction to 'Why Women Should Vote.'" In *One Woman, One Vote: Rediscovering the Woman Suffrage Movement*, edited by Marjorie Spruill Wheeler, 179–95. Troutdale, Ore.: NewSage Press, 1995.

Buechler, Steven Michael. "Social Change and Movement Transformation: The Deradicalization of the Illinois Women's Rights / Woman Suffrage Movement, 1850–1920." Ph.D. diss., State University of New York at Stony Brook, 1982.

———. *The Transformation of the Woman Suffrage Movement: The Case of Illinois, 1850–1920*. New Brunswick, N.J.: Rutgers University Press, 1986.

Burford, Cary Clive, and Guy McIlvaine Smith. *The History and Romance of Danville Junction; or, When Rails Were the Only Trails*. Danville, Ill.: Interstate Publishing, 1942.

Butler, Anne M. *Daughters of Joy, Sisters of Misery: Prostitutes in the American West, 1865–90*. Urbana & Chicago: University of Illinois Press, 1987.

Case, Victoria, and Robert Ormond Case. *We Called It Culture: The Story of Chautauqua*. Garden City, N.Y.: Doubleday, 1938.

Catherwood, Mary Hartwell. *The Spirit of an Illinois Town*. Boston & New York: Houghton, Mifflin, 1897.

Cherrington, Ernest Hurst, ed. *Standard Encyclopedia of the Alcohol Problem*. 6 vols. Westerville, Ohio: American Issue Publishing, 1925–30.

"Cleona Lewis: Farm Girl to Economist." *Heritage of Vermilion County* 19 (Summer 1983): 10–11.

Cordasco, Francesco, with T. M. Pitkin. *The White Slave Trade and the Immigrants: A Chapter in American Social History.* Detroit: Ethridge, 1981.

Cornelius, Janet. *Constitution Making in Illinois, 1818–1970.* Urbana & Chicago: University of Illinois Press, 1972.

Cullen, Kevin. "Sad to Leave Home." *Danville Commercial News,* May 5, 1993.

Davis, Elizabeth Lindsay. *The Story of the Illinois Federation of Colored Women's Clubs.* Chicago: Federation of Colored Women's Clubs, 1922.

Deegan, Mary Jo, ed. *New Woman of Color: Collected Writings of Fannie Barrier Williams.* DeKalb: Northern Illinois University Press, 2002.

Donovan, Brian. *White Slave Crusades: Race, Gender, and Anti-Vice Activism, 1887–1917.* Urbana & Chicago: University of Illinois Press, 2006.

"Far from the Madding Crowd." *Heritage of Vermilion County* 29 (Summer 1993): 4–10, 16.

Fine, Lisa M. *Souls of the Skyscraper: Female Clerical Workers in Chicago, 1870–1930.* Philadelphia: Temple University Press, 1990.

Gere, Anne Ruggles. *Intimate Practices: Literacy and Cultural Work in U.S. Women's Clubs, 1880–1920.* Urbana & Chicago: University of Illinois Press, 1997.

Giele, Janet Zollinger. *Two Paths to Women's Equality: Temperance, Suffrage and the Origins of Modern Feminism.* New York: Twayne, 1995.

Ginzberg, Lori. *Women and the Work of Benevolence: Morality, Politics, and Class in the Nineteenth-Century United States.* New Haven, Conn.: Yale University Press, 1990.

Goldstein, Joel H. *The Effects of the Adoption of Woman Suffrage: Sex Differences in Voting Behavior—Illinois, 1914–21.* New York: Praeger Special Studies, 1984.

Gusfield, Joseph. *Symbolic Crusade: Status Politics and the American Temperance Movement.* Westport, Conn.: Greenwood Press, 1970.

"Hacker's Fair, Everyone's Store." *Heritage of Vermilion County* 29 (Summer 1993): 13, 16.

Harper, Ida H., ed. *History of Woman Suffrage.* Vol. 5. New York: National American Woman Suffrage Association, 1922.

Hendricks, Wanda A. *Gender, Race, and Politics in the Midwest: Black Club Women in Illinois.* Bloomington: Indiana University Press, 1998.

Hill, Patricia R. *The World Their Household: The American Woman's Foreign Mission Movement and Cultural Transformation.* Ann Arbor: University of Michigan Press, 1985.

"History of the Veterans Administration Hospital, Danville, Illinois." *Bulletin* (Veterans Hospital, Danville), April 3, 1965, 20–35.

Hobson, Barbara Meil. *Uneasy Virtue: The Politics of Prostitution and the American Reform Tradition.* New York: Basic Books, 1987.

Illinois State Archives. *Illinois Women: 75 Years of the Right to Vote.* Chicago: Chicago Sun Times, 1996.

Illustrated History of the National Home for Disabled Volunteer Soldiers, Danville Branch. Danville, Ill.: National Hope for Disabled Volunteer Soldiers, 1903.

James, Janet Wilson, ed. *Women in American Religion.* Philadelphia: University of Pennsylvania Press, 1980.

Jones, Lottie. *History of Vermilion County.* 2 vols. Chicago: Pioneer Publishing, 1911.

Jones, Mary. *The Women Who Pioneered St. James.* Danville, Ill.: St. James Methodist Episcopal Church, 1957.

Jones, Trevor. "An Ordinary Life in Illinois: The Diaries of Zay Wright." *Journal of Illinois History* 8 (Autumn 2003): 227–40.

Keiser, John H. "John H. Walker: Labor Leader from Illinois." In *Essays in Illinois History,* edited by Donald F. Tingley, 75–100. Carbondale: Southern Illinois University Press, 1968.

Knight, Louise W. *Citizen: Jane Addams and the Struggle for Democracy.* Chicago and London: University of Chicago Press, 2005.

Krumreig, Edward L. *History of the First Baptist Church of Danville, Illinois.* Danville: Illinois Printing, 1919.

Levin, Sam. "Joseph Cannon." *Heritage of Vermilion County* 4 (Summer 1965): 2–9.

Magalis, Elaine. *Conduct Becoming to a Woman: Bolted Doors and Burgeoning Missions.* New York: Women's Division, Board of Global Ministries, United Methodist Church, 1973.

Marks, Nora. "Living in Poorhouses." *Danville Weekly Press,* March 20, 1889. Reprint, *Illiana Genealogical and Historical Society* 36 (Spring 2000): 14–15.

Marshall, Susan. *Splintered Sisterhood: Gender and Class in the Campaign against Woman Suffrage.* Madison: University of Wisconsin Press, 1997.

Martin, Margaret. "Red Cross: The Vermilion County Chapter." *Heritage of Vermilion County* 17 (Summer 1981): 6–10.

Martin, Theodora Penny. *The Sound of Our Own Voices: Women's Study Clubs, 1860–1910.* Boston: Beacon Press, 1987.

McArthur, Judith. *Creating the New Woman: The Rise of Southern Women's Progressive Culture in Texas, 1893–1918.* Urbana & Chicago: University of Illinois Press, 1998.

McCarthy, Kathleen D. *Noblesse Oblige: Charity and Cultural Philanthropy in Chicago.* Chicago: University of Chicago Press, 1982.

Mervis, Sybil Stern. "The Danville Public Library: The Twentieth Century." *Heritage of Vermilion County* 19 (Summer 1983): 2–3, 14–15.

———. "The History of the Jewish Community in Danville, Illinois." *Heritage of Vermilion County* 38 (Winter 2001–2): 2–5, 14–15; 38 (Summer 2002): 8–11, 14.

Meyerowitz, Joanne L. *Women Adrift: Independent Wage Earners in Chicago, 1880–1930.* Chicago: University of Chicago Press, 1988.

Mills, Louise. "The Jones Family." *Heritage of Vermilion County* 4 (Winter 1967–68): 16–17.

Moore, Marie. *History of St. James United Methodist Church.* Danville, Ill.: St. James United Methodist Church, 1976.

Morrison, Theodore. *Chautauqua: A Center for Education, Religion, and the Arts in America.* Chicago: University of Chicago Press, 1974.

Murdock, Catherine Gilbert. *Domesticating Drink: Women, Men, and Alcohol in America, 1870–1940.* Baltimore: Johns Hopkins University Press, 1998.

Murolo, Priscilla. *The Common Ground of Womanhood: Class, Gender, and Working Girls' Clubs, 1884–1928.* Urbana & Chicago: University of Illinois Press, 1997.

Nelms, Louise, and Eleanor Yeomans. *The History of First Presbyterian Church, Danville, Illinois.* Revised ed. Danville, Ill.: First Presbyterian Church, 2001.

Norwood, Frederick A. *The Story of American Methodism.* Nashville: Abingdon Press, 1974.

Odem, Mary E. *Delinquent Daughters: Protecting and Policing Adolescent Female Sexuality in the United States, 1885–1920.* Chapel Hill: University of North Carolina Press, 1995.

Olmsted, Dan. *In Their Own Words: An Informal History of the Children's Home of Vermilion County.* Danville, Ill.: Center for Children's Services, 1989.

Pearson, Gustavus. *Past and Present of Vermilion County, Illinois.* Chicago: S. J. Clarke, 1903.

Phoenix, Joanna. *Making Sense of Prostitution.* New York: St. Martin's Press, 1999.

Pickett, Deets, ed. *Cyclopedia of Temperance, Prohibition and Public Morals.* New York: Methodist Book Concern, 1917.

Pivar, David. *Purity and Hygiene: Women, Prostitution, and the "American Plan," 1900–1930.* Westport, Conn.: Greenwood Press, 2002.

Poplett, Carolyn O. *The Woman Who Never Fails: Grace Wilbur Trout and Illinois Suffrage.* Oak Park, Ill.: Oak Park Historical Society, 2000.

Rawlings, Isaac D. *The Rise and Fall of Disease in Illinois.* Vol. 2. Springfield, Ill.: State Department of Public Health, 1927.

Report of the Senate Vice Committee Created under the Authority of the 48th General Assembly, State of Illinois. Chicago: State of Illinois, 1916.

Richter, Donald G. *Here Stands the Law.* Danville, Ill.: Vermilion County Museum, 1998.

———. "Railroads and People of Vermilion County, Part Three." *Heritage of Vermilion County* 28 (Winter 1991–92): 10–16.

Richter, Donald, and Sue Richter. "The Great White Store." *Heritage of Vermilion County* 23 (Winter 1986–87): 17.

Richter, Susan. "Y.W.C.A. Danville, Illinois." *Heritage of Vermilion County* 24 (Spring 1988): 2–9.

———. "Yesterday's Recipes." *Heritage of Vermilion County* 29 (Autumn 1993): 10–12.

Robert, Dana L. *American Women in Mission.* Macon, Ga.: Mercer University Press, 1977.

Rosen, Ruth. *The Lost Sisterhood: Prostitution in America.* Baltimore: Johns Hopkins University Press, 1981.

Roydhouse, Marion W. "Bridging Chasms: Community and the Southern YWCA." In *Visible Women: New Essays on American Activism,* edited by Nancy A. Hewitt and Suzanne Lebsock, 270–95. Urbana & Chicago: University of Illinois Press, 1977.

Sampson, Robert. "Incident at Grape Creek." *Journal of Illinois History* 11 (Spring 2006): 2–22

Santmyer, Helen Hooven. *". . . And Ladies of the Club."* New York: Putnam, 1984.

Schultz, Rima Lunin, and Adele Hast, eds. *Women Building Chicago, 1790–1990: A Biographical Dictionary.* Bloomington: Indiana University Press, 2001.

Scott, Anne Firor. *Natural Allies: Women's Associations in American History.* Urbana & Chicago: University of Illinois Press, 1991.

Short, Bobby. *Black and White Baby.* New York: Dodd, Mead, 1971.

Sims, Mary. *The Natural History of a Social Institution—the Y.W.C.A.* New York: Little & Ives, 1935.

Smith-Rosenberg, Caroll. *Disorderly Conduct: Visions of Gender in Victorian America.* New York: Knopf, 1985.

Standard Atlas of Vermilion County, Illinois. Chicago: Ogle, 1915. Facsimile ed. Danville, Ill.: Illiana Genealogical and Historical Society / Evansville, Ind.: Unigraphic, 1977.

Stapp, Katherine. *Footprints in the Sands: Founders and Builders of Vermilion County, Illinois.* Danville, Ill.: Interstate Printers & Publishers, 1975.

Stapp, Katherine, and W. I. Bowman. *History under Our Feet: The Story of Vermilion County, Illinois.* Danville, Ill.: Interstate Printers & Publishers, 1968.

Talbot, Mary Lee. "A School at Home: The Contribution of the Chautauqua Literary and Scientific Circle to Women's Educational Opportunities in the Gilded Age, 1874–1900." Ph.D. diss., Columbia University, 1997.

Tax, Meredith. *The Rising of the Women: Feminist Solidarity and Class Conflict, 1880–1917.* Urbana & Chicago: University of Illinois Press, 2001.

Thurmer, Manuela. "'Better Citizens without the Ballot': American Anti-Suffrage Women and Their Rationale during the Progressive Era." In *One Woman, One Vote: Rediscovering the Woman Suffrage Movement,* edited by Marjorie Spruill Wheeler, 203–20. Troutdale, Ore.: NewSage Press, 1995.

Trout, Grace Wilbur. "Side Lights on Illinois Suffrage History." In *Transactions of the Illinois State Historical Society for the Year 1921,* 93–116. Springfield: Board of Trustees of the Illinois State Historical Library, 1921.

Turner, Elizabeth Hayes. *Women, Culture, and Community: Religion and Reform in Galveston, 1880–1920.* Urbana & Chicago: University of Illinois Press, 1999.

Verdesi, Elizabeth Howell. *In but Still Out: Women in the Church.* Philadelphia: Westminster Press, 1976.

Welter, Barbara. "The Cult of True Womanhood, 1820–1860." *American Quarterly* 18 (Summer 1966): 151–74.

Wheeler, Adade Mitchell. *The Roads They Made: Women in Illinois History.* Chicago: Kerr, 1977.

Williams, Jack Moore. *History of Vermilion County.* 2 vols. Topeka & Indianapolis: Historical Publishing, 1930.

Wilson, Elizabeth. *Fifty Years of Association Work among Young Women, 1866–1916: A History of Young Women's Christian Associations in the United States of America.* New York: Young Women's Christian Association, 1916.

Woloch, Nancy. *Women and the American Experience*. 3rd ed. Boston: McGraw-Hill, 2000.

Wood, Mary I. *The History of the General Federation of Women's Clubs for the First Twenty-Two Years*. New York: General Federation of Women's Clubs, 1912.

Wright, Bob. *Danville: A Pictorial History*. St. Louis: Bradley, 1987.

Yohn, Susan M. *A Contest of Faiths*. Ithaca, N.Y.: Cornell University Press, 1955.

INDEX

ABOUT THE AUTHORS

JANET DUITSMAN CORNELIUS is retired from the history faculty at Danville Area Community College and is an adjunct professor at Eastern Illinois University. She is the author of *"When I Can Read My Title Clear": Literacy, Slavery, and Religion in the Antebellum South* and *Slave Missions and the Black Church in the Antebellum South*.

MARTHA LAFRENZ KAY is retired from the literature and humanities faculty at Danville Area Community College.